PICTURED WORLDS

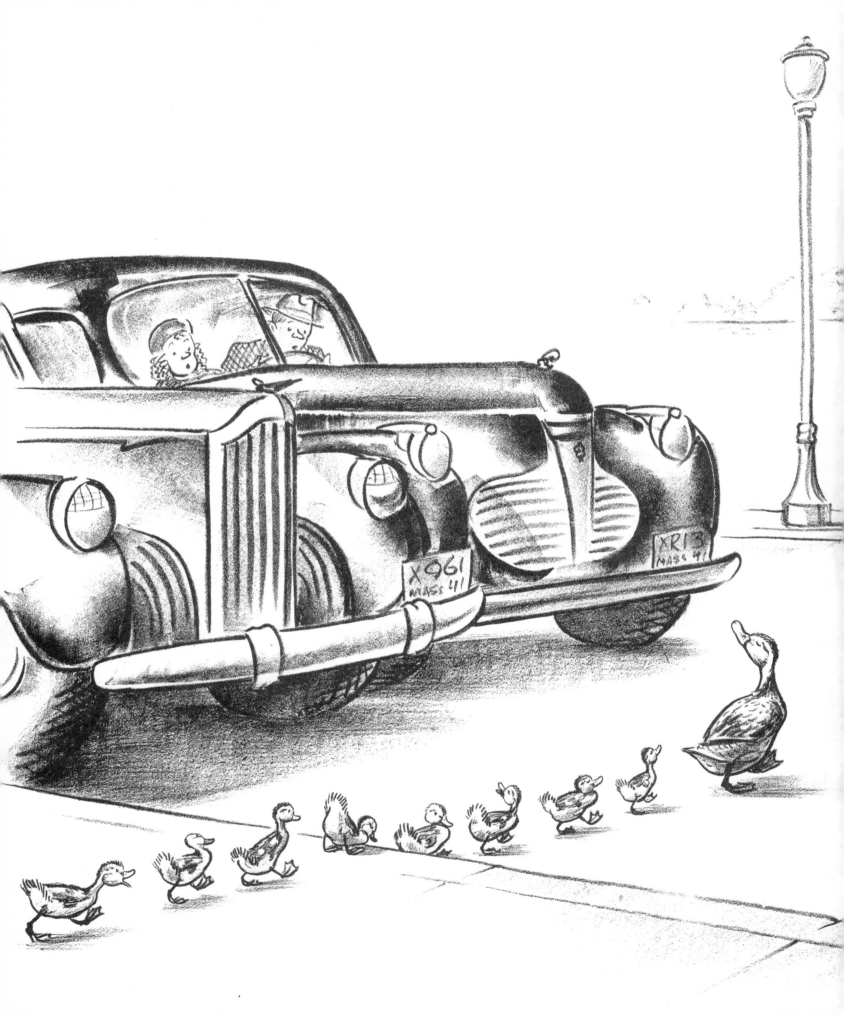

PICTURED WORLDS

MASTERPIECES OF CHILDREN'S BOOK ART
BY 101 ESSENTIAL ILLUSTRATORS FROM AROUND THE WORLD

LEONARD S. MARCUS

ABRAMS, NEW YORK

CONTENTS

INTRODUCTION

The ideal children's book, John Locke observed, is "easy, pleasant . . . and suited to [the child's] Capacity."[1] Published in London in 1693, Locke's revolutionary advice book was called *Some Thoughts Concerning Education* and had something to say about all aspects of a child's upbringing, starting with the body and ending with the mind. A child psychologist before his time, Locke speculated on the types of books best suited to young people's capabilities and interests. In doing so, he laid the groundwork for modern-day children's literature. Noting, for example, that a child who feels scolded or lectured to is less apt to pay attention than one for whom learning is cast as a game, he argued that a good children's book is one in which "the Entertainment that [the child] finds might draw him on, and reward his Pains in Reading." Locke listed brevity and the addition of illustrations as two other key elements of effective bookmaking for the young. Pictures, he said, were an essential ingredient because, from the child's perspective, showing always works better than telling.

Widely popular in the West, Locke's treatise inspired entrepreneurial bookmen like London's John Newbery—affectionately dubbed "Jack Whirler" by literary lion Samuel Johnson—to specialize in publishing juveniles in the mold of his forward-looking ideas. In doing so, Newbery established the first commercial market for children's books in the West.[2] Newbery's small, trim paperbacks sold briskly to the burgeoning ranks of upwardly striving middle-class English parents and were soon being imitated, or simply pirated, in North America. Half a world away, in the vibrant commercial city of Edo, Japan, a comparable retail trade in *akahon*, or "red-bound" picture books for young readers, had sprung up independently of developments in

Britain but for much the same reasons.[3] A clear pattern thus emerged that would repeat itself elsewhere around the globe many times over: the recognition of a critical link between literacy and economic and social advancement, and of the illustrated children's book as a gateway to literacy and a better life.

An occasional illustrated book for young readers had appeared in the West before Locke, most notably Johann Amos Comenius's *Orbis Sensualium Pictus* (1658), a picture encyclopedia and language primer that remained in print in one form or another well into the nineteenth century.[4] But it was Locke's prestigious endorsement that crystallized educated opinion and established the modern children's book's norms. By the time *Alice's Adventures in Wonderland*'s first readers were asked to consider, "What is the use of a book without pictures or conversations?," the answer was

The first English-language edition of this hugely influential book appeared in London in 1659.

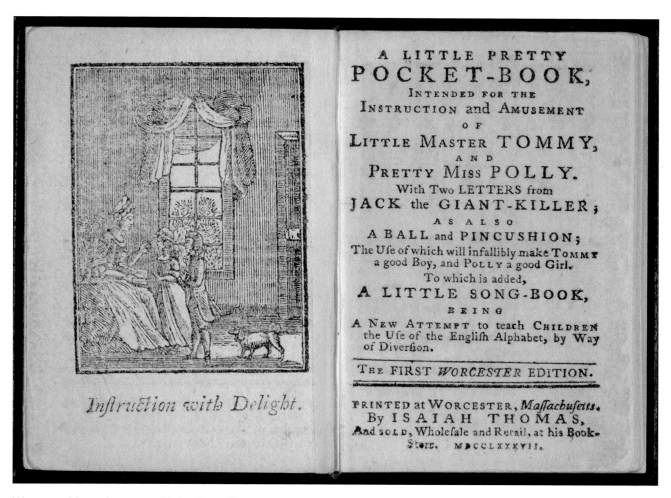

Worcester, Massachusetts, publisher Isaiah Thomas issued this popular North American edition of John Newbery's first children's book forty-three years after its initial 1744 publication in London.

plain, Locke's prescient "thoughts" having long since taken their place as literary guideposts for the new literature for young people.[5]

To illustrate his *Alice* fantasies, Charles Dodgson, the Oxford don known to the world as Lewis Carroll, turned to John Tenniel, the lead artist at Victorian England's most prestigious humor magazine, *Punch*. From the mid-nineteenth century onward, pictorial magazines and newspapers in England, Germany, France, the United States, and other countries served as a major recruiting ground for artists with the kinds of skills needed to meet the spiraling demand for juveniles, a knack for narrative and an irreverent spirit chief among them. Before the century was out, the European broadside and periodical press had spawned another lively new genre, the serial strip cartoon, whose cross-generational appeal made it a powerful circulation driver for newspapers on both sides of the Atlantic. The "funny papers," it soon became clear, were capable not only of entertaining but also, as in the case of the American Winsor McCay's *Little Nemo in Slumberland*, of thrilling readers with the antic verve and originality of their draftsmanship and narrative ambition.[6]

Soaring literacy rates and middle-class expectations fed the demand for children's books across the nineteenth-century industrial world, with London at the center. As advances in printing technology made color illustration an affordable option, the artistically

Was not that

a dainty Dish

(198)

(199)

Sing a Song for Sixpence, illustrated by Randolph Caldecott (London: George Routledge & Sons, 1880)

refined English picture book gathered steam and flourished. Edmund Evans, a noted London printer and proto-book-packager, presided over a popular line of "toy books" created by a stable of accomplished contract artists.[7] The select group included Walter Crane, Kate Greenaway, and, best of all, Randolph Caldecott, the red-bearded, self-taught illustrator whose jaunty wit and kinetic approach to drawing and composition propelled the picture book into exciting new graphic territory.[8] From then onward, narrative artists were keenly aware of the picture book as a viable art form for dabbling in if not building a solid career. Beatrix Potter, for one, who grew up in London with framed Caldecott originals on the walls of her parents' stately Kensington home, made a lifework of her "little books for little hands," which, starting with *The Tale of Peter Rabbit* (1902), spread rapidly in translation across

Europe and to North America, where they became mainstays of public library collections everywhere. In France, two trained academic painters, Louis-Maurice Boutet de Monvel and Edouard Léon Louis Edy-Legrand, seized the cultural moment by creating exquisite pictorial "albums" for children that were immediately hailed as genre touchstones. In Sweden, artists Carl Larsson and Elsa Beskow entered the field under the influence of their friend the visionary philosopher Ellen Key, who argued in *The Century of the Child* (1900) that the survival of mankind depended on a radical elevation of home life over formal education as the primary formative influence on the citizens of the future.[9]

For turn-of-the-last-century children, elegant gift editions of fairy tales and other classic stories came into fashion. England's Arthur Rackham and his

French-born rival Edmund Dulac made their names as masters of the genre, as did Americans, led by Howard Pyle and N. C. Wyeth, and the Russian illustrator Ivan Bilibin, who produced his first deluxe editions based on traditional Russian folk stories in collaboration with the tsar's own printer and somehow survived the Bolshevik Revolution with his reputation intact. As the literacy-minded middle class continued to expand, artists experimented with novelty formats that promised the added child appeal of a favorite toy. The unrivaled innovator of the three-dimensional pop-up or movable book was Germany's Lothar Meggendorfer, a satirical cartoonist by training who, like Randolph Caldecott, approached the illustrated children's book in a forward-leaning spirit that presaged the coming of the motion picture.[10]

Developments with far-reaching consequences unfolded in the United States around 1900 as social reformers fought to safeguard the well-being of the nation's children, especially those living in America's rapidly growing cities. As significant victories were won in the areas of medical care, public education, and child labor regulation, public librarians debated whether they, too, had a role to play in ensuring the welfare of minors. By the time industrialist Andrew Carnegie announced his historic gift of a national network of public library buildings, the question had been decided, and the world's first children's reading rooms were introduced as a standard feature of the libraries, to be staffed by the world's first full-time children's library professionals. Publishers took note of these changes and hired specialists of their own to meet the needs of the potentially vast new institutional market. Immediately after the First World War, American publishing houses in New York and Boston seized the moment to become the first firms in the world to establish editorial departments dedicated solely to juvenile literature.

It was not by chance that the modest new departments—consisting typically of a single editor and perhaps a secretary—were all staffed by women. The houses' male top executives patronizingly regarded publishing for children as "women's work." As a result, the pioneering professionals who accepted the jobs were often forced to withstand the withering slights of their employers. These editors, however, found strong allies in their librarian counterparts, and together the two groups worked symbiotically to establish high standards for children's books and to promote public appreciation of the books as a life-enhancing first experience of literature, art, and culture. By the mid-1920s, a heady boom time for American commercial and cultural enterprise alike, the librarians and editors had forged an impressive—and, as it turned out, durable—system for the achievement of their goals, an institutional structure that included Children's Book Week as an annual national publicity campaign, *The Horn Book* magazine as the world's first children's literature review journal, and the John Newbery Medal as the first literary prize awarded to a writer of books for young readers.[11]

European and, later, Asian publishers adopted aspects of the American model, but the zealous sense of purpose that propelled twentieth-century children's book publishing forward took other forms as well. In the Soviet Union after the 1917 Revolution, the central government embraced children's literature as an essential tool of nation building and sponsored the publication of illustrated books for the young designed to engage their interest in the collective dream of the new Soviet society. Like the era's graphically striking posters, picture books illustrated by Vladimir Lebedev, Mikhail Tsekhanoveskii, and others telegraphed inspirational messages in a spirited visual shorthand that not only helped shape the perceptions of millions of Soviet children but also fueled the experimental efforts of picture book artists in Paris and New York.

Building on the empirical observations of John Locke, Friedrich Fröbel, and others, early-twentieth-century psychologists systematically charted the stages of childhood development, and in the United States, progressive educators searched for ways to translate the psychologists' discoveries into more effective, child-centered approaches to teaching and learning. At New York's Bureau of Educational Experiments (later the Bank Street College of Education), founder Lucy Sprague Mitchell studied the natural arc of language development and its implications for books for children as young as two. Soon Mitchell's research findings put her squarely at odds with the

Study for *Ame no Hi no Orusuban* ("Staying Home Alone on a Rainy Day"), by Chihiro Iwasaki (Shikosha, 1968)

views of America's leading librarians. For young children, the librarians favored aesthetically refined picture books printed on heavy stock and with elegant cloth bindings, strong narrative art, and "once upon a time" texts meant to transport the child from the crassly commercial modern-day world to more fanciful realms where their imaginations might freely grow and flourish. Mitchell dismissed the librarians' view as Romantic sentiment, arguing that children were in fact little empiricists and sensory learners who longed for books about the "here and now" urban world they knew from experience. Mitchell also believed that young children were too often treated at library story hours as passive observers, and that it was more natural and beneficial for them to be encouraged to speak up, make noise, and participate as full collaborators in the reading and performance of books. For this reason, Mitchell favored picture book texts with a call-and-response or gamelike element and illustrations that depicted everyday subjects in a graphic, semiabstract manner that left more to the imagination than did a literal-minded, realist approach. Not satisfied with theorizing, she groomed a

The late Victorian illustrators Walter Crane, Kate Greenaway, and Randolph Caldecott all had their eyes opened wide by the arrival in the West of Japanese ukiyo-e prints by Hokusai, Hiroshige, and others, which showed them new ways to simplify an image, balance a composition, exploit white space, and integrate decorative elements within a scene. In fact, where illustrated children's literature was concerned, Japan's mid-nineteenth-century opening to the West resulted in a fruitful two-way flow of cultural influences. Japan's educational system and publishing industry both underwent systemic reorganizations based on Western models, and with the advent of a postal service and periodical publishing, a vibrant trade in Western-style illustrated children's magazines developed in Japan that culminated in the launch in 1922 of the artistically daring *Kodomo no kuni* (*Children's Land*), with illustrations that represented a fertile blend of traditional Japanese and European modernist graphic styles.[13]

In 1930s Japan, military glory and imperial conquest became the dominant themes of young people's illustrated books and magazines. In the United States, by contrast, picture books like Marjorie Flack's *Angus and the Ducks* (1930) and Virginia Lee Burton's *Mike Mulligan and His Steam Shovel* (1939) presented an insular and resolutely idyllic view of childhood. The darkening world situation prompted European illustrators such as H. A. Rey, Feodor Rojankovsky, and Tibor Gergely to flee to the safe haven of American shores—and to the creative cauldron that was mid-century Manhattan. The talent and energy these artists brought to their adopted homeland would greatly enrich the American picture book for decades to come.

As the American picture book gathered momentum throughout the years of the Great Depression, librarians decided the time had come for a companion prize to the Newbery Medal for distinguished work by an illustrator. In 1938, the Randolph Caldecott Medal became the world's first award honoring children's book art. As a public statement about library standards, it arrived none too soon, just as the new ten-cent comic books were captivating young readers by the millions with their action-packed (or, as critics argued, crudely sub-literary and escapist) fare. Most children could

corps of young writers, including Margaret Wise Brown and Ruth Krauss, and illustrators, including Leonard Weisgard and Clement Hurd, to put her insights into practice, and even persuaded a Bank Street nursery school parent to launch a publishing company dedicated to bringing their work to the marketplace. The clash of values represented by Mitchell's and the librarians' opposing visions resulted in years of bitter feuding and acrimonious debate and, when cooler heads finally prevailed, in a significant expansion of the picture book's expressive possibilities.[12]

afford to purchase comic books with their own pocket money and often did so when their adult caretakers were not looking—a clandestine arrangement that only added to the comics' allure. The line that librarians drew between high-culture picture books and low-culture comics would prove to be a largely American phenomenon, as Tintin, Astérix, and Moomin cartoons in Europe and manga in Japan all enjoyed broadly based cultural approval as well as commercial success on their home grounds.[14]

Another major challenge to the librarians' authority as literary gatekeepers came in 1942 with the launch of Little Golden Books, a line of colorful, trim, low-budget picture books that dispensed with some of the aesthetic frills favored by the library world in order to make picture books affordable for just about everyone.[15] Little Golden Books were marketed directly to parents at drugstores, five-and-dimes, and supermarkets at the bargain price of twenty-five cents each, a revolutionary approach that for the first time made it possible for families of modest means to create home libraries for their children even if they lived far from the nearest big-city bookstore.

After the Second World War, American juvenile publishing prospered in parallel with the rising birth rate, and idealistic editors in the United States and Europe searched for tangible ways to channel their efforts on behalf of children and their books into a force for world peace. In 1949, with support from the Western publishing community, a German Jewish journalist named Jella Lepman spearheaded the creation of the International Youth Library in Munich as a central repository for the world's children's literature, where visitors from afar might come together to discuss innovative ways to foster cross-cultural awareness through books.[16] In 1953, Lepman made a second major contribution as founder of the International Board on Books for Young People (IBBY), a nonprofit organization designed, in effect, to bring the International Youth Library's work to the rest of the world through a program of conferences, publications, and awards. Then in 1964, a third experiment in internationalist activism would prove to be perhaps the most effective one of all. In that year, the Bologna Children's Book Fair convened for the first time as an annual international

rights fair aimed at facilitating the commercial flow of children's books across national and cultural borders. Publishers from England, France, and Italy formed the core of the first Bologna gathering. The United States soon joined as an enthusiastic participant, as did Japan, whose publishers were eager to establish their place as cultural partners with their counterparts among the Western industrialized nations.[17]

After the war, American picture books became popular in Japan, at first in makeshift translations created by participants in the informal system of *bunko*, or home libraries, organized by volunteer mothers for the benefit of their local communities.[18] As the Japanese publishing industry rapidly reconstituted itself and resumed normal operations, Japanese-language editions of American picture books such as *Curious George* and *Make Way for Ducklings* and of British imports such as *The Tale of Peter Rabbit* became mainstays of the publishers' lists and cherished symbols of renewed friendship with the West. In the years that followed, American picture books not only influenced the direction taken by postwar Japanese writers and illustrators, but also set in motion a decades-long chain of influence that played an important role in the development of picture-book-making in Taiwan, South Korea, and, by the turn of the new century, China.

The postwar years also saw the rise to prominence of a new generation of graphic artists who believed that their work, too, had relevance for building a more harmonious and peaceful world. In Italy, Bruno Munari designed a set of nine unconventional picture books with ingenious paper-engineered, gamelike, three-dimensional novelty effects that blurred the boundary between book, toy, and sculpture and challenged children to approach life with a more open mind.[19] American designers Leo Lionni, Paul Rand, and Eric Carle transferred their facility for crafting poster, logo, and advertising images to picture books that made telling use of white space, boldly simplified forms, and brilliant color contrasts to communicate with children in a distilled pictorial language that was at once artful and accessible.[20] Their pared-down, semiabstract approach would inspire countless imitators in the decades to come and prove to be of particular value

He started to look for some food.

The Very Hungry Caterpillar, by Eric Carle (World, 1969)

as demand rose on the part of ambitious, college-educated parents of the 1970s and after for books for children in the very first years of life.

The cultural ferment of the 1960s expressed itself in children's books through a decisive turning-away from traditional narratives about idealized, morally innocent children in favor of more nuanced stories about real children in all their psychological and moral complexity. The quintessential expression of this altered perspective was Maurice Sendak's *Where the Wild Things Are* (1963), which, by reassuring young children that their powerful urges and inchoate emotions were a natural part of living, belatedly ushered the picture book into the Freudian age.[21]

As world markets grew more closely linked from the 1970s onward, picture books by the United States'

Maurice Sendak and Eric Carle, England's John Burningham and Helen Oxenbury, Dick Bruna of the Netherlands, Květa Pacovská of the Czech Republic, and others spread in translation around the globe. So, too, did the dazzlingly original work of the Japanese artist known in the West as Mitsumasa Anno, whose wordless picture books represented an adroit fusion of Eastern and Western imagery and cultural values.[22] At the same time, areas of the world not previously known for producing picture books of their own began generating their first such books in a reprise of the pattern previously played out in Europe, North America, and Japan. During the 1970s, this occurred in nations as culturally different from one another as Australia, Ghana, and Venezuela—all former colonies with a growing middle class for whom the production

of homegrown books represented a momentous milestone in their national coming-of-age.

By the early 2000s, the most spectacular case of a newfound national commitment to the genre was that of China, a five-thousand-year-old cultural megalith with a dour, no-nonsense educational tradition that in the past had left scant room for imaginative children's literature in the Western sense of the term. For the Chinese people, the twentieth century had largely been a time of convulsive social and political upheaval. The opening to Western cultural influences that followed in the wake of the Cultural Revolution found concrete expression in the determination of publishers, artists, and writers to provide the next generation of children with a more nurturing formative environment than had been possible during the radically disruptive final years of the Mao regime. As China's middle class underwent dramatic expansion and the nation's population passed the 1.4 billion mark, access to Western-style picture books came to be viewed as one of the keys to achieving this objective. By 2015, Chinese publishers had acquired rights to more than two thousand Western children's books, including all of the major American award winners, and were looking ahead to a not-too-distant future in which their own picture book artists and writers might assume a prominent role on the world stage.[23] Five years later, even as China's central government once again seemed intent on limiting the scope of Western cultural influence on its children, privately owned Chinese publishing companies were strengthening their ties to the Western children's book market, as exemplified by Trustbridge Global Media's acquisition of New York–based Holiday House, London-based Walker Books, and Walker's US outpost, Candlewick Press; and Thinkingdom Media Group's purchase of Europe's minedition and launch of a US editorial base called Astra Publishing House.

The digital revolution of the early 2000s presented illustrators with a new set of tools with which to paint and draw and spawned a new art form: the app, which combined aspects of animation and the illustrated book. The internet also allowed illustrators to showcase their work to a global market, a once-unimaginable opportunity that, in combination with the ease of electronically transmitting digital art to any locale, resulted in a sharp rise in the number of picture books created by collaborators working across national borders and at great distances from one another.

The new technologies, however, did not, as some had confidently predicted, render the traditionally printed picture book obsolete, but seemed rather to do just the opposite. For many in the children's book world, the ubiquity of digital imagery in everyday life highlighted the unique experiential value of the well-designed picture book that one could hold in hand as the centerpiece of an intimate encounter between an engaged caregiver and a child.[24] By 2015, the never-very-robust demand for electronic picture books all but evaporated in the United States, and publishers found themselves redoubling their efforts to fashion picture books that were alluring material objects. All this was happening as a generation of seasoned editorial illustrators, having seen demand for their work dwindle in the shrinking newspaper and magazine market, migrated to children's book illustration as a viable alternative outlet for their creativity. Synchronously, the audience for picture books and illustrated narratives generally was becoming more fluid as experimental zine and web-based comics artists, long accustomed to operating on the noncommercial fringe, suddenly found themselves embraced by mainstream publishers eager to build the graphic novel into a cross-generational phenomenon. Some of these artists went on to discover the picture book as well, bringing formal comics elements and, often, a hipster maverick sensibility to the genre that further enriched its narrative vocabulary.

By the turn of the new millennium, the audience for picture books had expanded to include a growing number of adult collectors, aficionados, and fans. The Chihiro Art Museum, the world's first museum of picture book art, had opened in Tokyo in 1977, initially as a local memorial to a beloved Japanese illustrator.[25] Not only did that pioneering museum undergo a dramatic expansion in its size and mission in subsequent years, but it also set the model for an international trend. Children's book art museums would later be established in the United States, the United Kingdom, the Netherlands, Finland, Germany, and South Korea, among

other countries, and university archives of children's book art and manuscripts would likewise proliferate alongside the academic study of the field.[26]

In the United States, the second decade of the new century also became the time for a long-overdue reckoning with regard to the publishing industry's historic marginalization of children's books by and about people of color, a bias also embedded in publishers' traditional hiring patterns. It was not that no effort of this kind had been made in the past, but rather that from the 1920 launch of the short-lived, NAACP-sponsored *Brownies' Book* magazine for the "children of the sun" onward, attempts at diversifying the literature and the professional community surrounding it had been sporadic at best and had typically received only very modest support from the white mainstream of librarians, educators, and individual book purchasers. In the picture book realm, milestone events charted the course of a slow but ultimately meaningful industry-wide cultural transformation: the awarding of the 1963 Caldecott Medal to Ezra Jack Keats's *The Snowy Day* (1962); the rise to prominence during the mid-to-late 1900s of African American author-illustrators such as John Steptoe, Tom Feelings, Ashley Bryan, Donald Crews, Jerry Pinkney, and Pat Cummings; the subsequent arrival on the scene of an impressive and much larger group of authors, artists, librarians, and publishing staffers representing not only the African American community but also those of Latinx peoples, Asian Americans, the LGBTQ+ population, and American Indians.

As the audience for picture books steadily expands and their cultural status continues to rise, the genre appears likely to flourish well into the twenty-first century, even as other categories of printed books—reference works and disposable series fiction among others—vanish into the digital ether. To many parents and grandparents who grew up on *Goodnight Moon* and *The Tale of Peter Rabbit*, it is still unimaginable to pass down a "classic" to the next generation in anything but tangible form. Yet in the end nostalgia will have had surprisingly little to do with the picture book's long-term prospects, at least when weighed against the genre's proven utility to engage young children in the kind of artful blend of instruction and delight

that John Locke recommended long ago, and which continues to prove its worth to an ever larger portion of the world's population.

The 101 artists featured in these pages each made an extraordinary contribution to the illustrated children's book—the picture book, its precursor formats, and near relations.

The roster of these books and illustrators, however, is not meant to be taken as a canon or pantheon. Old-fashioned exercises of that kind are bound to underestimate the extent to which they inevitably reflect a particular cultural or personal perspective or bias, and the reality that other, equally worthy lists are always possible. This is especially so in the case of a dynamic art form that continues to morph and grow. Just as every map has a point of view, so does a book like this one. Having said that, my aim has been to identify a cross-section of the world's most consequential contributions to the picture book and allied formats while also bringing to the fore a selection of books

The Snowy Day, by Ezra Jack Keats (Viking, 1962)

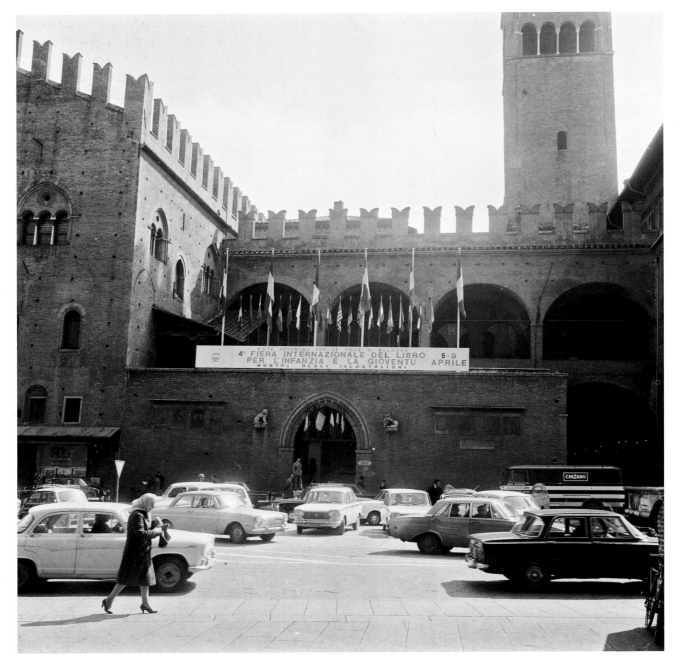

Bologna Children's Book Fair, Palazzo Re Enzo, Bologna, 1967

whose impact, though great, proved to be either more ephemeral or more regional in scope.

Of the 101 entries in *Pictured Worlds*, approximately one-third are about books first published in the United States. In choosing the US books, I focused on breakthrough works of artistic innovation and minority representation, and on those whose publishing histories tell a story of cross-cultural exchange, whether because they were created by immigrant artists or because they ultimately found an international audience. In the first several decades of the Bologna Children's Book Fair's history, US publishers tended to take part as sellers much more often than as buyers of foreign rights, and American picture books became an outsize presence on bookshelves in Europe, Asia, and Latin America. Happily, in recent years the trend has changed to resemble something more like a "two-way street."

I have placed the picture book at the center of my survey because it has long been the type of illustrated book for young readers within whose parameters artists across cultures have found the greatest freedom to innovate, participate as equal partners with the writer in storytelling, and blend form and content with the irreducible clarity and force of poetry. At the same time, I thought it relevant to locate the history of the picture book along a continuum of illustrated narrative formats, ranging from the deluxe gift books like those illustrated by Arthur Rackham, Ivan Bilibin, and N. C. Wyeth to the serialized strip cartoons of Crockett Johnson and Zhang Leping and the movable books of Lothar Meggendorfer and Bruno Munari. I have also traced the cross-pollination of picture book illustration and visual narrative forms not intended expressly for children such as display advertising, poster art, logo design, painting, sculpture, printmaking, and editorial illustration. In doing so, my aim has been to foster a fuller appreciation of an art form that has sometimes been misread as "simple" but in fact has deep roots in the great world traditions of creative visual expression.

Robert Lawson, author and illustrator of the American picture book classic *The Story of Ferdinand* (1936), observed: "No one can possibly tell what tiny detail of a drawing or what seemingly trivial phrase in a story will be the spark that sets off a great flash in the mind of some child, a flash that will leave a glow there until the day he dies."[27] Lawson was arguing for the importance of maintaining an unwavering commitment to the art of children's book creation while at the same time acknowledging the uniqueness and unpredictability of children's responses to a world not of their making. Lawson's words go a long way toward capturing the special nature of the illustrated children's book as an endlessly surprising art form and a bridge between generations.

—Leonard S. Marcus, 2022

A NOTE ABOUT DATES, NAMES, AND CAPTIONS

Years indicated in parentheses following book titles represent the year of first publication. Exceptions have been made when the year of publication can be readily inferred from the surrounding text. In this connection, please note that the American Library Association's Caldecott Medal is always given in the year after first publication.

Names of schools, periodical publications, and the like have been rendered in their original language followed (except when the meaning of the name is likely to be self-evident to an English-language reader) by the English-language translation in parentheses.

Artists are listed in the table of contents and essay headers by the name under which they published or publish their work. In the headers, full names and other variants follow. In the case of Asian artists, for whom the tradition is to place the patronymic first, I have honored this practice, except for references to Western editions in which the given name is listed first by the publisher.

Whenever possible, I have gathered examples of preliminary art for the books featured in these pages, much of it previously unpublished material. Captions have been provided for preliminaries and other images only when there is a particular story to tell.

ILLUSTRATORS

AKABA SUEKICHI

born 1910, Tokyo, Japan; died 1990, Tokyo, Japan

Biography: A self-taught painter, Akaba Suekichi never expected to make his living as an artist. Born in Tokyo in the waning years of the Meiji period, in 1932 he emigrated to northeast China, where he worked in industry for the next fifteen years while pursuing his love of painting as a hobby. In 1939, Akaba felt confident enough to submit his artwork to the prestigious Manchurian National Art Exhibition. His paintings received special notice in three of these annual competitions. Following his return to Japan in 1948, he took a job in the Civil Information and Educational Section of GHQ, then in the United States Information Service of the American Embassy in Tokyo, where he remained on staff for the next seventeen years.

Akaba was fifty in 1961 when he illustrated his first picture book, *Kasa Jizo* (*Roku Jizo and the Hats*), with drawings rendered in India ink as an experiment aimed at creating the maximum graphic contrast between the black of the line and the tale's ethereal snowy land-scapes. Among his other early picture books was *Suho no Shiroi Uma* (*Suho and the White Horse*), a Mongolian legend retold by Yuzo Otsuka and published in 1967. Akaba's arrival on the postwar Japanese children's book scene coincided with the rapid growth of the recently established Bologna Children's Book Fair, in which Japanese publishers played a key role. Two years after its initial publication in Japan, *Suho and the White Horse* was also available in an English-language American edition—a remarkable leap for the time. In 1980, Akaba became the first Japanese artist to win the Hans Christian Andersen Award in illustration.

About the book: *The Tongue-Cut Sparrow* (1982) is a vividly imagined and bracing traditional Japanese tale that juxtaposes a good-natured peasant's delight in life's simple pleasures (the companionship of a sparrow) with the fury and greed of his peasant wife (who silences the sparrow by cutting off its tongue and then demands riches from that very bird). The text was the work of Momoko Ishii, a noted contemporary children's book author and the Japanese translator of A. A. Milne's Pooh series. Akaba's illustrations are a

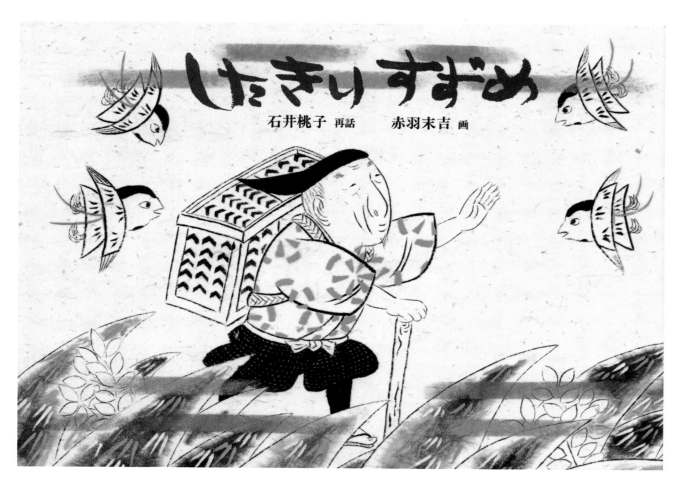

したきり すずめ

石井桃子 再話　　赤羽末吉 画

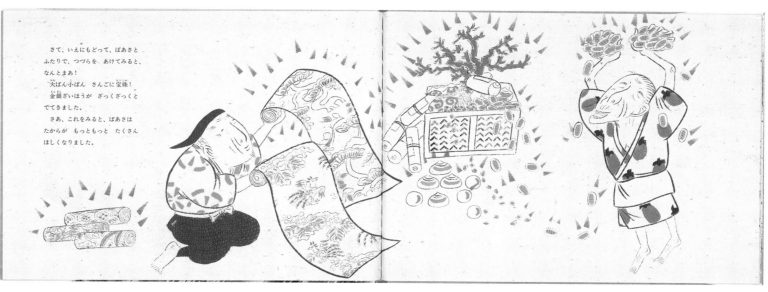

さて、いえにもどって、ばあさと
ふたりで、つづらを あけてみると、
なんとまあ！
　大ばん小ばん さんごに宝珠！
金銀ざいほうが ざっくざっくと
でてきました。
　さあ、これをみると、ばあさは
たからが もっともっと たくさん
ほしくなりました。

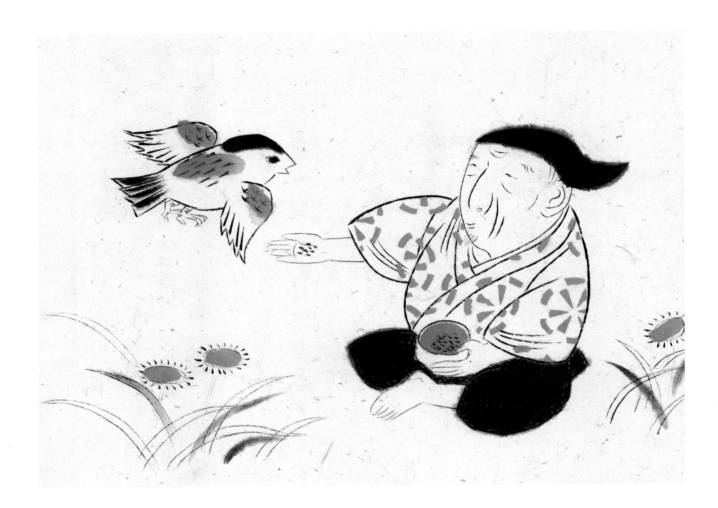

casual blend of spare yet dazzling line work and droll characterization, all illuminated by an occasional splash of color.

Publication history: As one of Akaba's major works as an Andersen laureate, *The Tongue-Cut Sparrow* was bound to garner international attention. In the United States, the celebrated children's book author Katherine Paterson, a two-time Newbery medalist (and herself a future Andersen honoree), translated Ishii's text into English, thereby guaranteeing the book widespread critical notice when the US edition was published in 1987. Korean- and Spanish-language editions followed. After Akaba's death in 1990, the artist's son donated his father's original paintings, drawings, and sketches to Japan's Chihiro Art Museum, where they can be viewed by the public and studied by scholars.

ANNO MITSUMASA

born 1926, Tsuwano, Japan; died 2020, Japan

Biography: The son of innkeepers from western Japan's scenic mountain country, Anno Mitsumasa was a Tokyo schoolteacher during the 1960s when the father of one of his students, the founder of the publishing house Fukuinkan Shoten, proposed that he try his hand at children's book illustration. *Topsy-Turvies: Pictures to Stretch the Imagination* appeared in Japan in 1968 and in the United States two years later. The picture book proved to be an art form ideally suited to Anno's passion for gently coaxing young people to open their eyes a bit wider to the world, to appreciate the role of paradox in human understanding, and to embrace all learning as a kind of play.

A restless, gregarious man with an internationalist outlook, Anno traveled extensively, absorbing Western cultural influences spanning the enigmatic artwork of René Magritte and M. C. Escher, the fairy tales of Hans Christian Andersen, and the Hollywood action-adventure films of John Ford. In a deliberate effort at cultural cross-pollination, Anno made a place in his groundbreaking picture books for these and many other references within Japan's centuries-long tradition of pictorial storytelling.

The range of Anno's creative projects steadily expanded over the years to encompass popular essays for adult readers on philosophy and mathematics, cover designs for Japan's equivalent of *Scientific American*, illustrated travelogues, illustrated editions of Shakespeare, and frequent appearances on Japanese educational television. In 2001, the Tsuwano town government opened the Anno Mitsumasa Art Museum as a permanent home for the artist's work and as an inspiration to children.

About the book: *Anno's Journey* (1978) is a triumph of wordless storytelling, a scroll-like picture-narrative that allows each reader to choose a unique path through a richly layered landscape. Gazing down on each scene from the same bird's-eye vantage point, readers may

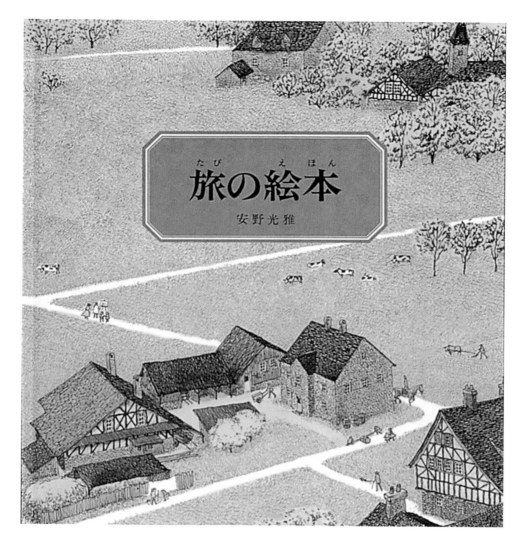

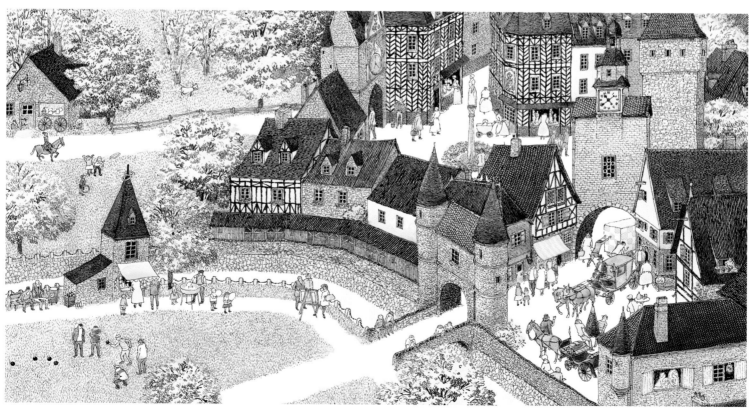

opt to follow Anno's lone horseman as he threads his way along a road through forested wilderness, farmland, a town, and back. Or we may instead choose our own path through the Bruegel-esque honeycomb of human activity—including a wedding, a funeral, a duel, a footrace, a robbery, and numerous scenes of workers working and children at play—that Anno has woven into these intricately choreographed landscapes. Prankish tricks of visual perspective and déjà-vu vignettes based on classic works of art lend an added dimension of surprise to illustrations in which—as in life—each reader sees only as much or as little as he or she is prepared to find. The unnamed setting of these accomplished pen-line and watercolor illustrations would appear to be somewhere in northern Europe, but in the spirit of open-ended discovery that is central to his aesthetic, Anno chose not to be specific about the locale, thereby rendering it a place of the imagination rather than one marked on any particular map.

Publication history: Anno began making books at a time when the world's leading juvenile publishers were first realizing the economic advantages of partnering for large-scale co-editions of full-color books with broad cross-cultural appeal. In this receptive atmosphere, Anno was among the first picture book artists to achieve international star status, winning the German Children's Literature Award (1973), a special British Kate Greenaway Medal citation (1974), and the Boston Globe–Horn Book Award for illustration (1975), among numerous other prizes for early books. *Anno's Journey* (Japan, 1977; United States, 1978) introduced a series of "journey" books that helped solidify his reputation with Western audiences. In 1985, he received the Hans Christian Andersen Medal in illustration for the body of his work.

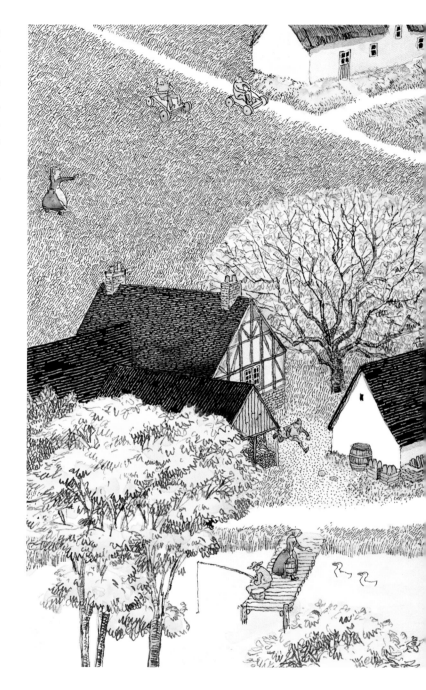

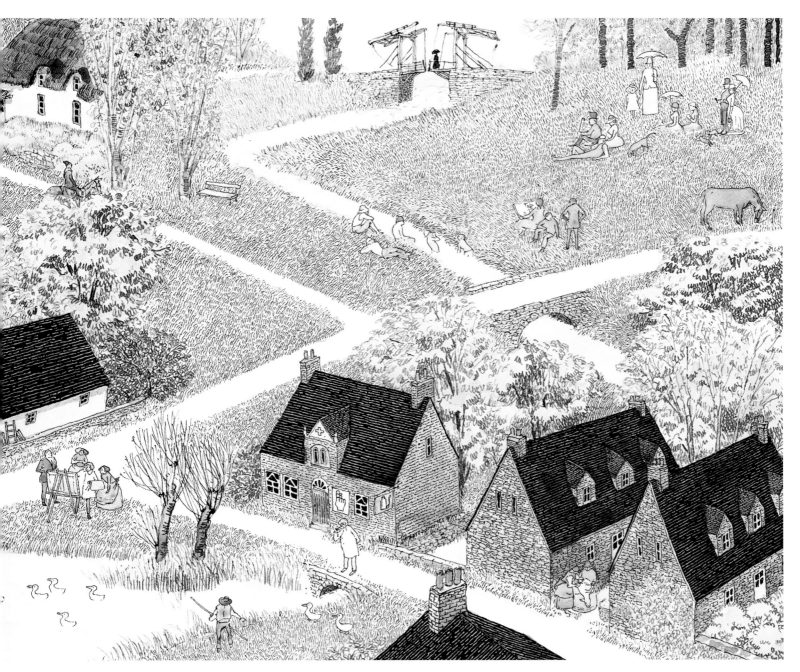

EDWARD ARDIZZONE

born 1900, Haiphong, French Indo-China;
died 1979, Rodmersham Green, UK

Biography: One of England's most compelling black-line artists and watercolorists, Ardizzone developed his craft by doodling on blotter paper while employed as a clerk at the Eastern Telegraph Company in London. With his parents both working for the British Foreign Service, he and his sisters were sent to live with their maternal grandmother in Suffolk from 1905 to 1913, after which the family reunited in London. He enrolled in evening classes at the Westminster School of Art, and, at the age of twenty-seven, in what his father regarded as a reckless act of rebellion, he resigned his job to draw and paint full-time. Marriage in 1929, followed by fatherhood, served to focus a major portion of his energies on creating illustrated stories for children, starting with *Little Tim and the Brave Sea Captain* (1936) and *Lucy Brown and Mr. Grimes* (1937). Ardizzone illustrated more than 170 books in all (including many not expressly intended for young people), while also producing a vast body of work as an official battlefront artist during the Second World War, a portrait and landscape painter, and a sketch artist.

About the book: Begun as an improvised bedtime story, *Little Tim and the Brave Sea Captain* launched one of the modern picture book's most memorable series, a collection of episodes in the life of an adventurous seven-year-old and his friends that eventually grew to eleven volumes. Ardizzone's initial scenario is a classic tale of innocence and experience: a young boy's romantic wish to run away to sea come true—and the cascading unintended consequences that result. Most distinctive about the narrative is the matter-of-fact conviction with which Ardizzone affirms Tim's absolute ability to get along without his parents under even the most treacherous of circumstances.

Also notable is the artist's distinctive approach to design and illustration. Ardizzone treated the book's outsize, vertically formatted pages almost like the leaves of a travel journal. The text was hand-lettered (not by Ardizzone himself, it turns out, but by his editor, Grace Hogarth), and the illustrations placed in a seemingly impromptu fashion, as in the sketchbook of an artist on the move. The spirit of animation and love of adventure that characterize the first Little Tim book and its sequels mark Ardizzone as one of Randolph Caldecott's most receptive and inventive heirs.

Publication history: *Little Tim and the Brave Sea Captain* firmly established Ardizzone's reputation both in Great Britain and in the United States, where the New York Public Library's Anne Carroll Moore declared the debut work a "large-size robust picture book [that] . . . appeals to big boys as well as to small ones."[1] The artist's reputation grew with each new installment, and in 1956 Ardizzone became the first recipient of Britain's Kate Greenaway Medal for the sixth volume, *Tim All Alone*.

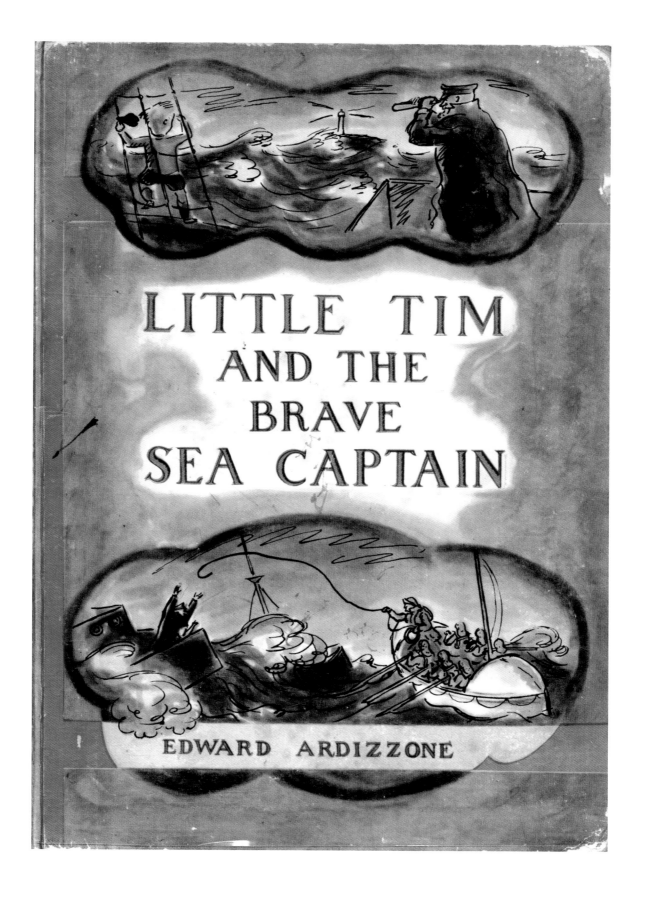

Little Tim
and the
Brave Sea Captain
by Edward Ardizzone

– To Philip *from* his father –

Oxford University Press
London New York Toronto

When they arrived alongside they clambered on board. Tim was left on the deck while the boatman went to see the Captain who was in his cabin.

The lifeboat came alongside and a life line was thrown to them, down which, first Tim, and then

ISABELLE ARSENAULT
born 1978, Sept-Iles, Canada

Biography: As a shy but inwardly venturesome school-child, Isabelle Arsenault enjoyed drawing at home and felt well supported by the steady encouragement of her teachers. She was just five or six when she won a drawing contest sponsored by a local newspaper, but several years passed before she first seriously considered a career in art. Arsenault studied fine arts at Cégep du Vieux Montréal, then transferred to the Université du Québec à Montréal to explore graphic design. A course in children's book illustration at the latter school piqued her interest but did not immediately suggest a career path. Arsenault illustrated her first book for young readers, *Le coeur de monsieur Gauguin* (2004), three years after graduation and promptly won Canada's most prestigious prize, the Governor General's Literary Award for Illustrated Books. From then onward, her work has been widely honored and praised. Arsenault was Canada's nominee for the international Hans Christian Andersen Award

both in 2018 and 2020 and in the latter year was short-listed for the prize. She won her second Governor General's Literary Award for Illustrated Books for *Virginia Wolf* (2012), a picture book written by Kyo Maclear.

About the book*: Virginia Wolf* tells the story of two young sisters, one of whom has just descended into one of her "wolfish," or depressed, moods and the other of whom swiftly steps into the breach to prove her worth as a caring, imaginative kindred spirit. For some well-versed readers, the girls' names—wolfish Virginia and sister Vanessa—will of course ring literary bells. But the real focus of both the text and Arsenault's sensuous and dazzlingly adept illustrations is the power of art infused with love to make life better.

In the early scenes meant to represent Virginia's felt experience, black silhouette cutouts and indistinct dark smudges suggest her significantly narrowed range of emotional responsiveness and perception. An Alice-like scene in which a silhouetted Virginia and her bedroom furnishings are shown tumbling in free fall underscores her chaotic sense of things coming apart, a state of mind that, it should not go unsaid, every child knows on occasion. Yet all is not darkness and gloom. When Vanessa asks her sister if there is anything that *might* make her feel better, Virginia has a ready response that prompts Vanessa to reach for her art supplies and begin painting an imaginary landscape so lush with colorful flowers and so all-around enticing that Virginia cannot help but let go of her worries and embrace the waking dream of that garden world. Before long, we find her joining in its invention as Vanessa's collaborator. Where, one might ask, are the "Wild Things" in contemporary picture books? This wise and daringly imagined book is one place to look.

Publication history: In addition to winning the Governor General's Literary Award for Illustrated Books, *Virginia Wolf* was the recipient of the Elizabeth Mrazik-Cleaver Canadian Picture Book Award, given by IBBY Canada, the White Raven Award of the International Youth Library, the Digital Book Award, and numerous other honors. It was been published in English, French, Chinese, Portuguese, Bosnian, Dutch, Italian, Japanese, Korean, Persian, Slovenian, Spanish, and Turkish.

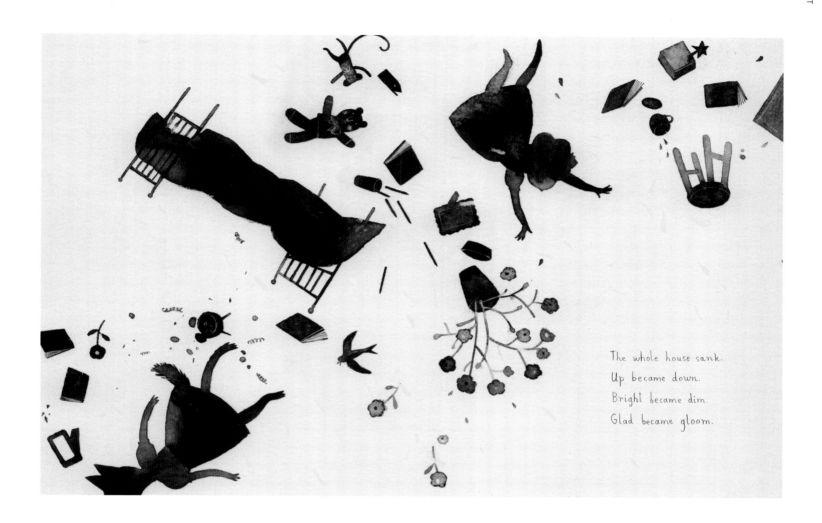

The whole house sank.
Up became down.
Bright became dim.
Glad became gloom.

I made a garden.
I painted trees and strange candy blossoms and green
shoots and frosted cakes. I painted leaves that
said *hush* in the wind and fruit that squeaked,
and slowly I created a place called Bloomsberry.
I made it look just the way it sounded.

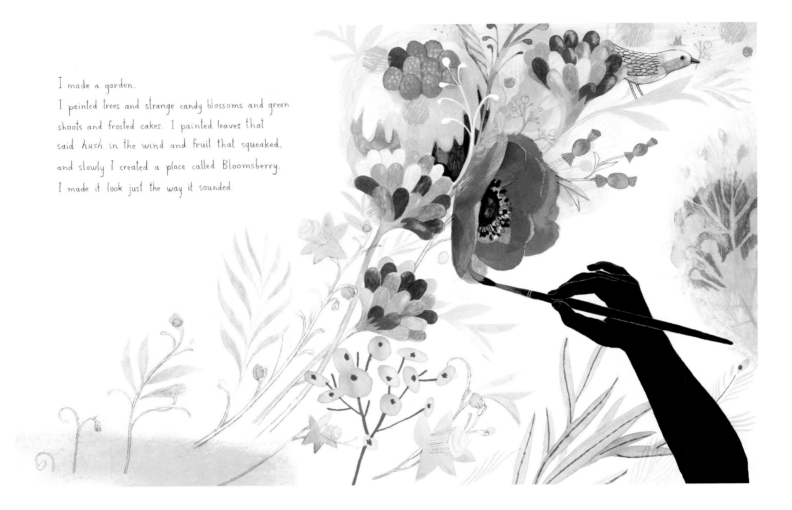

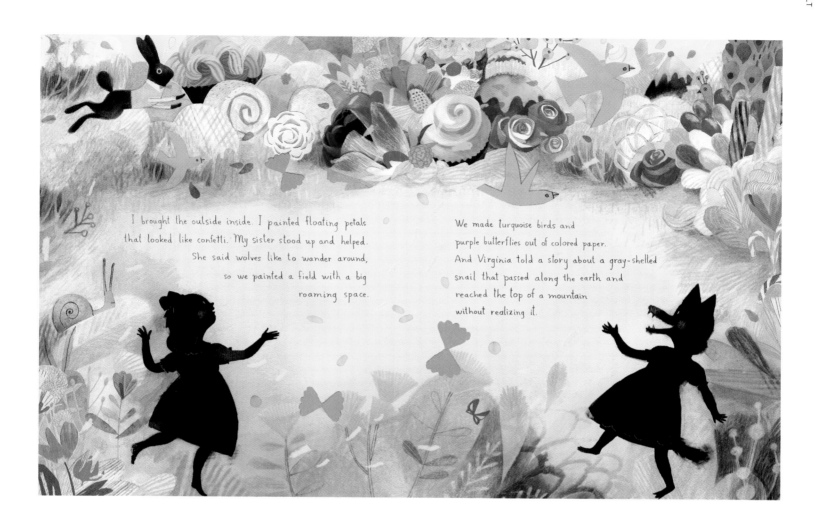

I brought the outside inside. I painted floating petals that looked like confetti. My sister stood up and helped. She said wolves like to wander around, so we painted a field with a big roaming space.

We made turquoise birds and purple butterflies out of colored paper. And Virginia told a story about a gray-shelled snail that passed along the earth and reached the top of a mountain without realizing it.

LUDWIG BEMELMANS

born 1898, Meran, Austria-Hungary; died 1962, New York, New York, US

Biography: Unlike several other European artists of his generation, Ludwig Bemelmans came to America for personal, not political reasons: in hopes, he later said, of making a fresh start after having fired a gun, as a teenager, at the abusive headwaiter at one of his uncle's Tyrolean hotels.[1] Like so much else in the background of this cunning, self-dramatizing popular artist, the raffish episode may or may not have actually occurred. Bemelmans, who blithely skimmed the surfaces of things in quicksilver, broad-brush paintings and loose-limbed drawings that appear to quiver and dash across the page, seemed in life as in art to prefer remaining something of a mystery.

He arrived in New York in 1914 as a sixteen-year-old and, after serving in the United States military during the First World War, learned the restaurant business at various New York establishments. This led to his becoming manager of Hapsburg House, a mid-Manhattan dining spot favored by publishers. It was there that Bemelmans met May Massee, the Viking Press's brilliant children's book publisher, who, after glimpsing a wall decoration painted by Bemelmans, offered him the chance to make picture books. Massee published each of his first three efforts, starting with *Hansi* (1934), but famously declined his fourth children's book, *Madeline* (1939), apparently on the grounds that its young heroine was too much of a troublemaker. His career as an illustrator and raconteur, meanwhile, spun out in other profitable directions, earning him fresh renown as a food and travel author-artist and as a cover artist for *The New Yorker*.

About the book: The generally astute May Massee rejected the book that was to become Bemelmans's signature work because—although here again one enters the shadowy realm of Bemelmans legend—she thought *Madeline* too "sophisticated" for a young audience.[2] Rebellious child-heroines were hardly the norm in mid-century American picture books; on that basis, Madeline's maverick manner might well have raised the alarm in a publisher known for such perfectly pitched bedtime read-aloud books as *The Story About Ping* and *Angus and the Ducks*. There may have been more to the story as well. In 1938, Newbery medalist

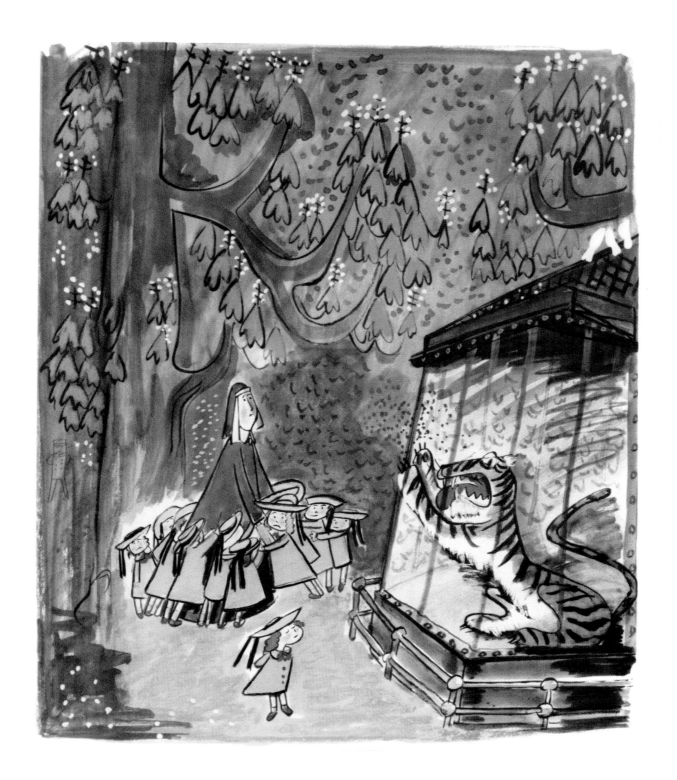

To the tiger in the zoo
Madeline just said, "Pooh-pooh,"

and brushed their teeth

and went to bed.

Rachel Field published a bestselling historical novel for adults, *All This, and Heaven Too,* based on the scandalous life of a nineteenth-century French courtesan who had hastily slipped out of France for a fresh start of her own as a private schoolmistress in New York's Gramercy Park, the same neighborhood where Bemelmans happened to be living nearly a century later. Would critics speculate that Bemelmans—in his tale about Miss Clavel and company—had made winking reference to the notorious Henriette Deluzy-Desportes, who was known for leading her own young charges two by two on a daily stroll around Manhattan's picturesque old park? Massee may well have felt she dared not risk the chance. It was thus that Simon & Schuster, then considered a brash young upstart firm, seized the opportunity to publish a picture book with the potential to generate publicity gossip and gold.

Publication history: Massee came to regret her decision after Bemelmans won the 1954 Caldecott Medal for the sequel, *Madeline's Rescue* (there would be five further installments, including two published post-

humously). She rebounded smartly by acquiring the rights to both titles, thereby reclaiming Bemelmans and Madeline for Viking once and for all.

In 1947, in return for a year and a half of free lodging, Bemelmans created a new Manhattan landmark by completing a series of *Madeline*-inspired murals for the chic Carlyle Hotel bar that now bears his name. Madeline was by then well on her way to achieving iconic status, with all the licensing opportunities that that implies. In 1952, an animated short based on the original story garnered an Academy Award nomination. A television cartoon series voiced by Christopher Plummer aired from 1990 to 1995. In 1998, a live-action feature film with Frances McDormand as Miss Clavel went into general release. The following year, a grandson of the artist, John Bemelmans Marciano, published what is likely to remain the definitive book about the creator of *Madeline* and launched his own illustration career by extending the life of his grandfather's most famous character, beginning with *Madeline in America and Other Holiday Tales* (1999).

ELSA BESKOW
born Elsa Maartman

born 1874, died 1953, Stockholm, Sweden

Biography: The second of six children, Elsa Maartman made her first attempts at storytelling almost as soon as she was able to speak. She identified so thoroughly with the fairy-tale characters her maternal grandmother had introduced her to that her siblings took to calling her Princess. Early on, the girl's love of make-believe merged with a deep affinity for the natural world, inspiring her first drawings and, later, her many picture books.

Maartman's family placed the arts at the center of their home life and embraced progressive social values and causes, notably Sweden's emerging women's rights movement. Members of her mother's family also founded a progressive school where traditional education by rote memorization gave way to play- and concept-based learning strategies as advocated by the American philosopher of education John Dewey and Sweden's Ellen Key, author of *The Century of the Child*. This culturally rich background prepared the aspiring artist for her life's work as Sweden's best-loved creator of children's picture books.

From 1892 to 1895, Maartman studied drawing at Konstfack, an arts, crafts, and design college in Stockholm. She had not yet graduated when she had her first illustration published in the children's magazine *Jultomten* (*Father Christmas*). After marrying Nathaniel Beskow, an artist turned theology student, in 1897, Elsa Beskow realized that she would need to be the family's principal breadwinner and resolved to build a steady career as a picture book author and illustrator while also helping to raise the couple's six children. As she once dryly summed up her life story: "Every year another book and every other year a boy."[1] Beskow's second picture book, *Peter in Blueberry Land* (1901),

became the first in an unbroken string of commercial successes.

About the book: *Children of the Forest* (1910) was Beskow's fifth picture book. In it, she reimagined the forest—always a potent symbol in Nordic myth and legend—as a child-friendly, playground-like environment where the roots of an old pine tree are home to a colony of diminutive toddler-ish creatures. Beskow's open-ended theme afforded her ample scope for incorporating a myriad of precisely rendered woodland flora and fauna in each and every scene. Against essentially naturalistic backdrops, her winsome Forest Children magically come to life as though nothing were more natural. Each elfin figure sports a festive inverted strawberry cap while engaging in such frolicsome pursuits as hunting for mushrooms, playing hide-and-seek with squirrels, and wading in a stream.

Publication history: Beskow's picture books came to embody twentieth-century Swedes' nostalgia for their nation's preindustrial past. Books like *Children of the Forest* also became a palpable source of national pride as distinctively Swedish contributions to the burgeoning modern tradition of children's literature—worthy companions to the fairy tales of Denmark's Hans Christian Andersen and the illustrated storybooks of Britain's Beatrix Potter. Beskow's fifth book was first translated into English in 1932 as *Elf Children of the Woods* for an edition published in the United States and Britain by Harper & Brothers. In 1970, the American poet William Jay Smith adapted the author's text for a new edition issued by Harcourt Brace. In more recent years, editions of the book have appeared in Japanese, German, Arabic, Spanish, and Chinese.

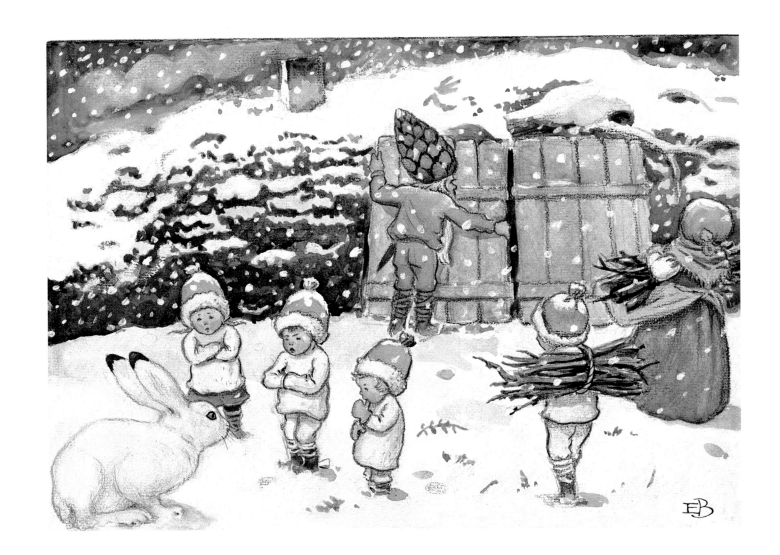

IVAN BILIBIN

*born 1876, St. Petersburg, Russia; died 1942,
Leningrad, USSR*

Biography: As a young man on the threshold of a career in art, Ivan Bilibin set out from cosmopolitan St. Petersburg on a pilgrimage to a secluded village in Tver Province, a region north of Moscow known as a wellspring of Russian folklore. While there, Bilibin painted his first watercolors based on traditional Russian themes, and on his return to the imperial capital he secured a commission from the tsar's Department of the Production of State Documents to illustrate a series of six deluxe books showcasing Russian fairy tales. He spent the next four years completing the task, refining his skill as a draftsman as he did so and learning important lessons about color reproduction from the tsar's official printer, with whom he worked hand in glove. As he committed himself wholeheartedly to the book arts—an idiosyncratic choice at the time—Bilibin drew close to members of the World of Art group, led by Sergei Diaghilev and Alexandre Benois, who wished to tear down the old hierarchical distinctions between the so-called fine arts and such "applied art" specialties as theater and book design and illustration. At this time, he also absorbed the paradigm-altering revelations of Japanese woodblock art and of the contemporary Western decorative art movement it inspired, Art Nouveau. He admired the illustration art of Louis-Maurice Boutet de Monvel, Aubrey Beardsley, and, in all likelihood, Walter Crane as well. But first and foremost it was the art and imagery of the deep Russian past that impelled his work.

About the book: Bilibin wrote of the illustrations for *The Tale of the Golden Cockerel* (1906), "The style is old Russian—derived from traditional art and the old popular print, but ennobled."[1] With their tightly packed scenes, foreshortened perspective, and elegant decorative flourishes, the illustrations for this

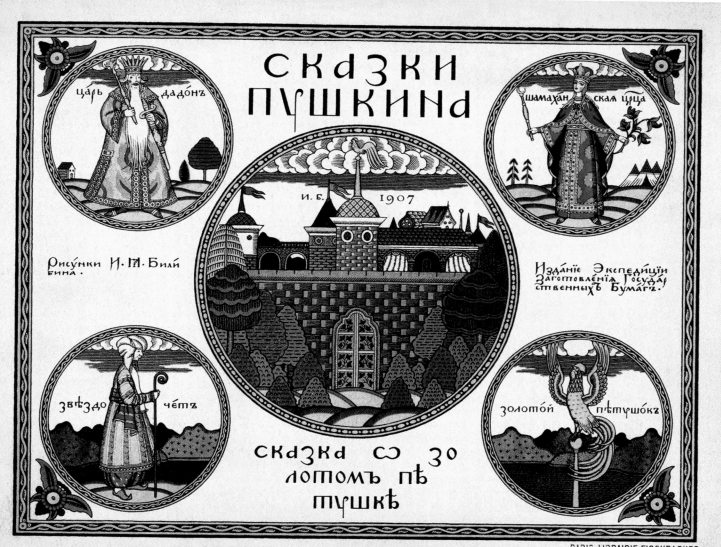

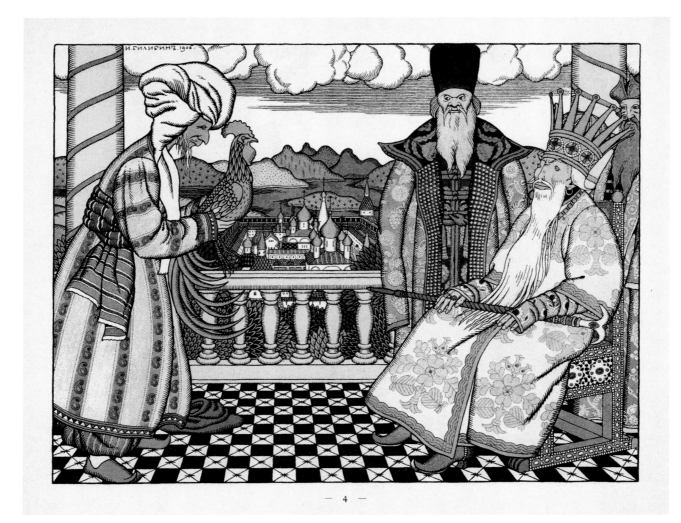

— 4 —

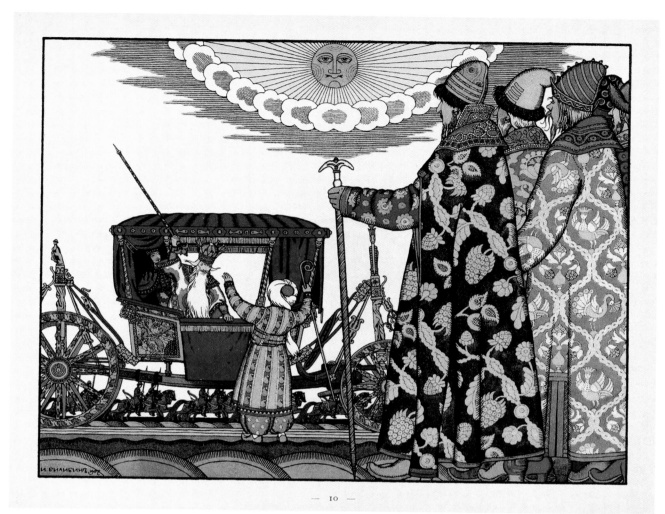

— IO —

literary fairy tale by Alexander Pushkin present a mix of stately pictorial balance and stylized drama on a grand scale. As an illustrator, Bilibin aspired to the aesthetic ideal summed up in his colleague Léon Bakst's catchphrase "the art of the beautiful line."[2] In this meticulously orchestrated work about a tsar's fatal blunder, he also revealed a taste and talent for satire.

Publication history: Bilibin illustrated the book as Nikolai Rimsky-Korsakov was composing the music for his *Golden Cockerel* opera, for which Bilibin had already agreed to design the sets and costumes. Work on the book doubled as a kind of dress rehearsal for the opera's original production, which opened at Moscow's Zimin Theatre on September 24, 1909. By then, the prestigious Tretyakov Gallery in Moscow had purchased the complete set of Bilibin's illustrations for *The Tale of the Golden Cockerel* for its collection.

Bilibin's illustration work remained in favor in the Soviet Union throughout the twentieth century—notwithstanding the incredibly turbulent politics of those years. By the 1970s, a major international Bilibin revival was under way elsewhere with the publication of editions of *The Tale of the Golden Cockerel* in the United States by Crowell in 1975 and in the UK by Dent the following year, and with the 1981 release of the monograph *Ivan Bilibin,* by Sergei Golynets, in Leningrad and New York.

QUENTIN BLAKE

born 1932, Sidcup, Kent, UK

Biography: Before starting his formal art training, Quentin Blake studied literature with F. R. Leavis at Cambridge and, as a practical matter, obtained a teacher's certificate. He had been drawing from the time he was a boy and was already publishing gag illustrations in magazines when he enrolled in the Chelsea School of Art. His favorite teacher there advised him against a career in illustration but cheered him on anyway. Before long, Blake had a regular stint at the English humor magazine *Punch*. He illustrated John Yeoman's children's book *A Drink of Water* in 1960 and published his own first picture book, *Patrick*, in 1969, just as full-color printing became available to the new generation of postwar English illustrators. In 1978, he became Roald Dahl's principal illustrator with the release of *The Enormous Crocodile*.

Blake went on to receive every major honor the English children's book world had to offer as well as the international 2002 Hans Christian Andersen Award. In 1999, he was appointed to a two-year term as Britain's first Children's Laureate, a position that gave renewed focus to his longtime efforts to promote childhood literacy. In 2005, Queen Elizabeth II made Blake a Commander of the British Empire and eight years later conferred a knighthood on him. In 2014, he realized

Quentin Blake

ZAGAZOO

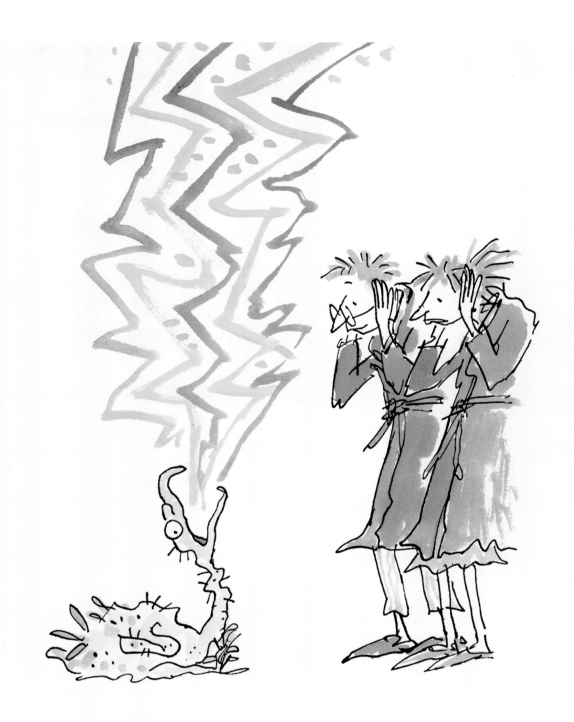

Its screeches were terrifying.

a long-standing dream with the opening of House of Illustration, a London-based museum that celebrates illustration as an art form in all its manifestations.

About the book: *Zagazoo* (1998) may be read as Blake's winking homage to *Where the Wild Things Are* or, viewed from a literary-historical perspective, as his playful critique of the grim theme of such classic post-Freudian fables of un-innocent childhood as Richard Hughes's *A High Wind in Jamaica* and William Golding's *Lord of the Flies*. Much to his caregivers' befuddlement and alarm, the new arrival in Blake's tale randomly morphs from baby vulture to elephant to warthog, dragon, bat, and other wild beasts, before at last assuming the form of an altogether agreeable young man. Blake's cartoonishly exaggerated point is that growing up is a messy, fitful affair prone to veering off at times in wholly unanticipated directions. The artist recalled for an interviewer: "When I first showed the book to my editor [Tom Maschler of Jonathan Cape], he thought it ought to be more realistic, that more background should be provided about the characters.

But I said, 'No, it's like a Eugène Ionesco play'—theater of the absurd. He liked that analogy, so the story stayed as it was!"[1]

Publishing history: Blake's international superstardom crystallized during the 1990s, culminating in his selection as the 2002 Hans Christian Andersen Award winner. In a classic demonstration of the economics of international copublishing of books with full-color art, *Zagazoo* was simultaneously released in 1998 in England (Jonathan Cape), the United States (Orchard Books), the Netherlands (De Fontein), and Denmark (Sesam). Other foreign-language editions were subsequently published in Catalan, Spanish, French, German, Slovenian, Swedish, Chinese, and Japanese. Related commercial opportunities had by then become ripe for the picking. One example: Blake designed a collection of wallpapers based on the book's characters for the British manufacturer and retailer Osborne & Little.

LOUIS-MAURICE BOUTET de MONVEL

born 1850, Orléans, France; died 1913, Nemours, France

An academic history painter who from the age of twenty-four exhibited his work in the annual Paris Salon, Louis-Maurice Boutet de Monvel came from a "family of gilt-edged artists," and turned to children's book illustration only when—as a new father—economic necessity compelled him to adjust his lofty goals.[1] He continued to paint long after the publication of his first illustrated books, notably the charming *Vieilles chansons et danses pour les petits enfants* (*Old Songs and Dances for Young Children*, 1883) and its sequel of the following year. He developed another lucrative specialty as a portrait painter of the children of the rich and wellborn. In an indication of his growing reputation, in 1887 Boutet de Monvel received the prestigious commission to illustrate *Nos enfants* (*Our Children*), a picture book by the esteemed French journalist, novelist, poet, and future Nobel laureate Anatole France. In 1888, Boutet de Monvel added to his laurels as the illustrator of a volume of twenty-two of the fables of Jean de La Fontaine, an edition that was widely hailed as a classic.

Having grown up in Orléans, site of a critical battle in the Hundred Years' War between England and France, Boutet de Monvel was steeped in the legends surrounding the romantic heroine of that fateful period, the fearless sixteen-year-old visionary Joan of Arc. In 1896, he published his picture-book retelling of Joan's story, a book that has ever afterward been regarded as one of the genre's towering achievements.

About the book: *Jeanne d'Arc* (*Joan of Arc*) is a work of incisive draftsmanship and stirring, panoramic action-adventure. The atmosphere is lyrical and contemplative, rather than bombastic, even in the most fearsome wide-angle tableaux of armies locked in battle. As the same time, few illustrators before or since have embraced so vigorously the impulse toward animation that Randolph Caldecott had first tapped so rewardingly only a decade earlier. Boutet de Monvel doubtless shared Caldecott's fascination with the rarified aesthetics of Japanese ukiyo-e prints, which had reached the West in the mid-nineteenth century. But as Gerald Gottlieb, the former curator of

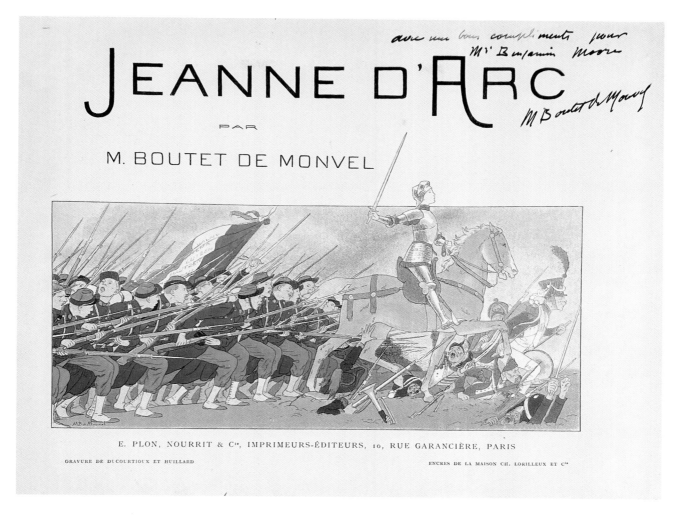

early children's books at the Pierpont Morgan Library, speculated, the artist may well have drawn inspiration, too, from the illuminated manuscripts of Joan's own early fifteenth-century France, such as the Limbourg brothers' *Très Riches Heures du Duc de Berry*. "The massed groupings of men and horses, the stylized backgrounds, and above all the opulent detail of robe and wall hanging," observed Gottlieb, "are all there to be seen."[2]

Publication history: *Jeanne d'Arc* was a resounding critical and commercial success in France from its first appearance. It was immediately translated into English and published with great fanfare a year later in the United States by Century. Feature articles about the artist appeared in *The Century, McClure's, Brush and Pencil, Good Housekeeping,* and *The Review of*

Reviews, among other publications. The original water-color paintings for *Jeanne d'Arc* and other works by Boutet de Monvel toured the United States in 1899 (with the artist in tow to lecture in French and paint children's portraits in every host city), and again in 1906–1907 and 1921. Among the contemporary artists to fall under Boutet de Monvel's spell were those of the Vienna Secession, who invited him to participate in their 1899 exhibition, and the American picture book illustrator E. Boyd Smith. More broadly, *Jeanne d'Arc* became one of the touchstone works by which America's influential children's book librarian-critics of the 1910s and beyond—led by the New York Public Library's Anne Carroll Moore—would weigh the merits of illustrated books for young readers for decades to come.

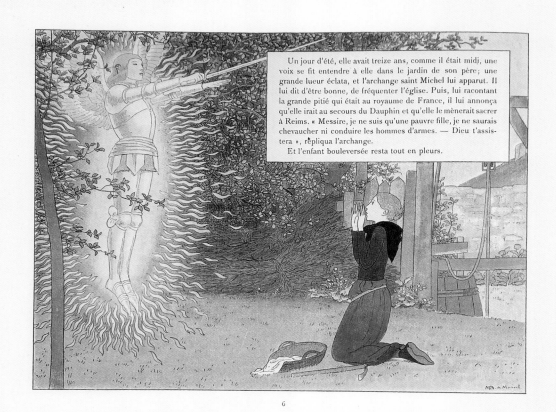

Un jour d'été, elle avait treize ans, comme il était midi, une voix se fit entendre à elle dans le jardin de son père; une grande lueur éclata, et l'archange saint Michel lui apparut. Il lui dit d'être bonne, de fréquenter l'église. Puis, lui racontant la grande pitié qui était au royaume de France, il lui annonça qu'elle irait au secours du Dauphin et qu'elle le mènerait sacrer à Reims. « Messire, je ne suis qu'une pauvre fille, je ne saurais chevaucher ni conduire les hommes d'armes. — Dieu t'assistera », répliqua l'archange.

Et l'enfant bouleversée resta tout en pleurs.

6

En effet, sans la prévenir, on avait attaqué la bastille de Saint-Loup. L'attaque avait échoué; les Français reculaient en désordre. Jeanne accourant les rallia, et, les ramenant à l'ennemi, elle recommença l'assaut. En vain Talbot essaya de porter secours aux siens. Jeanne, debout au pied des remparts, encourageait ses gens. Pendant trois heures les Anglais résistèrent. Malgré leur défense désespérée, la bastille fut prise.

19

Le 16 juillet, le Roi fit son entrée dans la ville de Reims à la tête de
ses troupes. Le lendemain, la cérémonie du sacre eut lieu dans la cathé-
drale, au milieu d'un grand concours de seigneurs et de peuple. Jeanne
se tenait derrière le Roi, son étendard à la main ; « son étendard avait
été à la peine, il était juste qu'il fût à l'honneur ». Lorsque Charles VII

3o

eut reçu de l'archevêque, Regnault de Chartres, l'onction
sacrée et la couronne, Jeanne se jeta à ses pieds, lui embras-
sant les genoux et pleurant à chaudes larmes. « O gentil Sire,
dit-elle, maintenant est accompli le plaisir de Dieu qui vou-
lait que je vous amenasse en votre cité de Reims recevoir
votre saint Sacre, montrant que vous êtes vrai roi, et qu'à
vous doit appartenir le royaume de France ! » — « Tous ceux
qui la virent en ce moment, dit la vieille chronique, crurent
mieux que jamais que c'était chose venue de la part de Dieu. »
« O le bon et dévot peuple, s'écriait la sainte fille en voyant
l'enthousiasme de la foule autour du Roi, si je dois mourir,
je serais bien heureuse que l'on m'enterrât ici ! »

31

26

Le 18 juin, Jeanne atteignit, près de Patay, l'armée anglaise con-
duite par Talbot et Falstaff.
« En nom Dieu il les faut combattre, dit-elle ; quand ils seraient
pendus aux nues, nous les aurons, parce que Dieu nous les envoie
pour que nous les châtiions. Notre gentil Roi aura aujourd'hui la
plus grande victoire qu'il eut. » Elle voulait se porter à l'avant-garde,
on la retint, et La Hire fut chargé d'attaquer les Anglais pour les
obliger à faire volte-face, afin de donner aux troupes françaises le
temps d'arriver. Mais l'attaque de La Hire fut si impétueuse que
tout céda devant lui. Lorsque Jeanne accourut avec ses hommes
d'armes, les Anglais se retiraient en désordre. Leur retraite devint
une fuite. Talbot fut pris.
« Vous ne pensiez pas ce matin que cela vous arriverait », lui dit
le duc d'Alençon. « C'est la fortune de la guerre », répondit Talbot.

27

MARCIA BROWN

born 1918, Rochester, New York, US; died 2015, Laguna Hills, California, US

Biography: "When I was a child, thinking that I would like one day to illustrate children's books," Marcia Brown recalled, "I always thought of the fairy tales that I loved."[1] Her father was a minister, and both her parents valued the arts. The modest home in which Brown, the youngest of three daughters, grew up was filled with music and books. Although she dreamed of a career as an artist or opera singer, the severe strictures of the Great Depression forced her to think about "practical" work, and she opted to prepare for the life of a teacher.

By her mid-twenties, however, Brown had made her way to New York City, where she worked by day at the New York Public Library's Central Children's Room and took evening classes in drawing at the New School and the Art Students League. For her first picture book, *The Little Carousel* (1946), Brown wrote a story based on the street life of her newly adopted neighborhood, New York's Greenwich Village. She continued to be

identified with the publisher of that book, Charles Scribner's Sons, for the remainder of her long career. In all, Brown published more than thirty picture books, many of them inspired by her fascination with world folklore traditions, and each one illustrated in the style and technique she felt best suited to the text at hand. Her continually expanding repertoire of art styles and techniques came to include black-ink and watercolor art, woodblock printmaking, gouache, and collage, among others. Technical challenges, including the rigorous requirements of pre-separated art, delighted her. In later years, she retired from book illustration and pursued her lifelong interest in Chinese brush painting. Brown was among the most honored of all children's book artists, the winner of three Caldecott Medals (a feat matched subsequently only by David Wiesner) and six Caldecott Honors (the American Library Association's runner-up award).

About the book: *Cinderella, or the Little Glass Slipper* (1954) earned Brown her first Caldecott Medal, following a remarkable run of six second-place prizes in just under a decade. Underlying the tart wit and diaphanous line work of Brown's elegant drawings was the artist's intensive research into the decorative arts and manners of the court of Louis XIV, the milieu where the classic French version of the story originated. Brown's quest for authenticity carried over into a concern for replicating the characteristic gestures and poses of period courtiers. Brown chose to illustrate Charles Perrault's late seventeenth-century French version of the story rather than the more blood-curdling rendering of the Brothers Grimm because, as she later recalled, "Perrault [made] kindness the miracle. Those large, foolish ladies attempting to squeeze into a small shoe were drama enough, without cutting off toes. They were very human."[2]

Publication history: Winning the Caldecott Medal gave Brown the financial means to undertake a long-dreamed-of trip to Europe, where for a year and a half she immersed herself in the art and landscapes of Italy, France, Germany, Holland, and England. The medal also assured that *Cinderella* would always remain in print, alongside Brown's subsequent medal books,

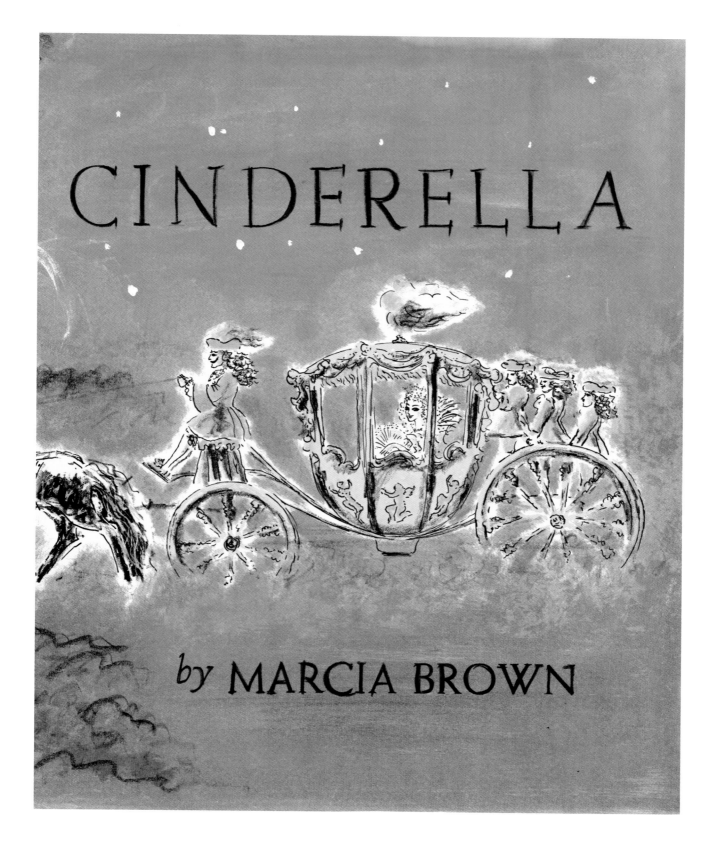

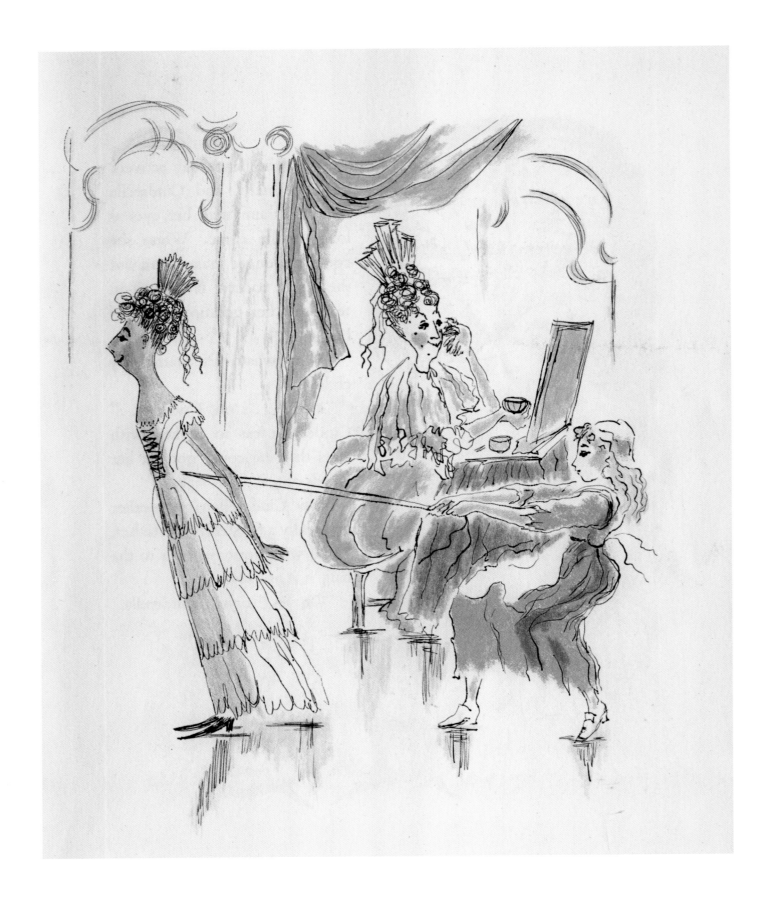

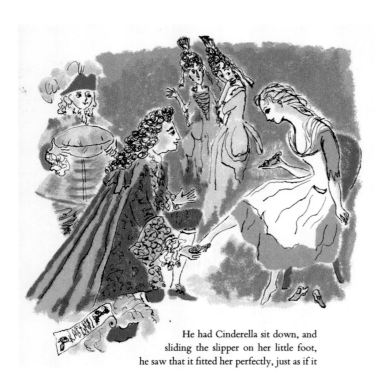

He had Cinderella sit down, and
sliding the slipper on her little foot,
he saw that it fitted her perfectly, just as if it

Once a Mouse (1961) and *Shadow* (1982). *Cinderella* was published in Japan (1969) and Korea (2008). Ironically, Brown's work has come to be better known to Asian readers than to those in the United States. Nonetheless, her death was widely reported in America's major newspapers. In its obituary, the *New York Times* quoted from a speech in which Brown summed up the importance she placed on the traditional tales she had so often chosen to illustrate: "The heritage of childhood is the sense of life bequeathed to it by the folk wisdom of the ages. It is a privilege to pass these truths on to children who have a right to the fullest expression we can give them."

ANTHONY BROWNE

born 1946, Sheffield, Yorkshire, UK

Biography: Not long after winning the 2000 Hans Christian Andersen Award for the body of his work, Anthony Browne surprised some of his admirers by telling the *Guardian* that he had always felt himself to be "a bit of an outsider to the British children's book illustration scene" because he did not work in line and wash. "I work in watercolour and sometimes gouache, so obviously my books look very different from the line work of Cruikshank, Ardizzone or Shirley Hughes, who are thought of as the great British tradition."[1] It was perhaps not so surprising that an artist known for crafting stories about outsiders would turn out to have always seen himself as one as well.

The second son of pub owners from northern England, the young Browne had grown up imagining possible futures for himself as a cartoonist, journalist, or boxer. He attended Leeds College of Art, where he concentrated in painting. In 1967, the need to support himself after graduation prompted Browne to try first medical illustration (excellent training but tedious and ultimately depressing work), then greeting card design (too narrow in scope but in retrospect a chance to develop characters with popular appeal, notably the gorilla that became the signature element of his books).

Browne published his first picture book, *Through the Magic Mirror*, in 1976. But it took some time for critics to warm up to his stark, surrealistic style of image making. With his sixth picture book, *Gorilla*, he finally hit his stride.

Browne's many professional honors include the Kate Greenaway Medal for *Gorilla* (1983) and *Zoo* (1992); the Hans Christian Andersen Award, of which he was the first British recipient, in 2000; and his selection as Great Britain's Children's Laureate for 2009–2011.

About the book: *Gorilla* (1983) is the bittersweet story of a lonely but imaginative child who lives with her over-busy, self-absorbed father. Because she is largely ignored by her dad (and her mother is nowhere to be

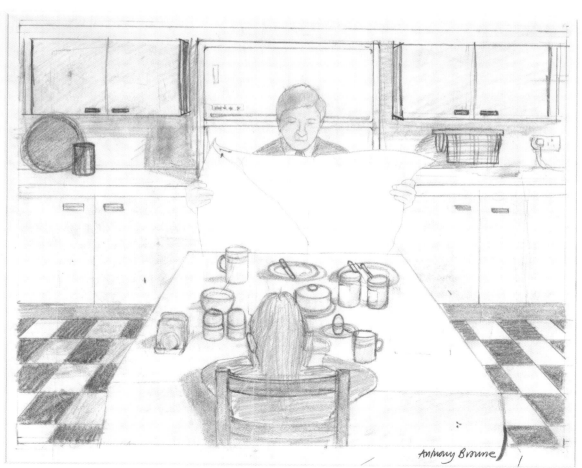

Anthony Browne

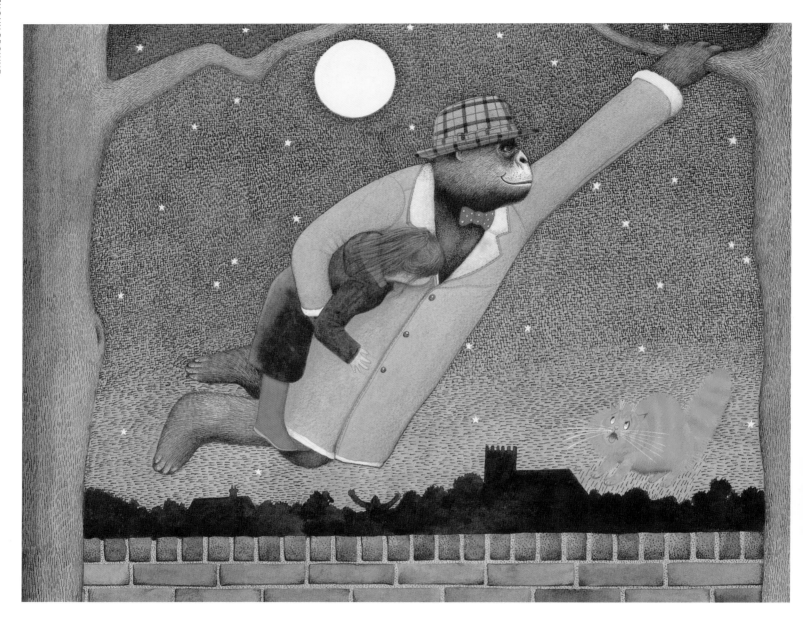

seen), the girl is left not only to entertain herself but also to maintain her own sense of well-being. Hannah manages this daunting task with admirable success thanks to her curiosity about gorillas—a human-like species that for her becomes not only a subject of study but also a focus of imaginative play and ultimately even a source of companionship. In this remarkable book, Browne walks the fine line between realism and fantasy, in much the same way that Hans Christian Andersen did in stories about children with the ability

Anthony Browne

to perceive instances of wonder and magic in the world that their elders simply miss.

Browne's accomplished, hyperrealist paintings offer a surprisingly stark and candid glimpse of a contemporary middle-class household in which love is in short supply. To counterbalance the emotional truth of these images, the artist highlights the wholehearted sincerity of Hannah's private quest—a healthy obsession that in the end, happily, her father is able to share with her.

Publication history: In addition to the Greenaway Medal, *Gorilla* was honored with a Kurt Maschler Award as a "[British] work of imagination for children, in which text and illustration are integrated so that each enhances and balances the other."[2] It has been translated into sixteen or more other languages, including Spanish, Catalan, French, Italian, German, Finnish, Swedish, Danish, Dutch, Welsh, Scottish Gaelic, Hebrew, Persian, Japanese, Chinese, and Korean.

DICK BRUNA

born 1927, Utrecht, Netherlands; died 2017, Utrecht, Netherlands

Biography: Scion of the Dutch publishing powerhouse A. W. Bruna & Zoon, Dick Bruna opted for an art career over the top spot reserved for him in the managing director's office. He nonetheless contributed steadily to the ongoing success of the family business, designing two thousand book covers and one hundred advertising posters for the firm over the course of more than half a century. A trim, elfin man with a sporty English mustache, Bruna betrayed no outward affinity for the cloak-and-dagger world of espionage and criminality that he brought to graphic life in his jacket designs for the bestselling novels of Ian Fleming and Georges Simenon, both mainstays of the company's list. Yet it was Bruna who forged indelible visual identities for both authors in the minds of millions of Dutch readers. Bruna's career took an unexpected turn when, during a family vacation in the early 1950s, the artist paused to observe—and draw—a rabbit as it hopped about in the dunes. Later that same day, as he improvised some stories about the fluffy creature for his one-year-old son, a character was born: Nijntje (or "Miffy" in English), a

white bunny clothed in a simple, brightly colored dress. Bruna later said that he chose to make his impromptu creation a girl because he preferred drawing a dress to trousers. *Miffy*, the first of dozens of diminutive books about the rabbit and her friends, appeared in 1955.

About the book: In the first of more than thirty books about the amiable rabbit, friendly animals come one by one to greet Miffy over the course of a day. By evening, she feels too drowsy for anything other than a good night's rest. Bruna's drawings of the bunny were a bit more relaxed and suppler-looking in this initial outing than they later became, suggesting that Miffy might be a plush toy bunny, rather than a real flesh-and-bone one, and soft to the touch. By the early 1960s, the character had developed excellent posture, more pronounced dot eyes, and a certain emotional intensity. Over time, Miffy's proportions continued to be fine-tuned and the black outline firmed and thickened, thereby completing the transformation from character to icon.

Publication history: Foreign rights to the Miffy books would prove to be among the most sought-after and lucrative properties at the Bologna Children's Book

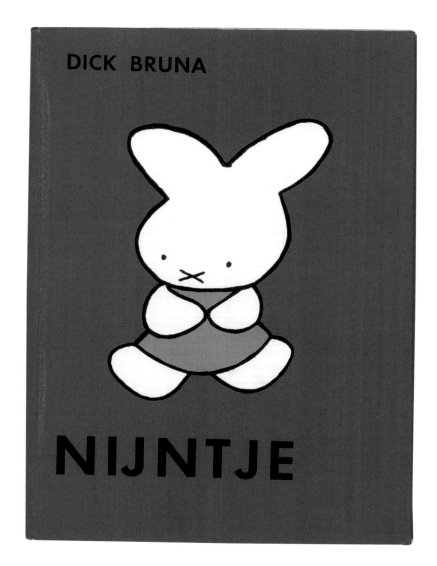

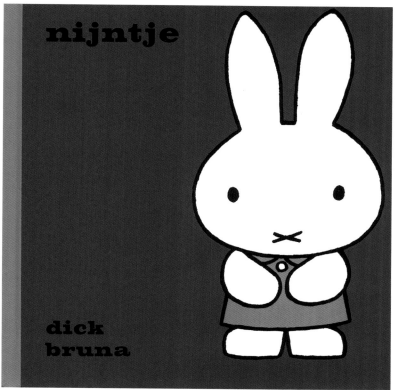

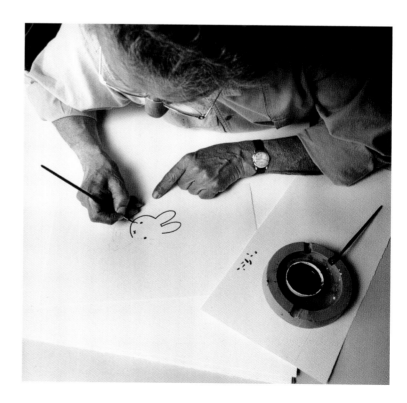

Fair. The books have sold more than eighty-five million copies in over fifty languages worldwide, although they have been notably less popular in the United States than in Europe and Asia, owing perhaps to the indifferent quality of the English-language translations. By the early 1990s, Miffy spin-offs and adaptations—both authorized and not—were multiplying like rabbits. Elements of the British Earth First! environmental movement co-opted (without permission) the adorable character as its mascot, and the first of two Miffy television series premiered.[1] Similarities between Hello Kitty, a licensed character first introduced in Japan in the 1970s, and Miffy prompted Bruna to initiate legal action in 2010 that resulted in a judgment barring the Japanese franchise within the Benelux nations. The full proceeds of the out-of-court settlement went to charity. Bruna's hometown, Utrecht, paid tribute to the artist by naming a public square—Nijntje Pleintje (Little Miffy Square)—in his honor and by creating the Miffy Museum as part of the city's Centraal Museum.

ASHLEY BRYAN

born 1923, New York, New York, US;
died 2022, Sugar Land, Texas, US

Biography: Ashley Bryan was a young schoolchild growing up in the South Bronx during the Great Depression when an art teacher first introduced him to two of his lifelong loves: illustration and bookmaking. From then onward, illustrated, homemade books were his gifts of choice for family and friends, and the neighborhood branch of the New York Public Library became a major source of inspiration: his gateway to the realms of poetry and folklore. Bryan, whose family heritage was a mix of Afro-American and Caribbean, would later call folk stories the "tender bridge" capable of uniting people of diverse ethnic and racial backgrounds.

Bryan studied art at New York's Cooper Union before being drafted into the still-segregated United States Army during the Second World War. Deployed to Europe, he kept art supplies inside his helmet and continued to draw wherever he went. The postwar years were a time of philosophical study and personal reflection, culminating in a return to art and a commitment to embrace forms of visual expression both as a universal language and a means to internalize and celebrate his cultural inheritance as a person of color.

Bryan's career as a children's book illustrator was launched when Jean Karl, head of the juvenile department at Atheneum, approached him about illustrating a collection of poems for young readers by Rabindranath Tagore (*Moon, for What Do You Wait?*, edited by Richard Lewis, 1967). Karl then offered him a contract for a book of African folktales, *The Ox of the Wonderful Horns* (1971). The civil rights movement of the 1950s and 1960s had begun to stir some editors to action in response to the near total lack of children's books that acknowledged and celebrated the multiracial makeup of American society. Over time, Bryan would emerge as a leading figure in the effort to preserve and reinvigorate African American story and song traditions for new generations of young readers.

About the book: Bryan created the art for *Let It Shine* (2007)—a pictorial interpretation of three traditional Negro spirituals—in cut-paper collage. The intricately layered, joyful expressionist style of the work suggests the influence of both Henri Matisse's monumental late cut-paper designs and the incisive allegorical image making of Harlem Renaissance artist Jacob Lawrence. The kaleidoscopic, visionary spreads gain immediacy from Bryan's brilliant color palette, bold sense of design, and the disarmingly humble, made-by-hand intimacy of the artist's cutouts.

A natural teacher, Bryan had an exceptionally varied career as an educator, having taught art to both kindergartners and undergraduates, the latter as the longtime art department chair at Dartmouth College. In *Let It Shine*, he challenged readers, too, to be more than passive consumers of art, overlaying onto the dynamic decorative swirls of the book's endpapers cutout images of child- and adult-sized pairs of scissors—tools of the collage artist's trade clearly meant as a reminder that a life of art-making can start at any age.

Publication history: Bryan won the 2008 Coretta Scott King Award for illustration for *Let It Shine*—his third King prize, in addition to his five King Honors until then. The previous year, he had received the Eric Carle Museum of Picture Book Art's Carle Honors Artist Award for lifetime achievement. Other major prizes and honors followed in rapid succession: the 2009 Laura Ingalls Wilder Award of the American Library Association (later renamed the Children's Literature Legacy Award) and the 2012 Coretta Scott King–Virginia Hamilton Award. In his Wilder acceptance speech, Bryan said: "Although now my books are printed in the thousands, it is the feeling of the handmade book that is at the heart of my bookmaking . . . In the integrity and dignity by which we validate time, our being, whatever the nature of our work, I feel we are feeding the hungry, clothing the naked, sheltering the homeless, because we are pursuing the ways of peace."

Oh, when the saints go marching in,
Oh, when the saints go marching in,

Oh, Lord I want to be in that number,
when the saints go marching in.

JOHN BURNINGHAM

born, 1936, Farnham, UK; died, 2019,
London, UK

Biography: A leader of the post–Second World War new wave of English children's book artists, Burningham had a seminomadic childhood, living for stretches at a time in a caravan with his parents and sister as they wandered the English countryside. His father was fascinated by new approaches to education, and at sixteen, Burningham entered A. S. Neill's experimental Summerhill School, where learning was largely self-directed. Although the tall, lanky, pugnacious teen did not decide then and there to dedicate his life to art or literature, Neill's magnetic presence and nonjudgmental mentoring style clearly left their mark not only on him personally but also on the groundbreaking picture books that followed.

During the late 1950s, Burningham studied illustration and design at London's Central School of Art. There he met his future wife, Helen Oxenbury, and fell under the spell of such contemporary artist-designers as Saul Steinberg and André François. Soon after graduation, he received a poster commission from London Transport that served him well as a unique sort of professional calling card as he scrambled to build a reputation. Not long after that, Burningham's first picture book, *Borka: The Adventures of a Goose with No Feathers* (1963), won the coveted Kate Greenaway Medal.

Burningham proved to be the most audacious and technically brilliant English picture book artist of his generation, able to mix media and degrees of representation and abstraction within an illustration with singular abandon and finesse. A gifted writer as well, he played a key behind-the-scenes role in shaping the texts of many of Oxenbury's books and produced an occasional coffee-table book on subjects of special

Mr. Gumpy's Outing
John Burningham

interest to him, including the English and French countryside, the experience of aging, and the pleasures of champagne. In 2009, he published an informal memoir, *John Burningham: Behind the Scenes.*

About the book: It is no great leap to imagine that Burningham's model for the title character of *Mr. Gumpy's Outing* (1965) was his own outwardly grumpy but enlightened onetime schoolmaster A. S. Neill. The story's surprise ending is a bell-clear affirmation of the profound empathy for young people that lay at the core of Neill's radical philosophy of education. When Mr. Gumpy's cautionary appeals go unheeded and the boat that contains him and his unruly assortment of passengers tips over, this old soul reacts not (as expected) with a stern, I-told-you-so rebuke but rather with a kindly, good-natured invitation to come again soon and repeat the experience.

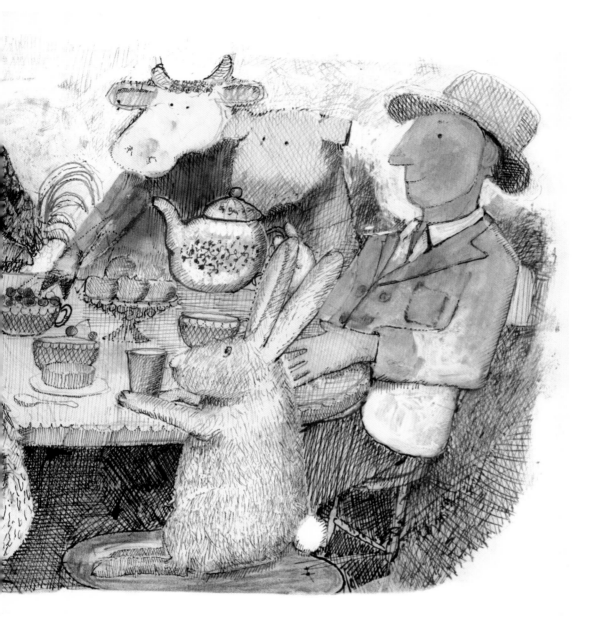

Burningham draws in a slightly wobbly, off-kilter line that renders his characters appealingly vulnerable-looking, imperfect, and silly. As *Kirkus Reviews* noted of *Mr. Gumpy's Outing*'s illustrations: "Burningham's sketchy yellow lines make the sun shine on his pages."[1] He was among the handful of illustrators who—much like their contemporaries, the Beatles—brought a celebratory spirit and refreshing madcap wit to post-austerity Britain's renewed cultural life.

Publication history: *Mr. Gumpy's Outing* earned Burningham his second Kate Greenaway Medal as well as a prestigious American award, the 1972 Boston Globe–Horn Book picture book prize. He was among the first stars of the Bologna Children's Book Fair, and as one of his strongest and most characteristic works, *Mr. Gumpy's Outing* was soon published in translation in French, Dutch, Danish, and Japanese, and afterward in Korean and Chinese, among other languages.

VIRGINIA LEE BURTON

born 1909, Newton Centre, Massachusetts, US;
died 1968, Boston, Massachusetts, US

Biography: During a comparatively brief but intensely creative life, Virginia Lee Burton distinguished herself in the fields of children's literature and the decorative arts. As founding director of Folly Cove Designers of Gloucester, Massachusetts, Burton oversaw the production of a line of finely handcrafted fabric designs that reinterpreted traditional folk-art motifs with modernist verve. Not long after becoming a mother, she turned to the picture book as a second creative channel. Houghton Mifflin published Burton's journeyman effort, *Choo Choo: The Story of a Little Engine Who Ran Away,* in 1937. Two years later, she produced her classic *Mike Mulligan and His Steam Shovel.* Burton won the 1943 Caldecott Medal for *The Little House* and continued over the next two decades to write and

illustrate books notable for their dynamic page layouts and typographic treatments, the folksy warmth and whirlwind technical brilliance of her illustrations, and the child-centered focus of the stories she told.

About the book: 1939 was an extraordinary year in American popular culture. From Hollywood came *The Wizard of Oz* and *Mr. Smith Goes to Washington*—films that celebrated American idealism, stick-to-it-ive-ness, and Depression-era faith that tomorrow would indeed be a brighter day. John Steinbeck published his heartrending migrant-worker saga *The Grapes of Wrath,* and composer Aaron Copland premiered his rambunctious ballet suite *Billy the Kid.* Among the year's notable picture books were Ludwig Bemelmans's *Madeline,* Ingri and Edgar Parin d'Aulaire's *Abraham Lincoln,* Hardie Gramatky's *Little Toot,* and Burton's *Mike Mulligan and His Steam Shovel.* The latter two books both sounded another of the period's

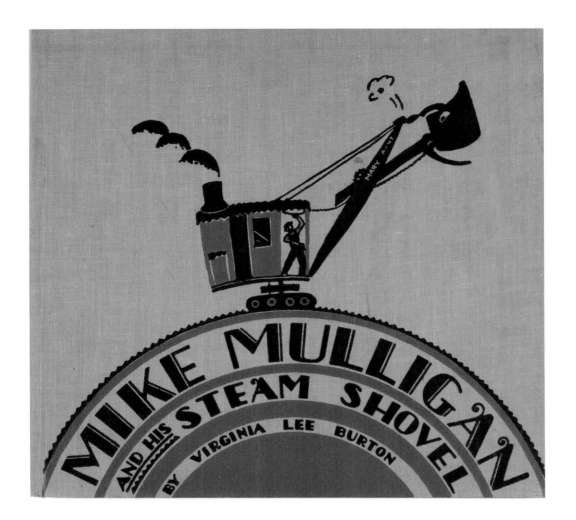

most resonant themes: the importance—in a nation of rising skyscraper cities and burgeoning industrial might—of recognizing the inherent worth of each and every individual, down to that of the smallest child.

Publication history: *Mike Mulligan* established Burton as a picture book artist of the first order. Nearly three decades later, the book's evergreen status was confirmed by a casual reference to it in Beverly Cleary's *Ramona the Pest* (1968), in which the eponymous heroine declares her preference for Burton's story about Mike and Mary Anne because "unlike so many books for her age, it was neither quiet and sleepy nor sweet and pretty."[1] Burton became one the American picture book artists most widely revered in postwar Japan. In addition to its Japanese edition, *Mike Mulligan* has been published in the United Kingdom, Sweden, Denmark, South Korea, and China.

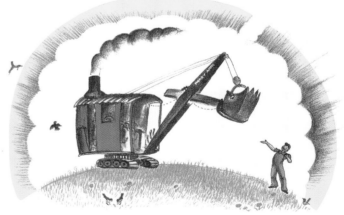

Mike Mulligan had a steam shovel,
a beautiful red steam shovel.
Her name was Mary Anne.
Mike Mulligan was very proud of Mary Anne.
He always said that she could dig as much in a day
as a hundred men could dig in a week,
but he had never been quite sure
that this was true.

3

They built the new town hall
right over Mike Mulligan and Mary Anne.
It was finished before winter.

42

Four corners . . . neat and square;
four walls . . . straight down,
and Mike Mulligan and Mary Anne at the bottom,
and the sun was just going down behind the hill.
'Hurray!' shouted the people. 'Hurray for Mike Mulligan
and his steam shovel! They have dug the cellar in just one day.'

Mike Mulligan had a steam shovel
A beautiful red steam shovel
Mike Mulligan very big and very strong
She could dig as much in one day
as a 100men could dig in a week

WILHELM BUSCH

born 1832, Wiedensahl, Kingdom of Hanover;
died 1908, Mechtshausen, German Empire

Biography: Although unable to afford a formal education for all their sons, Wilhelm Busch's parents arranged to send off the eldest of their seven children for several years of semiprivate instruction with a priest who was also the boy's uncle. Busch's fellow pupil was a stout lad later immortalized as "Max" alongside the artist's self-caricature as the skinny, cowlicked "Moritz." When the time came for the young man to consider his future, Busch's pragmatic father pressed him to train for a career in mechanical engineering, but art and literature ultimately exerted the stronger pull. After a fitful period of advanced art study in Düsseldorf, Munich, and elsewhere, Busch met the editor of the satirical weekly *Fliegenden Blätter* (*Flying Pages*) and, as a regular contributor, authored more than one hundred humorous pieces between 1861 and 1863. Having thus tasted success, he was keen to repeat the experience. However, his first four comic stories in book form flopped so badly that when Busch submitted his fifth, *Max and Moritz* (1865), to the same publisher,

the manager turned it down. This proved to be one of publishing history's most colossal blunders. Another publisher stepped into the breach, and within a few years' time the phenomenal popularity of *Max and Moritz* had freed Busch of financial worry once and for all. He remained productive but in later years grew increasingly withdrawn and melancholy.

About the book: In seven slapstick episodes, or "tricks," Busch's waggish antiheroes rob, terrorize, and wreak havoc on whatever grown-ups are nearest at hand. Busch presents the boys as irrepressible, devilishly fun-loving figures with a glint in their eyes. His nimble comic drawings have a coiled-spring energy that suits their subjects and is also a good match for the punchy rhymed couplets in which their outrageous misdeeds are archly chronicled without apology.

Publication history: *Max and Moritz (a Story of Seven Boyish Pranks)* did not immediately catch fire. But starting with the second printing of 1868, enthusiasm for the rascally book surged. By the time of the author's death in 1908, it had gone through a remarkable fifty-six editions for a total of 430,000 copies sold.

Max and Moritz's cultural influence far outstripped its immediate impact on readers. William Randolph Hearst, visiting Germany as a boy, discovered *Max and Moritz* and so enjoyed the merry pranksters' hijinks that he determined years later to offer his American newspaper readers a comparable experience. It was with this goal in mind that he hired German immigrant Rudolph Dirks to create *The Katzenjammer Kids*, a comic strip that debuted in the *American Humorist* Sunday supplement of Hearst's *New York Journal* on December 12, 1897, thereby establishing one of the foundational works of the modern comics genre. Both *Max and Moritz* and *The Katzenjammer Kids* would later become formative influences on the work of the visionary picture book artist Maurice Sendak, whose own Max and Mickey carry forward the tradition of the venturesome, inquisitive "bad" child with whom the young were expected to identify rather than shun as they reveled in making mischief (in Sendak's phrase) "of one kind or another."

Max und Moritz

eine

Bubengeschichte

in

sieben Streichen

von

Wilhelm Busch.

München,

Verlag von Braun und Schneider.

RANDOLPH CALDECOTT

*born 1846, Chester, UK; died 1886,
St. Augustine, Florida, US*

Biography: "There are so many beautiful things waiting to be drawn," wrote Randolph Caldecott to a budding six-year-old artist. "Animals and flowers oh! Such a many—and a few people."[1] The winking wit of the last phrase exemplifies the gently satirical outlook of Caldecott's spirited work as a magazine artist and picture-book-maker.

The frail son of a Cheshire hatmaker and accountant, Caldecott drew from an early age but bowed to his father's concern for his future by accepting a bank clerkship. Bank slips worked well as drawing paper, however, and while still in his teens the largely self-taught Caldecott sold his first sketches for periodical publication. At twenty-six, after stints at banks in Whitchurch and Manchester, he finally quit his safe career and moved to London, where, with regular exposure in *Punch, The Graphic,* and *London Society,* and as the illustrator of popular travel guides and story collections, he quickly consolidated his reputation.

When the high-end printing and publishing entrepreneur Edmund Evans needed a new picture book artist to replace Walter Crane (who had wearied of deadlines and wanted a break), he hired Caldecott and gave him free rein to experiment with a genre then still in its infancy. Caldecott embraced the challenge with inventiveness and verve and from 1878 to 1885 produced two books annually that added substantially to his fame. He died of chronic heart disease at not quite forty while touring the United States.

About the book: With a bank clerk's fine regard for the bottom line, Caldecott generally chose nursery rhymes and other cost-free public-domain material to illustrate in his picture books. *The Diverting History of John Gilpin* (1878) takes its title and text from a well-known comic ballad by the eighteenth-century poet and hymnodist William Cowper. As a tale about a runaway horse with a hapless rider astride its back, it afforded Caldecott ample scope for caricature and slapstick incident, and it allowed him to show off his preternatural talent for capturing motion on the page. His rapid-fire, seemingly improvised sepia line

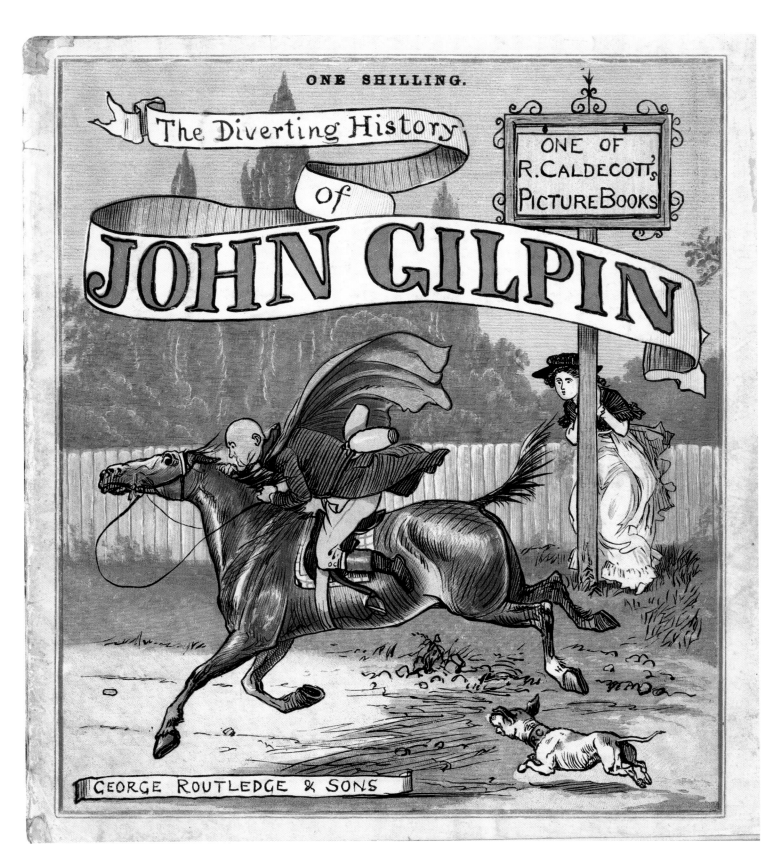

drawings swept past the fussy clutter of the art of his nearest rivals, Walter Crane and Kate Greenaway, to set a new standard in lifelike representation for successors from Beatrix Potter to Maurice Sendak and beyond. Caldecott once summarized his aesthetic by saying: "The art of leaving out is a science. The fewer the lines, the less error committed."[2]

Caldecott's startlingly open, minimalist page designs, which drew inspiration from the *Nocturnes* of James Abbott McNeill Whistler and Japanese ukiyo-e woodblock prints, among other sources, were equally revolutionary. The kinetic, modern look he established for the picture book suited an age that increasingly took rapid communication and transport for granted and would soon find its quintessential art form in the motion picture.

Publication history: Caldecott's *Diverting History* appeared in bookstalls alongside his *The House That Jack Built* in the fall of 1878, marking the artist's entrée into the picture book market. Evans issued the somewhat pricey one-shilling books in an initial print run of

ten thousand copies each. Both sold out immediately and repeatedly went back to press. Within weeks of the books' release, while traveling in France, the artist came across a glowing review of his work in a local French newspaper. His fame continued to spread, and before long American children were clamoring for "R. Caldecott's Picture Books" as well.

In the decades following Caldecott's premature death, reform-minded Americans pioneered library service for children as a professional specialty and singled out Caldecott's books and those of a select few others as high-water marks of aesthetic achievement that all young people deserved to experience. In 1938, leading figures within the American Library Association, wishing both to encourage and to reward homegrown children's book art, inaugurated the world's first prize for distinguished illustration for children. They limited eligibility to American citizens and residents but named the award for Randolph Caldecott, the English artist whose pathfinding work continued to point the way.

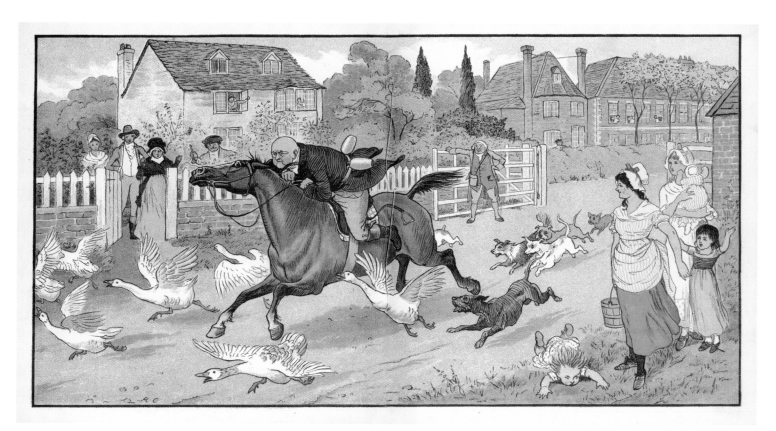

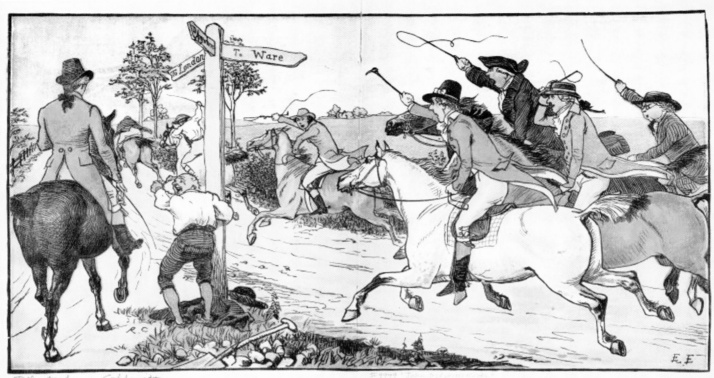

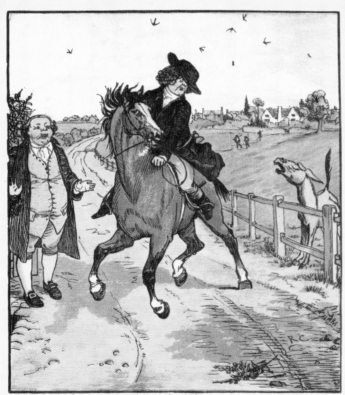

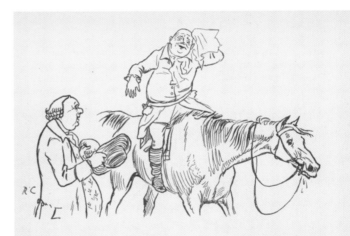

"But let me scrape the dirt away,
 That hangs upon your face ;
And stop and eat, for well you may
 Be in a hungry case."

Said John, " It is my wedding-day,
 And all the world would stare
If wife should dine at Edmonton,
 And I should dine at Ware."

So turning to his horse, he said
 " I am in haste to dine ;

"Twas for your pleasure you came here,
 You shall go back for mine."

Ah ! luckless speech, and bootless boast !
 For which he paid full dear ;
For while he spake, a braying ass
 Did sing most loud and clear ;

Whereat his horse did snort, as he
 Had heard a lion roar,
And galloped off with all his might,
 As he had done before.

22

ERIC CARLE

born 1929, Syracuse, New York, US; died 2021, Northampton, Massachusetts, US

Biography: Among Eric Carle's earliest childhood memories were snapshot impressions of family nature outings in upstate New York and of a sun-splashed kindergarten classroom well stocked with art supplies. These idyllic images go a long way toward defining the imaginative universe Carle would later inhabit as perhaps the best-known picture book artist of our time.

Carle's German-born parents chose to return to their homeland during the mid-1930s, when the Nazis were firmly in control. Already recognized by then by his American kindergarten teacher as having artistic talent, the very young Eric Carle balked at the stifling rigidity of the grade-school education he encountered in Stuttgart over the next several years. From high school onward, however, Carle received rigorous art and design training that later stood him in good stead. During a visit to the home of one of his German art teachers, he for the first time saw reproductions of the kinds of experimental modern art that the Nazi regime condemned as "degenerate" and expressly banned. It was a life-changing experience and one for the sake of which the teacher had in fact risked his own life.

In the immediate postwar years, Carle completed his education and designed posters for Amerika Haus, the US information center in Allied-occupied Germany, before returning to the United States in 1952.

In the years that followed, he achieved considerable success as an advertising designer and art director, but in mid-career he discovered a more fulfilling outlet for his talent when the writer Bill Martin Jr. invited him to collaborate on the children's picture book *Brown Bear, Brown Bear, What Do You See?* (1967). Soon after, Carle met Ann K. Beneduce, the editor with whom he would work closely from then onward, starting with *1, 2, 3 to the Zoo* (1968) and, the following year, *The Very Hungry Caterpillar*.

About the book: Beneduce urged Carle to rethink the initial concept and title of his second self-written picture book, which he had first presented to her as *A Week with Willi Worm*. As the narrative morphed into the story of a caterpillar's growth and transformation, she encouraged him to preserve the novelty elements he had originally envisioned for it: different-size pages with die-cut holes that made palpable the pathway of the little hero's wiggly odyssey. Manufacturing such a special book at an affordable price presented a significant challenge that Beneduce, who was one of the leading internationalist publishers of her generation, finally met by enlisting the cooperation of a Japanese printer she happened to know. Carle created his now-famous cut-paper collage illustrations from sumptuous hand-painted papers like those he had first made in class at the Akademie der Bildenden Künste (Academy of Art and Design) in Stuttgart. His striking use of bold, iconic forms and copious white space sig-

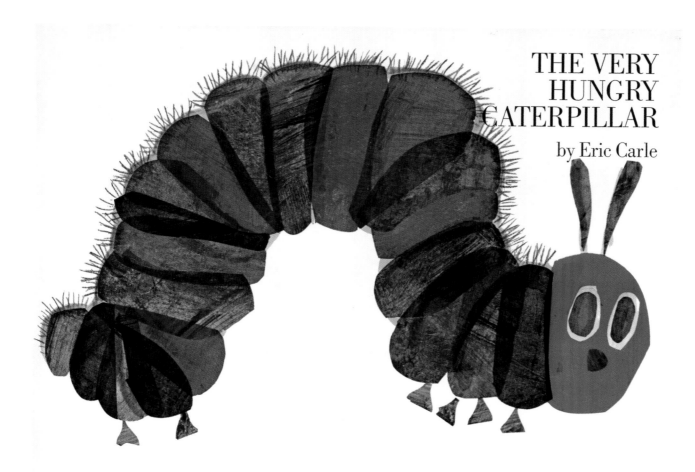

THE VERY HUNGRY CATERPILLAR
by Eric Carle

naled his allegiance to the contemporary international design movement that dispensed with ornament and historical allusion in favor of a streamlined modernist distillation of form and function. Carle joined Bruno Munari, Paul Rand, and his friend and mentor Leo Lionni in bringing to the picture book what they and other such polymath innovators had achieved in an array of specialties ranging from poster and furniture design to corporate branding.

Publication history: *The Very Hungry Caterpillar*'s toy-like novelty elements rendered the book suspect, for a time, in the eyes of America's influential librarian-critics, who had fought for decades for the picture book as an art form devoid of the slightest whiff of commercialism. It received a more positive reception, however, at the nation's preschools and day care centers, where play as a path to learning was enshrined as a first principle dating back to the teachings of John Dewey and Maria Montessori. A decade or so later, as research confirmed the developmental benefits of play as an element of early childhood education, the library world reversed itself and embraced Carle's work, by which time the artist had produced several more picture books in what had become his signature style. Drawing on his earlier life as an art director at an advertising agency, Carle organized his studio as a business from which numerous branded products, as well as books, began to flow at a prodigious pace. More than seventy foreign-language editions of *The Very Hungry Caterpillar* have been published, and it has been estimated that a copy of the book is sold somewhere in the world at the rate of one per second.

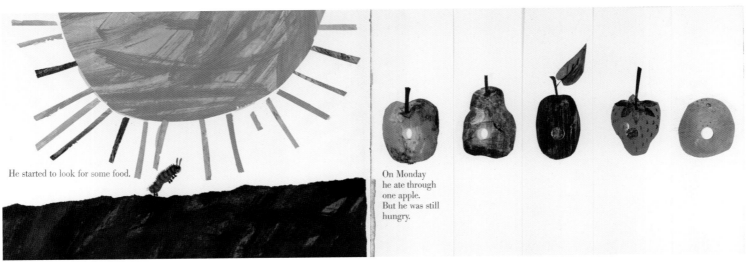

He started to look for some food.

On Monday
he ate through
one apple.
But he was still
hungry.

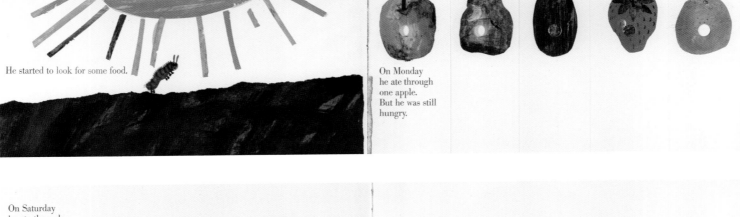

On Saturday
he ate through
one piece of
chocolate cake, one ice-cream cone, one pickle, one slice of Swiss cheese, one slice of salami,

one lollipop, one piece of cherry pie, one sausage, one cupcake, and one slice of watermelon.

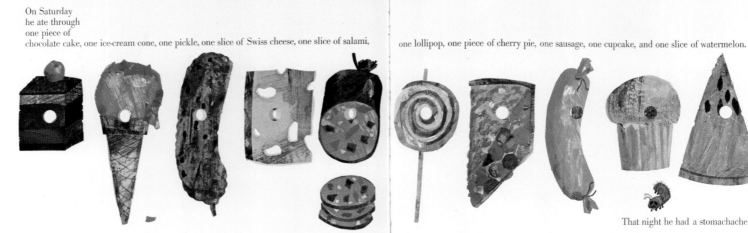

That night he had a stomachache!

Dummy for a preliminary version of
The Very Hungry Caterpillar

JEAN CHARLOT

born 1898, Paris, France; died 1979,
Honolulu, Hawaiii, US

Biography: A background of "sundry exotic ancestors" set the stage for Jean Charlot's eventful life of art-making, travel, and wide-ranging curiosity about indigenous cultures.[1] His Russian-born businessman father was a Bolshevik sympathizer. His mother's family had deep roots in the pre-Columbian Americas. After studies at the École des Beaux-Arts in Paris, Charlot made his way to Mexico, first as a visitor and later to live for a period of years. While there, he befriended Diego Rivera and the artists in his circle, took up mural painting and illustration, and emerged as a leading commentator on Mexican art.

In 1928, Charlot moved to New York, where he soon won acclaim as a painter, printmaker, and illustrator. His illustration work included images for collections of New World folktales, most notably *The Sun, the Moon and a Rabbit* (1935), a book of Aztec, Toltec, and Spanish legends retold by Amelia Martinez del Rio, and for picture books by Margaret Wise Brown.

Brown met Charlot while still an editor at W. R. Scott, the publishing offshoot of the Bank Street School, where Charlot briefly offered art instruction. True to form, she promptly composed a manuscript for the artist to illustrate. *A Child's Good Night Book* (1943) reads like a dress rehearsal for Brown's evergreen bedtime book of a few years later, *Goodnight Moon*.

The end of Charlot's picture book work coincided with Brown's premature death in 1952. Charlot by then had left New York for a teaching position at the University of Georgia. He later accepted a professionship in art at the University of Hawaii while continuing to lecture far and wide on art history. Throughout his long career, he remained productive in a range of media, including oil painting, printmaking, mural painting, and sculpture. In 1968, the Jean Charlot Foundation was established at the University of Hawaii to preserve and foster the study of his work.

A CHILD'S
Good Night
BOOK

By Margaret Wise Brown
Illustrations by Jean Charlot

Night is coming. Everything is going to sleep. The sun goes over to the **other side of the world. Lights turn on in all the houses. It is dark.**

About the book: Charlot created a suite of radiant and exquisitely tender lithographs for the small (5½ inches by 6½ inches) volume with a lyrical text that the author had composed on the back of an envelope. Brown had written a series of sharply drawn yet impressionistic observations of creatures great and small as they went to sleep at the end of the day. One line gave the illustrator particular trouble. "Night is coming," the passage read. "Everything is going to sleep." "I was a little mad at the author," Charlot later recalled, "for that particular page," which had forced him to find a way to compress the entire world into a single totemic image.[2]

Publication history: Brown's longtime association with the progressive Bank Street School had done much to alienate her from the powers-that-be at the New York Public Library. *A Child's Good Night Book*

The bunnies close their bright red eyes.

Sleepy bunnies.

was the first (and one of the very few) of her many picture books to receive the library's important endorsement on its annual list of Children's Books Suggested as Holiday Gifts. Charlot's exalted stature doubtless had made the difference for the librarians, who had been striving for years to win recognition for the picture book as a bona fide art form. They soon confirmed their admiration for Charlot by awarding *A Children's Good Night Book* a 1944 Caldecott Honor. Sales were strong enough to warrant a newly reformatted, larger edition of the book, which was better suited for library shelving, if also a compromise in terms of the author and artist's original intention. In later years, the book drifted out of print and developed the reputation of a cult classic. It returned to print, for a brief time, in a facsimile edition based on the original format, in 1992.

CHIHIRO IWASAKI

born 1918, Takefu, Fukui Prefecture, Japan;
died 1974, Tokyo, Japan

Biography: In 1971, Chihiro Iwasaki, by then one of Japan's best-loved picture book artists, wrote: "I experienced war early, as a force that dashes all youthful hopes. This has had a major influence on how I lived my life. I truly love peace, abundance, beauty, and adorable things. I feel limitless anger at the forces that would crush such things."[1]

For Chihiro, who began drawing as a small child and received her first formal training as a teenager, art was a reliable constant in a life marred by tragedy. Her first husband (from an arranged marriage) committed suicide in 1941, when she was still in her early twenties. Four years later, a wartime bombing raid destroyed the family's Tokyo home. After the war, attracted by its pacifist stance, Chihiro joined the Japanese Communist Party, began writing and illustrating for *Jimmin Shimbun* (the leftist "People's Paper"), and became a prolific magazine artist, poster designer, and illustrator of children's educational materials. In 1950, she married a fellow Communist, with whom she had her only child, a son who often served as a model for the children in her picture books.

In 1957, Chihiro wrote and illustrated her first picture book, *I Can Do It All by Myself,* and received the Juvenile Culture Award, sponsored by the publishing company Shogakukan, in recognition of her work for children. From then onward, picture books became an increasingly important part of her creative output. At her death from cancer at the age of fifty-five, Chihiro left behind an archive of nine thousand drawings.

About the book: *Staying Home Alone on a Rainy Day* (1968) was Chihiro's fifteenth picture book, and a breakthrough work not only for her personally but also for the modern Japanese picture book. It was published by Shiko-Sha, a specialty house whose founder, Yasoo Takeichi, set out boldly to publish a new kind of picture book that was "a work of art in itself" rather

あめの ひの おるすばん

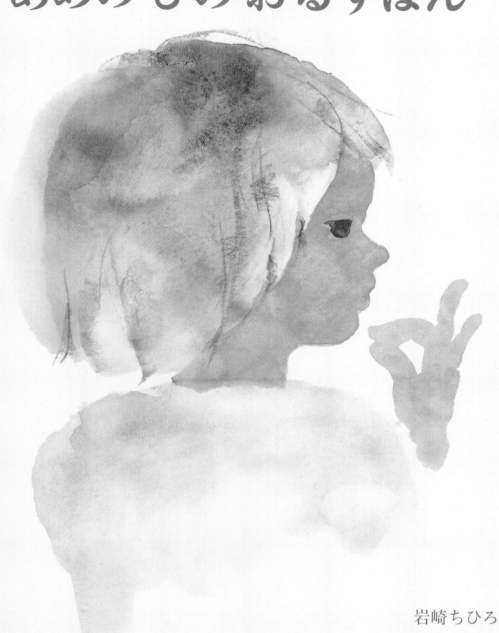

岩崎ちひろ／絵と文

武市八十雄／　案

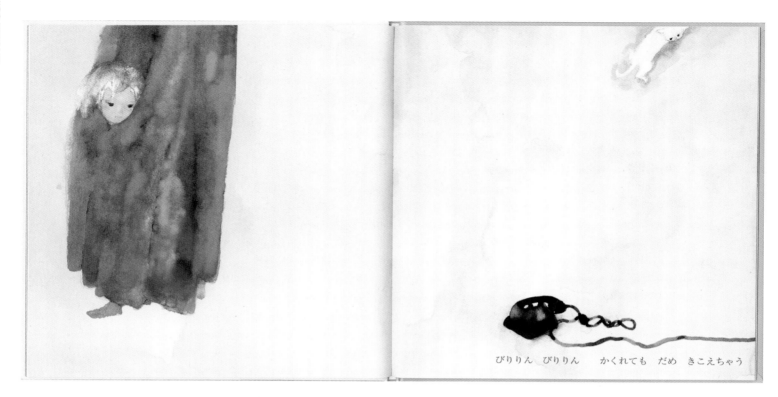

びりりん　びりりん　　かくれても　だめ　きこえちゃう

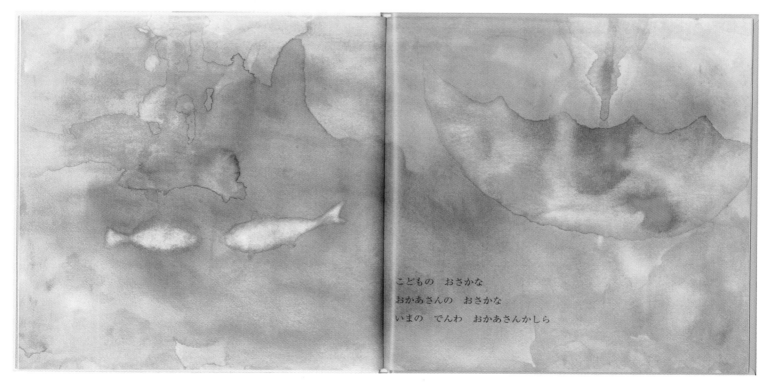

こどもの　おさかな
おかあさんの　おさかな
いまの　でんわ　おかあさんかしら

than a modest production that merely told a story in the traditional way.[2] With his artists'-book aesthetic and command of the latest color printing technology, Yasoo encouraged Chihiro to create illustrations for a given book in a variety of art media and on different textured papers. The production of these books became a kind of grand adventure, with the technical innovation and improvisatory spirit required to satisfactorily print them mirroring the spontaneous nature of young children's imaginative play—the very aspect of early childhood life that Chihiro recorded so persuasively in the wispy, enigmatic watercolors of *Staying Home Alone on a Rainy Day*.

Publication history: One year after its publication in Japan, Chihiro's first major picture book appeared in English-language editions in both the United States and the UK, the latter under the title *Momoko's Lovely Day* (1969). The flap copy of the UK edition, published by the Bodley Head, hinted at a great future for the "not yet widely known" Japanese artist, and in fact Chihiro's

reputation enjoyed a rapid ascent, with award recognition coming her way at the 1973 Bologna Children's Book Fair and the 1974 Leipzig Book Fair. Following her premature death in 1974, Chihiro's son and his wife responded to fans' requests to view his mother's original art by demolishing half of her Tokyo home and constructing an intimate museum. Royalty income later made it possible to build a dedicated museum structure—the world's first picture book art museum—on the same Nerima, Tokyo, site. In 1997, a second Chihiro Art Museum, nestled in the countryside of Azumino, Matsukawa-mura village, Nagano Prefecture, where the artist's parents settled to cultivate its land after World War II and where she herself loved to paint, was added. The museum's activities have done much to keep Chihiro's picture books in the forefront in Japan. Her illustrations for Andersen fairy tales have become her best-known books in the West, while her lyrical riffs on early childhood are equally familiar to Japanese and, increasingly, to Chinese mothers and children.

BRYAN COLLIER

born 1967, Pocomoke, Maryland, US

Biography: Even before he could read, Bryan Collier enjoyed piecing together stories from the pictures in illustrated books his mother brought home for him. Collier's mother, a teacher in the federal government–sponsored Head Start program begun in 1965 to help meet the developmental needs of the children of low-income families, chose well for her son: Ezra Jack Keats's *The Snowy Day* and *Whistle for Willie*, Maurice Sendak's *Where the Wild Things Are*, and Crockett Johnson's *Harold and the Purple Crayon*, among others. Without much prompting from anybody, he became serious about making art himself as a teenager, won a national competition, and earned a scholarship to New York's Pratt Institute. Collier was married with a family of his own when, a few years out of school, he realized how few picture books were being published that reflected the history, culture, and everyday lives of African Americans. Always mission-driven, he decided to dedicate his efforts to expanding the literature.

In the first picture book he wrote and illustrated, *Uptown* (2000), Collier paid tribute to Harlem, his adopted home, as a historic center of African American culture and vibrant present-day community. The

winner of the 2001 Coretta Scott King Award for illustration, it brought Collier to the fore as a leading figure in the younger generation of African American illustrators coming up behind Jerry Pinkney and Ashley Bryan and their contemporaries. A steady flow of books and awards followed.

The book: *Trombone Shorty* (2015), written by Troy "Trombone Shorty" Andrews, was the twenty-seventh picture book illustrated by Collier. The autobiographical first-person narrative, by a noted contemporary New Orleans musician, recounts his early determination to make a place for himself in his hometown's extraordinary music scene and the love and encouragement with which the entire community responded to his efforts. Collier's mesmerizing trademark watercolor and collage illustrations, supplemented by pen-and-ink line work, are an attempt to offer visual equivalents to the joyful, high-energy rhythm and drive and complex harmonies characteristic of the music for which Andrews is known. Intense portraiture, dramatic perspectives, surprising juxtapositions of painted surfaces and patterned bits of photographs clipped and collaged from magazine illustrations, and a sense of light that subtly introduces a spiritual dimension come together in Collier's forceful, yet tender, images. In

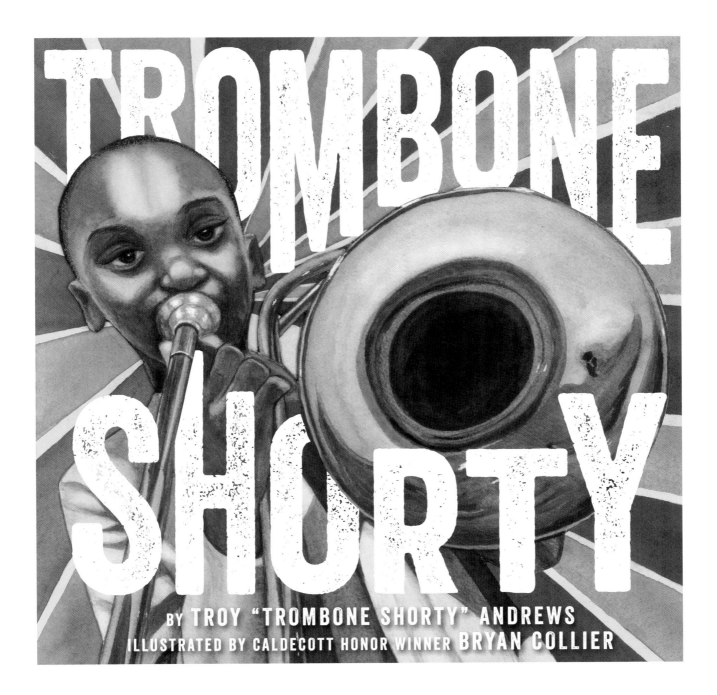

an Illustrator's Note, Collier writes: "One of my favorite images . . . is the one of Troy and his friends with their homemade instruments . . . The fact that [they] constructed their own makeshift instruments until they could get real ones conveyed both their strong desire to imitate the older musicians they loved and to make music themselves. To me, this showed the hope and promise in these boys. So I decided to give them crowns in my painting, because, early on, they were like royalty."

Publication history: Collier won his sixth Coretta Scott King Award for illustration for *Trombone Shorty* as well as his fourth Caldecott Honor. It has also been published in Chinese and Korean.

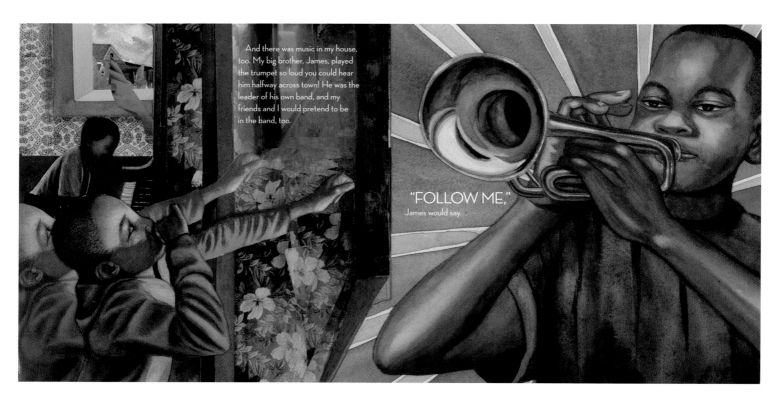

And there was music in my house, too. My big brother, James, played the trumpet so loud you could hear him halfway across town! He was the leader of his own band, and my friends and I would pretend to be in the band, too.

"FOLLOW ME,"
James would say.

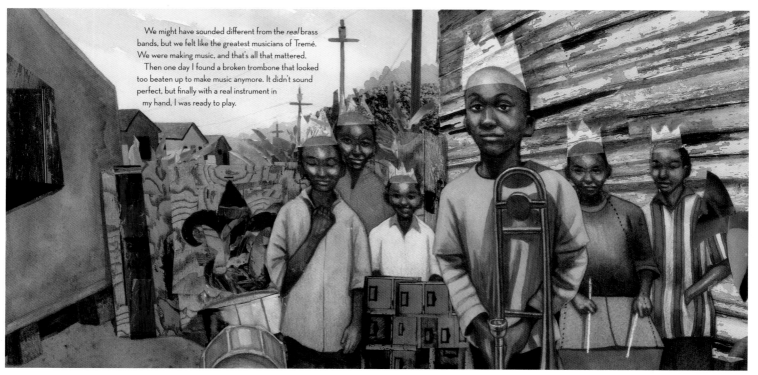

We might have sounded different from the *real* brass bands, but we felt like the greatest musicians of Tremé. We were making music, and that's all that mattered.

Then one day I found a broken trombone that looked too beaten up to make music anymore. It didn't sound perfect, but finally with a real instrument in my hand, I was ready to play.

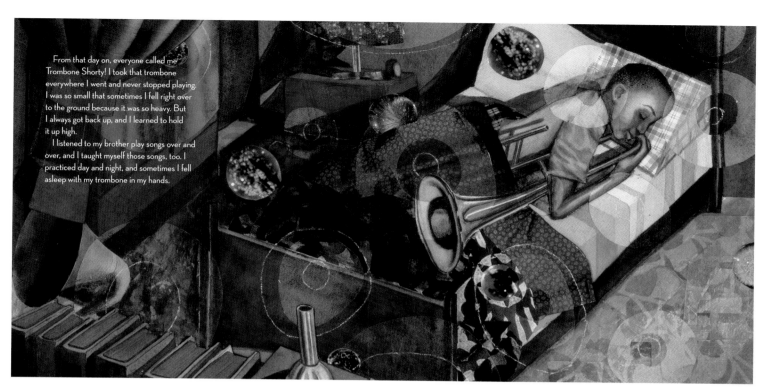

From that day on, everyone called me Trombone Shorty! I took that trombone everywhere I went and never stopped playing. I was so small that sometimes I fell right over to the ground because it was so heavy. But I always got back up, and I learned to hold it up high.

I listened to my brother play songs over and over, and I taught myself those songs, too. I practiced day and night, and sometimes I fell asleep with my trombone in my hands.

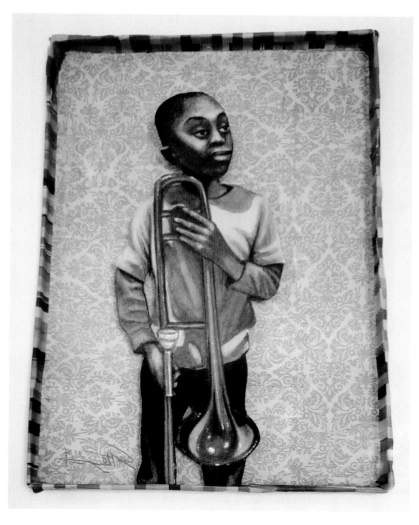

WALTER CRANE

born 1845, Liverpool, UK; died 1915,
Horsham, UK

Biography: Recognized as a prodigy, Walter Crane learned to draw in the studio of his father, a portrait painter and miniaturist of modest reputation, and from the engravings he pored over in the pages of the *Illustrated London News,* which he treated as his coloring book. He was apprenticed as a young teen to the noted London wood engraver W. J. Linton. By the age of seventeen he had left to embark on a career as an illustrator. The following year Crane met Edmund Evans, the innovative color printer and entrepreneur, who was eager to capitalize on the burgeoning middle-class demand for top-quality illustrated children's books. He commissioned Crane to design and illustrate a series of such "toy books." Over the next decade and a half, with Evans as his impresario and technical adviser, Crane would devote much of his

creative energies to the newly emerging genre of the artistic children's picture book. His great success in this field led to commissions to design decorative architectural friezes, ceramic tiles, and wallpapers in the Arts and Crafts style.

Crane's decision in the late 1870s to take time out from his work for Evans opened the door for two other equally distinctive illustrators, Kate Greenaway and Randolph Caldecott, to make their mark under Evans's tutelage. In later years, alongside his friend and colleague William Morris, Crane allied himself with England's socialist movement and created posters and other graphics in support of workers' rights.

About the book: Crane drew inspiration for his work from the principles of harmony, grace, and balance found in ancient Greek vase painting. This classicizing impulse is nowhere more evident than in the illustrations for *Beauty and the Beast.* So, too, is Crane's intense interest in architectural ornament and interior

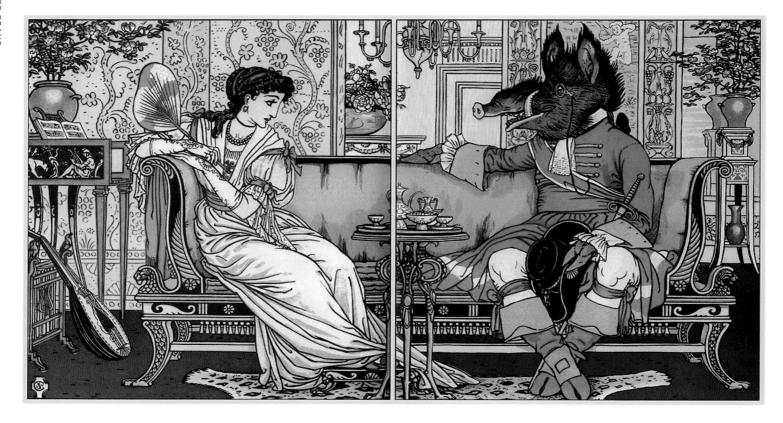

decoration. Crane seems to have used illustrations like these as a proving ground for his wallpaper and other decorative arts designs, and his elaborate attention to matters of decor doubtless enhanced the books' appeal for the parents who ultimately purchased them. He was a stickler for historical accuracy in period dress and furnishings, and another of the great appeals for parents of Crane's picture books must have been the spirit of absolute conviction with which he transported readers to another time and world via illustrations that had all the dash and sophistication of a West End costume drama.

Publication history: Crane's first picture books for Edmund Evans sold for an affordable sixpence each. *Beauty and the Beast* (1874) was one of five books published in 1874 that sold for the considerably higher sum of one shilling, an indication of a rising market and the artist's popularity. The English historian Rodney K.

Engen estimated the initial print run for each of the latter set of books at as high as fifty thousand, an impressive figure for the time. Crane earned a modest flat fee for his efforts, however, hardly an incentive to press onward as demand for his books spiraled upward. The toy books became known in the United States as well, and after 1906, when Anne Carroll Moore took charge of service for children at the newly consolidated New York Public Library, they were considered a staple of the picture book collection.

Randolph Caldecott thought Crane's illustration style overly ornate and mannered; Crane in turn disparaged Caldecott's style as too loose. But Kate Greenaway, the third star in Edmund Evans's brilliant picture book firmament, clearly learned important lessons from the perfectionistic attention to detail Crane poured into the making of his idealized and richly embellished imaginary worlds.

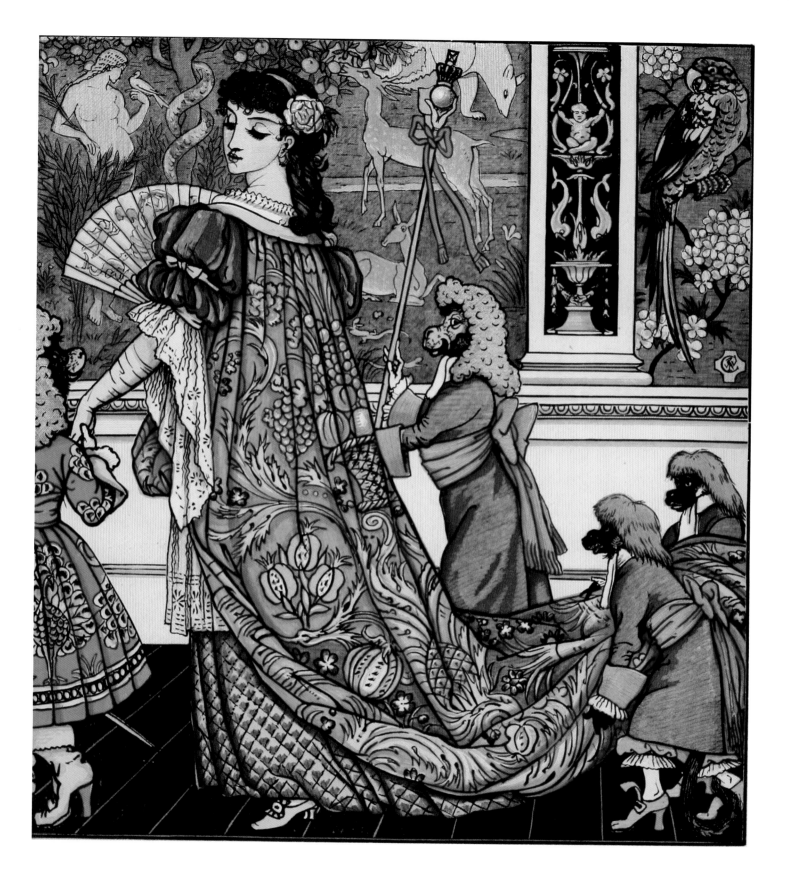

KITTY CROWTHER

born 1970, Uccle, Belgium

Biography: Raised in Belgium by an English father and a Swedish mother, Kitty Crowther grew up with a sense of self that transcended national identity and came to dwell in a deep curiosity about the meeting place of dream and myth. A child who loved to draw and felt a strong kinship with the natural world, she studied graphic design at the Institut Saint-Luc in Brussels and published her first picture book, *Mon royaume* (*My Kingdom*, 1994), not long after graduation. Working with traditional materials such as color pencils and pastels, she developed a highly expressive style that blends powerful linework with a rapturous, Fauve-inflected embrace of intense color, and has set an ambitious pace for herself by publishing two or more picture books in nearly every year of her professional career. Major European recognition came with the Dutch Silver Pencil Award in 2003 and 2005. In 2010, Crowther

was chosen as the recipient of the international Astrid Lindgren Memorial Award of the Swedish Arts Council—a prize comparable in prestige to the Hans Christian Andersen Award—that drew worldwide attention to her work. Her books have been translated into more than twenty languages.

About the book: Crowther's fascination with Greek mythology, marine biology and life-forms generally, and intimate human relationships converged in the emotionally raw, magical *Mère Méduse* (*Mother Medusa,* 2014). Crowther tells the strange story of a reclusive, shaman-like woman with a river of long, flowing golden hair, and the young daughter for whom that hair is quite literally a nesting place and bulwark against the outside world. Medusa loves her daughter, Irisée (*iridescent* in French), and calls her "my pearl," a term of affection that also hints at a primal connection between the wild and fiercely protective woman and the sea beside which they live. As the story unfolds,

Improvisatory drawing in which the character Mère Méduse first appeared to Crowther

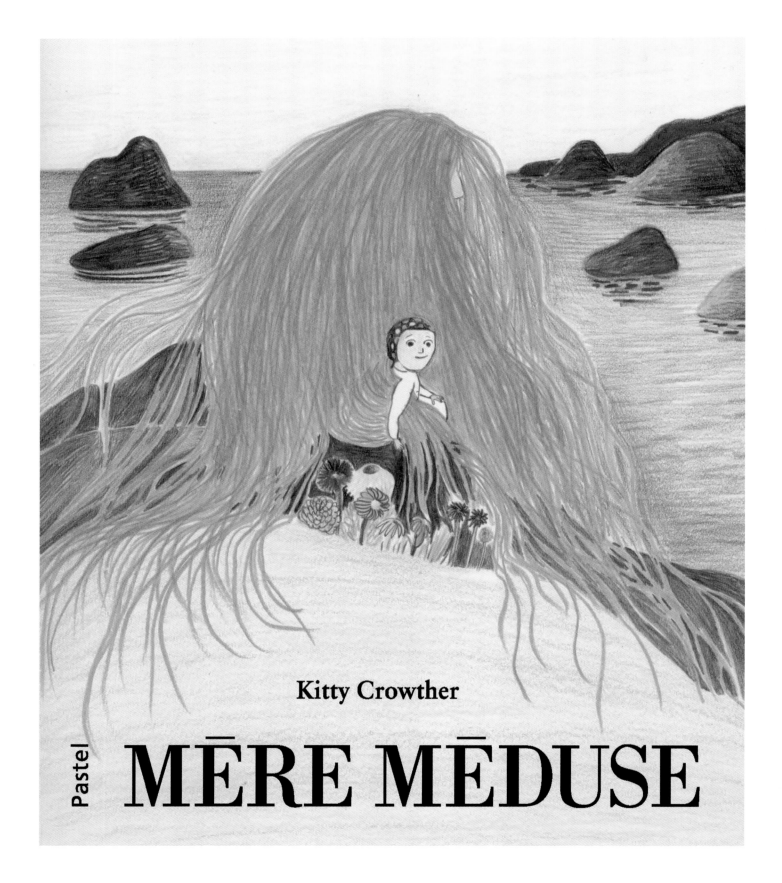

Kitty Crowther

Pastel MĒRE MĒDUSE

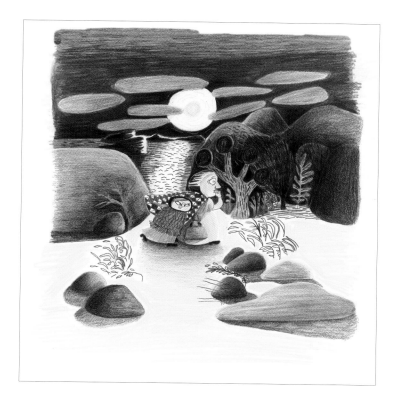

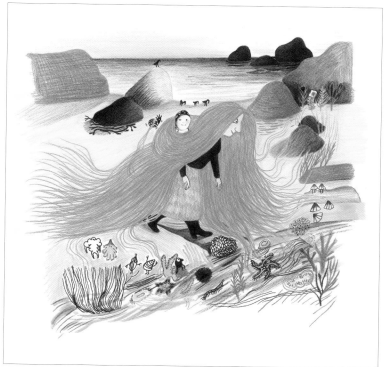

Crowther also shows that maternal love can have a problematic, darker side, a reluctance to let go that is finally resolved when the very sheltered Irisée catches a belated first glimpse of children her own age, and both mother and child realize it is time for the girl to emerge from the mythic nest and enter the social realm of friends and school.

As often happens for Crowther, her Medusa character simply appeared unbidden one day as a detail within a large drawing of fantasy characters. The story germinated over a long period of intensive travel following Crowther's Astrid Lindgren win. The seascapes, with their big, smoothly polished rocks, came into the illustrations after a visit with her mother on the west coast of Sweden. The lush vegetation that is a recurring element in Crowther's kinetic illustrations has a colorful decorative aspect but also the heft and mystery-laden presence of a collection of talismans. The look of Medusa's golden hair was inspired in part by the long tentacles of the type of jellyfish known by the same name. Jellyfish are among the earth's oldest life-forms, and, quite apart from the story, Crowther delighted in sketching them both for the elegance of their form and as a way of reconnecting with childhood memories of having tried to rescue those she found stranded on the beach, even after they had stung her.

Publishing history: Originally published in French as *Mère Méduse*, Crowther's beguiling story has been translated into Swedish, Basque, Catalan, Spanish, Dutch, and Chinese.

GEORGE CRUIKSHANK

born 1792, London, UK; died 1878, London, UK

Biography: The son and younger brother of caricaturists, George Cruikshank learned his craft at home and earned an early reputation as an acerbic pictorial observer of the political and social scene of his day. Drawing from the age of nineteen for *The Scourge*, a "Monthly Expositor of Imposture and Folly," he made the libertine Prince of Wales a favorite target, winning favorable comparisons with Britain's most fearless caricaturist of the previous generation, James Gillray, for his devil-may-care style of attack. When the prince ascended to the throne in 1820 as King George IV, Cruikshank's unrelenting barbs prompted the royal household to offer him hush money in return for his forbearance. He took the bribe but cheekily refused to be bound by the terms of the deal.

By the 1830s, as the fashion for satire abated, Cruikshank turned to book illustration, once again swiftly distinguishing himself. Among the first books he illustrated was Wilhelm and Jacob Grimm's land-mark *Collection of German Popular Stories*. Cruikshank went on to form a close, if at times contentious, association with Charles Dickens as the illustrator of the latter's *Sketches by Boz* and *Oliver Twist*. In later years, the Temperance Movement, in which Cruikshank himself became deeply engaged, became the major subject of his work. He even recast a collection of traditional stories in the *Fairy Library* of 1854 for the purpose of bringing his anti-drink message home to impressionable youngsters.

About the book: The publication in 1823 of the two-volume Brothers Grimm's *Collection of German Popular Stories* marked the first appearance in English of the folklore compilation that afterward became known to the world as "Grimm's fairy tales." Cruikshank brought his usual comedic zest to the project along with a full appreciation of the strange stories' darker meanings. He delighted in dramatizing the horrifying conduct of ogres and the impish escapades of troublemakers like Rumpelstiltskin and of the conspiring animals of "The Bremen Town Musicians," and had a high time playing for laughs the contrasting physical types and scale of the protagonists of such stories as "The Young Giant and the Tailor." The artist's particular fondness for giants may perhaps be best understood by the fact—often remarked on in his time—that Cruikshank himself stood well over six feet tall.

Publication history: Nearly two centuries after their initial publication, Cruikshank's illustrations remain widely available in editions of the Grimm tales. The vigor of Cruikshank's draftsmanship and the tartness and sprightliness of his humor have kept the art fresh, even as the core focus of line illustration, as exemplified by the work of such twentieth-century masters as Ernest H. Shepard and Edward Ardizzone, underwent a fundamental shift toward concern for the nuances of psychological portraiture. Exhibitions of Cruikshank's work have most often highlighted the artist's supporting role as Dickens's first illustrator. But his career as a whole has also received sustained attention, as in the major 1968 University of Louisville Libraries retrospective *The Inimitable George Cruikshank*.

"The Giant and the Tailor"

Top: Title page illustration for volume two; bottom left: "The Young Giant"; bottom right: "The Turnip"

Opposite: "Rumpelstiltskin"

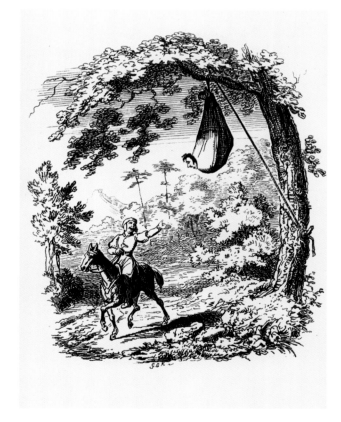

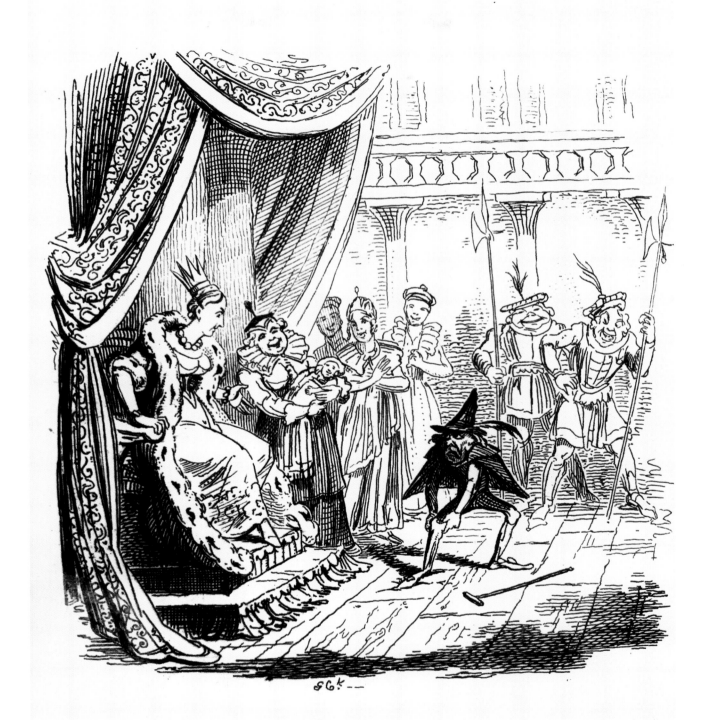

INGRI D'AULAIRE

born 1904, Kongsberg, Norway; died 1980, Wilton, Connecticut, US

EDGAR PARIN D'AULAIRE

born 1898, Munich, Germany; died 1986, Georgetown, Connecticut, US

Biography: "Choosing is creating," declared Anne Carroll Moore, the New York Public Library's founding supervisor of children's services and her field's leading critic and power broker for more than half a century.[1] When Moore met the D'Aulaires in New York in 1929 as newly arrived European émigré artists, she was quick to recognize their potential as picture-book-makers and persuaded them to try their hand at an art form that had not previously attracted their notice. Ingri had imagined a future for herself as a portrait artist specializing in child subjects, while Edgar, who had trained as an architect, had intended to continue his work as a lithographer specializing in deluxe illustrated books. Moore's impassioned cheerleading changed all that. The couple's first picture book, *Ola* (1932), established

their reputation as virtuoso lithographers dedicated to creating their dynamic, sun-splashed images the old-fashioned way, on slabs of Bavarian limestone that each weighed one hundred pounds or more, and as vivid, energetic storytellers. For the next thirty years, hardly a year passed without a new work from the team, including several books that added to their two major series: picture book biographies, including *Abraham Lincoln*, for which the D'Aulaires received the 1940 Caldecott Medal; and treasuries of classic myths and legends.

About the book: One of their last and culminating works, *Norse Gods and Giants* (1967) had special meaning for Ingri D'Aulaire, as it drew directly on the Icelandic sagas that her uncle had translated decades earlier into her native Norwegian. The D'Aulaires' collection was itself an epic undertaking, a distillation of outrageous tales told on the grand scale and, for all its salty humor, a venturing far deeper into the darkest recesses of human—and superhuman—nature than was par for the course in a 1960s American illustrated storybook for grade-schoolers. The D'Aulaires accom-

plished all this without diluting the ancient text they had started from in any appreciable way. As the novelist Michael Chabon would recall of his special affection for the book as an avid young reader during the decade in which it was first published: "I grew up in a time of mortal gods who knew, like Odin, that the world of marvels they had created was on the verge, through their own faithlessness and might, of Ragnarok, a time when the best impulses of men and the worst were laid bare in Mississippi and Vietnam, when the sub-urban Midgard where I grew up was threatened—or so we were told—by frost-giants and fire-giants who were sworn to destroy it. And I guess I saw all of that reflected in this book."[2]

Publication history: *Norse Gods and Giants* garnered strong reviews and became a standard on American public library and school library shelves. In 1987, the Children's Literature Association, a US-based group of academic scholars, selected it as one of only twenty "touchstones" or canonical "best" works of children's literature in the broadly defined category of fairy tales, fables, myths, legends, and poetry. By the time of its triumphant reissue as *D'Aulaires' Book of Norse Myths* in 2006 by the New York Review Children's Collection, however, the book had been out of print for several years. A Mandarin edition has been published in China.

JEAN DE BRUNHOFF

*born 1899, Paris, France; died 1937,
Montana, Switzerland*

Biography: French painter Jean de Brunhoff came to picture-book-making in the casual way that many talented artists of his generation did: by becoming a parent and rising to the challenge of giving more permanent form to the improvised bedtime tales that germinated at home. Coming from a family of luxury trade publishers doubtless speeded the transformation of a simple homemade diversion into a dazzlingly well-executed commercial venture. *The Story of Babar* debuted in 1931 in France as a sumptuous, hand-lettered gift book of suitably elephantine proportions. De Brunhoff completed six sequels before his untimely death of tuberculosis at the age of thirty-seven. His elder son, Laurent, who trained as a painter and began his career as an abstractionist, later turned his hand to extending the lives of Babar and his kingdom of loving family members, loyal subjects, and mortal enemies, in a long list of sequels.

About the book: De Brunhoff drops readers headlong into a wild and unpredictable jungle world where, as we soon learn, the worst can happen. Few picture books can claim a more tearful opening scene than the one that sets this story's events in motion, when a hunter takes aim at Babar's doting mother and makes quick work of her, thereby rendering her elephant child an orphan—frightened, angry, mournful, and alone. As in traditional fairy tales, the parent's death is the perfect setup for the coming-of-age story to follow, as part of which the elephant child makes his way to a city resembling Paris and learns the ways of refined modern urban living. Before long, however, Babar opts to return to the jungle where he feels he belongs, and where he is promptly elected king. Postwar critics Ariel Dorfman and Herbert Kohl ascribed an unacknowledged colonialist subtext to the trajectory of Babar's journey to the white man's civilization and back. Their point is well taken, although for many readers, a young child's emotional resilience is likely to be the more strongly felt theme. De Brunhoff's first picture book remains a triumph of extravagant yet intimate bookmaking, the picture book as tabletop theater par excellence.

Publication history: Two years after its initial release in France as *L'Histoire de Babar, le petit éléphant, The Story of Babar* appeared in the United States. Merle S. Haas of the New York firm of Smith and Haas had spotted a French-edition copy in a Greenwich Village shop window and decided to translate it herself. In the mid-1930s, when the firm merged with Random House under the latter name, the Babar books became mainstays of the juvenile list. Jean de Brunhoff's books have been translated into at least eleven other languages. His original art and that of his son Laurent have been the subject of art monographs and major exhibitions, and a substantial collection open to researchers resides at New York's Morgan Library & Museum. An animated television series produced by Nelvana premiered on Canadian television and HBO in 1989 and subsequently aired in thirty languages in over 150 countries. In 2010, Disney Junior created a computer-generated animated series. Countless licensed Babar toys and products have been marketed around the world.

Dans la grande forêt,
un petit éléphant est né.
Il s'appelle Babar.
Sa maman l'aime beaucoup.
Pour l'endormir,
elle le berce avec sa trompe
en chantant tout doucement.

– 3 –

Alors il s'achète :

une
chemise
avec col
et
cravate,

un
costume
d'une
agréable
couleur
verte,

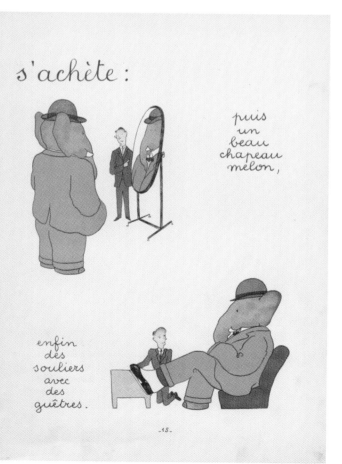

puis
un
beau
chapeau
melon,

enfin
des
souliers
avec
des
guêtres.

– 14 –

– 15 –

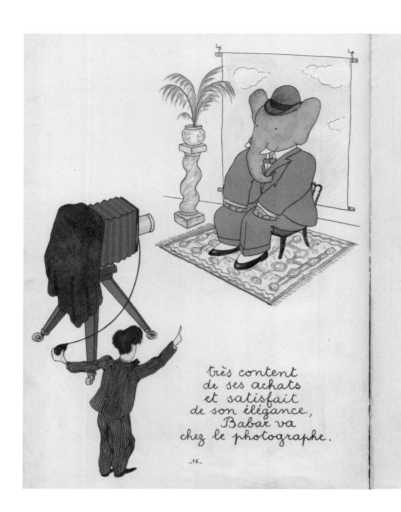

très content
de ses achats
et satisfait
de son élégance,
Babar va
chez le photographe.

-16-

Et voilà sa photographie.

-17-

Un savant professeur lui donne des leçons.
Babar fait attention
et répond comme il faut.
C'est un élève qui fait des progrès.

.22.

Le soir, après dîner, il raconte
aux amis de la vieille dame
sa vie dans la grande forêt...

W. W. DENSLOW
born William Wallace Denslow

*born 1856, Philadelphia, Pennsylvania, US;
died 1915, New York, New York, US*

Biography: Known to acquaintances as "the Growler" for his petulant manner, W. W. Denslow charted a restless, zigzag course as an illustrator on the make in the helter-skelter American periodical and book publishing world of the turn of the last century. Leaving Philadelphia behind at age fourteen following his father's death, Denslow headed for New York to study art and within a few years' time was earning a modest living as a theater sketch artist and poster designer. Seemingly incapable of holding any job for long, he tried his luck at newspapers in Chicago, San Francisco, and other cities around the United States, quarreling (and for a bad stretch also drinking) his way from one untenable position to the next. He returned to Chicago for a second go-round at

the time of the 1893 Columbian Exposition, sobered up, and at last established what for him was a stable professional life as Rand McNally's much-admired in-house book designer, with all the additional freelance work he could wish for from the William Morris–inspired Roycroft Press and other clients.

Denslow was a well-regarded local art-scene figure when in 1897 he was introduced to a writer named L. Frank Baum at the Chicago Press Club, where both were members. The two men were also the same age, but Baum had yet to solidify his own reputation and told Denslow that he was eager to make his name as a children's book author. They formed a partnership, and in 1899 they produced their first popular success, *Father Goose*, a collection of Baum's pithy rhymes and the artist's high-spirited graphics. The next year, they published *The Wonderful Wizard of Oz* (1900).

About the book: The name Oz had come to Baum one day as he glanced at the alphabetical label O–Z on a home filing cabinet. The story itself had been long in the making as improvised entertainment for the author's children. Baum and Denslow worked closely together, each influencing the other as the specifics of the story's fantasy world crystallized.

For *The Wonderful Wizard of Oz*, Denslow produced a series of tautly composed images in black outline that have all the impact and urgency of a poster while also incorporating droll comic touches and elegant decorative grace notes in the spirit of William Morris's Kelmscott Press. Japanese woodblock prints—with their flattened perspective, incisive line work, and ingenious use of negative space—were another important influence. Twenty-four full-page illustrations were printed in color.

Denslow later recalled the trial-and-error process from which the iconic look of the various characters emerged: "I made twenty-five sketches of the two monkeys before I was satisfied with them. You may well believe that there was a great deal of evolution before I got that golf ball in the Scarecrow's ear or the funnel on the Tin Man's head."[1]

Publication history: In a then-common business arrangement, Baum and Denslow agreed to share the

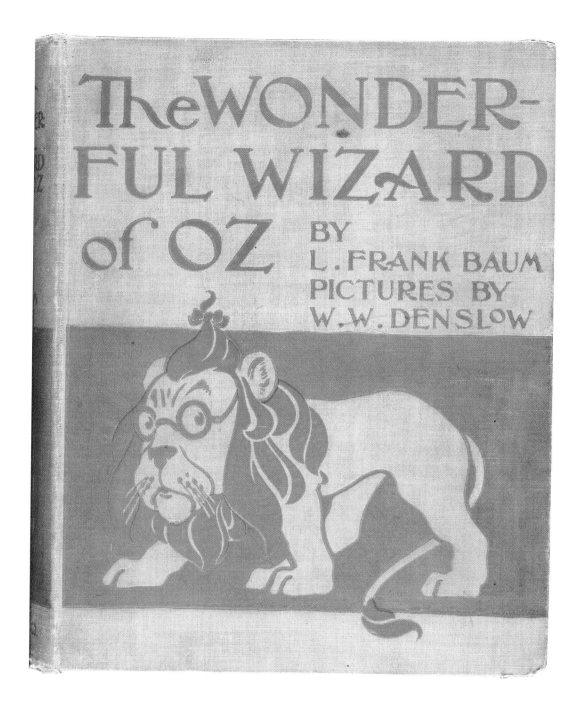

book's production costs with their Chicago-based publisher, George M. Hill, in return for a larger percentage of the profits. The gamble paid off, as *The Wonderful Wizard of Oz* sold more than thirty-seven thousand copies in the first fifteen months, a solid showing even though it did not quite live up to the public's response to *Father Goose*.[2] Then, in February 1902, Hill went bankrupt, months before the premiere of the musical adaptation, which opened in Chicago before embarking on an immensely lucrative national tour. In April 1903, with the touring musical still in high gear, Bobbs-Merrill reissued *The Wonderful Wizard of Oz* to skyrocketing sales.[3] Baum and Denslow, meanwhile, had begun to quarrel over the division of income from the theatrical production, for which the latter had designed the sets and costumes. The rift proved permanent, and Baum replaced Denslow as Oz illustrator with John R. Neill, starting with the first sequel, *The Marvelous Land of Oz*.

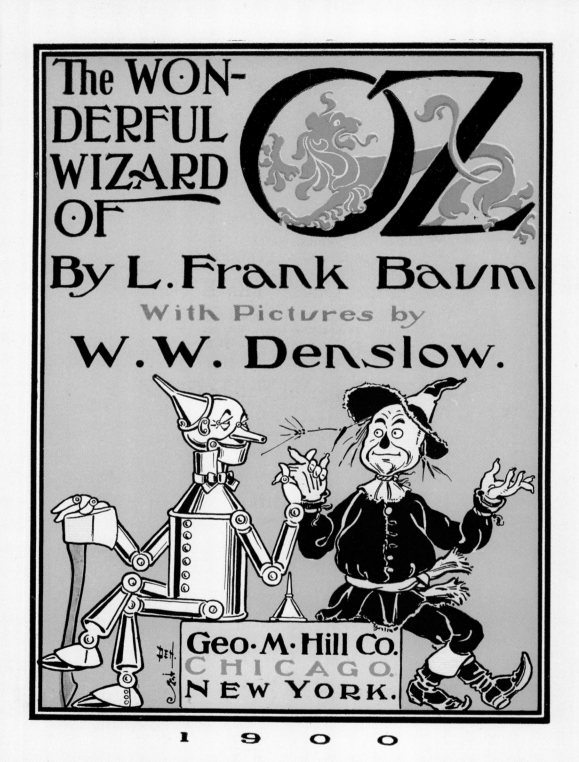

"You ought to be ashamed of yourself!"

"Exactly so! I am a humbug."

Chapter III
How Dorothy saved the Scarecrow.

Chapter XI.
The Wonderful Emerald City of OZ.

RICHARD DOYLE

born 1824, London, UK; died 1883,
London, UK

Biography: Known to all as "Dickie," Richard Doyle was one of seven children of the respected London political cartoonist John Doyle (or "HB"), who enthusiastically welcomed his sons and daughters into his studio and gave them all the art instruction they desired. Young Dickie was one of three to find his life's work in this way. By age nineteen, Doyle had become a regular contributor to *Punch,* Britain's smart new humor magazine, where John Leech was the lead illustrator. Young Doyle was routinely called upon when an inventive decorative border or initial letter was needed, and in 1849 he drew the iconic *Punch* masthead that remained in place for a century. A devout Catholic, he parted company with the weekly after eight years, in

1850, following the publication of a series of venomously anti-papal cartoons.

Doyle by then had already established himself as a book illustrator, notably of *The Fairy Ring* (1846), a new English-language Grimm translation; *Punch* owner-editor Mark Lemon's *The Enchanted Doll* (1849); and John Ruskin's literary fairy tale *The King of the Golden River* (1850). Alas, he did not always do well at meeting his deadlines, a professional shortcoming that in the long run damaged his standing. (On one occasion Doyle is said to have explained away his tardiness to an anxious engraver by citing a shortage of pencils.) From 1869 to 1870, the noted color printer Edmund Evans assembled a portfolio of Doyle's fantasy watercolors in a lavishly engraved, oversize volume titled *In Fairyland: Pictures from the Elf-World* (1870). Advertised as a children's book but enjoyed by adult readers as well, it created a sensation.

About the book: In the reverse of the usual order of business, Evans had started with Doyle's extravagant artwork and commissioned a text to partner with it. The author recruited for the assignment was Irish poet and diarist William Allingham. Doyle had drawn the illustrations with his characteristic light touch and fluid line, and with the uncompromising conviction of a visionary manqué. The overall effect was every bit as absorbing as it was entertaining: Doyle's images offered instant entrée into a wonderland world just as strange and credible in its way as the one conjured up only a few years earlier by Lewis Carroll and John Tenniel.

Publication history: The first edition of *In Fairyland* sold out quickly, as did the second edition, which followed in 1875. In a curious twist, Doyle's illustrations next reappeared, in a substantially altered form, in 1884 as illustrations for a completely different text, a literary fairy tale by Andrew Lang titled *Princess Nobody.* Among collectors of illustrated books, first-edition copies of *In Fairyland* have ever afterward been highly prized both for Doyle's sumptuous illustrations and Evans's refined color printing. In 1979, Viking Press issued an elegant new edition that for the first time brought together the Allingham and Lang texts with the art that inspired them both.

The Fairy Queen takes an airy drive in a light carriage, a twelve-in-hand, drawn by thoroughbred butterflies.

Cruel Elves.

Stealing.

Elf and Owls.

Dressing the Baby-Elves.

The Fairy Queen's Messenger.

The Elf-King asleep.

EDMUND DULAC

born 1882, Toulouse, France; died 1953, London, UK

Biography: The son of a traveling salesman with a hobbyist's interest in art, Edmund Dulac bargained with his parents for evening art classes in return for daytime law studies at l'Université de Toulouse. During the first two years of his preparations for the French bar, Dulac began publishing his drawings in reputable magazines, achieving enough success to justify dropping out of law school to devote all his efforts to pursuing the art career he had wanted all along. Having fallen under the spell of Walter Crane, William Morris, and Aubrey Beardsley, Dulac had in effect resolved to become not just an artist but an *English* artist. He took to wearing spats and to sporting a cane, changed the spelling of his name from "Edmond" to "Edmund," and in 1905 moved to London, epicenter of the luxury illustrated gift book trade. There he won a succession of top-drawer commissions, starting with sixty watercolor illustrations for a deluxe complete set of the Brontë sisters' novels. Arthur Rackham, also based in London,

had entered the gift book market a few years earlier and was about to make a major splash as the illustrator of Washington Irving's *Rip Van Winkle* (1905). The two ambitious illustrators signed on with rival publishers and were soon perceived to be brilliant rivals themselves. Dulac illustrated a book a year through the late 1910s, when the First World War upended the fashion for his type of work. Dulac thereafter was compelled to channel his talents in other directions, including portraiture and the design of British postage stamps and bank notes.

About the book: Dulac painted in a sumptuous palette inspired in part by Persian miniatures. These and other examples of non-Western art also influenced his rejection of traditional Western two-point perspective in favor of flattened, dreamlike symbolic spaces, lush expanses of decorative patterning, and a seductive use of atmospheric lighting and painterly fireworks. Dulac's trademark tendencies are all in full flower in *Stories from Hans Andersen* (1911), as was most appropriate, considering Andersen's own fascination with the *Arabian Nights* and imperial China as inspirations and settings for his storytelling. The collection is comprised of seven Andersen tales: "The Snow Queen," "The Nightingale," "The Real Princess," "The Garden of Paradise," "The Mermaid," "The Emperor's New Clothes," and "The Wind's Tale."

Publication history: London's Leicester Gallery, which also showed the work of Arthur Rackham, put Dulac under contract for a substantial sum to illustrate one book a year to be published by Hodder & Stoughton, with the original art to become the gallery's property for exhibition and sale. In 1911, Hodder & Stoughton published *Stories from Hans Andersen* under this agreement. The book was issued with twenty-eight tipped-in color illustrations in a limited edition of one hundred signed and numbered copies and simultaneously released in a trade edition in London and New York. Dulac's Andersen illustrations have remained well known in the West, influencing important twentieth-century artists such as America's Gustaf Tenggren, Czechoslovakia's Jiří Trnka, and Austria's Lisbeth Zwerger.

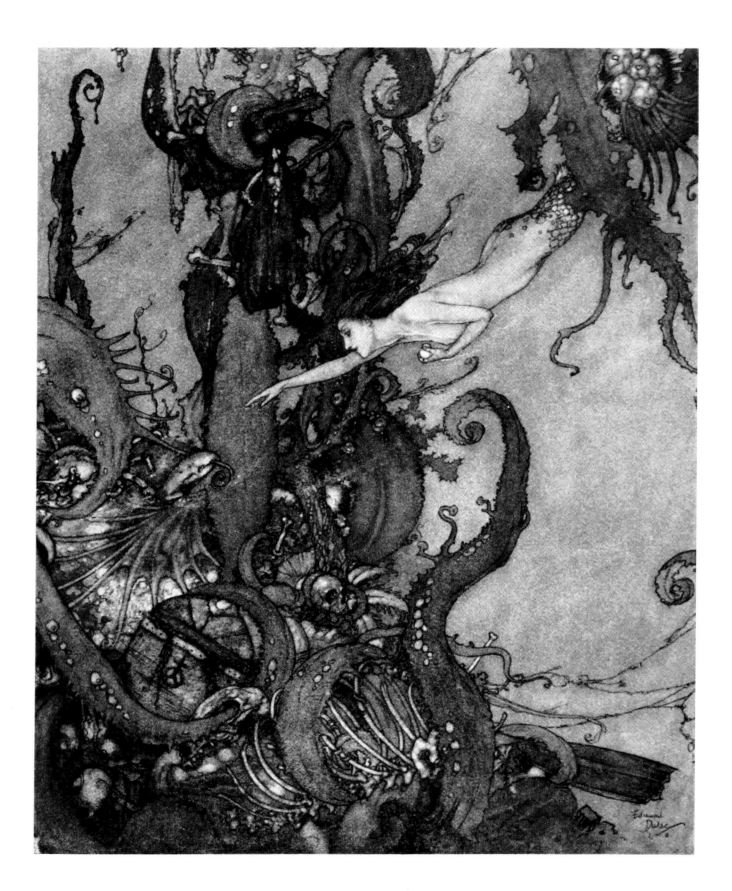

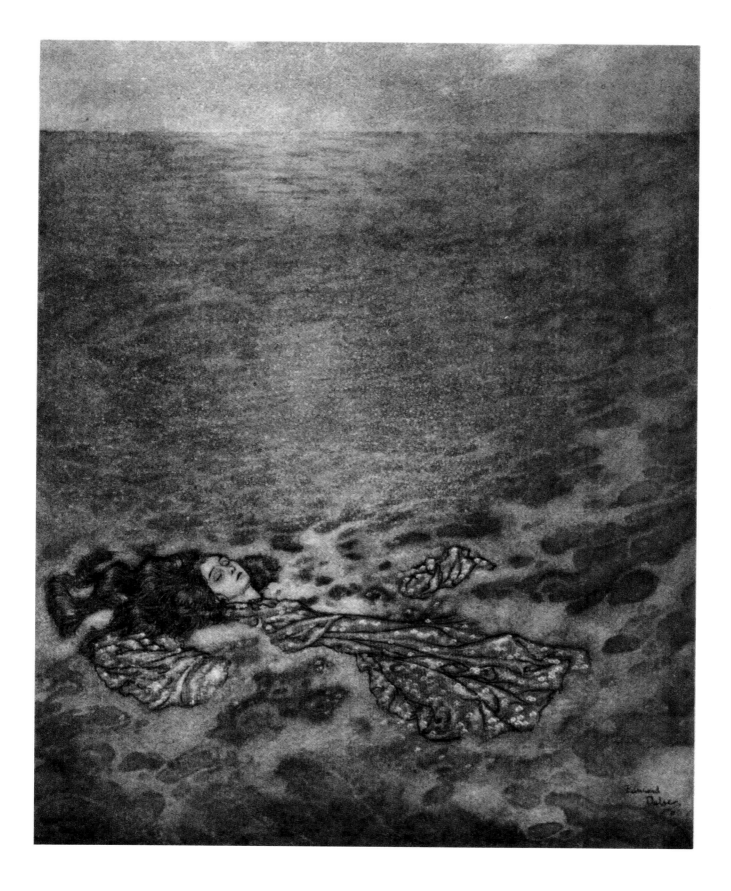

ROGER DUVOISIN

born 1900, Geneva, Switzerland; died 1980, Morristown, New Jersey, US

Biography: Roger Duvoisin led a many-faceted life in the applied arts across two continents. Starting out in his native Switzerland, he tried his hand at theatrical set design, mural and poster art, and illustration, then went to France, where he designed textiles and managed a pottery. Textile work brought him to New York in 1927 in the employ of H. R. Mallinson, a high-end silk manufacturer. According to historian Barbara Bader, Duvoisin arrived in America harboring the dream of one day making his name as a Hollywood set designer. As it happened, other absorbing career opportunities awaited him instead. In 1932, after Mallinson went bankrupt, Duvoisin ventured into the book world as the author-illustrator of a well-received picture book published by Scribner, *A Little Boy Was Drawing*. While

following up on this latest venture, on February 2, 1935, Duvoisin published his first *New Yorker* cover, thereby launching an association with the magazine that ran to thirty-two cover designs over twenty-four years. Other career highlights include Duvoisin's sumptuous 1936 *Mother Goose*, edited by William Rose Benét, and his full-page display ads for New York luxury retailer Lord & Taylor. In every guise in which they appeared, Duvoisin's drawings came to epitomize European elegance and joie de vivre for American readers.

Following the Second World War, Duvoisin increasingly devoted himself to picture-book-making. In 1948 his efforts were rewarded with that year's Caldecott Medal for *White Snow, Bright Snow*, a wintry picture book tone poem written by Alvin Tresselt. The first of the popular Petunia books followed, and in 1954 Duvoisin collaborated for the first time with his Swiss-born wife, Louise Fatio, on *The Happy Lion*.

THE HAPPY LION

by Louise Fatio pictures by Roger Duvoisin

WHITTLESEY HOUSE
McGRAW-HILL BOOK COMPANY, INC. NEW YORK TORONTO LONDON

About the book: *The Happy Lion* is a fable about a "wild" but clearly benign creature. The lion is universally adored when encountered by spectators through cage bars at the zoo but feared and reviled by the same people when met under less controlled circumstances. Only young François, the zookeeper's son, maintains his affection for the lion throughout, thereby proving himself, in the Romantic logic of the tale, to be a wiser and truer friend than the grown-ups—a natural ally of the wild things of this world.

Duvoisin's drawings combine the candor, zest, and blithe disregard for perspective of young children's art with a governing Gallic concern for compositional balance and carefully managed decorative charm. The pre-separated art has a graphic, poster-like stylization with flat areas of monochromatic color crisply delineated, almost like regions on a map. The lion's mane is a one-off wonder of furiously scribbled line work—a lighthearted art brut gesture that points to Duvoisin's affinity with another European émigré *New Yorker* cover artist of his generation, André François. Summing up his feeling for the value of his work, Duvoisin wrote that a picture book artist ought to do more than "merely entertain," that he also felt himself to have a solemn obligation to "pass on to children what we think of our world."[1]

Publication history: *The Happy Lion* has been published in at least fourteen foreign-language editions: French, Spanish, Catalan, Swedish, Danish, Norwegian, Finnish, German, Dutch, Hebrew, Japanese, Korean, Chinese, and Afrikaans. The German-language edition was honored with Germany's 1956 inaugural Deutscher Jugendliteraturpreis. Duvoisin and Fatio went on to produce nine *Happy Lion* sequels.

And he never found out what they were going to do, because
François put his hand on the lion's great mane and said,
"Let's walk back to the park together."
"Yes, let's," purred the happy lion.

CHRISTIAN EPANYA

born 1956, Douala, Cameroon

Biography: Christian Kingue Epanya began to draw at the age of three, but as no school in his native Cameroon offered graphic arts instruction, he chose to study biology and chemistry. From 1983 to 1990, Epanya worked as a loading master of crude oil for the Cameroon-based drilling company Elf Serepca before leaving for France to pursue his dream at the École Émile Cohl in Lyon. At art school, he concentrated on drawing, animation, and cartooning. Epanya graduated in 1992 and embarked on a career as a children's book author and artist, winning the prestigious UNICEF Award at the Bologna Children's Book Fair the following year for his illustrations for a story titled "Bintou's Everyday Life." In 1994, he broke into print in dramatic fashion with three picture books, each published by a different house in a different country: *Der Sprechende Kürbis* (*The Talking Pumpkin*, Nagel & Kimche, Switzerland); *Ganekwane and the Green Dragon* (Albert Whitman, United States); and *Le Petit Frère d'Amkoullel*, written by Amadou Hampâté Bâ

(Syros, France). Epanya has made France his permanent residence but periodically returns to Cameroon in addition to traveling to book fairs and other professional gatherings around the world.

About the book: Set in Senegal, *Le Taxi-Brousse de Papa Diop* (*The Bush Taxi of Papa Diop*, 2005) chronicles the adventures of a small-time entrepreneur who gives up his business as a peanut merchant to operate a minivan for the transport of passengers between Saint-Louis and Dakar. Papa Diop's midlife career change exemplifies the modernization of the French West African regional economy while also highlighting the engaging personality of the story's protagonist. Thanks to his friendly nature, Papa Diop never wants for customers and is given the opportunity to meet people from all walks of Senegalese life, from a traveling band of traditional musicians to a Muslim holy man and a young woman who is about to give birth. Narrated in the voice of Papa Diop's young nephew Sène, Epanya's amusing and affectionate tale yields a panoramic glimpse of contemporary Senegalese society—a view enhanced by the artist's intensely colored and closely observed illustrations.

Publication history: Epanya has emerged as a leading figure in the effort begun during the 1970s in postcolonial Francophone Africa to create children's literature for and about the young people of the region to supplement the standardized kinds of reading material associated with rudimentary classroom learning. He has stated that he is driven in part by the conviction that "the history of Africa and Africans should be more known than it is now."[1] The Bibliothèque nationale de France (French National Library) has played an important role in this endeavor, documenting, evaluating, publicizing, and generally encouraging the creation of such books by French publishers and others. *Le Taxi-Brousse de Papa Diop* originated in a French edition and was subsequently published in Sweden and Japan. In 2013 and 2014, it was featured in the New York Public Library's exhibition *The ABC of It: Why Children's Books Matter*, in a display showcasing the historic role of children's books in the process of nation-building.

MARIE HALL ETS

*born 1895, North Greenfield, Wisconsin, US;
died 1984, Inverness, Florida, US*

Biography: Marie Hall Ets showed clear signs of artistic talent from an early age—earning a place in an adult drawing class as a first grader—but she embarked on an art career comparatively late, after years of university studies in the social sciences and experience as a social worker. A research project undertaken at Columbia University to study children's responses to art may be what finally focused her attention on the picture book as an art form aimed primarily at the very young. Her dedication to fostering children's creativity and helping young people in need would carry over into the themes of the books she produced for young audiences.

Although an accomplished draftsman, Ets more often than not favored an unpolished and seemingly guileless style of illustration art. For her first picture book, *Mister Penny* (1935), and for several later ones, she worked in a highly textural printmaking technique called paper batik that yielded an old-fashioned, home-spun feel. As for the focus of her stories, several books, including her Caldecott Medal–winning *Nine Days to Christmas* (coauthored with Aurora Labastida, 1959) were notable for the concern they demonstrated—rarely expressed in the picture books of her time—for the children of the poor. Still more unusual was *The Story of a Baby* (1939), a book for young children that candidly chronicled—and depicted—every stage of the human birth process. *Play with Me* (1955), her tenth book, was notable simply for being a perfect example of picture book storytelling.

And as I still sat there without making a sound
(So they wouldn't get scared and run away),

Out from the bushes where he had been hiding
Came a baby fawn, and looked at me.

About the book: *Play with Me* was the first book Ets illustrated in color, an option she exercised with remarkable restraint in order to create an atmosphere of hushed calm and intimacy. The effect is magical. The drawings, although exquisitely composed, have the casual feel of sketchbook improvisations, with Ets leaving so much of the picture plane unfilled as to give readers the beguiling sensation both of seeing the young child's world and of seeing through it, as in a dream. In Ets's drawings, the little girl who seeks a friend among the animals she meets in the forest has a rooted, thoughtful, almost Buddha-like presence that sets her apart from the typical picture book child protagonists of the day. It would not be surprising to learn that Maurice Sendak admired this soulful, subtle picture book, in which a lone child is shown to possess natural dignity and a complex inner life.

Publication history: *Play with Me* has been published in French, German, Swedish, Japanese, Korean, Chinese, Thai, Afrikaans, Hebrew, and Arabic. Ets's books were among the American picture books to have a powerful impact in post–Second World War Japan, at first through exposure to small groups of mothers and children in the bunkos organized by activist mothers. In the early postwar years, Japanese-language translations were pasted over the original English in precious copies of American books imported from the United States. Later, as the Japanese publishing industry revived, translated editions became widely available. By the last quarter of the twentieth century, Ets's books were far better known in Japan than in their country of origin and have doubtless influenced the work of contemporary Japanese picture book artists, such as Komako Sakai, author-illustrator of *Emily's Balloon*.

30 31 Black

MARJORIE FLACK

born 1897, Greenport, New York, US; died 1958, Pigeon Cove, Massachusetts, US

Biography: "As far back as I can remember," wrote Marjorie Flack, "pictures were always an important part of my life. I can remember drawing pictures in the sand, pictures on the walls (and being punished for it), and pictures on every piece of paper I could find. For every picture there would be a story, even before I could write."[1] Flack, like so many aspiring artists of her generation, made the obligatory student pilgrimage to New York City and enrolled in classes at the Art Students League, where she met her first husband, Swedish-born American artist Karl Larsson. In 1928, Flack had been out of school for a decade when she illustrated her first children's book, *Tak Tuk, an Arctic Boy*, by Helen Loman, whose story, based on the author's travels, had an authentic ring that was always an essential ingredient for Flack. The project marked the start of her lifelong association with one of the leading editors of her day, May Massee. When, as a foolhardy Depression-era cost-cutting measure, Massee's first employer, Doubleday, dismissed her only to see her immediately snapped up by the newly founded Viking Press, Flack loyally (and wisely) followed Massee there.

Flack both wrote and illustrated most of the more than two dozen children's books that bear her name. Notable exceptions were *The Story About Ping* (1933), written by Flack and illustrated by Kurt Wiese, and *The Country Bunny and the Little Golden Shoes*, written by DuBose Heyward (1939).

Flack's marriage to Karl Larsson, with whom she had a daughter, ended in divorce. In 1941, she married the Pulitzer Prize–winning poet William Rose Benét, who, like Larsson, collaborated on an occasional children's book with her.

About the book: *Angus and the Ducks* (1930) was Flack's third children's book and the first in what would become a popular five-volume series. In it, all of Flack's assets as a picture-book-maker are at full strength: her playful, child-focused storytelling voice; her consummate skill at rendering realistic animals—in this instance a Scottish terrier and a pair of ducks—as convincing characters with thoughts and emotions much like our own; her preference for striking, expressionist color combinations; and her knack for giving a pictorial image a poster-like impact. Flack also demonstrated a thorough understanding of the picture book format—its suspenseful page-turns and evocative placement of type—as pioneered by Randolph Caldecott and carried into the twentieth century by William Nicholson, Wanda Gág, and others.

Publication history: *Angus and the Ducks* spawned four sequels and remained in print almost continuously from its time of publication. Looking back at the series, critic Louise Seaman Bechtel, in a 1941 survey for *The Horn Book* of the comparatively new category of "Books Before Five," commented: "Clever relation of words to pictures; fine simplicity of both."[2] Thirty years later, historian and critic Barbara Bader found the book so artfully written, paced, and designed as to be "virtually impossible to read [aloud] ineffectively."[3] *Angus and the Ducks* was first published in the United Kingdom in 1970, in Japan in 1974, and in Korea in 1997, the same year that it was also adapted for video by Weston Woods Studios.

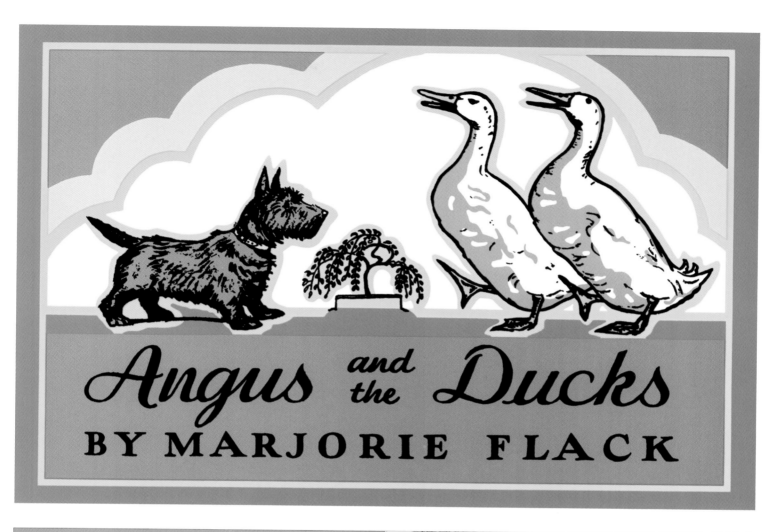

Angus and the Ducks

BY MARJORIE FLACK

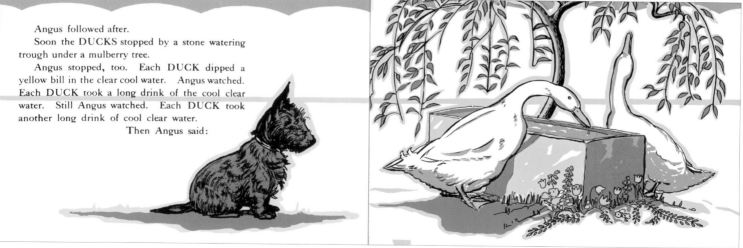

Angus followed after.

Soon the DUCKS stopped by a stone watering trough under a mulberry tree.

Angus stopped, too. Each DUCK dipped a yellow bill in the clear cool water. Angus watched. Each DUCK took a long drink of the cool clear water. Still Angus watched. Each DUCK took another long drink of cool clear water.

Then Angus said:

ANTONIO FRASCONI

born 1919, Buenos Aires, Argentina; died 2013, Norwalk, Connecticut, US

Biography: "Language," wrote Antonio Frasconi of his childhood as the son of Italian immigrants living in Argentina and Uruguay, "was always a question (so I felt)."[1] Frasconi's family spoke Italian at home and Spanish elsewhere, and the multiple means of human expression continued to fascinate him as, over the objections of his parents, he gravitated toward a life in the visual arts. Frasconi came to New York in 1945 on a Guggenheim fellowship and enrolled in painting classes at the Art Students League. He developed a preference for woodblock printmaking, in part because he enjoyed the physical struggle with the block itself. "Sometimes the wood gives you a break," he told *Time* magazine in 1963, "and matches your conception of the way it is grained. But often you must surrender to the grain, find the movement in the scene, the mood of the work, in the way the grain runs."[2]

Frasconi illustrated more than one hundred books during a long and distinguished career. The first of these, *Twelve Fables from Aesop* (1955), was published by the Museum of Modern Art. The following year he published *See and Say: A Picture Book in Four Languages* (1956), a children's book that was notable for its simple text printed in English, Spanish, Italian, and French.

Much of Frasconi's work gave visual expression to the artist's progressive political views and commitment to social justice. As he wrote: "If artists want to be [a] part of society, they have to be aware of society. They should not only paint for it, they should think about it. One reason the graphic-art media have been so influential is that they can reach more people."[3] Frasconi considered his children's books an opportunity to engage and inspire the next generation.

About the book: Multilingual books for young people have a long but spotty history. An early landmark work in the history of juvenile literature, the *Orbis Sensualium Pictus* (1658), was published in Nuremberg with a bilingual Latin and German text and was issued soon afterward in a Latin and English edition. A picture book like Frasconi's, however, was quite rare at the time of its publication, and reflected not only the artist's lifelong interest in linguistic and cultural variation but also the postwar internationalist outlook of his editor, Margaret K. McElderry.

From 1946, when she became director of Harcourt Brace's juvenile imprint, McElderry was a leader of the small but determined group of publishers in the United States, Europe, and Japan who believed that children's literature had a role to play in building a more peaceful world. Knowing of her eagerness to publish new talent from abroad, the head of the New York Public Library's Print Room, Karl Kup, introduced McElderry to Frasconi. The meeting laid the groundwork for a decades-long relationship that resulted in, among others, the sequel *See Again, Say Again* (1964) and the Caldecott Honor–winning English/French-language book *The House that Jack Built* (1958).

Publication history: Frasconi wrote: "I believe that children's literature should show a broader panorama: the diversity of other people, their culture, their language, etc. That should be the first step in the making

of character—respect for other nationalities and the understanding of their cultures."[4] He created *See and Say* for his own young son, Pablo. Frasconi by then was a widely admired graphic artist. To mark the publication of his first children's book, *Print* magazine reproduced a four-page spread from the book and published a detailed account by McElderry of its creation. As historian Barbara Bader later observed, "Hardly a book on illustration has appeared since without something from it, usually the mighty murmurous whale."[5] As for multilingual picture books, Frasconi's forays remained anomalies for decades. The next significant American effort to extend the multilingual/multicultural tradition of the picture book would come from a small nonprofit publishing company founded in the mid-1970s expressly with that goal in mind: San Francisco's Children's Book Press.

fly
fly

mosca
mos-kah

mouche
moo-sh

mosça
mos-kah

peas
peez

piselli
pee-zél-lee

pois
pwah

guisantes
ghee-sán-tays

dog
dawg

cane
káh-nay

chien
sh'eyng

perro
pér-roh

shoes
shooz

scarpe
skár-pay

souliers
sool-yea

zapatos
thah-páh-tos

bed
bed

letto
lét-toh

lit
lee

cama
káh-mah

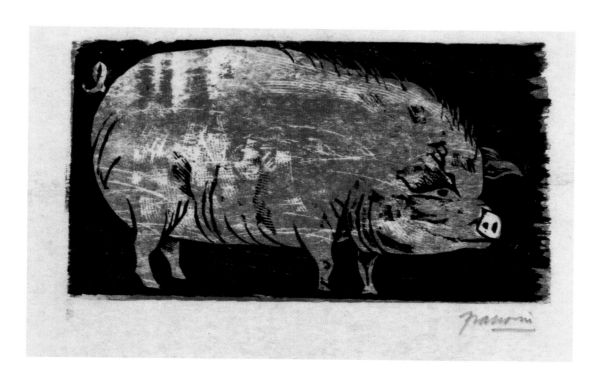

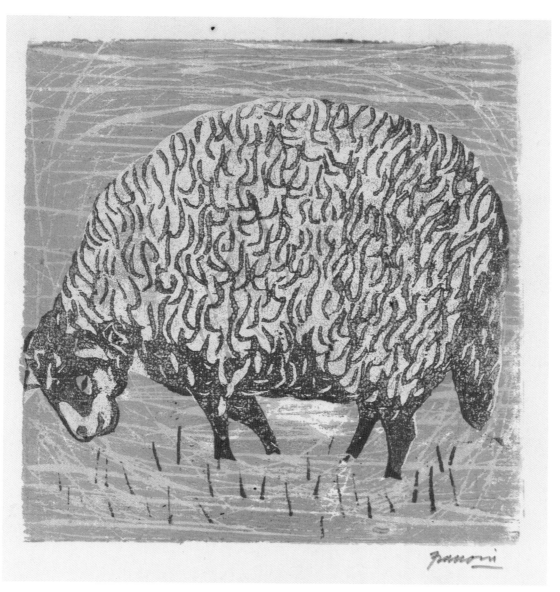

DON FREEMAN

*born 1908, San Diego, California, US; died 1978,
New York, New York, US*

Biography: Don Freeman was a second grader when, following the death of his mother, he was placed in a guardian's care. Art became a lifeline in the young boy's radically disrupted life. By the age of ten, Freeman's world revolved almost entirely around drawing and painting.

Music was his second love, although primarily because performing provided him with a ready source of cash. By 1929, Freeman played jazz trumpet well enough to make his way cross-country to New York as a pickup band musician. On his arrival—just a few days before the stock market crash that signaled the start of the Great Depression—he enrolled in the Art Students League, taking classes with the celebrated American urban realist painter John Sloan and with Harry Wickey, a well-regarded etcher and sculptor.[1] One evening, when Freeman was returning to his Greenwich Village apartment from an Italian wedding where he had

performed, he left his trumpet on the subway. The loss of his sole means of support pushed him to begin submitting his drawings for publication. By then Freeman had also fallen in love with the New York theater scene. Before long, his sly, impassioned images of Broadway's backstage theatrics were a staple of the drama pages of the *New York Times* and the *New York Herald Tribune*. He became an accomplished printmaker as well, his teeming, humanity-packed scenes of New York street and theater life bearing the stamp not only of his two great teachers' influence but also that of his hero, the nineteenth-century French satirical artist Honoré Daumier.

In 1948, Freeman left New York with his wife, Lydia, a painter, and returned to California. Not long after the birth of their son, Roy, they collaborated on a picture book, *Chuggy and the Blue Caboose* (1951). Although the couple originally intended their illustrated storybook only for home consumption, Freeman, at a friend's urging, sent it to Viking's May Massee, thereby opening the door to his lifelong association with that consequential editor and house. *Pet of the*

Corduroy watched them sadly as they walked away.

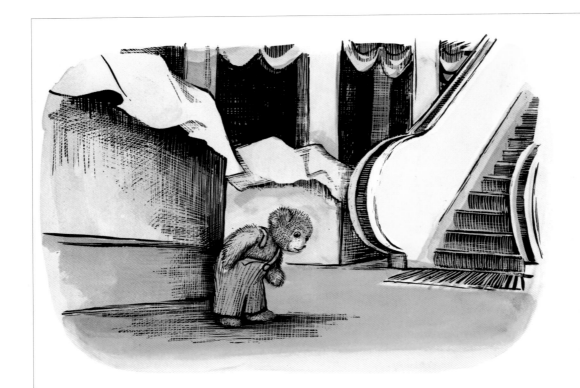

shelf and began searching everywhere on the floor for his lost button.

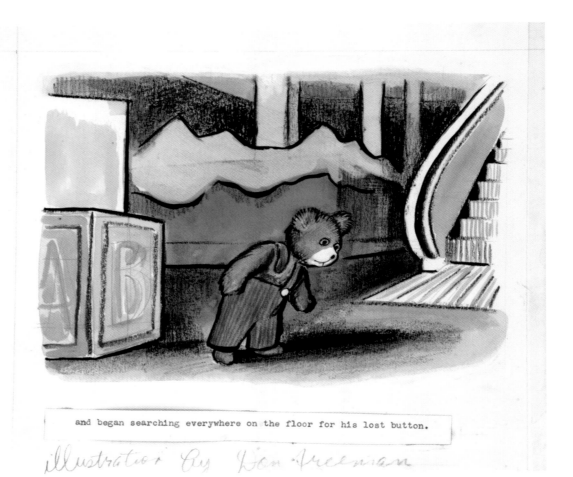

and began searching everywhere on the floor for his lost button.

illustration by Don Freeman

Met (1953), which drew directly on the artist's familiarity with the New York music world, followed in 1953 as a second collaboration. From then onward, Lydia Freeman remained in the background as an informal story consultant, while Freeman went on to create more than thirty more picture books.

About the book: As a fable about a well-loved toy that comes to life, *Corduroy* (1968) belongs to the tradition of such time-honored tales as "The Steadfast Tin Soldier," *The Adventures of Pinocchio,* and *The Velveteen Rabbit.* But it is also a story with realistic elements that in 1968 clearly set it apart from nearly all other American picture books of the time. The young girl who finds the stuffed toy bear with a missing button on a department store shelf, and eventually gets to take the bear home with her, is a single-parent child of color. Apart from the picture books of Ezra Jack Keats, African American children were a rare occurrence in the literature of the era—a fact that had only recently become a matter of concern within the publishing community amid the tumultuous events of the national struggle for racial equality. Freeman's decision to depict Lisa without comment as a Black child was a forthright expression of his progressive politics. In a letter to his last editor at Viking, Linda Zuckerman, he elaborated on other inspirations for *Corduroy.* He had wanted, he said, to "do a story about a department store in which a character wanders around at night after the doors close . . . [and a] story to show the vast difference between the luxury of a department store [and] the simple life [of most people]."[2]

Publication history: The popular and critical success of *Corduroy* prompted Freeman to produce a sequel, *A Pocket for Corduroy* (1978). After his death, his publisher commissioned a long list of spin-off picture books that capitalized on affection for the furry little character with a missing button. A half-hour-long animated television program based on *Corduroy* aired on American and Canadian public television stations during the 2000–2001 season. Editions of *Corduroy* have appeared in French, Spanish, Russian, Japanese, Chinese, Korean, and Hebrew.

WANDA GÁG

born 1893, New Ulm, Minnesota, US; died 1946, Hunterdon County, New Jersey, US

Biography: As the eldest of seven children, Gág (rhymes with "fog") routinely helped her parents out at home by regaling her younger siblings with lively tales inspired by folklore. Her Bohemian-émigré artist father, who died when she was fifteen, encouraged her to develop her creative talents, reportedly declaring on his deathbed, "What Papa couldn't do, Wanda will have to finish."[1] After completing her initial training at various Minnesota art schools, Gág went to New York, where she enrolled at the Art Students League and secured freelance work as an advertising and fashion artist and illustrator of books and magazines, including the radical publications *New Masses* and *The Liberator*. Gág's early attempts at building a career as a children's book author-illustrator met with

meager success, and it was as a printmaker that she first achieved widespread acclaim, regularly showing her work at New York's Weyhe Gallery and frequently earning a spot on the American Institute of Graphic Arts' coveted annual Fifty Prints of the Year list. After viewing an exhibition of her prints, Coward-McCann's editor, Ernestine Evans, approached the artist about illustrating a children's book. Evans found Gág's graphic work "full of the wonder of common things," but Gág was less than enthusiastic until Evans proposed that she illustrate a story of her own making.[2] Undertaken casually as a one-off moneymaker, *Millions of Cats* (1928) proved instead to be the pivotal work that redirected the course of her career.

About the book: *Millions of Cats* allowed Gág to give free rein to her practiced gift for tall-tale narrative invention and her formidable technical and dramatic skills as an artist. She framed the book's sequence of

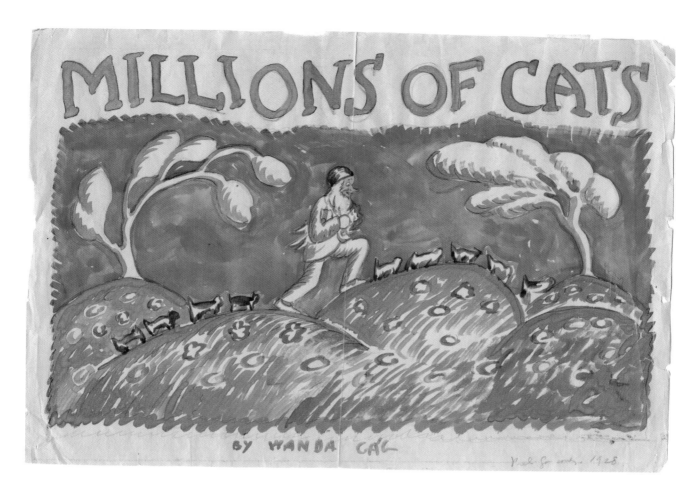

black-ink illustrations in an unconventionally long, narrow horizontal format modeled (at Evans's suggestion) on the one chosen by William Nicholson for his recent picture book *Clever Bill* (1926). Gág pushed the format further than Nicholson in her freewheeling reimagining of the pictorial plane as a panoramic landscape, and in the sheer expansiveness of the images, each elaborated in her distinctively homespun expressionist style featuring rounded, rhythmical shapes and a unifying whirlwind embrace of abstract elements of pattern and design. Adding to the intimate feel of the book was the hand-lettered text contributed by the artist's brother Harold, another device borrowed from Nicholson. "A child," declared the New York Public Library's Anne Carroll Moore in her bellwether *Herald Tribune* review column, "will almost feel that he has made this book."[3]

Publication history: Published at the peak of the prosperous 1920s—the post–Great War decade when Americans had begun to clamor for homegrown cul-tural achievements on par with their triumphs in the military and industrial spheres—*Millions of Cats* was universally hailed as a classic by critics. At a time when Americans considered the English picture books of Randolph Caldecott, Beatrix Potter, and others as the high-water marks of the genre, Gág's spirited volume came as welcome proof that American artists could indeed do as well. Issued in both a standard trade book and a deluxe, signed edition, *Millions of Cats* won a 1929 Newbery Honor, a rare tribute for a picture book text (the Caldecott Medal for illustration did not yet exist). Gág's first picture book remained continuously in print from then onward. It was among the first Western children's books to be translated into Chinese, in 1946, by the noted Shanghai children's author, translator, and educator Chen Bochui, and has been translated into over fifteen other languages, including French, Spanish, Italian, German, Dutch, Persian, Hebrew, Korean, Thai, Japanese, Tamil, and Chamorro.

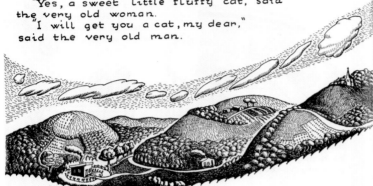

"If we only had a cat!" sighed the very
old woman.
"A cat?" asked the very old man.
"Yes, a sweet little fluffy cat," said
the very old woman.
"I will get you a cat, my dear,"
said the very old man.

And he set out over the hills to look for
one. He climbed over the sunny hills. He
trudged through the cool valleys. He walked
a long, long time and at last he came to a
hill which was quite covered with cats.

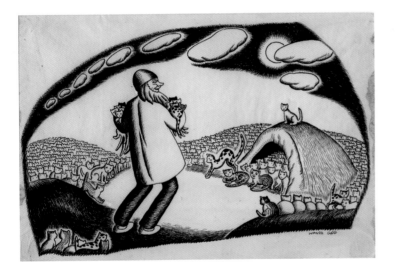

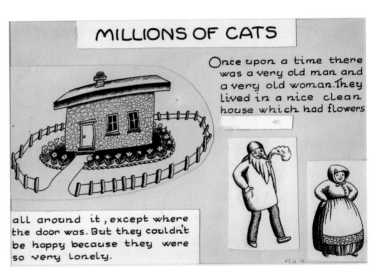

MILLIONS OF CATS

Once upon a time there
was a very old man and
a very old woman. They
lived in a nice clean
house which had flowers
all around it, except where
the door was. But they couldn't
be happy because they were
so very lonely.

TIBOR GERGELY

*born 1900, Budapest, Hungary; died 1978,
New York, New York, US*

Biography: Tibor Gergely was as adept at the art of
self-reinvention as he was at the art of creating picture
books steeped in respect for working-class people and
a soulful regard for the joy of living. As a Hungarian
Jewish child, he showed an early knack for caricature
but had no point of reference at home or school for
imagining a future for himself as an artist. His widowed
mother did factory work and hoped her son might
become an engineer. Gergely's fascination with mod-
ern art and leftist politics propelled him in other direc-
tions, prompting him to become the youngest member
of the famed Sunday Circle of Hungarian artists and
intellectuals that also included Béla Bartók, György
Lukács, Karl Mannheim, and the artist and poet Anna
Lesznai, whom Gergely married. Under Lesznai's tute-

lage and spell, he took up oil painting and matured as a
draftsman. By 1921, when for political reasons Sunday
Circle members fled Budapest for Vienna, Gergely had
developed a somber expressionist style as a landscape
and still life painter and become a sketch artist with a
sure and lively touch.

In Vienna, he secured work as a caricaturist for the
daily *Der Tag* and founded *Gong*, an experimental pup-
pet theater. The war disrupted everything, however,
and when he and Lesznai resettled in New York in the
spring of 1939, they encountered a local art scene that
was largely indifferent to their work. A legendary figure
in Budapest, Lesznai was reduced to a life of obscu-
rity, teaching private art classes to make ends meet.
Gergely made a better adjustment, selling a few cover
illustrations to *The New Yorker* and rapidly establish-
ing himself as a favorite of the editors responsible for
Little Golden Books. Gergely would go on to become
that hugely successful publishing venture's most fre-

Ding, ding, ding! goes the fire engine bell. **The chief is on his way.**

quent illustrator while also illustrating books for other publishers, including the 1953 Caldecott Honor book *Wheel on the Chimney* (published by Lippincott, with text by Margaret Wise Brown). Gergely's moody paintings, on the other hand, failed to find a receptive audience in New York, and they remained rolled up in the back of his closet for the rest of his life.

About the book: Within a few years of the phenomenally successful fall 1942 launch of Little Golden Books, the two partners in the enterprise, Simon & Schuster and the Western Printing Company, began to explore

a range of new illustrated book formats, in part with the idea of holding on to their young audience for years after they had outgrown basic stories like *The Poky Little Puppy* (1942). Gergely's *Great Big Fire Engine Book* (1950) was among the "Great Big Golden Books" that aimed at giving a slightly older child a more grown-up experience. One has only to glimpse the artist's meticulously observed renderings of fire engine Number 1 to appreciate the irresistible appeal of such images for a young person curious about the way the real world works. As a Golden Books illustrator, Gergely hit upon a subtle way to express his radical politics as well, by

Crank, crank. Up go the ladders. Up go the firemen with hoses.

making a specialty of books that highlighted the dignity of working-class people. When he was not paying tribute to the dash and daring of firemen, he was tipping his hat to cab drivers (*The Taxi That Hurried*, 1946), mail sorters and delivery personnel (*Seven Little Postmen*, 1952), and truckers (*The Happy Man and His Dump Truck*, 1950).

Publication history: Golden Books were generally printed in press runs of fifty thousand to one hundred thousand copies. *The Great Big Fire Engine Book* appears to have remained in print through 1973, sug-

gesting that it must have had a sizeable if not massive readership in its first two decades. A Spanish-language edition was published in Mexico in 1960. In 1987, the book became the subject of a work of fine art when a Cuban-born American photographer, Abelardo Morell, who recalled *The Great Big Fire Engine Book* with fondness from childhood, photographed a standing, open copy of the book in such a way as to give the viewer a fractured, simultaneous view of several of Gergely's turbocharged images. The book was reissued in the United States in 2003 and published in Japan the following year.

KATE GREENAWAY

born 1846, London, UK; died 1901, London, UK

Biography: Although only modestly accomplished themselves, both of Kate Greenaway's parents played key roles in setting the direction of their daughter's phenomenal career. Her father, an engraver, gave Greenaway her first insider's look at the fast-changing Victorian world of art drawn or painted with mechanical reproduction in mind. From her milliner mother came her initial fascination with the hats and other frills and accouterments that would later adorn the idealized child characters in her books. The carefree life Greenaway depicted on the page memorialized the wished-for childhood she had resolutely imagined for herself as an antidote to the unremarkable facts of her family's drab petty bourgeois existence. A vast international public, it turned out, was primed to share in her dreams.

Although socially awkward and retiring in manner, Greenaway had a brilliant head for business and a talent for driving a hard bargain. Almost from the time she first made her mark as an artist in the newly minted British greeting card trade, she seems to have known how to command her price. Looking to expand her horizons, she went to see the esteemed color printer Edmund Evans in 1877 or 1878 about illustrated book projects. Evans was already an admirer of her popular card designs and agreed to hire her (as well as her exact contemporary Randolph Caldecott) to create a series of children's picture books comparable to those he had previously contracted for from Walter Crane. Greenaway's first book, *Under the Window: Pictures & Rhymes for Children* (1879), featured her own quaint rhymes and was a big success. For the next decade, demand for her work, which was fueled in part by lavish praise from the celebrated English art critic John Ruskin (who had developed an intense fixation on her) was unquenchable.

About the book: Before completing the illustrations for *Under the Window*, Greenaway designed and hand-sewed the costumes in which her child models would pose. One reason that adult viewers responded to the published art in a nostalgic spirit is that Greenaway based her designs on the old-fashioned style of provincial dress she had observed while on a visit to her family in the Staffordshire village of Rolleston. Greenaway's painstaking approach to art making, and the art itself, so impressed Evans that he felt justified in investing extravagantly in the book's color printing, and in ordering a substantial initial print run of twenty thousand copies of a book that would have to bear the steep retail price of six shillings.

Publication history: Evans later recalled: "We soon found that we had not printed nearly enough to supply the first demand; I know booksellers sold copies at a premium, getting ten shillings for each of them . . . I could not print fast enough to keep up the sale."[1] He went back to press for an additional seventy thousand copies. German and French editions meanwhile also sold briskly, and Greenaway was building a large and ardent fan base in the United States as well. She

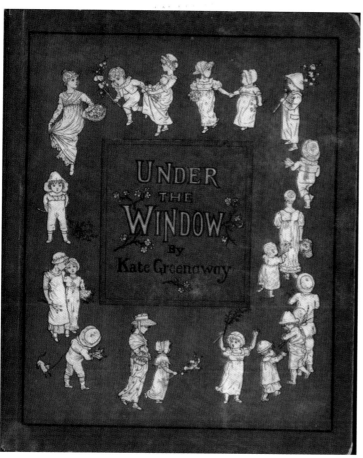

soon made history as one of the first artists to have her books merchandized, with a children's clothing line adapted from her characters' costumes and with reproductions of her illustrations turning up on handkerchiefs, china collectibles, and the like. Greenaway also parlayed *Under the Window*'s signal success into a more favorable contract with Evans. Starting with her second book, the artist received half the profits from every copy sold instead of a third.

Right: Sketches for (top) cover illustration; (middle) "I saw a ship that sailed the sea" and "'Margery Brown, on top of the hill'"; (bottom) "A butcher's boy met a baker's boy"

FIVE little sisters walking in a row;
Now, isn't that the best way for little girls to go?
Each had a round hat, each had a muff,
And each had a new pelisse of soft green stuff.

Five little marigolds standing in a row;
Now, isn't that the best way for marigolds to grow?
Each with a green stalk, and all the five had got
A bright yellow flower, and a new red pot.

IN go-cart so tiny
 My sister I drew;
And I've promised to draw her
 The wide world through.

We have not yet started—
 I own it with sorrow—
Because our trip's always
 Put off till to-morrow.

HEIGH HO!—time creeps but slow;
 I've looked up the hill so long;
None come this way, the sun sinks low,
 And my shadow's very long.

They said I should sail in a little boat,
 Up the stream, by the great white mill;
But I've waited all day, and none come my way;
 I've waited—I'm waiting still.

They said I should see a fairy town,
 With houses all of gold,
And silver people, and a gold church steeple;—
 But it wasn't the truth they told.

My house is red—a little house,
 A happy child am I,
I laugh and play the livelong day
 I hardly ever cry.

I have a tree, a green, green tree,
 To shade me from the sun;
And under it I often sit,
 When all my work is done.

My little basket I will take,
 And trip into the town;
When next I'm there I'll buy some cake,
 And spend my bright half-crown.

BROOMSTICK RIDE.

LITTLE boys, and little girls,
 Will you come and ride;
On my pretty broomstick,
 Flying far and wide.

First around the blazing Sun,
 And then around the Moon;
And then around the steeple,
 To hear a merry tune.

TOMMY was a silly boy,
 "I can fly," he said;
He started off, but very soon,
 He tumbled on his head.

His little sister Prue was there,
 To see how he would do it;
She knew that, after all his boast,
 Full dearly Tom would rue it!

THE boat sails away, like a bird on the wing,
And the little boys dance on the sands in a ring.
The wind may fall, or the wind may rise—
You are foolish to go; you will stay if you're wise.
The little boys dance, and the little girls run:
If it's bad to have money, it's worse to have none.

ROLLING HOOPS.

OH! roll away. Oh! roll away!
 As far and fast, as you can run;
Whoever can the fastest go,
 Will surely be the winning one.

Now, helter—skelter—off you roll!
 But Fanny stubs her little toe;
And sadly falls upon the ground,
 While swiftly on the others go.

But soon, she'll get upon her feet,
 And with the others race away;
And if she doesn't beat them now,
 Perhaps she will another day!

HERGÉ
born Georges Remi

born 1907, Etterbeek, Belgium; died 1983, Brussels, Belgium

Biography: Born into a Belgian working-class household where both French and Dutch were spoken, young Georges Remi excelled at school, fell in love with the movies, and benefited greatly from his years as a member of the Boy Scouts, a youth organization whose straight-arrow moral code and keen appreciation of wilderness environments would later serve as key elements of *Tintin*. Remi was still in his teens when his first published drawings appeared in a Scout magazine. After high school, however, he entered a confused period during which he drifted in and out of art school and into the army, an experience that proved to be equally unrewarding. He was twenty when he secured a job as a reporter and illustrator for *Le Vingtième Siècle* (*The Twentieth Century*), a Brussels-based Catholic newspaper with fascist sympathies. Remi created the earliest *Tintin* stories, featuring the far-flung adventures of an intrepid Belgian boy reporter and his stalwart fox terrier Snowy, as a serialized comic strip for the paper's weekly children's supplement, *Le Petit Vingtième* (*The Little Twentieth*), which he also edited. It was then that he adopted the pen name "Hergé," which he derived by reversing his initials (*GR* to *RG*) as pronounced in French. In a foretaste of *Tintin*'s subsequent global popularity, the paper's circulation always jumped on Thursdays, the day when Remi's strip ran.

The topic of the inaugural story, *Tintin in the Land of the Soviets*, was assigned to Hergé by his employer and faithfully mirrored the newspaper's anti-Communist agenda. The second story, *Tintin in the Congo*, did the same for the paper's pro-colonialist views and white-supremacist assumptions about race. With

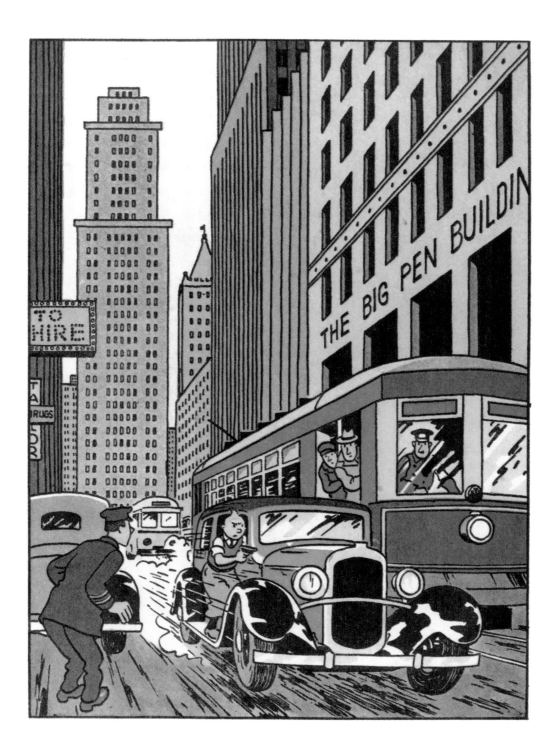

Tintin en Amérique.

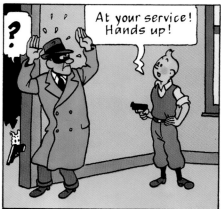

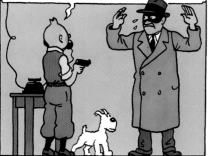

Tintin in America, Hergé finally got his chance to explore the part of the world that most fascinated him personally.

During the Second World War, the German occupation of Belgium resulted in the shutdown of *Le Vingtième Siècle*, but the ever nimble and opportunistic Hergé managed to move to *Le Soir*, Belgium's largest Francophone daily, and resume work on *Tintin* from there even as the German authorities looked over his shoulder. After the war, Hergé faced repeated accusations of collaboration with the Nazis, although formal charges were never brought against him. Nonetheless, *Tintin*'s popularity continued to grow, via the newly founded *Tintin* magazine in 1946, a first film adaptation the following year, and skyrocketing sales of the Belgian publisher Casterman's book-length *Tintin* albums. In 1950, the artist founded Studios Hergé in Brussels with a staff of as many as fifteen artists to support his creative work. In his last years he focused more on *Tintin* film projects and on documentations of his life and career.

About the book: Weekly installments of *Tintin in America*, with its rousing, thrill-a-minute tale of the determined young hero's skirmishes with a clutch of Chicago gangsters, ran in *Le Vingtième Siècle* from September 1931 to October 1932. Hergé, who had not yet visited the United States, relied on a variety of sources for his research: Georges Duhamel's social critique *America the Menace: Scenes from the Life of the Future*; a special issue of the magazine *Le Crapouillot* (*The Mortar Shell*) on modern-day American life; Paul Coze and René Thévenin's 1928 *Moeurs et Histoire des Indiens Peaux-Rouges* (*Customs and History of the Red Indians*); and information from Brussels's ethnographic museum. Implied throughout is a harsh critique of American capitalism—in particular the relentless cult of acquisitiveness, the prevalence of crime, and the rampant victimization of minority populations as represented by members of the Blackfoot Sioux. Hergé's depictions of the Chicago of Al Capone and the desert habitats of American Indian warriors have a cartoonish, secondhand feel to them, as though glimpsed through the distorting lens of Hollywood action pictures or the popular novels of turn-of-the-last-century German romance writer Karl May (who had not set foot in the Americas either). But his relationship to his subject was hardly a simple one. In his drawings of American Indians, Hergé routinely reached for the nearest racial pictorial stereotype while at the same time hitting the mark in matters of material culture *and* exposing the systematic injustices that resulted in the theft of American Indian lands and mineral wealth.

Publication history: Hergé revised *Tintin in America* twice: in 1945, when he redrew the art in color for the 1946 first Casterman edition, and again in 1973, when he made several changes at the request of his American publisher—replacing for example a stereotypically broad-lipped African American doorman with an inoffensive white substitute. The story was adapted as a 1991 episode of *The Adventures of Tintin*, a Canadian and French television collaboration. The *Tintin* books have been published in more than seventy languages and have been adapted for more than enough media and merchandise spin-offs to warm the heart of any hard-driving capitalist.

TANA HOBAN

born 1917, Lansdale, Pennsylvania, US;
died 2006, Louveciennes, France

Biography: Tana Hoban's father, who worked by day as
the business manager of the Yiddish-language *Jewish
Daily World*, was a connoisseur of cleverness. He kept
a glass jar filled with nickels by his side at the dinner
table and paid out a five-cent coin each time one of
his children—Tana was the eldest of three—made a
smart or witty remark. Abraham Hoban took pleasure
in showing his daughter his Graflex press camera, the
kind that made an impressive *BOOM!* when the mag-
nesium flash powder ignited, and encouraged her early
interest in art. She entered art school as a painter and
draftsman and left as a photographer.

In the years that followed, Hoban achieved suc-
cess as both a commercial and fine-art photographer.
Following a meeting with Edward Steichen, she earned
a coveted spot in Steichen's landmark 1955 *Family of
Man* exhibition at New York's Museum of Modern Art.

In 1968, she read an Associated Press account of an
experiment conducted by the Bank Street College of
Education in which six- and seven-year-old school-
children from disadvantaged homes were taken out
into the city streets with handheld movie cameras in an
effort to encourage the children to look more closely
at their surroundings. Inspired by the project, and by
a conversation with Macmillan's children's book pub-
lisher Susan Hirschman, Hoban decided that a pho-
tographically illustrated children's book might have
the same effect and went to work on the first two of
her more than fifty picture books, *Shapes and Things*
(1970) and *Look Again!* (1971).

About the book: Hoban was introduced to Hirschman
by her brother, Russell Hoban, who by then was well-
known as the author of the Frances books and *The
Mouse and His Child* (1967). In a conversation with
Hirschman at about this time, historian and critic
Barbara Bader had remarked that "no one had ever
used the camera in a picture book the way a graphic

Photogram studies

artist used a pencil."[1] To do so now became Hoban's overarching goal. The captionless images of *Shapes and Things* (1970)—photograms that depicted such everyday objects as a button, a lollipop, and a hammer as silhouetted white-on-black abstract forms—were designed to concentrate a young child's attention and set in motion a simple naming game at which the child was likely to succeed. In later books, Hoban played out numerous variations on the theme of the picture book as an exploratory visual learning environment, eventually making street photography and color important elements of her practice.

Publication history: Hoban's timing was excellent. Her gamelike approach in *Shapes and Things*, aimed at enlisting a very young child's active participation, was just gaining broad acceptance in the United States in 1970 as preschool education and day care centers became mainstream phenomena, and publishers recognized a growing market for "concept books" that fostered play-based learning. (Eric Carle, whose *The Very Hungry Caterpillar* appeared the previous year, would ride the same wave to even greater heights.) Outside of the United States, Hoban's books were most popular in France, where the artist lived for the last twenty-plus years of her life. Selected books were also published in German, Danish, Spanish, Japanese, and Chinese editions. Hoban was gratified to discover late in her career that her wordless books had proven to be of special value for children with learning disabilities. "Having no words liberates the child to some extent," she told an interviewer. It "provoke[s] young children to talk and to express themselves."[2]

HEINRICH HOFFMANN

born 1809, Frankfurt am Main, Germany;
died 1894, Frankfurt am Main, Germany

Biography: Heinrich Hoffmann was a medical doctor, a man with progressive political and social views, and a cultured literary dabbler when at Christmastime 1844 he went shopping for a gift for his young son. Put off by the sentimentality and didacticism of the children's books he found on offer in the shops, Hoffmann purchased a blank notebook instead and proceeded to fill its pages with comically exaggerated images of naughty boys and girls, and with rhymes that spelled out in lurid, tongue-in-cheek detail the awful price each child paid for disobedience. Hoffmann fashioned the little gift book without any thought of publication, but when family members urged this possibility on him, he offered the manuscript to the firm of publisher friends Rütten & Loening. The modest first printing of 1,500 copies disappeared from store shelves, Hoffmann would record with pride, "like a drop of water on a hot stove."[1] The first two printings were published under a pseudonym, and not until the fifth printing did Hoffmann give the book the title of *Struwwelpeter* (1845), or *Slovenly Peter,* by which the world soon came to know it.

Hoffmann's occasional subsequent forays as an author-illustrator for young people lacked the spontaneity and irreverent spirit of his impromptu first effort and failed to capture the public's interest. In later years, he devoted himself to improving the treatment of the insane and considered his work in this area to be his major achievement. Not surprisingly, however, when his grandson arranged for the posthumous publication of the good doctor's memoir, the title he chose for the volume was *Struwwelpeter-Hoffmann* (1926).

About the book: As a family physician, it was Hoffmann's practice to distract his young patients by drawing them amusing pictures as he worked. He must have taken some interest in the art of his day, as he clearly modeled his iconic portrait of Peter, with his talon-like hands and wild mane of hair, on *Les enfants terribles* (1842), a popular lithograph by the French satirical

illustrator Paul Gavarni. First published in Frankfurt in 1845 as *Lustige Geschichten und drollige Bilder—für Kinder von 3-6 Jahren (Pleasant Stories and Funny Pictures—for 3-to-6-Year-Olds)*, Hoffmann's first children's book, with its bracing humor and implicit avowal of respect for children's own judgment, anticipated, and perhaps even helped inspire, Lewis Carroll's equally iconoclastic Alice books of a generation later.

Hoffmann's own intentions concerning the book are well known, but, curiously, readers of *Struwwelpeter* have long been divided into two camps: those who take the book at face value as an astringent cautionary tale and those who recognize the author's parodic intent. It is as though Hoffmann had devised a cunning kind of literary litmus test for gauging the parenting style and family atmosphere and culture in which each child is raised.

Publication history: Hoffmann's book went swiftly back to press in the original German and soon began its travels around the world. It first appeared in English in 1848; in 1891, Mark Twain, while on a visit to Berlin, pre-

pared the third English-language translation, although it remained unpublished until 1935. Foreign-language editions proliferated, including a Finnish translation in 1869; in 1921, there was even an Esperanto edition. Parodies multiplied as well. In 1940, British satirists Robert and Philip Spence produced *Struwwelhitler: A Nazi Story Book,* for the benefit of the *Daily Sketch* War Relief Fund. During the American Watergate scandal of the 1970s, Richard "Tricky Dick" Nixon was similarly skewered in a savage send-up of Hoffmann's original. In 1977, the Struwwelpeter Museum opened in Frankfurt, Germany, to document the story of Hoffmann's most famous children's book and his pioneering work in psychiatry. While it is doubtful that many parents still read *Struwwelpeter* to their young children at night, it continues to reverberate across Western popular culture, inspiring homages and parodies as diverse as filmmaker Tim Burton's 1990 fantasy romance *Edward Scissorhands* and an acclaimed 1998 operatic theater piece by the British musical trio The Tiger Lillies.

Die Geschichte vom bösen Friederich.

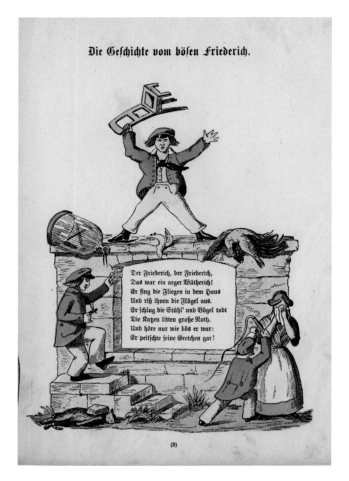

Der Friederich, der Friederich,
Das war ein arger Wütherich!
Er fing die Fliegen in dem Haus
Und riß ihnen die Flügel aus.
Er schlug die Stühl' und Vögel todt
Die Katzen litten große Noth.
Und höre nur wie bös er war:
Er peitschte seine Gretchen gar!

(3)

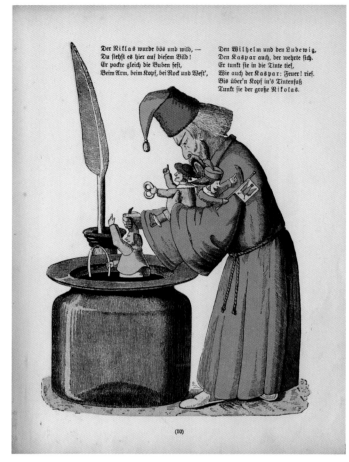

Der Niklas wurde bös und wild, —
Du siehst es hier auf diesem Bild!
Er packte gleich die Buben fest,
Beim Arm, beim Kopf, bei Rock und West',

Den Wilhelm und den Ludewig,
Den Kaspar auch, der wehrte sich.
Er tunkt sie in die Tinte tief,
Wie auch der Kaspar: Feuer! rief.
Bis über'n Kopf in's Tintenfaß
Tunkt sie der große Nikolas.

(10)

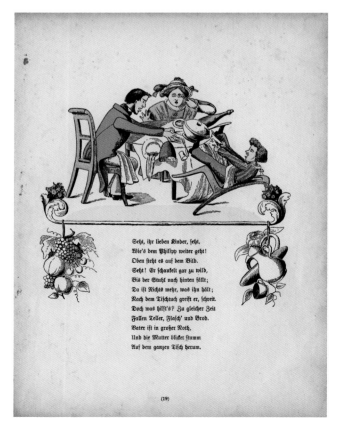

Seht, ihr lieben Kinder, seht,
Wie's dem Philipp weiter geht!
Oben steht es auf dem Bild.
Seht! Er schaukelt gar zu wild,
Bis der Stuhl nach hinten fällt;
Da ist Nichts mehr, was ihn hält;
Nach dem Tischtuch greift er, schreit.
Doch was hilft's? Zu gleicher Zeit
Fallen Teller, Flasch' und Brod.
Vater ist in großer Noth,
Und die Mutter blicket stumm
Auf dem ganzen Tisch herum.

(19)

VI. Der Struwwelpeter.

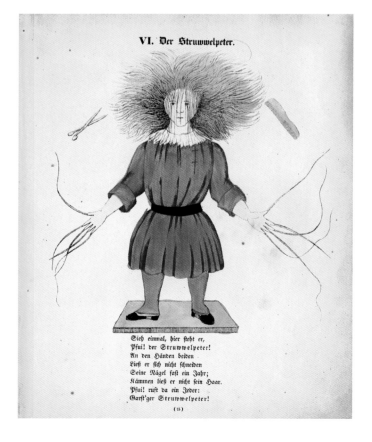

Sieh einmal, hier steht er,
Pfui! der Struwwelpeter!
An den Händen beiden
Ließ er sich nicht schneiden
Seine Nägel fast ein Jahr;
Kämmen ließ er nicht sein Haar.
Pfui! ruft da ein Jeder:
Garst'ger Struwwelpeter!

(15)

Top left: Preliminary art from Hoffmann's sketchbook; top right: watercolor and pen-and-ink illustration from the author's 1844 manuscript; bottom: illustration "Un enfant terrible," by Paul Gavarni, published in Paris in *La Caricature* (March 29, 1840)

CLEMENT HURD

born 1908, New York, New York, US; died 1988, San Francisco, California, US

Biography: A New York banker's son, Clement Hurd spurned the family business in favor of a life in art. After graduating from Yale, he headed for Paris, where he studied with Fernand Léger and Jean Lurçat. He returned to New York two years later and was making his way as a decorative artist when an enterprising editor who had seen his work at a friend's house approached him about illustrating picture books. Hurd had not considered this possibility before but needed the money and was game to try. The editor, Margaret Wise Brown, was also a prolific and brilliantly inventive writer for whom it was easy enough to compose a suitable manuscript to order for any artist she wished to publish. Their first collaboration, *Bumble Bugs and Elephants* (1938), was an experimental board book inspired by the theories of early childhood development advanced by Brown's mentor, Bank Street School founder Lucy Sprague Mitchell. A year later, Hurd scored a coup by winning the competition to illustrate Gertrude Stein's first children's book, *The World*

Is Round (1939), a project in which Brown also played a key editorial role. Hurd had barely completed the art for what was to become his first major commercial success as Brown's illustrator, *The Runaway Bunny* (1942), when wartime military service put his career on hold. Three years later, when the artist returned to New York and civilian life, Brown had the manuscript for their next collaboration—*Goodnight Moon* (1947)—waiting for him as a welcome-home present. Hurd married Brown's Bank Street classmate writer Edith Thacher, and the couple went on to collaborate on more than forty well-regarded books, none of which, however, ever approached the popularity of *Goodnight Moon*.

About the book: When new, *Goodnight Moon* seemed a strange book indeed. At just three hundred words, its text was far shorter than that of most picture books of the day. It lacked both a hero and a narrative in the traditional sense. Stranger still, it had, in effect, only a single illustration: a room interior viewed from different angles and distances, in black-and-white on some pages and in color on others. What Brown and Hurd *had* created was something extraordinary: a hypnotic lullaby that gave young children and their parents

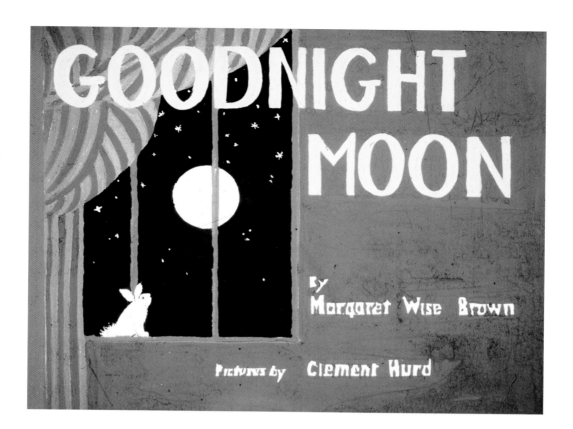

the framework for a satisfying bedtime ritual for acting out—and improvising on—as they wished. Brown's Bank Street training had left her acutely aware of small children's absorption in their immediate surroundings, their affinity for the music and rhythm of words, and their need for a secure emotional center. The Great Green Room is an embodiment of that center: a safe and intimate home base that holds within its walls life's necessities of food, clothing, and a sheltering warmth, while also offering up a glimpse of the farthest reaches of the universe. As the room gradually darkens, this deceptively simple picture book reassures the young that the world they are just beginning to know is in fact a solid and steady place, and that a vast world of possibilities awaits them.

Publication history: Not surprisingly, given its unconventional nature, *Goodnight Moon* met with a mixed initial reception. While some in the popular press praised its originality, the editor of the *Horn Book* magazine—a bellwether of librarian sentiment—chose to ignore it altogether, and the influential New York Public Library declined to purchase the book for its collection until 1974. Librarians resisted *Goodnight Moon* in

part for what might be considered ideological reasons. Intent on providing children with story-hour books of the highest aesthetic merit, they remained deeply wary of social scientists like Bank Street's Lucy Sprague Mitchell, who claimed to have determined by empirical means what children's books were best. As Mitchell's chief protégée, Brown and her work suffered accordingly. Public librarians of the postwar years were not yet keen, in any case, on serving the needs of children too young to read independently. Against this backdrop, *Goodnight Moon* might well have faded into oblivion had not Frances Ilg and Louise Bates Ames, cofounders of the Gesell Institute and writers of a nationally syndicated advice column for young mothers, recommended the book repeatedly, from 1953 onward, to their legion of readers. By the time of *Goodnight Moon*'s fiftieth-anniversary celebration in 1997, it had become the quintessential birth gift, with more than eleven million copies in print and with foreign-language editions published in Japanese, French, Spanish, Italian, Hebrew, Chinese, and Korean.

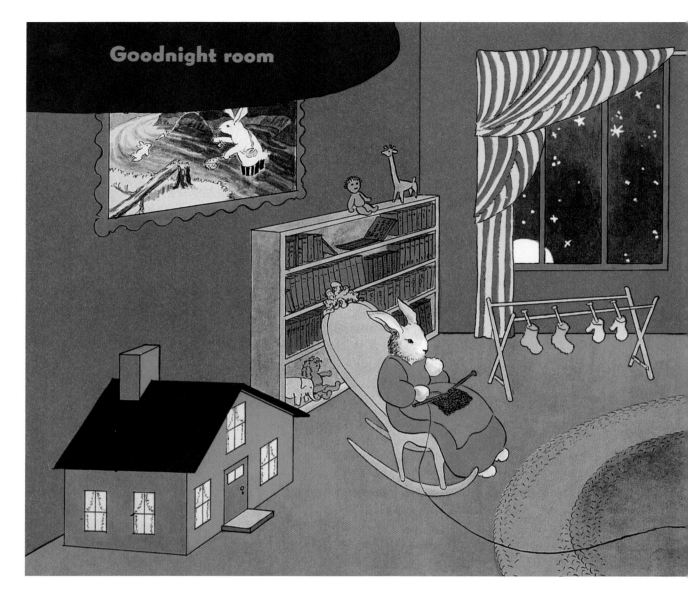

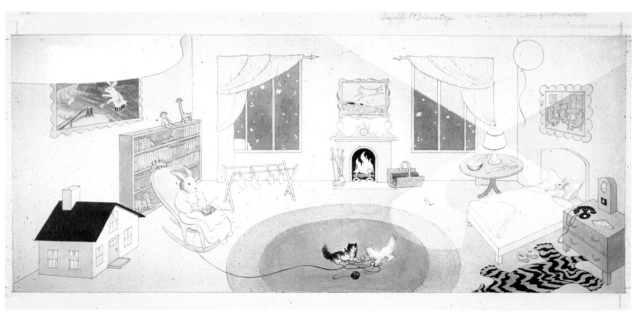

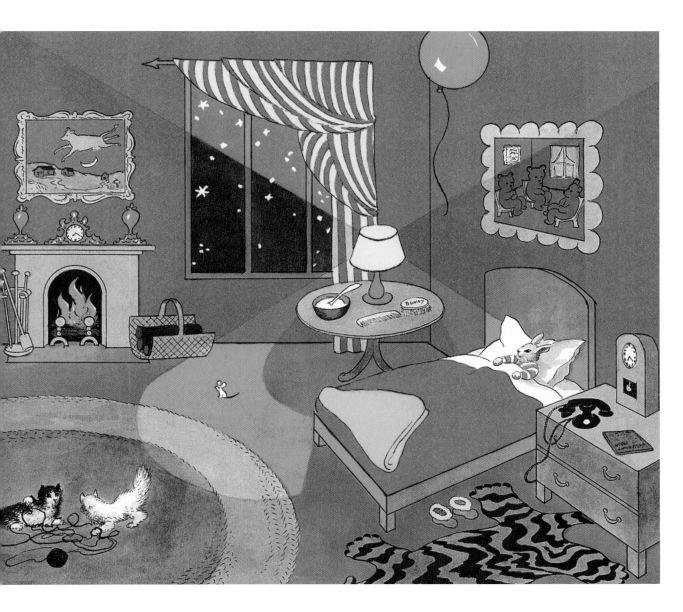

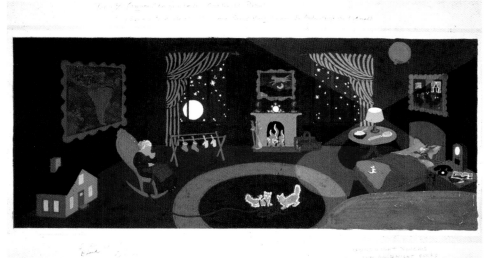

ROBERT INGPEN

born 1936, Geelong, Australia

Biography: In the fall of 1955, when seventeen-year-old Robert Ingpen took up residence in Melbourne to begin his art and design studies at the Royal Melbourne Institute of Technology (RMIT), he realized he had found his place in the world. Up until then, the old-fashioned educational practices of Geelong, his provincial Australian hometown, had left him feeling "totally lost"—except for the encouragement offered him by one life-changing art teacher. But at RMIT, instructors routinely challenged him in a new and nourishing way, and Melbourne's thrumming cosmopolitan energy agreed with him as well. A high point of his training was an advanced course called the Art of the Book, taught by renowned Australian illustrator and muralist Harold Freedman. Upon graduation, Ingpen joined the staff of the Commonwealth Scientific and Industrial Research Organization, where for the next ten years he produced illustrated informational materials on agricultural topics. The experience shaped his concern for the environment, and by the time he left in 1968 to set up shop as a freelance artist, he had also developed an unwavering commitment to rigorous research and narrative clarity. These first principles would stand him in good stead as the illustrator of scores of books ranging from classics by Robert Louis Stevenson, Jules Verne, and Hans Christian Andersen to his own *Voyage of the Poppykettle* (1980) and *The Dreamkeeper: A Letter from Robert Ingpen to his Granddaughter Alice Elizabeth* (1995). The designer of several Australian postage stamps and works of public art, Ingpen is also Australia's most celebrated children's book illustrator. In 1986, he received the Hans Christian Andersen Award for illustration, the first Australian artist to be so honored.

About the book: Ingpen framed *The Dreamkeeper* as a letter addressed to his young granddaughter—and all children—reassuring them that nightmares are ultimately not to be feared. To make his case, he posited the existence of a Dreamkeeper, or benign protective spirit, whose timely interventions, in sync with those of

his two trustworthy aides, may be counted on to keep bad dreams from ever spilling over into waking-world disasters. Ingpen bolsters his claim by offering a finely wrought account of the Dreamkeeper's unseen machinations, which in turn gives ample scope for him, both as writer and artist, to exercise his gifts for fantastical invention and blarney. Even as a high schooler, Ingpen had demonstrated a powerful command of the drawn line, and in the illustrations for this book he gives a bravura display of classical draftsmanship in service of an Arthur Rackham–like total immersion in a densely imagined Faerie realm. The influence of Leonardo da Vinci, Johannes Vermeer, and N. C. Wyeth are all felt at times, and the close physical resemblance of the Dreamkeeper to the artist himself in later life would seem to confirm this agile, bred-in-the-bone fable as

perhaps the most personal of all Ingpen's more than one hundred book projects.

Publication history: First published in Australia by Lothian in 1995, *The Dreamkeeper* appeared that year on the Children's Book Council of Australia's annual list of notable books. Its first American publication followed three years later in an edition issued by the small independent house Star Bright Books. By 1998, the twentieth anniversary of Ingpen's Hans Christian Andersen Award win, *The Dreamkeeper* had gone out of print, and minedition, then a Penguin imprint under the direction of Michael Neugebauer, took the occasion of the milestone year to reissue the book internationally.

ROBERTO INNOCENTI
born 1940, Ripoli, Italy

Biography: A self-taught artist, Roberto Innocenti was born in a small town near Florence. At the age of thirteen, he went to work in a steel mill. Five years later, he headed for Rome, where, despite his lack of formal training, he managed to land a job in an animation studio and to publish his first drawings as an editorial illustrator. During the 1970s, he and a few friends opened a graphic design studio in Florence. It was at around this same time that Innocenti discovered the children's books of Maurice Sendak, Tomi Ungerer, and Étienne Delessert, which a new generation of adventurous Italian children's book publishers were proudly introducing in Italy. The example of these innovative artists inspired him to develop his own original approach to book illustration, despite the fact that he saw little chance of making a living in the low-paying Italian publishing industry.

Innocenti had been experimenting with watercolor as a medium of personal expression. When he met Delessert, who was then an editor at a small American publishing company as well as an illustrator, he presented his plan for a haunting picture book project called *Rose Blanche* (1983), which blended elements of the Grimm fairy tale "Snow White and Rose Red" with realistically rendered scenes of the Nazi occupation of Europe. Delessert decided then and there to publish the book in the United States. Several foreign editions followed, including—twenty years later—an Italian one. This set the pattern for Innocenti as an Italian illustrator who originated his work abroad. Subsequent books—handsomely produced, large-format interpretations of "the classics" in the Rackham-Bilibin-Dulac-Wyeth tradition—proved to have widespread appeal, and in 2008 Innocenti became Italy's first recipient of the Hans Christian Andersen Award.

About the book: Innocenti set his meticulously researched illustrations for *The Adventures of Pinocchio* in author Carlo Collodi's nineteenth-century Tuscany, achieving an uncanny, near-photorealist effect in his sepia-tinged depictions of the story's town- and

landscapes. His characters are expressionist in treatment, darkly lit, often a bit distorted in their proportions, and borderline grotesque, but always painted with absolute conviction. His intensely dramatic compositions are cinematic in approach, with the artist always finding the most impactful "camera" angle with which to propel the reader headlong into the scene. Few illustrators have created such a mystery-laden and magical pictorial world as has this amazing visual storyteller.

Publication history: *The Adventures of Pinocchio* (1988), Italy's quintessential children's tale, was both the obvious and the ideal book for Innocenti to solidify his international reputation as an illustrator. Reviewers were rhapsodic in their praise. It was first published in 1988 in the United States by Knopf and simultaneously by Jonathan Cape in the UK. Spanish, Irish, German, French, Japanese, and Chinese editions followed. An Italian-language edition appeared in 2005.

ISOL
born Marisol Misenta

born 1972, Buenos Aires, Argentina

Biography: Isol waded into her career as a picture book artist after having first prepared to teach art rather than to make it. She studied at the Escuela Nacional de Bellas Artes Rogelio Yrurtia and at la Universidad de Buenos Aires. Following a brief stint in the classroom, in 1997 she published her first picture book, *Vida de perros* (loosely translated, *A Dog's Life*, 1997), as a result of having received an honorable mention in a contest sponsored by the Mexican publishing house Fondo de Cultura Económica (FCE). The FCE competition was part of its visionary editor Daniel Goldin's ambitious plan to bring high-quality picture books to the Spanish-language world. Goldin became the fledgling artist's mentor and champion, publishing several more of her picture books. Meanwhile, Isol branched out in other directions as well, from 2000 to 2005 drawing a weekly page for children in *Clárin* (*Clarion*), Argentina's leading Sunday newspaper, while also embarking on a pop music career as a recording artist and the lead singer of the band Entre Ríos. Her reputation as an illustrator coalesced rapidly, with her name soon figuring regularly on international prize lists. In addition to writing her own stories, she undertook collaborations with others, notably with the Argentinian poet Jorge Luján. In 2013, Isol won the Astrid Lindgren Memorial Award for a body of work consisting of more than twenty picture books that the jury characterized as "humorous with surprising twists, occasionally philosophical and always subtle."

Petit can be very nice to Grandfather Paco

and very mean to pigeons.

His mother asks him, "How can such a good boy sometimes do such bad things?"

Petit doesn't know how to answer.

About the book: *Petit, the Monster* (2006) is a picture book of lightly navigated philosophical reflection. In it, as a young child puzzles over one of life's Big Questions, the meaning of "good" and "bad," he exposes and clarifies the ambiguous nature of two concepts all too often foisted upon children in black-and-white terms. Isol's illustrations—a mongrel mix of scraggly, wild-child line art and elegantly Photoshopped solid expanses of color—reinforce the notion that life itself is inherently a bit out of register and that a flexible and fluid perspective is more apt to capture the truth about things than a doggedly single-minded one. Isol leaves the illustrations rough enough to suggest that a child might have drawn them. The message is clear. As the Lindgren committee observed in its award citation: "Isol is on the children's side."[1]

Publication history: In recent decades, Mexico has emerged as a leading force in Latin America in the publication of picture books of literary and artistic merit. *Petit, the Monster* is one of a handful of books by Isol that originated in Mexico and were later acquired for foreign-language editions in English, French, Swedish, Korean, and Chinese. While her concern for the nuances and intensities of young people's emotional lives marks her as a spiritual child of Maurice Sendak, Isol's technical facility with both traditional drawing and computer art places her near the center of what increasingly looks to be the characteristic international style of illustration in the early twenty-first century.

CROCKETT JOHNSON
born David Johnson Leisk

1906, New York, New York, US; died 1975, Norwalk, Connecticut, US

Biography: With the sure instincts for conceptual clarity that served him so well as a cartoonist, storyteller, and abstract painter, this artist dropped the Scottish surname that childhood friends had stumbled over and combined it with a favorite nickname to become "Crockett Johnson." Radicalized during the Great Depression, Johnson art-directed the Communist Party magazine *New Masses* for a time, then edged gingerly toward the publishing mainstream as a cartoonist for *Collier's*, a weekly with a long history of progressive activism. He first gained fame as the creator of *Barnaby* (1942–1952), a satirical strip cartoon published in the left-leaning New York daily *PM*. The title character was a stalwart five-year-old watched over by a fairy godfather of dubious character. (Other artists for the paper included Theodor Geisel—later known to the world as Dr. Seuss—and painter Ad Reinhardt.)

In 1943, Johnson married writer Ruth Krauss. That same year, he illustrated his first children's book, a nonfiction work by Constance J. Foster titled *This Rich World: The Story of Money* (1943), and Krauss met Ursula Nordstrom, the visionary Harper editor with whom the couple would long be associated. Two years later, these career strands came together in a memorable first Krauss/Johnson Harper picture book collaboration, *The Carrot Seed* (1945). The couple created three more books together in addition to pursuing projects with other collaborators and on their own. Of his solo efforts, the most significant one by far is without a doubt *Harold and the Purple Crayon* (1955).

About the Book: An inspired work of conceptual art for children, *Harold and the Purple Crayon* takes its doughty young hero's crayon as a metaphor for the child's inherent creativity and resilience. The drawings' featureless white backgrounds suggest a parallel between the artist's or writer's blank page and the naturally curious child's world of pure possibility. Johnson professed not to enjoy the act of drawing. Here, as in *The Carrot Seed* before it, he opted for a minimalist approach whose rigorous rejection of incidental detail serves to concentrate the reader's attention entirely on the little hero's creative, self-generated responses to

HAROLD
and the
PURPLE
CRAYON
by
Crockett Johnson

HarperCollins*Publishers*

Copyright © 1955 by Crockett Johnson
Copyright renewed 1983 by Ruth Krauss
All rights reserved. Manufactured in China
For information address HarperCollins Children's Books,
a division of HarperCollins Publishers,
195 Broadway, New York, NY 10007.
Library of Congress catalog card number: 55-7683
ISBN: 0-06-022935-7
ISBN: 0-06-022936-5 (lib. bdg.)
ISBN: 0-06-443022-7 (pbk.)
16 17 18 SCP 50 49 48 47 46 45

challenging and ever-changing circumstances. Harold epitomized the naturally inquisitive, self-directed child envisioned by John Dewey and other progressive educators of the day. The diminutive trim size of the original edition likewise suited a story aimed at encouraging young children to confidently take life into their own hands.

Publication history: In one of the biggest (and, she would soon decide, most embarrassing) blunders of her career, Ursula Nordstrom reacted negatively at first to Johnson's dummy for the book. The editor had failed to grasp the psychologically grounded logic of the story and mistaken Johnson's tale for a twee flight of fancy. Within a week's time she recanted and proceeded rapidly to publication. The book went on to receive strong reviews and to earn a spot in the 1958 American Institute of Graphic Arts children's book exhibition of distinguished work from the preceding three years.

In 1957, first-time filmmaker David Piel produced an animation based on the book. The quality of the work was high, but financing unraveled before the film could go into commercial release. In 1990, an hour-long musical based on *Crayon* and created by Theatre-Works USA premiered at the off-Broadway Promenade Theater and later toured the United States. Published in fourteen languages, *Harold and the Purple Crayon* would also inspire a board game (2001), an Emmy Award–winning television series (2001–2002), and another play (2009). As of 2021, plans for a feature film had long been rumored in Hollywood.

He made lots of buildings full of windows.

He made a whole city full of windows.

EZRA JACK KEATS
born Jacob Ezra Katz

born 1916, Brooklyn, New York, US; died 1983, New York, New York, US

Biography: The son of eastern European Jewish immigrants, Keats was born and raised in meager circumstances in the far reaches of tenement Brooklyn. While his mother encouraged the artistically inclined child to draw at—and on—the kitchen table, his father openly feared for his son's future. Nonetheless, Benjamin Katz took the boy to the Metropolitan Museum of Art, where, in a life-changing epiphany, young Jack caught sight of Honoré Daumier's *The Third-Class Carriage* and realized that art could celebrate the dignity of ordinary people. Years later, in picture books about children living a makeshift, no-frills inner-city existence, he did as much himself.

After military service and a sojourn in Paris during the postwar heyday of the ragged-edged art brut revelations of Jean Dubuffet, Keats returned to New York to launch a career as a work-for-hire illustrator. He amassed an eclectic portfolio of book jackets and interior illustrations, none of which foretold the great creative leap represented by *The Snowy Day* (1962). The triumphant reception of that book was another life-altering experience. In the years that followed, Keats returned to that story's young Peter and surrounded him with friends who shared in one another's growing pains and adventures, often against a backdrop of graffiti-strewn walls and hardscrabble vacant lots.

About the book: For years, Keats had kept by his drawing table a *Life* magazine clipping of a sequence of photographs of a young child of color. He later said that he modeled Peter on the boy. The text of *The Snowy Day* makes no reference to the protagonist's racial identity, and the cut-paper collage illustrations present Peter as a kind of Everychild reacting intuitively to the seemingly magical transformation of his familiar surroundings by the addition of a blanket of snow. Working at the height of the American civil rights movement, an effort with which he was in complete sympathy, Keats was well aware of the political statement he was making by opting to depict an African American child without fanfare as a typically imaginative and playful youngster—a gesture with few historical precedents in the American picture book—and wanted to be subtle and nonprescriptive about it. In his 1963 Caldecott Medal acceptance speech, he came as close as he ever did to explicitly stating his intention when he said: "I

Crunch, crunch, crunch, his feet sank into the snow. He walked with his toes pointing out, like this:

He walked with his toes pointing in, like that:

can honestly say that Peter came into being because we wanted him; and I hope that, as the Scriptures say, 'a little child shall lead them,' and that he will show in his own way the wisdom of a pure heart."[1]

Publication history: Amid the turmoil in which American society then found itself over the issues of racial equality and justice, the selection of *The Snowy Day* as the winner of the 1963 Caldecott Medal was widely hailed as a landmark event. Keats was instantly lifted out of obscurity and praised as a new star of the field. It was not long after that, however, that he also faced the stiffest criticism of his career. In a much-discussed essay in the *Saturday Review* titled "The All-White World of Children's Books," educator Nancy Larrick (who, like Keats, was white) faulted the creator of *The Snowy Day* both for not having written directly about Peter's Black heritage and for having perpetuated in his depiction of Peter's mother the unflattering stereotype of an overweight, mammy-like Black woman with a bandanna in her hair.[2] Larrick forcefully made the larger point that an occasional book like *The Snowy Day* came nowhere close to meeting publishers' responsibility to diversify their lists with regard to America's minority children and prompted an industry-wide discussion. But her critique of the book itself largely fell on deaf

ears, and over the years, *The Snowy Day* continued to be regarded as one of the Caldecott committee's most courageous, consequential, and popular choices.

Shortly before his death, Keats arranged with his lifelong friends Martin and Lillie Pope to organize and administer a foundation funded by royalties from his books for the benefit of children, schools, libraries, and the people who create picture books. An image of Peter became the foundation logo and the emblem for a foundation-sponsored award designed to support writers and artists new to the field. In 1997, the image of Peter appeared writ large in bronze as the centerpiece of a playground in Prospect Park, Brooklyn, not far from where Keats had spent his childhood. In 2012, a musical play based on the book premiered at the Adventure Theatre in Glen Echo, Maryland. A second Keats-inspired musical opened off-Broadway in New York in 2017. That same year, the US Postal Service issued four stamps honoring Keats and *The Snowy Day*, and in 2020, as part of its 125th-anniversary celebration, the New York Public Library announced that *The Snowy Day* was the most frequently borrowed book, past or present, in its vast collection. Editions have been published in sixteen languages, among them Spanish, French, Japanese, Chinese, Korean, Swedish, and Catalan.

It was a stick

— a stick that was just right for
smacking a snow-covered tree.

14

15

VOJTĚCH KUBAŠTA

born 1914, Vienna, Austria; died 1992, Dobřiš, Czech Republic

Biography: Trained as an architect and civil engineer against the wishes of his father, who had urged him to study law, Vojtěch Kubašta suffered an early professional setback when, with the outbreak of war in Europe in 1939, new construction in Czechoslovakia ground to a standstill. Undaunted, Kubašta turned to commercial art and book design for his livelihood, proving himself to have a popular touch for visual communication and a seemingly endless supply of ideas and ambition. By the late 1940s, he had added three-dimensional novelty card designs to his repertoire, creating attention-grabbing custom advertising pieces for clients such as Pilsner Urquell beer, Praha light bulbs, and a sewing machine manufacturer. In 1953, he continued his explorations of 3D image making by creating his first children's pop-up book, *Christopher Columbus*, which the state-owned Czech publisher and foreign trade company Artia released domestically and made available for publication abroad. In the decade that followed, he designed nearly one hundred more pop-up books.

About the book: In 1961, Kubašta launched a pop-up series about the comical adventures of a pair of mechanically adept best friends, one skinny and impulsive, the other chubby and cautious by nature. *Tip and Top Build a Motorcar* was one of the two initial titles in a series that ran to at least six volumes (definitive publication details for ephemeral works such as these can be hard to pinpoint). In one thrilling subsequent installment, Tip and Top journey to the moon and back in a homemade rocket—a Cold War fantasy come to life. Kubašta knew how to extract the maximum impact from the most basic techniques and materials, producing three-dimensional tableaux that fold out uncomplicatedly from the center of the book without pull-tabs or other high-end paper-engineering apparatus. "What's astounding about Kubašta," Robert Sabuda commented in the *New York Times*, "is that he achieved his effects using a single piece of paper. That is the real magic of Kubašta. Look at one of his pop-ups from the side, and it looks like a staircase. The positive space is missing from the background, because it has been cut out, but you don't notice it. The simplicity of it, from a paper engineer's point of view, is simply amazing."[1]

Publication history: Kubašta's books were published in dozens of languages. The Tip and Top books became popular 1960s childhood entertainments in the United Kingdom and in parts of Europe but made much less of an impression in the United States, perhaps because prosperous Americans had so much else to choose from as the postwar juvenile publishing industry expanded in tandem with the rest of the US economy.

Kubašta is universally credited with having inspired the late twentieth-century revival of interest in pop-ups and other "movable book" formats, a technology dating back to the Middle Ages, when illustrations featuring paper flaps, gatefolds, and three-dimensional elements were first employed to illustrate scientific treatises on astronomy, medicine, and other technical topics. Retrospectives of his work have been mounted at the Bienes Museum of the Modern Book (2005, Fort Lauderdale, Florida), at the Grolier Club (2014, New York), in Prague, and elsewhere.

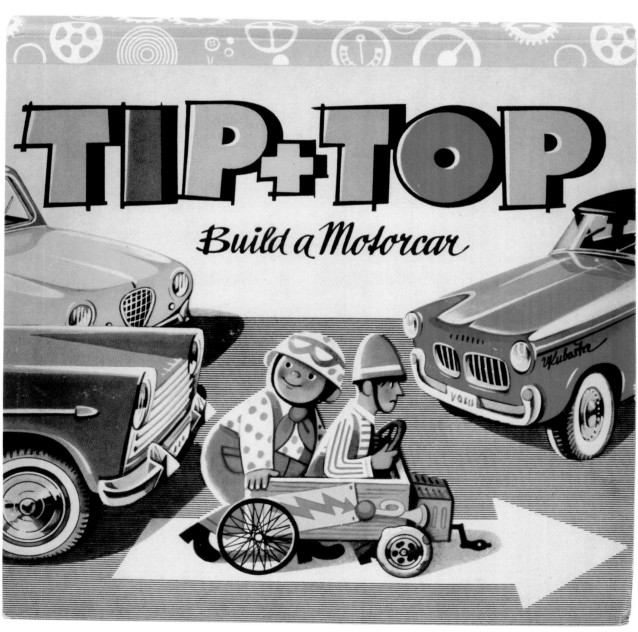

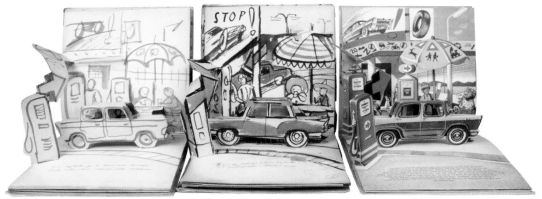

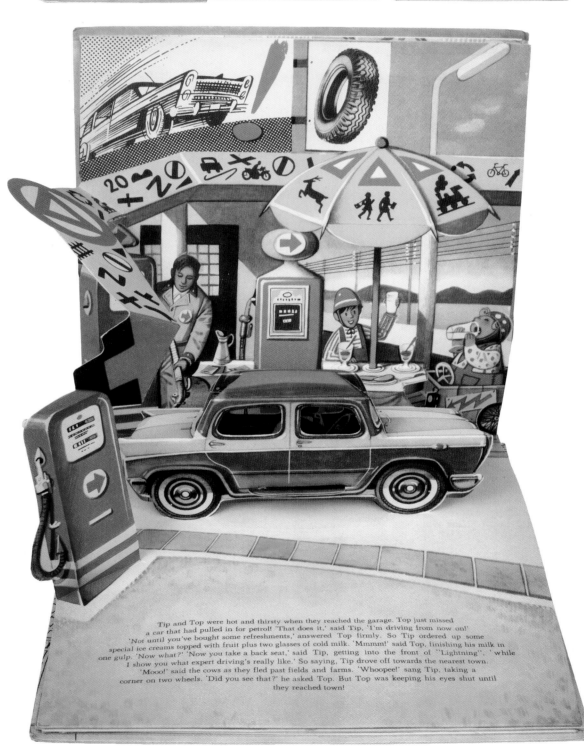

Tip and Top were hot and thirsty when they reached the garage. Top just missed
a car that had pulled in for petrol! 'That does it,' said Tip, 'I'm driving from now on!'
'Not until you've bought some refreshments,' answered Top firmly. So Tip ordered up some
special ice creams topped with fruit plus two glasses of cold milk. 'Mmmm!' said Top, finishing his milk in
one gulp. 'Now what?' 'Now you take a back seat,' said Tip, getting into the front of "Lightning", 'while
I show you what expert driving's really like.' So saying, Tip drove off towards the nearest town.
'Moool' said the cows as they fled past fields and farms. 'Whoopee!' sang Tip, taking a
corner on two wheels. 'Did you see that?' he asked Top. But Top was keeping his eyes shut until
they reached town!

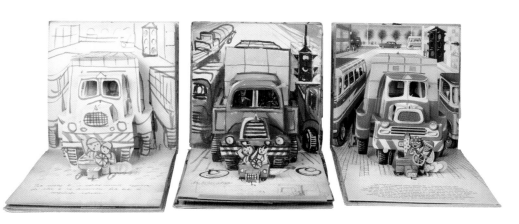

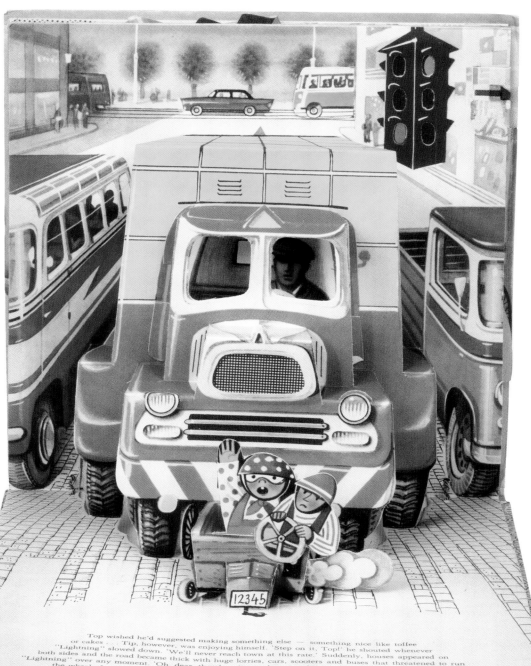

Top wished he'd suggested making something else — something nice like toffee or cakes . . . Tip, however, was enjoying himself. 'Step on it, Top!' he shouted whenever 'Lightning' slowed down. 'We'll never reach town at this rate.' Suddenly, houses appeared on both sides and the road became thick with huge lorries, cars, scooters and buses that threatened to run 'Lightning' over any moment. 'Oh, dear, there's going to be a crash!' groaned Top as the car skidded past the wheel of a giant lorry, bounced up the pavement and crashed back onto the road. 'Don't worry, Top, we'll make it,' said Tip, shooting past an angry policeman and stopping by the traffic lights. 'Now then, you two, take that car off the road before you get hurt,' said the policeman. So Tip and Top took their car off the road and pushed it slowly through the town.

CARL LARSSON

born 1853, Stockholm, Sweden; died 1919, Falun, Sweden

Biography: Carl Larsson grew up in abject poverty amid a troubled family environment dominated by a ne'er-do-well father and a mother who struggled heroically to provide for her two sons. Larsson discovered art—and his salvation—at a school for the children of the poor and, with the encouragement of a teacher there, gained acceptance to the Royal Swedish Academy of Fine Arts while still in his early teens.

Highly motivated, Larsson overcame his initial sense of rootlessness and inferiority to emerge as something of a star among his fellow students. His undeniable talent for drawing and caricature led to

steady work for the humor magazine *Kasper* and the influential illustrated weekly *Ny Illustrerad Tidning* (*New Illustrated Newspaper*)—and to the satisfaction of having the means to help pay his parents' bills. Still restless, however, he left for Paris in 1877 to pursue a painting career, aligning himself with a group of Swedish émigré artists who, it seemed, preferred keeping to themselves rather than joining the ranks of the French avant-garde. For a time, Larsson's prospects appeared to be on the wane, as his oils consistently failed to garner much attention. But while he was living in the Swedish artists' colony of Grez-sur-Loing, near Paris, two developments permanently lifted his fortunes. He began painting in watercolor, the medium that would soon bring him lasting fame; and he met his future wife, Karin Bergöö, an artist and interior designer associated

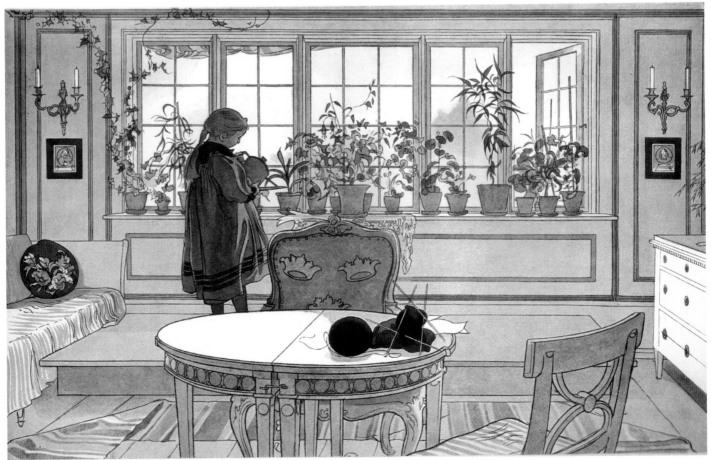

with the Swedish Arts and Crafts movement. Their loving relationship proved to be transformative for both.

The couple and their young children returned to Sweden and, in 1888, took up residence in a picture-postcard cottage in rural Sundborn, Dalarna. They treated their house, called Lilla Hyttnäs, as an art project and showcase, lavishing attention on every detail of its design and decoration. Larsson would later memorialize their joint creation in the twenty-six watercolors that comprise his first major illustrated book, *Ett hem* (*A Home*, 1895).

In addition to the books that became the central focus of his work, Larsson built a substantial reputation as a fresco painter and creator of other monumental public art works. His career concluded on an unexpectedly bitter note when the Nationalmuseum in Stockholm rejected a large mythological painting it had commissioned from him as a companion to several others by Larsson already on view in the museum. History had found a perversely dark and vexing way to repeat itself, restoring Larsson in the end, for all his accumulated fame, fortune, and achievements, to the marginalized outsider's role.

About the book: Curiously, Larsson's best-known children's book started out as a work intended primarily for adult readers with an interest in interior design and the decorative arts. Late nineteenth-century advances in color printing had opened the door to the publication of breathtakingly beautiful, illustrated albums like *Ett Hem*. The happy family life Larsson shared with Karin Bergöö and their eight children—so unlike the sturm und drang of his own early years—inspired him to create a compelling portrait of the Larsson household that doubled as a showcase for his own and his wife's design aesthetic. The interior views Larsson recorded, with their delicate stencil patterns, subtly tinted striped fabrics, and countless other decorative touches, were representative not so much of the look and material culture of a typical Swedish country cottage as of the highly refined and aestheticized ideal of rusticity that he and his wife assiduously cultivated. Swedes sliding headlong into the industrial age warmly embraced Larsson's images with a mixture of pride, nostalgia, and doubtless fear for all that they might be about to lose forever.

Publication history: Bonnier published *Ett hem* in Sweden in 1899 in an exquisitely printed large-format edition that served to crystallize Larsson's reputation. The artist's text summarized the Larssons' ideas about home decor and included anecdotes about their family. Publication preceded by just one year that of feminist and educator Ellen Key's *The Century of the Child* (1900), a widely read monograph on modern-day child-rearing practices and family relationships. Key was a friend of the Larssons, and her essay, in effect, endorsed the relaxed, craft- and play-focused domestic life depicted in *Ett hem*.

After the 1909 German edition, titled *Das Haus in der Sonne* (*The House in the Sun*), proved to be an even greater success, Bonnier published new Swedish editions in 1910 and 1920. Then, nearly half a century later, Larsson's illustrations were given new life alongside an original text by Lennart Rudstrom written expressly for young readers. The 1968 Swedish edition had crossover appeal as a family story for children and as a design book that seemed timely as the international handcraft revival gathered momentum. In the mid-1970s, translations followed for American, British, German, and French readers.

It is interesting to note that copies of *Ett hem* were to be found in the New York Public Library's Central Children's Room as early as 1911, presumably because Larsson's illustrations provided young people with vivid glimpses of life in another part of the world. One American picture book artist who may well have been inspired by Larsson was Robert McCloskey, who, working in a similar vein in *One Morning in Maine* (1952) and *Time of Wonder* (1957), created emblematic depictions of himself and his family and their deliberately homespun life in Maine.

The impact of *Ett hem* has far exceeded the realm of illustration, as Larsson's images have continued to exercise a major influence on contemporary Swedish designers and retailers, including Eva Schildt and Ikea.

EDWARD LEAR

born 1812, Holloway, Middlesex, UK; died 1888, Sanremo, Liguria, Italy

Biography: Edward Lear was born into a family that might easily have served as the premise for one of his limericks. The twentieth of his middle-class parents' twenty-two children, he was soon packed off to live with an older sister, the already crowded main family living quarters having reached the breaking point with his arrival. As a child, he suffered from asthma, bronchitis, epilepsy, and depression ("the Morbids," as he said), and he seems to have been wracked with guilt about each of these afflictions because they made him a burden on others. But an extraordinary talent for art emerged early, too. By sixteen, he was drawing "for bread and cheese" and rapidly establishing himself as an ornithological artist of exceptional promise. He published his first major work, *Illustrations of the Family of Psittacidae, or Parrots* (1832), just three years later.

Lear was in his mid-thirties when he launched a second career as a writer and illustrator of nonsense verse. He demonstrated caution as he did so, signing *A Book of Nonsense* (1846) with a winsome pen name—"Derry down Derry, who loved to see little folks merry"—so as not to dilute his reputation for serious work. The great success of the book prompted him to conjure forth a handful of follow-ups, including *Nonsense Botany* (1888), in which he made fun of his own scientific predilections. Nor did Lear confine his nonsense entirely to the printed page. Asked to introduce himself, he would sometimes reply: "Mr. Abebike Kratoponoko Prizzihalo Kattefello Ablegorabalus Ableborinto Phashyph."[1]

About the book: *A Book of Nonsense* represented a complete departure from the meticulous creative work for which Lear had garnered critical praise and the patronage of the Earl of Derby. He composed the first several rhymes, and doodled the corresponding illustrations, for the amusement of his patron's children. It was the earl himself who urged Lear to share his silly side with the world. The immediate and resounding success of the published volume did much to popularize the limerick as a light verse form—though Lear himself did not call his rhymes "limericks," and the term appears not to have entered the language until sometime after his death.

Publication history: It is striking that Lear's first foray into children's literature debuted within a year of German medical doctor Heinrich Hoffmann's *Struwwelpeter*, another homespun venture that likewise made maximum use of outlandish comic exaggeration to lampoon the stifling social norms of the day. Both books were bellwethers of changing attitudes toward children and their books, expressions perhaps of the Lockean view that children learned more about life from their playtime experiences than they did from adult attempts at moralizing and fearmongering.

Lear's book was reprinted in more than twenty editions in his lifetime. The expanded 1861 edition was the first to bear the author's own name. Lear's decision to go public doubtless owed something to the absurd speculation that had sprung up, as a kind of sideshow to the public's fascination with the rhymes, about their author's identity. The Earl of Derby was sometimes mentioned, in part (or so the tenuous argument ran) because "Earl" was an anagram of "Lear." The author himself, who suffered from chronic melancholy, once recalled that while riding aboard a train he had overheard a fellow passenger deliver an impassioned defense of that theory: "Hitherto I kept my silence," Lear remembered, "but as my hat was, as well as my handkerchief and stick, largely marked inside with my name, and as I happened to have in my pocket several letters addressed to me, the temptation was too great to resist, so, flashing all these articles at once on my would-be extinguisher's attention, I speedily reduced him to silence."[2]

There was an old person so silly – He poked his head into a Lily –
But six bees who lived there – filled him full of despair
they stung that old person so silly.

A

BOOK OF NONSENSE.

BY EDWARD LEAR.

There was an Old Derry down Derry, who loved to see little folks merry;
So he made them a Book, and with laughter they shook
At the fun of that Derry down Derry.

LONDON:

FREDERICK WARNE AND CO.,

BEDFORD STREET, COVENT GARDEN.

NEW YORK: SCRIBNER, WELFORD, AND CO.

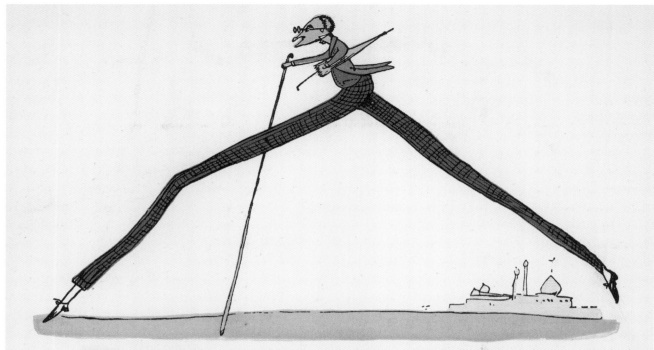

There was an Old Man of Coblenz, the length of whose legs was immense;
He went with one prance from Turkey to France,
That surprising Old Man of Coblenz.

There was an Old Man of Whitehaven, who danced a quadrille with a Raven;
But they said, "It's absurd to encourage this bird!"
So they smashed that Old Man of Whitehaven.

There was a Young Lady whose chin resembled the point of a pin;
So she had it made sharp, and purchased a harp,
And played several tunes with her chin.

There was an Old Man with a beard, who said, "It is just as I feared!—
Two Owls and a Hen, four Larks and a Wren,
Have all built their nests in my beard!"

SUZY LEE
born 1974, Seoul, South Korea

Biography: A private person who has rarely spoken to interviewers about her childhood, Suzy Lee studied painting at Seoul National University and then, having fallen under the spell of artists' books, enrolled in graduate school in the book arts program of London's Camberwell College of Arts. For her master's thesis, she illustrated *Alice in Wonderland* (2002) and exhibited a dummy for the project at the Bologna Children's Book Fair, attracting interest from the innovative independent Italian publisher Corraini Edizioni. Lee went on to originate book projects in Italy, Switzerland, the United States, and Korea, and to become well-known both for her children's books and her artists' books, and for her inventiveness in blending aspects of these two specialties of her artistic practice in surprising and fruitful ways. In all, she is the author and illustrator of more than twenty books and the illustrator of work by the Chinese writer Cao Wenxuan, Americans Bernard Waber and Richard Jackson, and the Korean actor Park Jeong-Sun. In recent years, the computer has served her as a tool for finalizing a composition, but drawing by hand has remained central to her intimate, craft-inflected approach to bookmaking. Lee, who has lived at various times in Singapore, the United States, and Korea, has been the recipient of numerous prizes in the United States, Korea, and Europe. In 2016, as Korea's nominee, she was short-listed for the Hans Christian Andersen Award for illustration, and in 2022 Lee was the Andersen winner.

About the book: *Shadow* (2010) is the culminating work in Lee's Border Trilogy, a series of three wordless picture books that explore the boundary between reality and fantasy. Like *Mirror* (2003) and *Wave* (2008), *Shadow* enlists physical elements of the book in its visual storytelling, in this case by rotating the picture plane ninety degrees so that the gutter becomes the horizontal dividing line between the upper and lower halves of each double-page-spread illustration. In the early spreads, the upper-half pages represent the real world of a cluttered home attic where a young girl has gone to play before dinner, and the lower-half pages depict the shadows cast by the girl and her surroundings. Further on in the story, however, as the girl lets her imagination take flight, she starts to see the shadows differently, as playfully dramatic projections of an imaginary world, until at last the shadows cast by a bicycle, a vacuum cleaner, a ladder, and sundry other items take on lives of their own, and both she and the shadows cross the line to join each other in a thrilling, Wild Rumpus–like dance or game. The final scenes, in which the story's real and imaginary worlds have fully merged, feel inevitable and represent a culminaion of sorts in this astonishing artist's quest for fresh ways to bring the printed page to life.

Publication history: *Shadow* originated in the United States at Chronicle Books. Like *Wave* before it, it was chosen for the *New York Times*'s ten Best Illustrated Children's Books of 2010. *Shadow* has been published in Korean, Chinese, Italian, Japanese, and French editions.

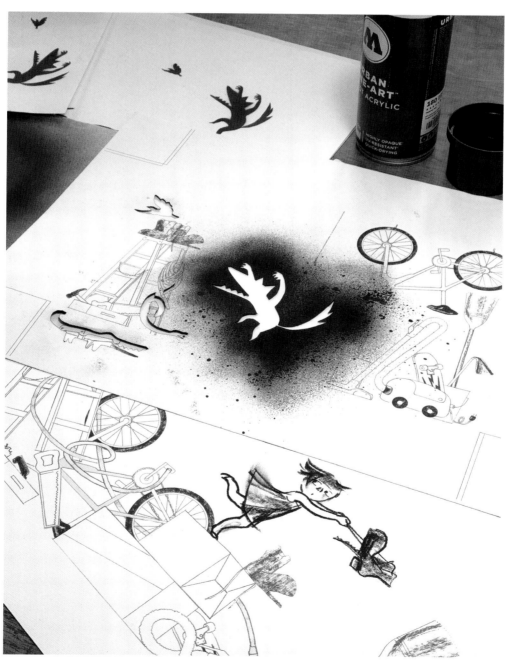

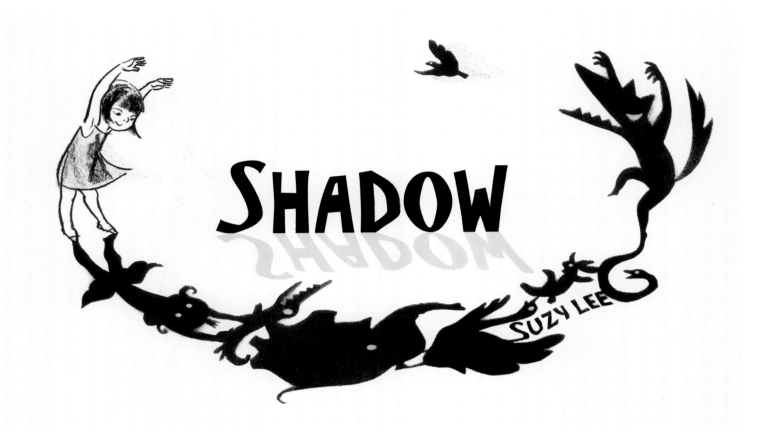

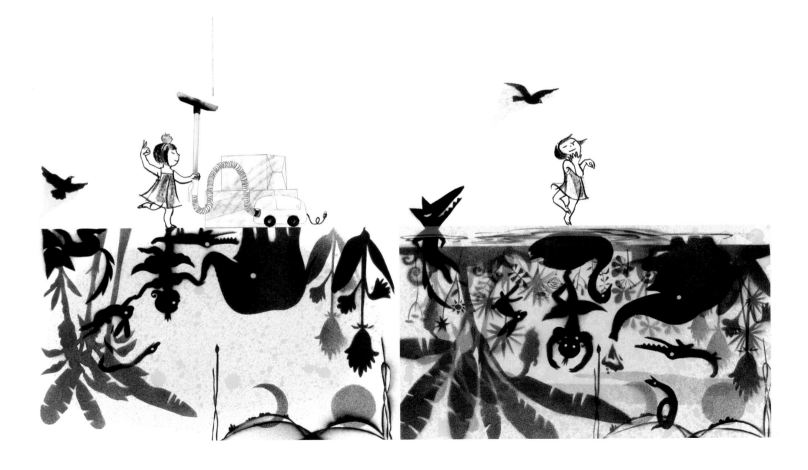

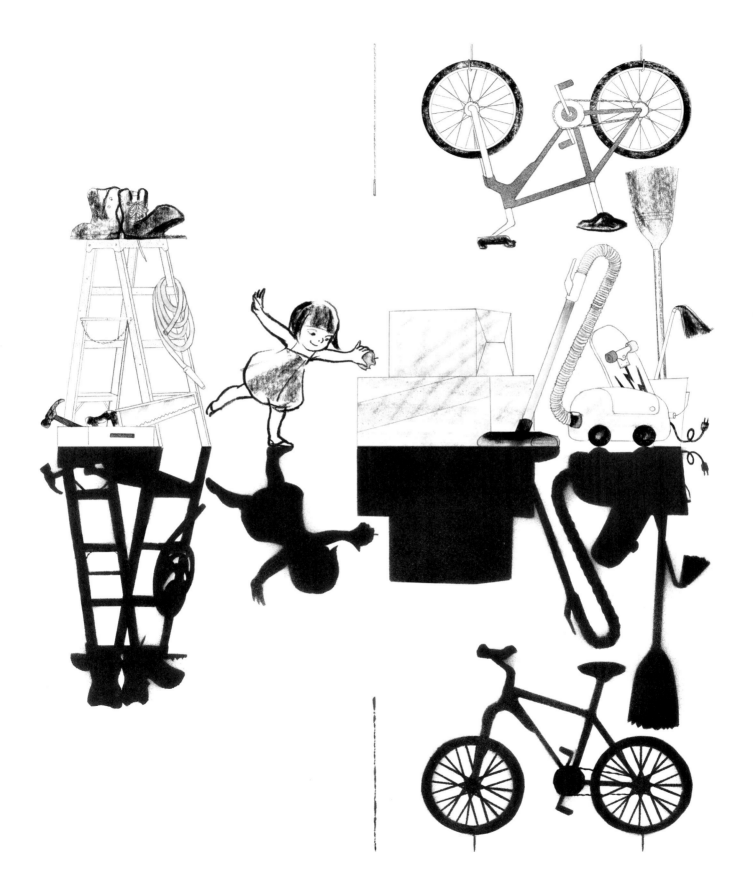

LEO LIONNI

born 1910, Amsterdam, the Netherlands;
died 1999, Radda, Chianti, Italy

Biography: As a child, Leo Lionni kept a terrarium in his bedroom as a home for pet mice, snails, and caterpillars—the same kinds of creatures that later inhabited his picture books. His mother was an opera singer. His father was a diamond cutter and an accountant. A small painting by Marc Chagall hung in their modest apartment—"a happy canvas with cheerful colors that seemed to flutter like ribbons in an icy wind," as he recalled in his memoir.[1] Late in life, Lionni would wonder whether Chagall's quicksilver dream fantasia, which he had gazed at daily with pleasure for years, was not the "secret birthplace of all the stories I ever wrote, painted, or imagined."[2]

Lionni's parents immigrated to the United States when their son was twelve, leaving him in the care of grandparents while he completed his education. He studied art and economics in Italy, associating himself

for a time with the Italian Futurists. By the late 1930s, however, war loomed in Europe, and because Lionni's father's family were Jews, his own Jewish heritage now put his life at risk. In 1939, he joined his parents in Philadelphia and launched a successful career in advertising, commissioning artwork by Saul Steinberg, Andy Warhol, and others for major national campaigns. In 1948, Lionni became *Fortune* magazine's art director, a prestigious post that he held for the next twelve years. Among his freelance commissions from this period was perhaps the best-known art book design of all time, that for the Museum of Modern Art's 1955 landmark *Family of Man* exhibition catalog.

Torn between the worlds of art and commerce, Lionni returned to Italy in 1960 just as he was embarking on a new career as a picture book author and illustrator with the publication of *Little Blue and Little Yellow* (1959). He went on to create more than two dozen picture book fables while also devoting much of his later years to painting and sculpture.

About the book: In each of his picture books, Lionni reflected on a different aspect of the same basic question that all schoolchildren must confront: how best to maintain one's individuality amid the conflicting pressures and rewards of group life. In *Inch by Inch* (1960), his second picture book, he considered the theme in its most primal form, in a trickster tale in which a vulnerable inchworm must use his wits to escape the fate of becoming a tasty morsel on some opportunistic fellow creature's menu. Having arranged the action as a series of close encounters between the wiggly protagonist and a succession of brightly plumed birds many times his size, Lionni proceeded to create a suite of graphically suave and colorful images, in some of which the birds appear to be too big for even the artist to capture on the page in their entirety.

Lionni's playful use of the space beyond the picture frame is one of several devices that set *Inch by Inch* apart as a paradigmatic work of postwar modernist design. Cut- and torn-paper collage elements placed against open expanses of white space define an uncluttered, impactful new approach to the picture book that owed less to the classic narrative tradition of picture book art—although Randolph Caldecott had indeed begun to move in that direction—than it did to recent developments in such mass-communication media as poster art and advertising.

Publication history: *Inch by Inch* was originally published by Ivan Obolensky, a Russian nobleman living in New York who, a few years later, left the book business behind for a high-powered (and presumably more lucrative) career as a financial analyst. Obolensky sold his company to Astor-Honor, a New York firm that sublicensed *Inch by Inch* to a number of other publishers before the Lionni estate was able to reunite it with the artist's many other children's titles at Random House in 2007. *Inch by Inch* has been translated into Italian, German, French, Spanish, Danish, Persian, Chinese, and Japanese and adapted for video by Weston Woods Studios.

Opposite and below: Lionni used the same background for two of his illustrations, swapping out the bird and worm cutouts but leaving the rest of the scene intact.

DAVID MACAULAY

born 1946, Burton upon Trent, Lancashire, UK

Biography: When David Macaulay's family pulled up roots and left Lancashire, UK, for a new life in Bloomfield, New Jersey, they traveled in style, as passengers on the biggest and fastest ocean liner in history, the SS *United States*. Macaulay arrived at age eleven with his fascination for mechanical devices of every kind intact. In 1964, he enrolled in the Rhode Island School of Design (RISD), pursuing a course in architecture, with a fifth-year honors-program adventure added on that took him, sketchbook in hand, to Rome, Herculaneum, and Pompeii.

Designing buildings, not creating illustrated books about their design, was his initial goal, and in the years immediately following graduation Macaulay took steps toward establishing himself in his chosen profession. He also began teaching art and design, first in junior high school and then at RISD. When a book idea initially occurred to him, it was for an off-the-wall fantasy about a gargoyle beauty pageant set in medieval France. Macaulay brought his book proposal to Houghton Mifflin's Walter Lorraine, who sensed another, more compelling idea in the background. When pressed about this, Macaulay described the bare bones of a plan for what would become his first published work, *Cathedral: The Story of Its Construction* (1973).

About the book: A driven, perfectionistic researcher, Macaulay headed for Amiens, France, in January 1973 to make detailed sketches of that city's soaring thirteenth-century Gothic landmark and to hammer out a draft of the narrative. He intended to chronicle the building of a prototypical cathedral rather than to document that of a particular historic structure, and to populate the text with representative characters, not historical figures. He worked rapidly, drawing with pen and ink in a spiral-bound sketchbook. Many of the final illustrations would be constructed by patching together portions of these elaborately detailed drawings.

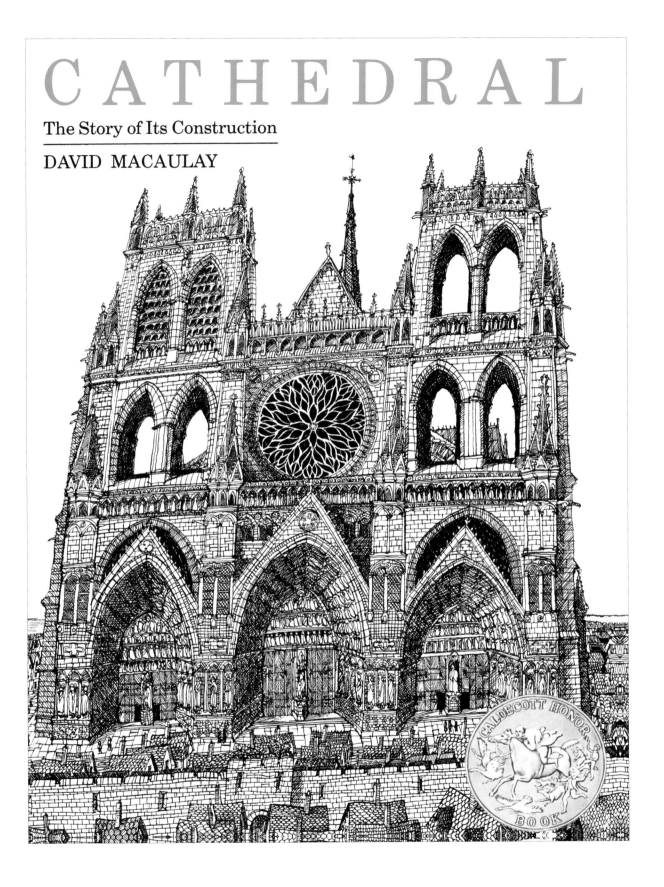

CATHEDRAL

The Story of Its Construction

DAVID MACAULAY

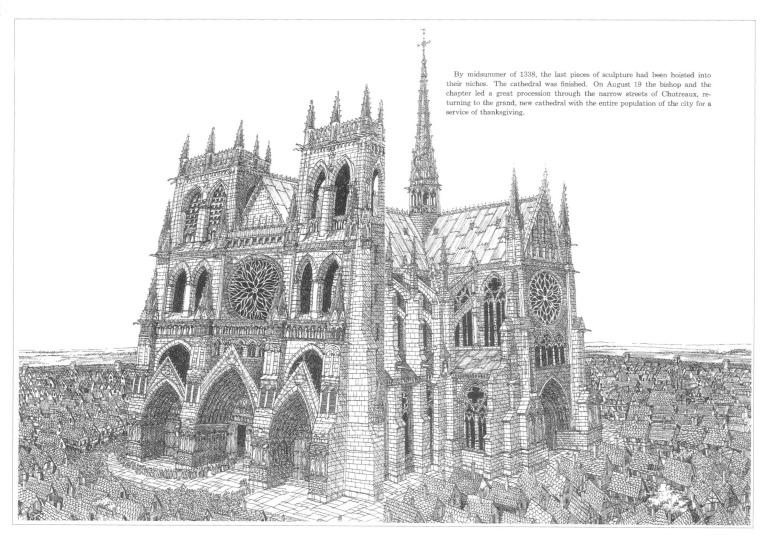

By midsummer of 1338, the last pieces of sculpture had been hoisted into their niches. The cathedral was finished. On August 19 the bishop and the chapter led a great procession through the narrow streets of Chutreaux, returning to the grand, new cathedral with the entire population of the city for a service of thanksgiving.

Publication history: Booksellers and librarians were unsure at first what to make of *Cathedral*. The outsize, copiously illustrated volume straddled the traditional line between fiction and nonfiction. If viewed as the latter, it was not clear whether the book was best classified as history or architecture, or even whether it was primarily a book for young readers or for adults. *Cathedral* was too tall to fit on many standard bookstore and library shelves. The awarding of a 1974 Caldecott Honor to Macaulay for the book helped to sweep away some of the confusion. As booksellers embraced *Cathedral* as a "crossover book" for hand selling to a wide range of customers, librarians made room for the book on their shelves.

Macaulay followed the initial success of *Cathedral* with *City: A Story of Roman Planning and Construction* (1974), with several more large-format books about the creation of other monumental man-made structures. He branched out in other directions as well, including fantasy and satire. Macaulay won the 1991 Caldecott Medal for *Black and White*, a picture book experiment involving "split-screen" page layouts and four interwoven storylines.

Cathedral reached an international audience via foreign-language editions in French, Spanish, Portuguese, Italian, Dutch, Danish, Finnish, Japanese, Korean, and Chinese. In 1999, one year after the book's twenty-fifth anniversary, Macaulay published *Building the Book Cathedral* (1999), a pithy, supersize volume that detailed the process of crafting his first literary landmark. In 2010, he revisited the book once again, this time for a compendium that also included *Castle* and *Mosque*, not only redrawing the illustrations but also adding color for the first time.

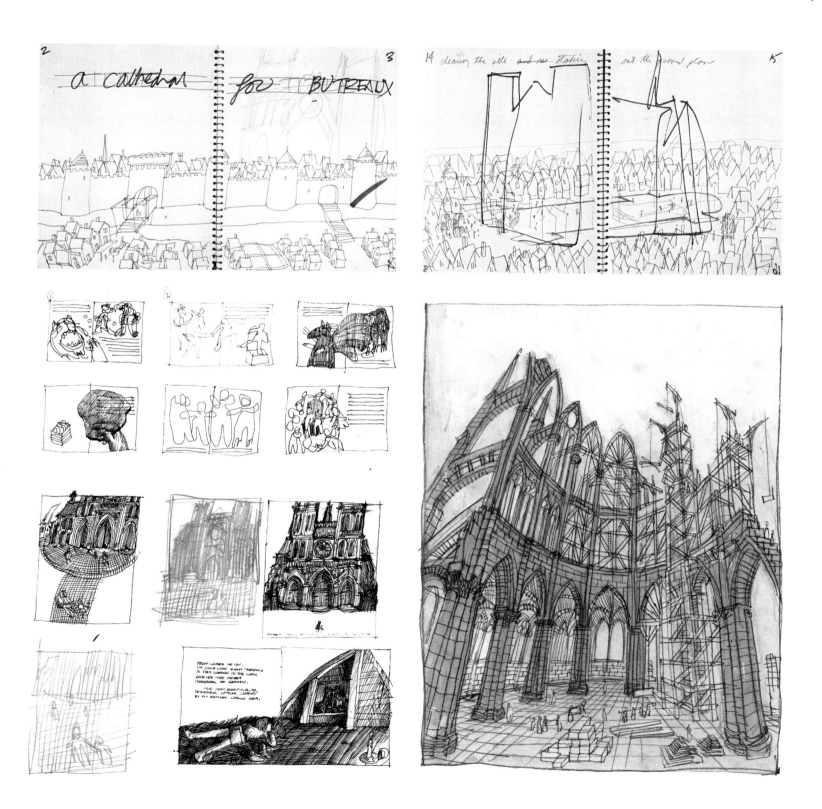

JAMES MARSHALL

born 1942, San Antonio, Texas, US; died 1992, New York, New York, US

Biography: A knowing wit and raffish spirit of irreverence defined the picture books and public persona of the prolific author and illustrator James Marshall. The son of a Texas railroad executive, Marshall felt drawn to the arts at an early age, training seriously for a career as a violist before changing direction. As a visual artist, Marshall was largely self-taught, and the seemingly guileless comic style he cultivated doubtless delayed critical recognition of his singular achievement, although the popularity of his books with children was undeniable from the start. Marshall cited Maurice Sendak, Edward Gorey, Arnold Lobel, and Tomi Ungerer as formative influences, along with the Japanese ukiyo-e master printmakers, whose asymmetrical compositions, elegance and clarity of line, and use of flattened perspective all appealed to him. In 1990, he received a Caldecott Honor for the

illustrations for his own retelling of *Goldilocks and the Three Bears*. Following Marshall's death, friend and fan Maurice Sendak illustrated *Swine Lake* (1999), an unpublished Marshall manuscript that spoofed classical ballet. In 2007, the American Library Association posthumously awarded him the Laura Ingalls Wilder Medal for lifetime achievement.

About the book: Marshall claimed to have adopted his characters' names, George and Martha, from those of the tormented combatants in Edward Albee's searing drama of marital discord, *Who's Afraid of Virginia Woolf?* If so—though it was often impossible to tell when Marshall was pulling your leg—he took great liberties with his models, creating a pair of hippopotamus friends whose occasional spats and disagreements always end in a stronger feeling of mutual respect and affection. Marshall noted: "He [George] bumbles into things through, I think, innocence, and she gets a little grand in places."[1] In the five mini stories of this volume, the comically outsize animals in human dress live in

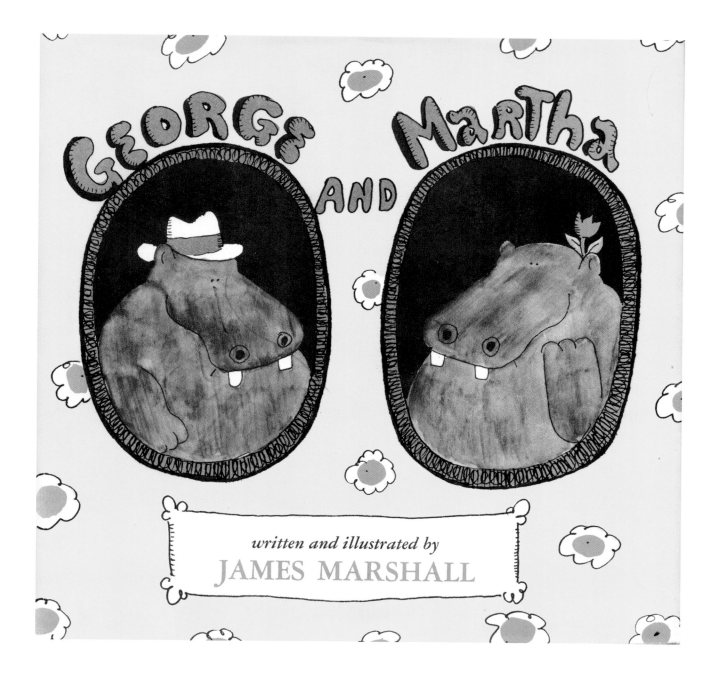

dollhouse-like surroundings and take part in such an incongruous mix of childish and adult behaviors as to elude categorization as anyone or anything other than themselves. That, no doubt, was just as Marshall wished it. His episodic mini texts are little miracles of narrative wit and concision, and Marshall labored feverishly—"sweated bullets," in a favorite phrase of his—to make his drawings look just as effortless. He designed *George and Martha* (1972) meticulously and, with a certain courtly flair, announced each vignette with a formal title card charmingly reminiscent of those once used in silent pictures.

Publication history: The success of *George and Martha* prompted the creation of six sequels and, after Marshall's death, an animated television series (1999). Books from the series have been published in Japan, China, Korea, Sweden, Norway, Germany (where George and Martha are known as Egon and Agatha), Spain, Israel, and South Africa.

Martha was very fond of making split pea soup. Sometimes she made it all day long. Pots and pots of split pea soup.

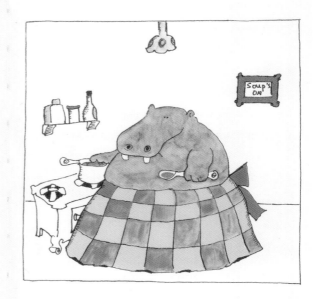

If there was one thing that George was not fond of, it was split pea soup. As a matter of fact, George hated split pea soup more than anything else in the world. But it was so hard to tell Martha.

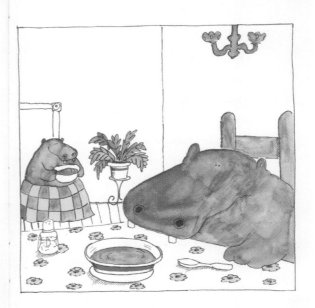

"I'm going to be the first of my
species to fly!" said George.
"Then why aren't you flying?"
asked Martha. "It seems to me that you
are still on the ground."
"You are right," said George. "I don't
seem to be going anywhere at all."
"Maybe the basket is too heavy,"
said Martha.

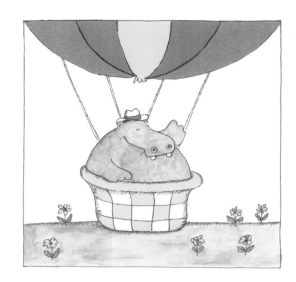

"Oh dear!" cried George. "Now what
have I done? There goes my flying
machine!"
"That's all right," said Martha. "I
would rather have you down here
with me."

ROBERT McCLOSKEY

*born 1914, Hamilton, Ohio, US; died 2003,
Deer Isle, Maine, US*

Biography: The Hamilton, Ohio, of Robert McCloskey's Depression-era youth was not quite the idyllic American small town the artist would later depict in his first picture book, *Lentil* (1940). Manufacturing played a major part in the local economy. Industrial sludge had long since rendered the Great Miami River, which flowed through the center of town, unswimmable. As a boy, McCloskey (like his young protagonist Homer Price) loved to tinker with machinery, and like many of his contemporaries he grew up idolizing Thomas Alva Edison. He also showed an early talent for music and art, the latter of which was encouraged by a photographer uncle but not by his stern Protestant mother. A Scholastic Art & Writing Award scholarship gave him the ticket he needed to leave Hamilton for art school in Boston, originally with the goal of becoming a painter and muralist.

The mother of a Hamilton friend, as it happened, was the sister of the Viking Press's famed children's book editor May Massee. Armed with a portfolio and a personal introduction, the young artist went to see Massee in New York. The editor's initial response was mixed but encouraging enough to plant the seed of a lifelong working relationship. The publication of his first book, *Lentil*, by Viking in 1940, set his reputation as a rising star in the children's book firmament, and his marriage that same year to a children's book librarian who was also the daughter of Newbery Medal winner Ruth Sawyer caught the library world's attention, too. In 1942, McCloskey won the American Library Association's Caldecott Medal for his second picture book, *Make Way for Ducklings*, and nearly every subsequent book received major award recognition. In 1958, McCloskey became the first artist to win a second Caldecott Medal, for *Time of Wonder*. The end of McCloskey's most productive period coincided almost exactly with May Massee's death in 1966. Still, honors continued to come his way, culminating in 2000 in his being named a Living Legend by the Library of Congress.

About the book: During their first encounter in her office, Massee had advised McCloskey to draw what he knew. Taking her advice to heart, he based the story of *Make Way for Ducklings* on a news item he had read in one of the Boston papers and spent considerable

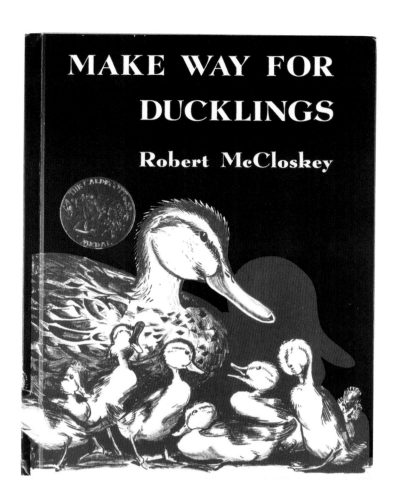

He planted himself in the center of the road, raised one hand to stop the traffic, and then beckoned with the other, the way policemen do, for Mrs. Mallard to cross over.

DURING THE DAY THEY FOLLOWED THE
SWAN BOATS AND ATE PEANUTS AND *...*

The only known color study for the book

time making preparatory sketches in that city's streets and Public Garden. His determination to draw Mr. and Mrs. Mallard and their ducklings with a high degree of accuracy also prompted him to study preserved specimens at New York's American Museum of Natural History and ultimately to bring a crate-load of live ducklings into his Greenwich Village studio. (Ironically, the birds featured in the quintessential children's book about Boston were in fact Long Island ducklings.) McCloskey had by then already shown himself to be a formidable draftsman and a quick learner, but Massee nonetheless declined to allow him—still a comparative novice—to illustrate the seventy-two-page book in costly full color. She also thought better of his working title: "Boston Is Lovely in the Spring." The illustrations are lithographs for the creation of which McCloskey drew in reverse in grease pencil directly on zinc plates. To bring a greater feeling of warmth to the art, he proposed that the images be printed in sepia rather than black.

Publication history: *Make Way for Ducklings* became one of the best-loved Caldecott Medal selections in the award's history. During the Second World War, McCloskey's story about a mallard mother who makes a safe home for her children and a mallard father who keeps his promise to return home was read by many as a reassuring home-front fable. In 1987, a bronze sculpture by Nancy Schön based on the book's characters was installed in the Boston Public Garden and rapidly became one of the city's most visited landmarks. As a peace gesture four years later, First Lady Barbara Bush presented an exact replica of the sculpture to the children of the Soviet Union. Outside of the United States, *Make Way for Ducklings* is best known in Japan.

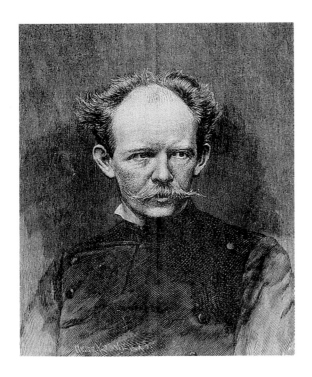

LOTHAR MEGGENDORFER

born 1847, Munich, Germany; died 1925, Munich, Germany

Biography: As the youngest of his father's twenty-five children by two marriages, Lothar Meggendorfer had ample opportunity to discover what children find entertaining in books even before he embarked on a career as a humor writer and illustrator. He first published his work in the satirical publications *Fliegende Blätter* (*Flying Pages*) and *Münchener Bilderbogen* (*Munich Picture Book*), and then from 1889 in the journal he himself founded, *Meggendorfers Humoristische Blätter* (*Meggendorfer's Funny Pages*). Meggendorfer created his first movable book, *Lebende Bilder* (*Living Pictures*, 1878), as a gift for his son and soon found there was a receptive market for his ingeniously constructed juvenile novelties,

which often operated by means of pull tabs linked to a system of interconnected cardboard levers concealed between brightly chromolithographed pages. The British historian and bibliophile Eric Quayle has called Meggendorfer's toy books "marvels of ingenuity, a single tab at the side or bottom of the page making apes swing from trees, crocodiles swallow little boys, umbrellas open, boats roll and houses collapse."[1] Published in 1887, his *Internationaler Zirkus* (*International Circus*), which relied on other paper-engineering techniques for its impact, was immediately hailed as a masterpiece.

About the book: Maurice Sendak, a fervent Meggendorfer collector, observed that *Internationaler Zirkus* was "like no other Meggendorfer. . . . The 'book' fans out. . . . A tremendous sense of depth is achieved and we have a thrilling tumult, just what a circus should be."[2] Sendak proposed calling Meggendorfer's *Zirkus* a "pop-out" rather than a pop-up book because its various elements—constructed from 450 individual cutout parts—were designed to create the absorbing impression of an intricately layered three-dimensional world rather than simply to swing into action. Arrayed on a tabletop or open shelf, the overall effect was spectacular, with each performer or spectator's face an amusing caricature worthy of close inspection, and with an abundance of colorful incident in every nook and cranny.

Publication history: Meggendorfer enjoyed enviable success as the creator of more than one hundred books with total sales of over one million copies in his lifetime. No less than the exquisitely illustrated gift books by the likes of Ivan Bilibin, Arthur Rackham, and Edmund Dulac, Meggendorfer's incomparably clever movables made suitable holiday gifts for the children of industrial-age Europe's expanding middle class. *Internationaler Zirkus* ran through seven German-language printings and, like many of the artist's other children's books, was distributed to great success in Great Britain and France. Given the wear and tear that was inevitable to such books, intact copies were bound to become exceedingly rare, notwithstanding the lighthearted caution that the artist himself issued in *Immer Lustig!* (*Always Jolly!*, 1886):

Lothar Meggendorfers

INTERNATIONALER CIRCUS

Verlag von J. F. Schreiber in Eßlingen & München.

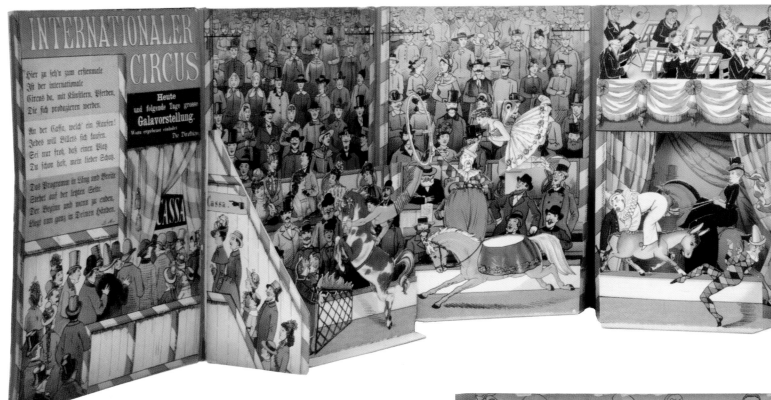

With this book, my own dear child,
Are Various pictures gay,
Their limbs they move with gestures wild,
As with them you do play.
But still they are of paper made,
And therefore, I advise,
That care and caution should be paid,
Lest woe and grief arise;
Both you and pictures then would cry
To see what harm is done,
And sigh would follow after sigh
Because you've spoilt your fun.

In 1980, Viking Press published an English-language facsimile edition of Meggendorfer's *International Circus* from an early copy in the collection of the Metropolitan Museum of Art. Its enthusiastic reception did much to spur renewed interest in the movable book as an art form and to seal Lothar Meggendorfer's reputation as the greatest of all practitioners of that art.

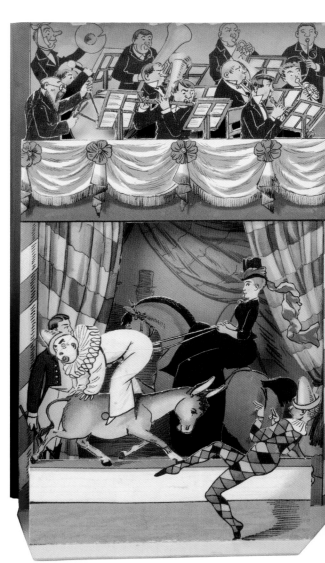

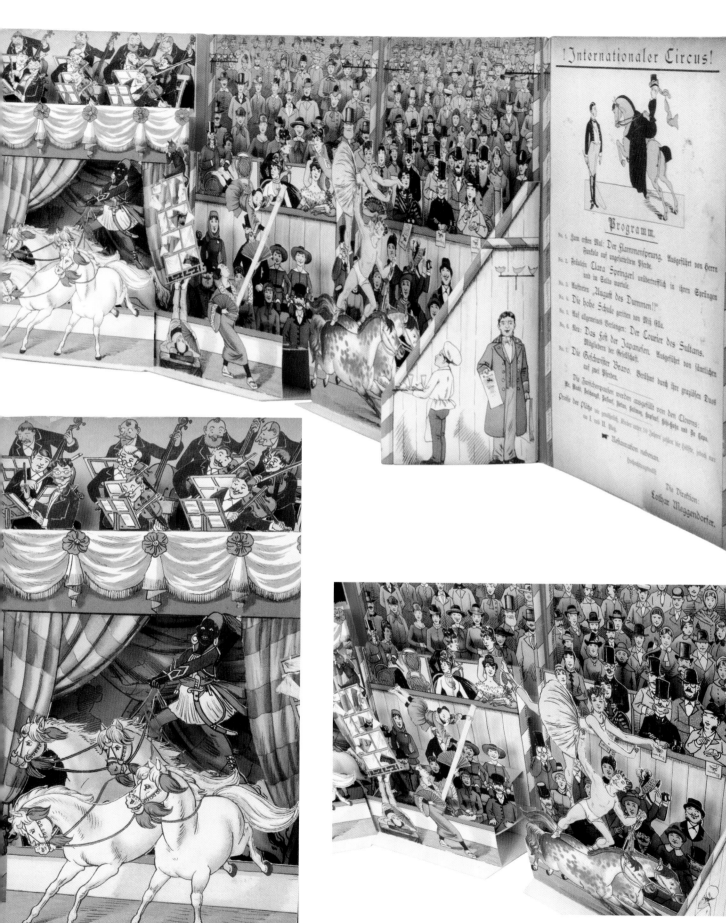

!Internationaler Circus!

Programm.

ROGER MELLO
born 1965, Brasilia, Brazil

Biography: Roger Mello grew up amid the sleek modernist architecture of Brazil's planned capital city, which was just five years old when he was born, and in a dark time of dictatorial rule (1964–1985). As a child, he loved to read and draw and went on to receive a degree in industrial design and visual programming from Universidade Federal do Rio de Janeiro (Rio de Janeiro State University) and to serve an apprenticeship in the studio of the Brazilian comics artist, children's author, and journalist Ziraldo Alves Pinto. His many children's books—more than one hundred illustrated by him, more than twenty with his texts—reflect a restless urge for self-reinvention and, in the case of such picture books as *Meninos do Mangue* (*Mangrove Children*, 2002) and *Carvoeirinhos* (*Charcoal Boys*, 2009), a deep concern for the welfare of Brazil's neglected underclass, most especially its children.

Mello has received many national and international honors. In 2014, he became the first Latin American illustrator to win the Hans Christian Andersen Award. (Two Brazilian authors, Lygia Bojunga Nunes and Ana Maria Machado, had previously won the Andersen prize as writers.) That same year, he was the recipient of the Chen Bochui International Children's Literature Award for the Best Foreign Author in China. He has had major exhibitions of his work at the Bologna Children's Book Fair, the International Youth Library (Munich), the Chihiro Art Museum (Tokyo), and Nami Island (Korea).

About the book: Working in collage with bits of garbage bags and other found materials, Mello set out in *Meninos do Mangue* to create images that mimic the patchwork shantytown dwellings, built high on stilts, of the children who earn their meager livings harvesting crabs in the coastal mangrove swamps of Recife. Mello considers the friendship of two such boys, Sorte and Preguiça, who make a bet over who can catch the crab with the most legs. Sorte wins with eight and, keeping his end of the bargain, Preguiça proceeds to tell his friend eight short stories about the world as he knows it. In this way, Mello introduces readers to a precarious kind of existence in which the fortunes of people with barely enough to survive rise and fall with the changing tides, their future increasingly undermined by the steady buildup of garbage in the swamp that is their lifeblood. Mello felt moved to create this book in part by his happy memories of visiting his uncle as a child in the coastal state of Bahia, and of later returning to the region to art direct a film, *The Cycle of the Crab*, inspired by *Geography of Hunger* (1946), a pathfinding study by the Brazilian sociologist Josué de Castro, who argued that hunger causes overpopulation, not the other way around, as developed- world economists had long assumed.

Publication history: Mello won the International Award of the Swiss-based Fondation Espace Enfants for *Meninos do Mangue* in 2002. That same year, he was also the recipient of Brazil's most coveted literary prize, the Prêmio Jabuti (Tortoise Prize). *Meninos do Mangue* has been published in one foreign-language edition, in China.

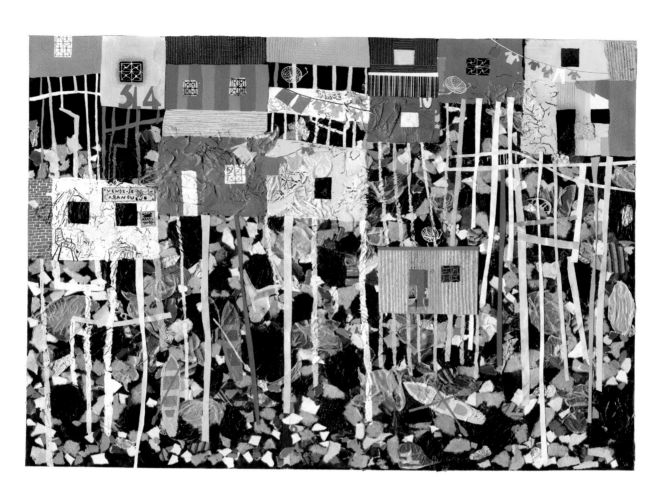

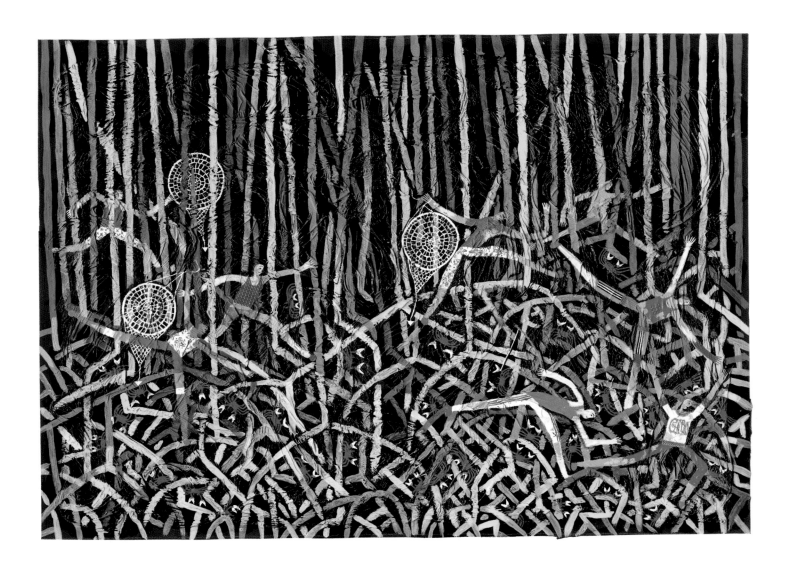

YUYI MORALES
born 1968, Xalapa, Veracruz, Mexico

Biography: Sewing played a formative role in Yuyi Morales's early life as the eldest of four children growing up in Xalapa, an eastern university town and cultural hub that is also known as the Flower Garden of Mexico. To support the family, her mother crafted decorative cloth animals for sale to tourists. To save money, she made all her children's clothes; by age five, Yuyi had learned to operate her mother's sewing machine and made herself a vest. Drawing was another childhood interest but not one, it seemed, with a promising future. Later, when a career in illustration proved to be a viable option, Morales put her childhood exposure to handicrafts to good use in artwork that at times incorporated collage elements as well as photographically depicted handmade puppets and tabletop theater scenery that added a tactile third dimension to her pictorial storytelling.

Marriage and motherhood led Morales to move to San Francisco, where she discovered that the children's room of the local public library had a great deal to offer not only her young son but also an adult like herself who was just learning English. Reading picture books inspired her to want to make picture books, too. She taught herself to paint, joined a critique group, and, after winning a prize aimed at encouraging illustrators at the start of their careers, was offered her first book project. Publishers were beginning to respond to the dearth of children's books by, for, and about people belonging to the United States' rapidly growing Latinx population. Morales arrived on the scene just as the need for such books was becoming widely appreciated.

About the book: *Niño Wrestles the World* (2013) was the fourth picture book written and illustrated by Morales. It represented a bold leap beyond the short list of then-standard topics for Mexico-themed US children's books. Rather than write about tacos or other generic Mexican foods, or about the annual Day of the Dead celebration or an iconic historical figure such as Frida Kahlo, Morales now created a hilarious, high-drama tale about the flamboyant and wildly popular form of free-style wrestling called *lucha libre*, in

. . . too terrifying for him.

NIÑO
VS

EL
CHAMUCO

Niño's best move ever:

¡TAKA!

If you can't defeat them . . .

join them!

LOS TRES HERMANOS

now
accepting

ALL COMERS

which combatants all wear colorful masks intended to strike fear in the hearts of their opponents. The hero of this exuberant parody of a superhero adventure story is not a conventional fighter, however, but a small boy with uncanny superpowers who makes short work of one formidable opponent after another until, in a wonderful surprise twist, he meets his match in the two baby sisters who, upon awakening from their nap, easily take him down. With illustrations styled on the flamboyant graphics traditional to lucha libre poster art, Morales's book is at once an authentic introduction to a quintessential Mexican contact sport, a sly com-

ment on childhood fantasies about turning the tables on the adult world, and a knowing nod to the binding power of loving sibling relationships.

Publication history: In 2014, Morales won her fourth Pura Belpré Award for illustration for *Niño Wrestles the World*, setting a record for a recipient of that prize. The book was critically praised in the United States but to date has not been published in any other language, including Spanish.

BRUNO MUNARI

*born 1907, Milan, Italy; died 1998,
Milan, Italy*

Biography: Pablo Picasso called him "the new Leonardo." The artist himself advised: "Take life as seriously as a game."[1] Sculptor, painter, illustrator, author, inventor, filmmaker, and educator, Bruno Munari was a founding father of Italian industrial design and one of the picture book's shape-shifting innovators. As a young man, he allied himself with Futurism, but his maverick creativity soon proved to be unclassifiable in ideological terms. As the artist's names for two long-term projects suggest—"Useless Machines" and "Unreadable Books"—Munari always preferred paradox over categorization, regarding the latter as the enemy of originality of thought and perception. No wonder young children—intensely curious, naturally playful, and not yet set in their ways—appealed so greatly to him as an audience, especially after 1945, when his own son was the right age for picture books.

In that same year, Munari created dummies for ten such books, each with die-cuts, paper flaps, differently sized pages, and other toy-like novelty features aimed at enlisting the child reader's enthusiastic collaboration. Mondadori was able to publish seven of the ten. In later decades, Munari's industrial design work earned him his greatest worldwide renown. But it was his ongoing experiments with the picture book that remained central to his goal of harnessing art in the service of a better, brighter world in which imagination trumped all manner of dogmatism and dull routine.

About the book: *Animals for Sale* (1945) was one of the original group of picture books created by Munari for his son, Alberto. Collectively, these graphic confections laid the groundwork for a newly playful approach to picture book design. Art historian Giorgio Maffei aptly characterizes the books as "a direct legacy of the surrealist boîtes, [which go] beyond the conventional role of telling stories to become . . . toy-object[s], holding surprises."[2] Munari himself recalled: "I thought of designing these books with very simple stories. When you talk to somebody—either a child or an adult—you have to start with the world they know. Then you can take them somewhere else using their imagination."[3]

Publication history: Velma Varner, editorial director of the World Publishing Company of New York and Cleveland, was a leading proponent of children's literature as an instrument of international understanding. In 1957, Varner became the first foreign publisher to champion Munari's work with the release in the United States of three of the original seven Mondadori titles, including *Animals for Sale*. That December, the *New York Times* highlighted World's "three ingeniously designed picture books by a gifted Italian artist" on its list of Outstanding Books of the Year.[4] In 1983, L'école des loisirs published *Marchand d'animaux* in France. Although his books have not remained continuously in print outside Italy, their impact has been immense as an inspiration for Eric Carle, Anno Mitsumasa, Komagata Katsumi, and countless other artists and designers around the world.

BRUNO MUNARI

il venditore di animali

CORRAINI EDITORE

– Lo vuoi un fenicottero tutto rivestito
 di piume rosse? È un bellissimo
 animale e lo puoi tenere in anticamera.

– No. Non lo voglio perché fuma la
 pipa. Dammi un'altra bestia.

XX

WILLIAM NICHOLSON

born 1872, Newark upon Trent, UK; died 1949, Blewbury, UK

Biography: The youngest child of an agricultural machinery manufacturer and Conservative member of Parliament, Nicholson received early family encouragement to study art. Perhaps modeling himself on his pragmatic father's example, he at first favored opportunities that assured him a livelihood as well as a creative life. Newly married in 1893, Nicholson teamed up with his brother-in-law James Pryde to design posters and other commercial work under the joint name of the Beggarstaffs, or Beggarstaff Brothers. Their bold, spare, impactful images for Rowntree's Elect Cocoa, *Harper's Magazine,* and other clients helped to set a new standard for Western graphic design that rejected late-Victorian visual clutter in favor of extreme clarity and a seemingly offhand simplicity redolent of the Japanese woodblock print tradition and the minimalist art of James McNeill Whistler.

The Beggarstaffs disbanded around 1899, by which time Nicholson had established a thriving solo career as a printmaker and illustrator of such books as *An Almanac of Twelve Sports* (verse text by Rudyard Kipling, 1897), *An Alphabet* (1898), and *The Square Book of Animals* (text by Arthur Waugh, 1899). With prompting from Whistler himself, he turned his hand to painting still lifes, landscapes, and portraits. Nicholson also designed the stage sets for the landmark original 1904 London production of *Peter Pan.*

Although his early books were undoubtedly aimed at a mixed readership of adults and children, Nicholson later undertook projects that were expressly meant for story-hour enjoyment. He achieved the greatest popular success of his career as the illustrator of Margery Williams's *The Velveteen Rabbit* (1922). Two picture books of his own followed, *Clever Bill* (1926) and *The Pirate Twins* (1929).

About the book: The artist's biographer, Colin Campbell, writes: "*Clever Bill* was, as Nicholson pointed out, a 'new kind of book,' a remark which alludes to the novelty of a story told by twenty-one full-page colour drawings, reproduced lithographically."[1] Nicholson was an accomplished artist in his fifties with grandchildren

and a young daughter of his own from his second marriage when he turned his attention to crafting a picture book with the intimate look and feel of a homespun production. The doodle-y, childlike, hand-lettered cover design and the sequence of rough-hewn interior illustrations that followed all contributed to the desired effect, as did certain amusing, one-off touches: the letter from Mary's aunt that can only be properly read by turning the book upside down, and the many misspellings to be spotted in young Mary's reply. Nicholson, who as a child had delighted in Randolph Caldecott's robust picture books, now adopted the Victorian innovator's dynamic approach to segmenting a brief text across several pages as a narrative device for amplifying comic timing and page-turning suspense. The "reveal" of the last page recasts the title of this richly entertaining, tongue-in-cheek confection in a new and surprising light. Yet every detail of Nicholson's deceptively simple picture book has prepared the ground for that revelatory moment.

Publication history: In the United States, where the book would find its most ardent admirers, Doubleday published *Clever Bill* in 1927, one year after its British release by Heinemann. A copy of the Doubleday first edition with annotations by Nicholson himself is in the archive of the New York Public Library and reveals the artist's profound disappointment at the quality of the American printing. America's leading librarian-critics nonetheless hailed the book as a touchstone work—"gay and original," in the words of the influential Anne Carroll Moore.[2] Its elongated horizontal format is known to have served as a template for Wanda Gág's *Millions of Cats* (1928). Over the following decades *Clever Bill* drifted in and out of print. When Farrar, Straus and Giroux reissued the book in the United States in 1977, Maurice Sendak gave his enthusiastic endorsement, commenting, "*Clever Bill*, I have long felt, is among the few perfect picture books ever created for children."[3]

HELEN OXENBURY

born 1938, Ipswich, UK

Biography: Theater design gave Oxenbury her professional entrée into the world of art. Motherhood compelled her to turn to an art form that could be practiced at the kitchen table. From greeting-card illustrations, Oxenbury extended her reach to become a picture book illustrator, at times using her own young children as models. Her first book, *Numbers of Things*, appeared in 1967. Just two years later, she captured the coveted Kate Greenaway Medal for *The Quangle Wangle's Hat* (1969) and *The Dragon of an Ordinary Family* (1969)—the first time that that award had been given jointly for two books because the committee could not choose between them.

Oxenbury's husband, John Burningham, had entered the children's book field just ahead of her. The couple pursued separate careers for decades before finally collaborating on *There's Going to Be a Baby* (2010), a picture book written by Burningham and illustrated by Oxenbury. Prior to that, they each became known around the world for, among other things, memorable board book series designed for babies and toddlers. Oxenbury's books in this vein, along with those by the American Rosemary Wells, were the very first contributions to the genre that combined deft draftsmanship, psychological nuance, and touches of wit wisely aimed at holding the parent's attention.

Oxenbury was one the central figures in the group of artists and writers who, starting in 1978, became identified with the ambitious new publishing company founded by Sebastian Walker, Walker Books, and later with its American offshoot, Candlewick Press. Walker revolutionized picture book publishing in the UK by lavishing more attention on the design and physical makeup of its books than was standard practice until then, and by placing special emphasis on books for children of the youngest ages. Oxenbury designed Walker's original bear-and-candle logo and the variant that from 1991 served as Candlewick's first logo as well.

About the book: *We're Going on a Bear Hunt* (1989), with text by Michael Rosen based on a traditional song, played to all Oxenbury's strengths as an illustrator. It allowed her to make the most of her considerable powers of characterization, her eye for the offhand

Splash splosh!
Splash splosh!
Splash splosh!

comic moment, and her feeling for landscape and light. At a time when the principal market for picture books had shifted decisively from the library world to retail and when attention-grabbing illustration art was increasingly regarded as a major "selling point," Oxenbury had to argue for the right not to illustrate every page of the book in full color. She preferred instead to alternate color with black-and-white spreads, the better to engage the imaginative participation of her young readers. Equally characteristic of her thoughtful, child-centered point of view was her delight in allowing the older brother who leads the family expedition—the surrogate parent in her pictures—to look a bit foolish at times, as well as exhausted. As Oxenbury told an interviewer: "One of the most important things is to laugh with your children. . . . As a picture book artist, I don't think one can ever be too much on the side of the child."[1]

Publication history: *We're Going on a Bear Hunt* appeared at the height of the second postwar baby boom, a demographic upturn generated in part by college-educated parents who took for granted—as perhaps no generation before them had to the same extent—the importance of reading to their children. The book suited their needs perfectly, found its way onto countless book recommendation lists, and won both the 1989 Nestlé Smarties Book Prize (UK) and the Mainichi Newspapers Japanese Picture Book Award, Outstanding Picture Book from Abroad (Japan). The unusually large format (for the time) helped draw attention to the book when it was displayed face out on the shelves of the growing number of big-box retail stores where parents went in search of books for their children. By the 1990s, public libraries in the United States had begun for the first time to commit themselves to serving children as young as toddler and preschooler age. *We're Going on a Bear Hunt* was immediately recognized as an ideal read-aloud choice for these groups at story hour. It has been published in board book and pop-up editions and translated into more than thirty languages, including Breton, Galician, Dutch, Italian, Vietnamese, Somali, Arabic, Chinese, Korean, Albanian, Polish, Gujarati, Urdu, Bosnian, Punjabi, Korean, Basque, Tamil, Bengali, Hebrew, German, French, Turkish, Maori, Spanish, Welsh, Serbian, Russian, Portuguese, Gaelic, and braille.

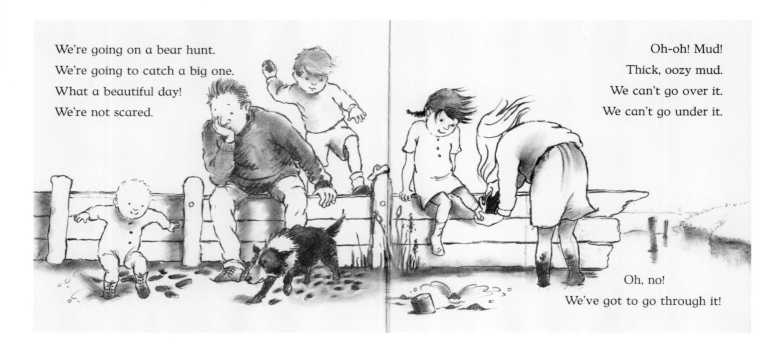

We're going on a bear hunt.
We're going to catch a big one.
What a beautiful day!
We're not scared.

Oh-oh! Mud!
Thick, oozy mud.
We can't go over it.
We can't go under it.

Oh, no!
We've got to go through it!

KVĚTA PACOVSKÁ

born 1928, Prague, Czechoslovakia

Biography: "A drawing is [what] it is. It should not and cannot pretend."[1] Much history lay behind Květa Pacovská's deceptively simple declaration of aesthetic first principles. She had come of age just as Europe was emerging from the tyranny of Hitler, and her native Czechoslovakia was adjusting to the repressive new Soviet-dominated regime. Art for her represented a brave and honest response to attempts to rein in free expression. It was a pure, unfettered gesture of the right to individual thought and feeling and of hope for the future.

Pacovská graduated from the Prazská Umeleckoprumy Skola (Prague School of Applied Arts), where her mentor was Emil Filla, a painter and sculptor known as a leading figure of the Czech avant-garde. Pacovská studied bookmaking and graphic design, and under Filla's influence, she left committed to bridging the traditional divide between the so-called fine and applied arts. Her nearly sixty picture books reflect the indelible impression made upon her by the twentieth-century European art world's most audacious free spirits, most notably Wassily Kandinsky, Kurt Schwitters, Paul Klee, Joan Miró, and Pablo Picasso.

In 1991 Pacovská received Germany's Deutscher Jugendliteraturpreis, and the following year she won the Hans Christian Andersen Award in illustration. Recognition of her achievements continued at the highest level when she was chosen as the 1997 recipient of the Gutenberg Prize of the City of Leipzig.

About the book: *Eins, fünf, viele* (*One, Five, Many*, 1990) extends the modern tradition of the picture-book-as-toy-like-interactive-experience inaugurated by Bruno Munari in the mid-1940s and carried forward in subsequent decades by Eric Carle and others. As this characteristic book of hers makes clear, Pacovská has almost always been less interested in engaging her audience in the thread of a continuous narrative than in creating an immersive visual environment in which the reader is given an intense experience of saturated color and emotional warmth as well as a taste of life's playful, fantastic dimension. Pacovská has taken full advantage of advances in color-printing technology and manufacturing techniques: the extensive use of die-cuts, for instance, and the insertion of bits of Mylar as a reflective surface. Instead of the witches and wizards of traditional tales, her books derive their magic from intriguing window-like portals, idiosyncratically shaped pages, and brilliant splashes of color.

Publication history: Pacovská's picture books, with their emphasis on design over character and story, epitomize the distinctly different sensibility that has often set European picture books apart from their American counterparts. Not surprisingly, her work has not proven to have broad commercial appeal in the United States, although *One, Five, Many* may be said to have enjoyed a *succès d'estime* in the afterglow of her Andersen win. The *New York Times Book Review*, for instance, noted that Pacovská interpreted "the numbers from 1 to 10 in much the same way that a jazz musician might take up a standard tune . . . as a starting point for a series of playful riffs and bravura circlings around a familiar old theme."[2] In addition to the English-language translation issued in 1991 by New York's Clarion Books, *One, Five, Many* went on to be published in German, French, Italian, Spanish, and Japanese editions.

eins, fünf, viele

Květa Pacovská

minedition

NATHALIE PARAIN
born Natasha Tchelpanova

born 1897, Kiev, Russian Empire; died 1958, Sceaux, France

Biography: This artist's two names signal the two major phases of a highly cultured and productive life. Natasha Tchelpanova grew up in Moscow, the daughter of a professor of philosophy and founder of Russia's first psychological institute. Her art studies at Moscow's Stroganov Academy of Design and Applied Arts ended in 1917 amid the turmoil of the Bolshevik Revolution but continued in the studio of Pyotr Konchalovsky, a founding member of the Knave of Diamonds group of early Russian avant-garde painters. From Konchalovsky, she learned to harness the power of intense colors in striking juxtaposition and

the expressive potential of geometric forms—lessons key to the approach she later adapted to her brilliant work as a children's book illustrator.

In 1926, Tchelpanova married Brice Parain, the cultural attaché at the French embassy in Moscow. Soon afterward, the couple moved to Paris, where the artist's husband found work at Éditions de la Nouvelle Revue Française (later Gallimard), and the Russian expatriate—now known as Nathalie Parain—illustrated a children's book, André Beucler's *Mon chat* (1930), published by the same house. Parain's debut attracted the attention of the innovative educator-turned-publisher Paul Faucher, who engaged her to illustrate the first books in what was to become a celebrated line of pedagogically sound, strikingly well-designed and illustrated, and affordable picture books issued by Flammarion, *Les Albums du Père Castor* (*Father Beaver's Picture Books*). Among the other artists soon to join the project was Parain's friend and fellow Soviet expat, Feodor Rojankovsky.

Faucher named the collection for an animal known for its prowess as an instinctive builder. The first books illustrated by Parain embraced young children as intuitive learners, offering three- to six-year-olds a playful activity- or concept-based experience rather than a traditional story: a book with paper masks to cut out and wear on their make-believe adventures; a book about circles and squares. Influenced by Kazimir Malevich and fellow illustrator Vladimir Lebedev, Parain distilled color and form down to a building-block graphic language that allowed for instant communication with pre-readers.

Parain illustrated forty picture books, remaining active almost until the time of her death. In 1944, she received the French Académie des Beaux-Arts' Prix du Centenaire in recognition of her life's work.

About the book: *Les Jeux en Images* (*The Picture Play Book*) was one of four Père Castor titles that Parain illustrated for Paul Faucher in 1933. The nimble read-aloud text, addressed directly to young children, was by Rose Celli, a frequent contributor to the list as well as a novelist and translator of Virginia Woolf. Parain's depictions of children playing tennis and hopscotch, digging in the sand, riding a go-cart, and feeding a

doll combine refined graphic elegance with a pal-
pable delight in the immersive satisfactions of self-
directed childhood activities. While the seriousness of
purpose that Parain sees in each of her young subjects
reverberates with echoes of Maria Montessori's classic
remark that "play is the work of the child," one never
doubts that her charming youngsters are also having
a very good time.

Publication history: The Artists and Writers Guild, a
subsidiary of the Western Printing and Lithograph-
ing Company, published an English-language edi-
tion under the title *The Picture Play Book* in 1935.
Arrangements for the American Père Castor editions
were engineered by Samuel Lowe, the same Guild
executive who had initiated Western's Big Little Books
novelty format and negotiated a prescient long-term

book-licensing agreement with Walt Disney. A few years later, Faucher's pioneering line would also serve the Guild as an important model for Little Golden Books, which Western launched in 1942 in partnership with Simon & Schuster.

The Guild edition of *Les Jeux en Images* was hailed by progressive educator Dorothy Baruch as "one of my favorites with its modern and vivid pictures."[1] It has long been out of print in the United States, but in France, Parain's work was much admired in her lifetime and has enjoyed a major revival through the efforts of Éditions MeMo, an independent publishing house with a select list of picture books both old and contemporary.

JERRY PINKNEY

born 1939, Philadelphia, Pennsylvania, US;
died 2021, Sleepy Hollow, New York, US

Biography: As an African American child growing up in Philadelphia in the middle of the last century, Jerry Pinkney learned early on what it meant to be treated as a second-class citizen. As a young person living in an all-Black working-class neighborhood, he discovered his passion for drawing—and soon realized that the part of town where the city's fabled art museums were located was effectively off-limits to people of color. Later, a teacher at the vocational high school he attended tried to discourage him from applying to art colleges, arguing that a Black commercial artist would never find enough work to make a living. Pinkney's determination was great, however, and his timing was fortunate.

Upon graduating from the Philadelphia Museum School of Art, he took a job at a Boston design firm where he was asked, as a one-off assignment, to illustrate a picture book, *The Adventures of Spider: West African Folk Tales* (1964), retold by Joyce Cooper Arkhurst. By this accidental route, Pinkney gained his first experience of his future vocation.

As a father with young children at home, Pinkney had become keenly aware of the dearth of children's books about African American experience and culture. As he involved himself in community-based activities aligned with the civil rights movement, he came to recognize this gap as one more instance of the larger problems of inequality and cultural exclusion in the United States. It was not until the late 1980s, however, that he felt a calling—and saw the opportunity—to play a key role in efforts to expand the literature as the creator of children's books that celebrated Black history and family life. In 1988, Pinkney illustrated *Mirandy and Brother Wind*, a picture book fantasy rooted in Black Southern traditions, written by Patricia C. McKissack and published by Knopf. Soon afterward, a fateful meeting with Dial Press's Phyllis Fogelman began a publishing relationship that resulted in a long and distinguished list of African American themed books illustrated by Pinkney, with texts by McKissack, Julius Lester, the artist himself, and others. Proud of this substantial body of work but determined not to be pigeonholed as an "African American illustrator," Pinkney made a point from time to time of taking on other types of projects as well. He won the 2010 Caldecott Medal for *The Lion & the Mouse*, a wordless retelling of a favorite Aesop fable remembered from childhood.

About the book: *John Henry* (1994) was Pinkney's fourth collaboration with Julius Lester following their three Brer Rabbit story collections. Up until *John Henry*, the two men had never met or even spoken. When the new project came up for consideration, however, both collaborators found they wanted to discuss the audacious tall tale and what it meant to them personally. Their conversations laid the groundwork for a rewarding friendship and many future collaborations.

For Pinkney, *John Henry* represented a creative turning point as the first picture book in which he felt free to depart from the descriptive level of the text and introduce interpretative narrative elements of his own. His art had also become more complex in terms of both composition and character development, and for the first time form, not line, defined the illustrations, a shift that represented a more organic approach to image making and greatly intensified the impact of the work. Known up until then as an accomplished draftsman, Pinkney now revealed himself to be a master watercolorist as well.

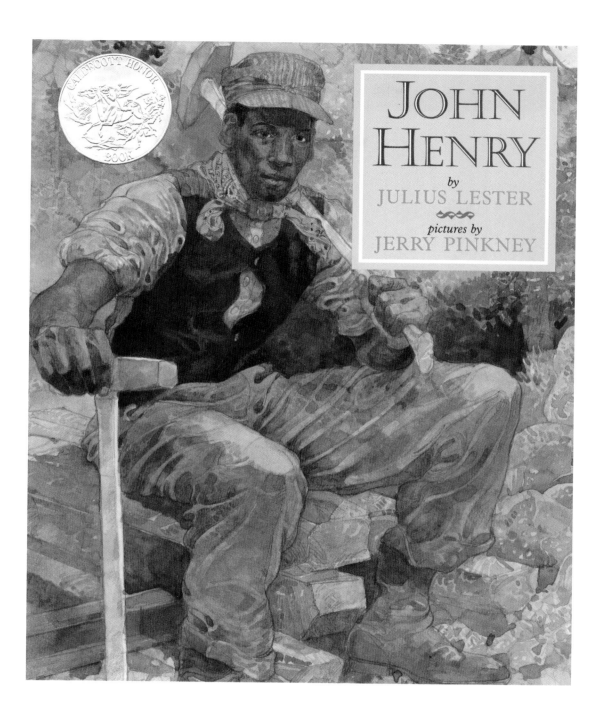

Publication history: *John Henry* earned Pinkney the third of five Caldecott Honors. More critical acclaim was to follow. In addition to the 2010 Caldecott Medal, he received five Coretta Scott King Book Awards, five King Honors, and the American Library Association's 2016 Laura Ingalls Wilder Award (renamed the Children's Literature Legacy Award two years later) for the body of his work. In 2010, the Norman Rockwell Museum organized a major career retrospective that subsequently toured the US for several years.

NIKOLAI POPOV

born 1938, Saratov, USSR; died 2021,
Moscow, Russia

Biography: Nikolai Popov was born in Saratov, a city in central Russia situated along the banks of the Volga River. Popov later recalled his birthplace as a "typical Russian town, old, beautiful, rather provincial, green, and cozy, [with] a university, a few theaters, a conservatory, and a wonderful museum."[1] It was against the backdrop of this idyllic setting that the future artist first witnessed the brutality of war. Too young during the German bombardment of Saratov to understand why the grown-ups around him spirited him into an underground shelter night after night, he and his friends continued to play with abandon in the rubble by day, collecting shrapnel as though it were shiny pieces of treasure, until one such found object exploded in a boy's hands, crippling him for life. This episode and its aftermath turned Popov into a lifelong pacifist. His core belief in the futility of war is the theme of his classic picture book, *Why?* (1995).

Popov graduated from the Moscow Polygraphic Institute in 1962 and joined the Artists' Trade Union of the Russian Federation five years later. He became well-known for his work in animation and as an illustrator for the long-running Soviet children's magazine *Murzilka*, and in 1975 he published his first book, an illustrated edition of Daniel Defoe's *Robinson Crusoe*, for which he created a series of lithographs. He was honored with several major awards over the years: the Biennial of Illustration Bratislava Grand Prix BIB for *Robinson Crusoe*; two gold medals from the Leipzig Book Fair; designation in 1998 as Honored Artist of Russia; and, in 2000, selection as Russia's Hans Christian Andersen Award nominee.

About the book: Rendered in a sequence of sensuous, velvety, full-bleed watercolors, the wordless landscapes of *Why?* present a discordant, split-screen view of life much like the one Popov first experienced as a child growing up in a picture-postcard city beset by war. In this allegory played out as an increasingly violent battle between frogs and mice, the world in

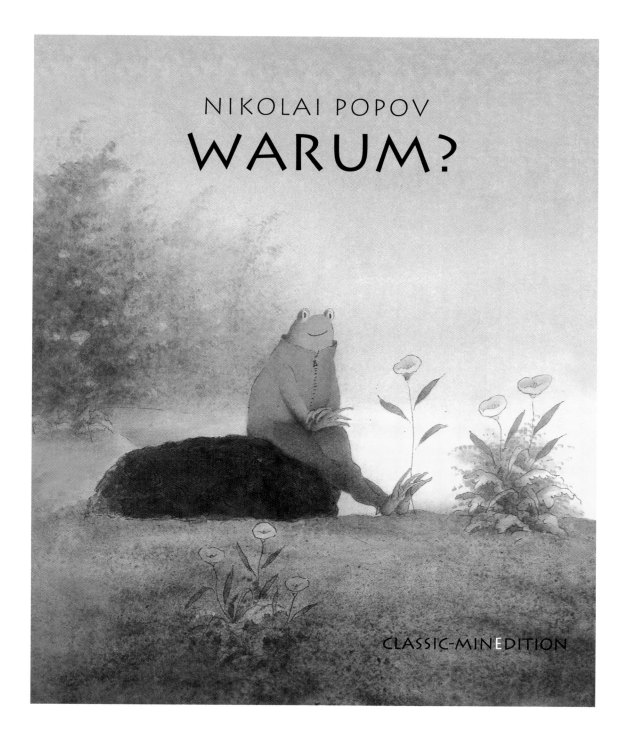

NIKOLAI POPOV
WARUM?

CLASSIC-MIN**E**DITION

its natural harmoniousness and splendor bears silent witness to the smallness and destructiveness of which its inhabitants are all too capable. By the final scene, the story's Edenic setting has been reduced to a post-apocalyptic wasteland where victory and conquest can have no meaning, thereby leaving readers to ponder the deceptively simple question posed by the title: Why?

Publication history: *Why?* was first published in Switzerland in 1995 in French- and German-language editions with an autobiographical note by the author. The first US edition appeared the following year. In 2016, a brief narrative text was added to a new American edition but was subsequently dropped in 2021 (and later) reissues in the United States, China, Japan, Korea, Thailand, France, Germany, Greece, Italy, Turkey, and Spain.

DIE MAUS WOLLTE AUCH SO EINE SCHÖNE BLUME
HABEN.

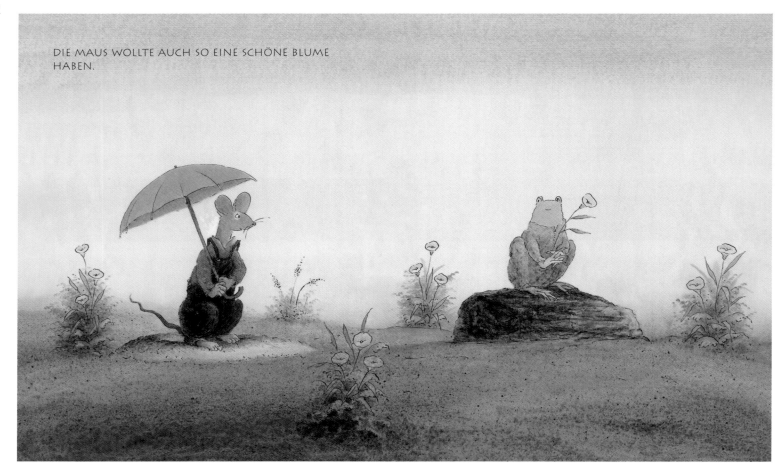

„GIB MIR DIE BLUME!", ZISCHTE DIE MAUS UND RISS SIE
DEM FROSCH AUS DEN HÄNDEN.

DA KNATTERT DIE ARMEE ÜBERS LAND.
DER KRIEG BEGINNT.

WARUM?

BEATRIX POTTER

*born 1866, South Kensington, London, UK;
died 1943, Near Sawrey, UK*

Biography: As a child, Potter presided over a nursery menagerie of small furry animals and taught herself to draw in part by drawing them. Accompanied by her father, a barrister and skilled amateur photographer, she periodically visited the studio of Sir John Everett Millais. Rupert Potter collected art by Randolph Caldecott, the most original children's book illustrator of his day, and the Caldecotts on view at home would prove to be another inspiration, as would the family's summer excursions to the Lake District and Scotland, where she honed her craft as a botanical watercolorist. Delicacy and steely precision are equally the hallmarks of her compelling work in that vein, which might have led to a distinguished career in scientific research and illustration had those choices not been barred to a woman of Victorian England.

Intent on making her mark, Potter turned instead to greeting card design and self-published a children's book based on an illustrated letter she had sent to her former nanny's son. The instant success of the privately printed *Tale of Peter Rabbit* (1901) prompted a commercial house to express interest in relaunching the little book on grander terms, and a complex, lifelong association with Frederick Warne & Company was the result. Potter would have married one of the Warnes (over her parents' objections to having a "tradesman" in the family) had Norman Warne not died quite suddenly of pernicious anemia at the age of thirty-seven. Years later, when the publisher's finances unraveled in scandal, Potter helped pull the firm back from the brink. Then and always, as an author, illustrator, and businesswoman, she went from strength to strength. In 1913, she married a country lawyer named William Heelis and in later life largely devoted herself to sheep farming and, as a major benefactor of Britain's National Trust, to preserving vast expanses of the English countryside from development.

About the book: Like Lewis Carroll's Alice—a character Potter knew well from her childhood reading—Peter lets his curiosity get the better of him and override the lessons he has learned about being a good and well-behaved child. Ignoring his mother's warnings, he heads straight for the garden where temptation—and mortal danger—both await. Which will it be? Peter wiggles his way under the fence in his fine blue, brass-buttoned jacket and gorges himself to his heart's content until the farmer, Mr. McGregor, comes along, and the young rabbit must flee for his life. Stumbling and panicking, Peter, thanks to his buttons, gets caught in a gooseberry net. As he pulls himself free he leaves his jacket behind, and the next thing we know he's stark naked, as if to signal that his untamed, impulse-driven animal self is now completely in charge. Potter, like Carroll before her, leaves readers with the unmistakable impression that Peter's choice to enter the garden is an altogether reasonable—and natural—one, that it was not the Devil that made him do it but life itself. Yet, as she also takes care to note, in a world in proper

balance, disobedience is not without its consequences. Thus Peter just barely outruns the rake-wielding Mr. McGregor, and his gluttony is repaid with a tummy ache. (Peter's father, Potter remarks in passing, was not so quick.) A robin that reappears unobtrusively in several of the watercolors, but is never mentioned in the text, watches over the proceedings as a kind of lower-level guardian angel, tilting the odds slightly perhaps in favor of a happy conclusion. Peter himself is never less than adorable, and yet he is nobody's fool. Deep down he knows just how vulnerable he really is, and it is because small children so often feel exactly as he does that Potter's story has lasted.

Publication history: Potter's trim, self-published 1901 first edition featured black-and-white relief prints made from zinc line blocks. Although the visual impact of the illustrations was a bit austere, the first 250 copies sold briskly, as did the second printing of two hundred. Having decided to try for a commercial edition, Potter initially had a hard time, hearing from one dour rejecter that rabbits were passé. Warne accepted the book with the stipulation that she would reillustrate the art in color. The Warne first edition, issued in 1902, proved to be an overwhelming success and made Potter famous on both sides of the Atlantic. The following year, the entrepreneurial artist registered a patent for a Peter Rabbit doll of her own design. (German-made Peters of lesser quality would become a lifelong irritant.) In 1911, she introduced a Peter Rabbit coloring book and in 1921 oversaw the translation of her text into French for the first of many foreign editions. Curiously, Potter later claimed to dislike the illustrations of her most famous children's book. "I think them bad," she wrote the New York Public Library's Anne Carroll Moore in 1937. "The rabbit on the cover I have always thought a horrid monstrosity."[1] It puzzled and doubtless disappointed her that of all her creations the world favored *Peter*—she herself much preferred *The Tailor of Gloucester*. Ever the dry-eyed tabulator of things as they are, however, she accepted the fact.

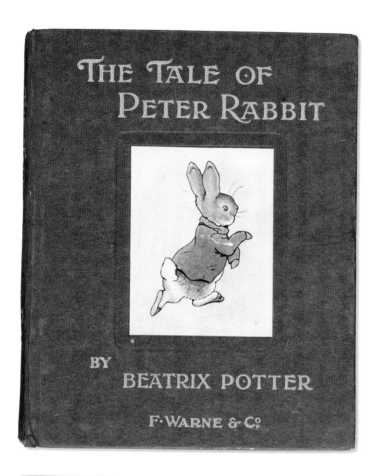

"Now run along, and don't get into mischief. I am going out."

AND squeezed under the gate!

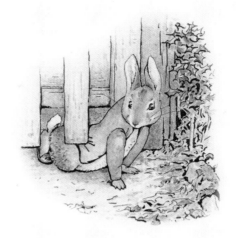

20

21

AND then, feeling rather sick, he went to look for some parsley.

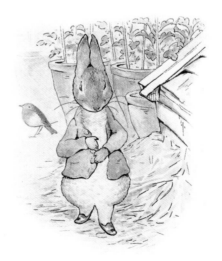

24

25

ALICE PROVENSEN

*born 1918, Chicago, Illinois, US; died 2018,
San Clemente, California, US*

MARTIN PROVENSEN

*born 1916, Chicago, Illinois, US; died 1987,
Clinton Corners, New York, US*

Biography: In the years before this couple met in Los
Angeles as young working artists, they were, it seems,
living parallel lives, first as children frequenting the
same Chicago Public Library reading room, then pur-
suing similar interests in art. Each moved to Califor-
nia and was drawn to the burgeoning animated film
industry. Martin won a coveted spot in the Walt Disney
Studios Story Department. Alice joined the animation
team of the rival Walter Lantz Productions, creators
of Woody Woodpecker. During the Second World
War they both made instructional films for the armed

forces. Then, with an introduction from former Disney
Studios star artist Gustaf Tenggren, they headed for
New York and launched second careers as illustrators
of Golden Books.

The Provensens, who sat back-to-back at twin
drawing tables in their idyllic upstate New York studio/
barn, claimed to routinely collaborate on individual
illustrations but would never be specific about their
division of labor. Citing the medieval workshops that
produced exquisite—and unsigned—illuminated manu-
scripts, and the collective approach to art making typ-
ical for animation, they insisted that individual credit
was beside the point. Fastidious researchers with an
elegant design sense and an impressive technical rep-
ertoire, they tackled projects ranging from Margaret
Wise Brown's winsome *Color Kittens* (1949) to Jane
Werner Watson's retelling of *The Iliad and the Odyssey*
(1956). While their work was popular with individual
book purchasers and much admired by their peers, the
Provensens did not receive major award recognition
from the library establishment until after parting ways
with Golden Books (whose lingering down-market
reputation remained a factor at award time) in the late
1970s. The couple received a 1982 Caldecott Honor for
their illustrations for Nancy Willard's *A Visit to William
Blake's Inn* (Harcourt Brace) and the 1984 Caldecott
Medal for *The Glorious Flight: Across the Channel with
Louis Blériot, July 25, 1909* (Viking).

About the book: As children, the Provensens had both
looked up in awe at the pyrotechnics of barnstorming
Midwestern stunt pilots, and as artists they remained
fascinated by the early history of flight. Not wanting
to undertake a project as obvious as a new Wright
Brothers biography for children, they thrilled to learn of
the lesser-known exploits of Louis Blériot, the intrepid
first pilot to fly solo across the English Channel. The
couple had a store of Paris street-scene sketches to
draw upon from a trip to France. At the nearby Old
Rhinebeck Aerodrome, they studied a life-size replica
of Blériot's rickety biplane. Martin even took flying les-
sons. The cartoonish dummy they prepared incorpo-
rated speech balloons as well as space for a traditional
running text. The finished art, rendered in acrylics and
black ink, was more refined and emotionally focused

THE GLORIOUS FLIGHT
ACROSS THE CHANNEL WITH LOUIS BLÉRIOT
BY ALICE AND MARTIN PROVENSEN

but retained the dummy's amusing dialogue and sound effects, which added to the book's playful spirit.

Publication history: The Provensens were already the illustrators of over forty books, nineteen of which they had also written, when they published *The Glorious Flight*. At the banquet where they received their Caldecott Medal, Alice, who felt more comfortable in front of an audience than her husband, delivered the speech for them both. She refused, however, to have her voice recorded; accordingly, Martin created the taped version that was given to attendees as a keepsake. In their remarks, the couple explained why they preferred picture-book-making to other art forms they might have pursued. "Making books for children,"

they noted, "is one of the very few areas left where old ways of working still apply. You have time to plan, to discard, to choose between alternatives, to explore possible solutions."[1] The couple's virtuosity in combination with their dedication to craft earned them the respect of subsequent generations of illustrators and an important legacy as creative role models. Exhibitions of their work were held at the Eric Carle Museum of Picture Book Art in 2005 and 2006 and at the National Center for Children's Illustrated Literature in 2017. Foreign-language editions of *The Glorious Flight* have been published in French, Chinese, Japanese, and Korean. *The Art of Alice and Martin Provensen*, the first comprehensive illustrated monograph about their work, appeared in 2022.

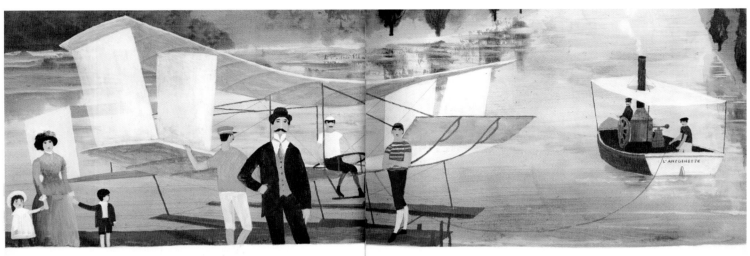

This is more like it. Here is «BLÉRIOT II,» a glider. Big enough to hold a man.
Papa has not yet learned to pilot, so Gabriel Voisin, his good friend, will fly.

16

A motorboat will tow it into the air as the glider has no motor.
All is in readiness. Gabriel gives the signal.

17

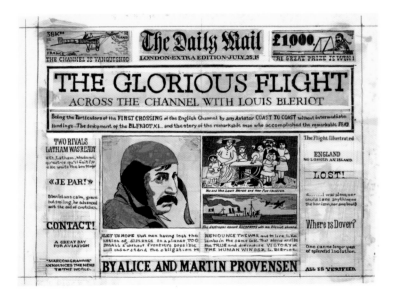

Above left and right: Two studies for the cover image

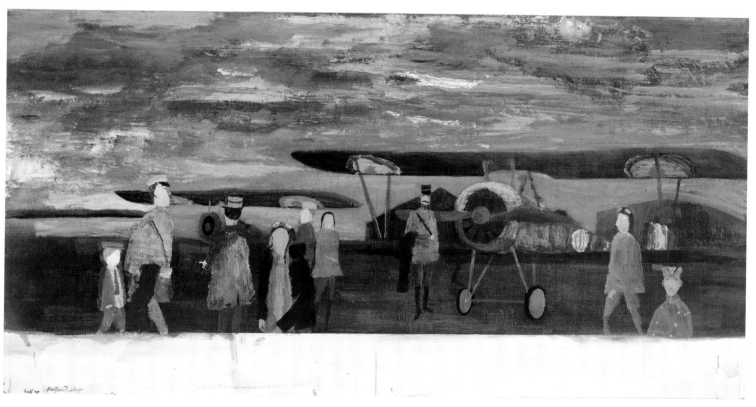

Tempera experiment

HOWARD PYLE

born 1853, Wilmington, Delaware, US; died 1911, Florence, Italy

Biography: During a long and consequential career, Howard Pyle did more than any narrative artist to bring about the transition from American cultural indebtedness to England to an era of newfound creative independence. The son of Delaware Quakers, Pyle was a daydreamy child and avid fairy tale reader. After three years of art training, he submitted drawings to *Harper's Monthly*, *St. Nicholas*, and other national magazines, enduring repeated rejection before finally gaining a foothold. One of his first two book assignments—color illustrations for a picture book titled *Yankee Doodle* (1881)—strongly suggests Pyle's admiration for the lively graphics of contemporary English illustrator Randolph Caldecott, and in particular for the latter's *Three Jovial Huntsmen* (1880), published only a year earlier. Pyle was also aware of England's William Morris, whose

revival of craft-oriented techniques and styles of book design and decoration reminiscent of the work of the Middle Ages influenced Pyle's own *Merry Adventures of Robin Hood* (1883) and other major book projects.

For much of his career, Pyle also taught illustration, work that he considered a cultural responsibility in a nation poised to develop its own art traditions. To be selected for the small school he founded at Chadds Ford, Delaware, was the equivalent of elevation to a knighthood. Pyle encouraged his students to trust their imagination and to work from direct experience, urging N. C. Wyeth, for instance, to go west to sketch real cowboys in their natural surroundings like the ones he had been commissioned to paint for a magazine assignment for the *Saturday Evening Post*. Such was Pyle's influence on a generation of young narrative artists that he came to be known as the "father of American illustration."[1] Besides Wyeth, his students over the years included Jessie Willcox Smith, Violet

Oakley, Maxfield Parrish, Elizabeth Shippen Green, Ethel Franklin Betts, and Frank Schoonover.

About the book: Pyle had felt let down by the quality of the color printing in *Yankee Doodle* and its companion volume, *The Lady of Shalott* (1881). Compounding his disappointment, both books had simply been cobbled together from old texts that happened to be in the public domain. Resolving to make his next book project a better showcase for his true capabilities, Pyle turned back to easier-to-control black-and-white line work as his medium and, after researching traditional sources, composed an ambitious original retelling of the legend of Robin Hood for young readers. His goal, it seems, was to make his own mark on the shelf of classic fantasy works that had so transported him as a boy, and by any measure he succeeded brilliantly, producing an illustrated volume of literary charm and breathtaking graphic distinction. In the heyday of the American robber barons, he reinvented the swashbuckling highway-

man of the old ballads as a compelling populist hero who "robbed from the rich to give to the poor."

Publication history: *The Merry Adventures of Robin Hood* was published simultaneously in the United States and England and was warmly received by readers in both countries. Even William Morris expressed his admiration for the book, and Robert Lawson, an American writer and illustrator of a later generation, called it simply "the most perfect of children's books."[2] Pyle's *Merry Adventures* did much to enshrine Robin Hood in the pantheon of popular-culture heroes, inspiring a spate of books by others (among them Paul Cheswick's *Robin Hood*, with illustrations by Pyle's former student N. C. Wyeth), as well as dramatizations for film and television, including the 1938 Warner Brothers *The Adventures of Robin Hood* starring Errol Flynn and Olivia de Havilland.

THE
MERRY ADVENTURES
of
ROBIN HOOD
of Great Renown, in *Nottinghamshire*.
WRITTEN and ILLUSTRATED
By HOWARD PYLE.

NEW YORK:
Printed by CHARLES SCRIBNER'S SONS at
No. 743 & 745 Broadway, and sold by same

MDCCCLXXXIII.

The·Merry·Friar·carrieth·
Robin·across·the·Water·:·

Robin·Hood·meeteth·the·tall
Stranger·on·the·Bridge·

Little·John·overcomes·Eric·o'·Lincoln

Merry·Robin·stops·a·Stranger·
in·Scarlet·:·

ARTHUR RACKHAM

born 1867, Lewisham, London, UK; died 1939, Limpsfield, UK

Biography: Arthur Rackham's extraordinary career in illustration coincided with a period of explosive growth in the Anglo-American children's book market in parallel with the rapid expansion of an educated middle class eager to lavish beautifully designed and illustrated books on their young. Artists in several nations built their careers on the demand for such gift books, which typically arrived on store shelves just in time for the Christmas trade. Among these artists, Rackham was king.

A frail child, Arthur Rackham was the son of the Admiralty Marshal of the High Court of Justice. He had his early schooling in London, then spent some convalescent time in Australia as a teenager before enrolling in evening classes at the Lambeth School of Art while working by day as a junior clerk at the Westminster Fire Office, an insurance company.[1] Rackham did a brief stint as a journalist as well and contributed drawings to a variety of illustrated papers and to *Cassell's Magazine*

and the juvenile monthly *Little Folks* before scoring his first success in the book realm as the illustrator of Richard Barham's *The Ingoldsby Legends* (1898). For the next three decades he published at least one book nearly every year, and often two or more.

About the book: It was inevitable that Rackham would illustrate the Grimms, whose collected "wonder tales" had long since come to be revered as foundational texts of the modern culture of childhood. Rackham brought to the project his highly developed powers of draftsmanship, notably his muscular line work, strong feeling for atmosphere, and skill at rendering landscapes that blended naturalistic and phantasmagorical detail with a theatrical flourish.

Publication history: The 1909 *Grimm's Fairy Tales* represented a partial reworking, and deepening, of previously published material. As Rackham himself explained in a prefatory note: "Some years ago a selection of 'Grimm's Fairy Tales' with 100 illustrations of mine in black and white was published—in 1900 by Mssrs. Freemantle & Co., and afterwards by Mssrs.

Archibald Constable & Co., Ltd. At intervals since then I have been at work on the original drawings, partially or entirely re-drawing some of them in colour, adding new ones in colour and in black and white, and generally overhauling them as a set, supplementing and omitting, with a view to the present edition."[2]

The 1909 edition, which featured forty full-color illustrations, has remained in print in various forms ever since, including an elegant 2012 limited-edition facsimile volume from the UK's Folio Society. Rackham's influence on subsequent illustration has been substantial, inspiring artists as varied as Maurice Sendak, Lisbeth Zwerger, Walt Disney, and, perhaps most surprisingly, David Hockney.

Left: "Spindle, Shuttle, and Needle";
right: "The Nose Tree"

Overleaf left: "The Seven Ravens";
overleaf right: "Little Red Riding Hood"

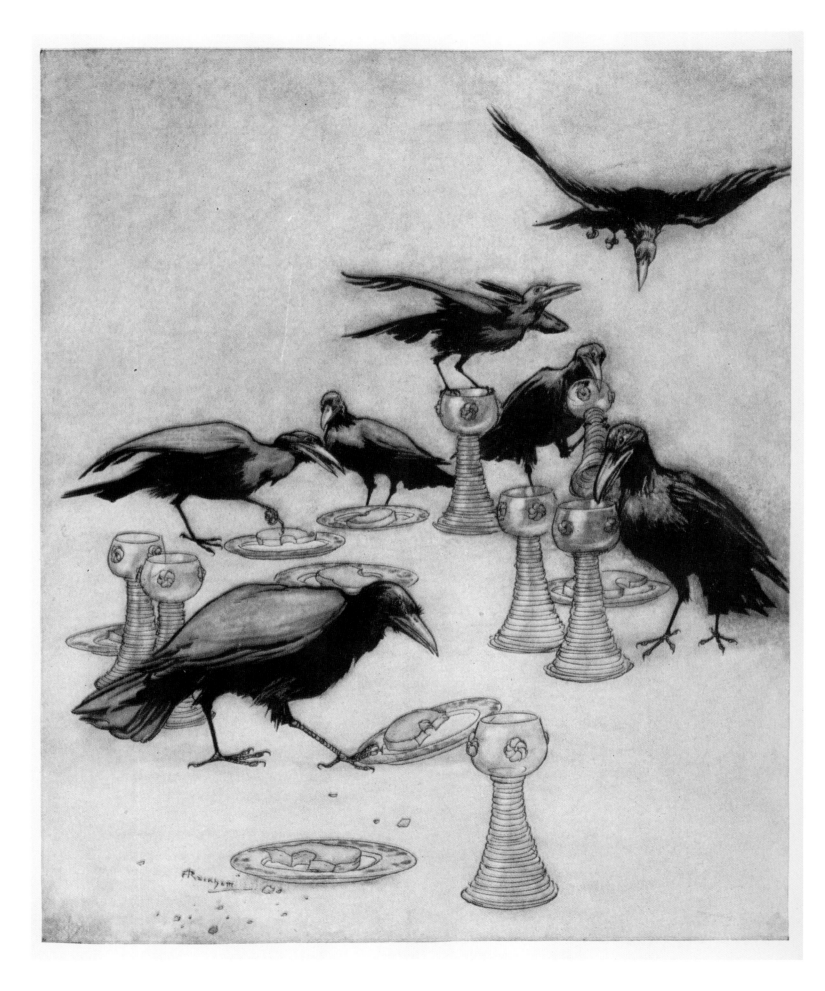

PAUL RAND

*born 1914, Brooklyn, New York, US; died 1996,
Norwalk, Connecticut, US*

Biography: One of the twentieth century's most dynamic and versatile graphic designers, Paul Rand made a specialty of institutional branding and logo design after taking himself on as his own first client. Born Peretz Rosenbaum at a time when Jews were routinely barred from working in the New York design world, Rand adopted a natty, classically symmetrical name for himself that allowed his brilliant work to find its audience. His magazine cover and layout designs and advertising campaigns quickly established his reputation as an inspired problem-solver able to combine the savoir faire of the European modernist aesthetic with a pragmatic American emphasis on getting the job done. Rand's writings—notably the manifesto *Thoughts on Design* (1947)—and various stints as a teacher and lecturer further extended the reach of his worldwide influence, as did his logo designs, starting in the 1950s, for IBM, Westinghouse, UPS, ABC, and a long list of other corporate giants. It was also during the 1950s that Rand became a father and that he and

his first wife, Ann, who was a writer, collaborated on four picture books.

About the book: Rand might also have had picture books in mind when in *Thoughts on Design* he observed: "In an advertisement, copy, art, and typography are seen as a living entity; each element integrally related, in harmony with the whole, and essential to the execution of the idea."[1] *Sparkle and Spin: A Book About Words* (1957) was his and Ann Rand's second picture book, the follow-up to *I Know a Lot of Things* (1956). The playful theme of *Sparkle and Spin*, as Walt Disney might have phrased it, was the "wonderful world of words." Each spread highlighted a different expressive quality of language—onomatopoeia on one page, homophones on another. It fell to Paul Rand to devise visual equivalents for each of these verbal special effects. The result was a tour-de-force, a graphically unified yet continually surprising confection of cut-paper and photographic collage elements, knowingly childlike black-line drawing, fanciful and classic type fonts effortlessly juxtaposed and harmonized, luxuriant white space, and color galore.

Sparkle and Spin

A book about words

by Ann & Paul Rand

What are words?
Words are how what you think inside comes out
and how to remember what you might forget about.

Publication history: *Sparkle and Spin* was published by Harcourt Brace's Margaret K. McElderry, a leader in the field known for her internationalist outlook and keen interest in bold contemporary design. At a minimum, McElderry's imprimatur, in combination with Paul Rand's own professional standing, assured *Sparkle and Spin* a respectful reception. The *New York Times Book Review* went much further, hailing *Sparkle and Spin* as one of 1957's "ten best illustrated books of the year." It was also featured in the American Institute of Graphic Arts Children's Book Show of 1958. But in a review of that exhibition, the usually broad-minded critic Louise Seaman Bechtel raised a strange and troubling objection: "The most 'modern' books in the show are those illustrated by Bill Sokol, Paul Rand, Nicolas Sidjakov, and Nicolas Mordvinoff with a very new style. Their pictures for me have a nightmare quality, and I doubt that picture book age children get any artistic message from them. Yet these advanced styles are much more stimulating than the familiar competence of some of the traditional artists."[2] After a long period of being out of print, Abrams reissued *Sparkle and Spin* in 1991. Then, after another out-of-print period, Chronicle Books again reissued the book in 2006. Reviewing this last edition in the *New York Times*, historian and critic Steven Heller praised it as a "pioneering example of a children's book subgenre one might call designed picture books."[3] Foreign-language editions have been published in Italian, German, Spanish, Japanese, and Chinese.

Some words are as big
as tintinnabulate,
while a word like <u>a</u>,
as you can see,
is just as small
as a baby bumblebee.

Sometimes one word sounds
the same as another
like hair and hare
or pair and pear.

CHRIS RASCHKA

born 1959, Huntingdon, Pennsylvania, US

Biography: On the morning of the first day of class at the medical school where he was duly enrolled, Chris Raschka decided not to be a doctor after all, and to devote his life to art instead. In college he had studied biology but also become serious about painting. On that morning in Ann Arbor, Michigan, a dream long in the making had crystallized for him in one momentous flash.

As he rethought his future, Raschka found work as an editorial cartoonist. When friends commented that his drawings looked like they belonged in a children's book, he developed the dummy for a picture book inspired by a favorite musician. The look and design of *Charlie Parker Played Be Bop* (1992) was deliberately unconventional, meant to evoke the freedom and sizzle of jazz improvisation. Since he was uncer-

tain what to do with his new creation, he once again turned to a friend, who urged Raschka to submit it to an editor known for championing offbeat books, Richard Jackson. (Judy Blume and fantasy writer Nancy Farmer were among his discoveries.) The association that resulted from this bit of good advice was to prove immensely productive.

About the book: In *Charlie Parker Played Be Bop*, Raschka played masterfully with the picture book form, reimagining its visual elements—including the letterforms—as characters in a loosely scripted performance. Raschka's watercolor and line portraits of Parker are buoyant and monumental, with the legendary saxophonist appearing in one instance to have levitated off the ground. In other scenes, inanimate objects such as street signs, lollipops, and a cavalcade of shoes dance with abandon to the fast-paced rhythms of Parker's hard-driving sound. A cat—as in "cool cat"—wanders in and out of the picture frame as a sort of watchful, presiding presence, somewhat like the robin in *The Tale of Peter Rabbit*. Wisps of meaning ride the wave of the text's propulsive beat. Meaning in the usual sense is the least of it, although an intuitive kind of sense rooted in the music of language gives Raschka's words all the coherence they need. All in all, it was an astonishing debut.

Publication history: Raschka's first picture book received widespread praise from critics, who voiced their admiration for the artist's daring and largely successful attempt to capture on the page the vertiginous thrill and athleticism of a live jazz performance. Its publication clearly heralded the arrival of an artist to watch, one whose all-in commitment to experimentation felt akin to that of the young Maurice Sendak. Subsequent books proved Raschka worthy of that initial assessment as he continued restlessly to reinvent his approach to picture-book-making and to challenge the bounds of what a book for young children could be about and do. He won a 1994 Caldecott Honor for his second book, *Yo! Yes?*, and the Caldecott Medals for 2006 and 2012 for *The Hello, Goodbye Window* (text by Norton Juster) and *A Ball for Daisy*, respectively.

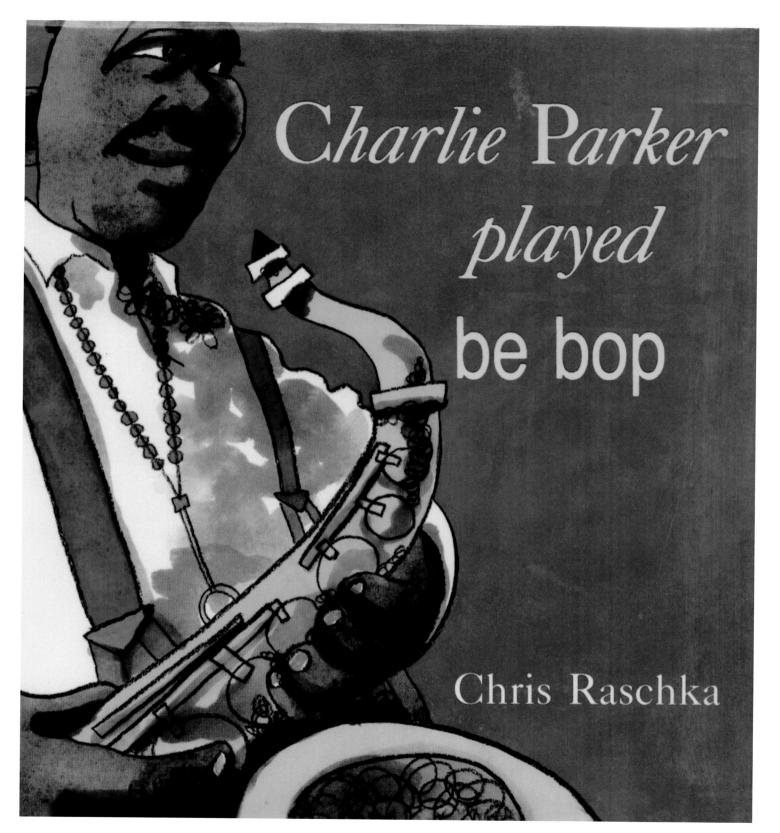

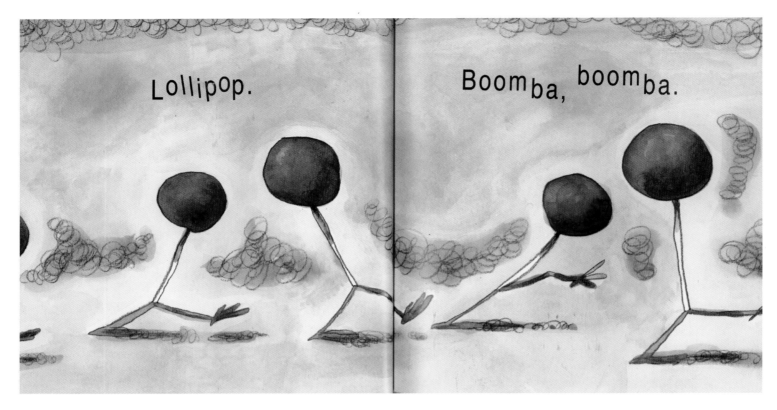

Lollipop.

Boomba, boomba.

Charlie Parker played no trombone.

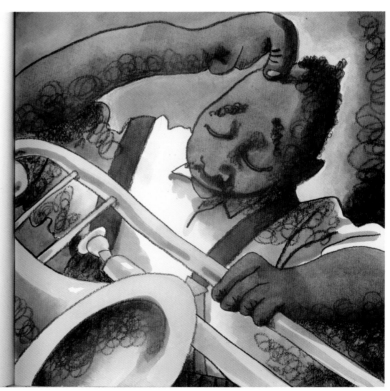

H. A. REY
born Hans Augustus Reyersbach

born 1898, Hamburg, Germany; died 1977, Boston, Massachusetts, US

MARGRET REY
born Margarete Elisabeth Waldstein

born 1906, Hamburg, Germany; died 1996, Cambridge, Massachusetts, US

Biography: As a child Hans Reyersbach frequented Hamburg's Hagenbeck Zoo; as a self-taught artist he put his love of animals to good use. Along the way, as a student at the University of Hamburg, he studied philosophy and natural sciences and mastered four languages. Following the bitter experience of military service during the First World War, he resolved to leave the Old World behind, and in 1923 he teamed up with relatives in a business venture in Brazil. While there, he and a fellow Hamburg Jew, Margarete Waldstein, married and became "the Reys." Waldstein was the daughter of a member of the Reichstag and a graphic artist with Bauhaus training. Together, they headed to

Paris for what was meant to be their honeymoon but instead became a fateful four-year interlude. While in Paris, Hans Rey's humorous animal drawings led to a commission to create a children's book. Before long, the couple were making picture books together, with Margret (with her own newly shortened name) serving as art director as well as writer.

The catastrophic unraveling of the political situation as Hitler's army swept across Europe made France unsafe for Jews. The couple escaped by bicycle hours before the German army of occupation seized Paris. When they reached New York in the fall of 1940, the Reys had among their belongings the art and manuscripts for four unpublished children's books, which they hoped to sell as a means of tiding themselves over. Among these was an early version of the book that in time made them famous, *Curious George* (1941). The Reys went on to create five Curious George sequels and over a dozen other children's books. In later years, they donated the lion's share of their substantial earnings to a variety of progressive charitable organizations.

About the book: The working title of the story that proved to be the most important of the four manuscripts the Reys brought to New York was not *Curious George*, but "Fifi." Immediately on arrival in New York, the Reys contacted Houghton Mifflin, whose juvenile editor they had met in London—and were rewarded with the offer of a rare four-book contract. "Fifi," however, would not do as a title, the Reys were told, and a Houghton Mifflin staffer proposed *Curious George* as an alternative. Hans Rey had prepared a complete set of watercolor illustrations for the book, apparently on the assumption that American color printing practices were the same as in France. Such was not the case, however. Rather than create a set of printing plates by the costly photographic method, American publishers typically required their illustrators to do the work of the camera themselves. This meant that the artist had to analyze his or her final color choices and, for each color ink to be used in the printing, to produce a series of color-specific drawings, or "separations," from which the corresponding plates for each color would be made. Rey's extreme facility with such technical matters came to his aid as he mastered a completely new

and challenging method of preparing art for publication. Given the nature of the pre-separation process, the predictable result was that the illustrations for *Curious George* and Rey's other American books became more graphic and less painterly than those he had published in Europe.

In the character of George, the Reys had fashioned an impish but lovable trickster in the tradition of Max and Moritz and Peter Rabbit. Years later, as the story of the couple's harrowing escape from Nazi-occupied Europe became known, the quick-witted monkey's knack for survival was revealed to have had an autobiographical meaning for them as well.

Publication history: Reviewers praised *Curious George* from its first appearance, in one instance comparing the book favorably to the ten-cent comic books that competed with library-approved picture books for young children's loyalty and attention. Librarians were desperate to find books that children might prefer to the ten-cent magazines they considered substandard and believed that George's adventures and Rey's art were both lively and child-friendly enough to do the trick.

Although Hans Rey had made a name for himself as an illustrator in England and France, he was a complete unknown in America when *Curious George* appeared in 1940, and initial sales of the book were anemic. As wartime paper rationing prompted publishers to favor their tried-and-true authors, copies of *Curious George* were hard to come by for a time. George's American fortunes soared during the postwar years, along with birth rate.

By then, a British edition of the book had also been published—but under yet another title: *Zozo* (1942). The American title would not do in a country whose king was George VI and where "curious" could mean "gay." In later years, the Reys' best-known work would become the basis of a franchising empire, with countless toys, children's clothing items bearing George's spry image, multiple television and film projects, and a long list of spin-off books written and illustrated by others.

The crucial role played by Margret Rey as the story's principal author went unacknowledged in the early editions of *Curious George* and its sequels. From the late 1970s onward, however, she received credit as the books' cocreator.

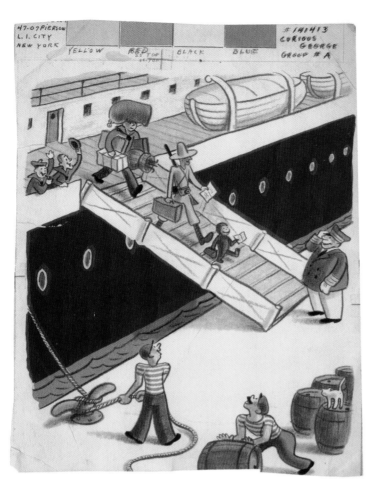

Color page proofs for page 25 ("After that George was more careful . . .")

FEODOR ROJANKOVSKY

*born 1891, Mitava, Latvia; died 1970
Bronxville, New York, US*

Biography: The son of a high school headmaster and teacher, Feodor (sometimes spelled Fedor) Rojankovsky and his family moved periodically as his father's work took him to various outposts of the Russian tsar's empire. A talent for drawing emerged at an early age, with animals a favorite subject. The ability he developed then to adapt to new surroundings and circumstances later served him just as well. Rojankovsky gained admission to the prestigious Moscow School of Painting, Sculpture, and Architecture but had his training cut short upon being drafted into the imperial army during the First World War. He was dragged into military service a second time in the chaotic revolutionary period, eventually landing, seriously ill, in a Polish prisoner of war camp. Upon his release, he made his way west, finding work as an artist in Poznan,

Berlin, Paris, and finally, New York. Rojankovsky arrived in New York with an exclusive contract to illustrate Little Golden Books, a well-financed new line of affordable picture books inspired by the Père Castor imprint he had contributed to in Paris. In a later phase of his career, he worked for more traditional houses and won the 1956 Caldecott Medal for *Frog Went A-Courtin'* (1956), published at Harcourt Brace by legendary editor Margaret K. McElderry.

About the book: *Daniel Boone* (1931) was the first and most brilliant achievement of two American expatriate women living in Paris, Esther Averill and Lila Stanley, who together operated the Domino Press. The partners met Rojankovsky when he came to them with an ABC book he had created in Poland and hoped to sell into the American market. They urged him to attempt a different project instead and settled on Daniel Boone as a suitable theme. Rojankovsky shared the fascination of so many Europeans of his generation with the romance of the American wilderness and relished the chance to depict an abundance of animals in the wild. *Daniel Boone* was initially planned as a wordless sequence of large-format tableaux rendered in five-color stone lithography. But to solidify its salability as children's nonfiction, Averill and Stanley fashioned a workmanlike narrative text and published the book in both French- and English-language editions.

Publication history: In 1931, the Domino Press issued four different editions of *Daniel Boone*: trade editions in English and French, and deluxe editions in both languages, the latter pair each limited to twenty-five numbered copies. That same year, Faber & Faber released its own small edition and was rewarded by having the extravagantly outsize volume declared *The Observer*'s "choice among all the children's books of the season."[1] Copies of the Domino French-language edition made their way to Germany, where *Gebrauchsgraphik*, a journal of "useful" (or commercial) art, commented appreciatively: "Who but a Russian would ever venture to beset a grass-green meadow with violet trees, heighten the effect by introducing a chrome-yellow tree, and crown the whole by perching a red squirrel in the branches."[2] In the United States, Boston's

DANIEL BOONE

Historic Adventures of an American Hunter among the Indians

lithographs in colour by

Fedor Rojankovsky

Edited by Esther Averill and Lila Stanley

Domino Press, Paris

influential Bookshop for Boys and Girls distributed the book, and that store's offshoot publication, *The Horn Book*, nodded its approval, as did the New York Public Library's Anne Carroll Moore, who endorsed *Daniel Boone* as a "unique first book in American history."[3] In 1945, Harper & Brothers published a newly redesigned and scaled-down edition with an impressive first printing of fifty thousand.[4] Although long out of print, *Daniel Boone* is now widely regarded as a landmark work of children's illustrated literature.

For twelve years Boone had dreamed of seeing Kentucky. One day he filled his powder horn, called his dog, and tried to make his way alone into the Wilderness. But hardships drove him back.

Then at last his dream came true. With his old friend, Finley, and four other men, he struggled westward over the buffalo trails into the unexplored country.

KENTUCKY — THE HUNTER'S PARADISE

ROBERT SABUDA

born 1965, Wyandotte, Michigan, US

Biography: Among Robert Sabuda's favorite childhood art supplies were the oaktag file folders his mother brought home from the office where she worked as a secretary. Sabuda's father was a carpenter and mason, and young Robert, the second of three children, grew up with a strong feeling for the inherent value of handcrafted work that he retained even after the advent of computer technology presented him with less labor-intensive alternatives.

The "class artist" from his earliest school years, Sabuda went east to study at New York's Pratt Institute, where an assignment to construct a three-dimensional pop-up image ignited his imagination. The following year, an internship in the children's book department at Dial Press began to give more concrete shape to his plans. Sabuda illustrated ten conventionally formatted picture books before publishing his first "movable," *The Christmas Alphabet* (1994). His timing was fortunate in that, spurred by appreciation for the ingenious paper-engineered books of Vojtěch Kubašta, an American book packager named Waldo Hunt was just then leading a major pop-up revival, in part by issuing facsimile editions of the classic works of Lothar Meggendorfer and others. Hunt's company, Intervisual Communications, took advantage of low-cost skilled labor in Latin America and later in Asia to manufacture these complex books at an affordable price and was thereby able to capitalize on the growing Western retail demand for collectible illustrated children's books. Sabuda's exceptionally high level of skill, ingenuity, and passion for three-dimensional illustration swiftly elevated him to the apex of this children's book–world niche, earning him the title of Reigning

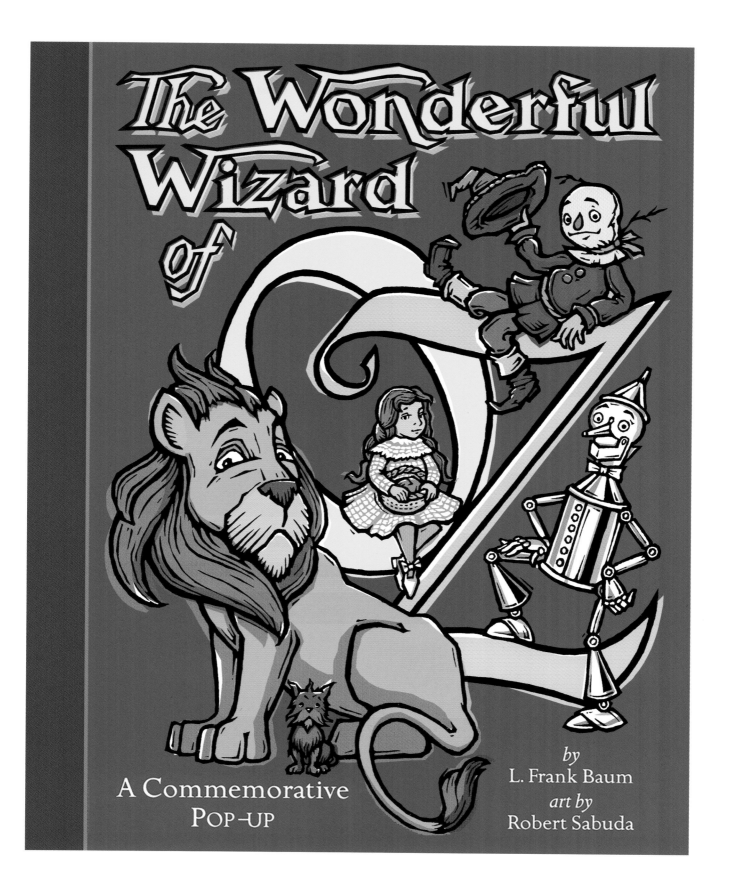

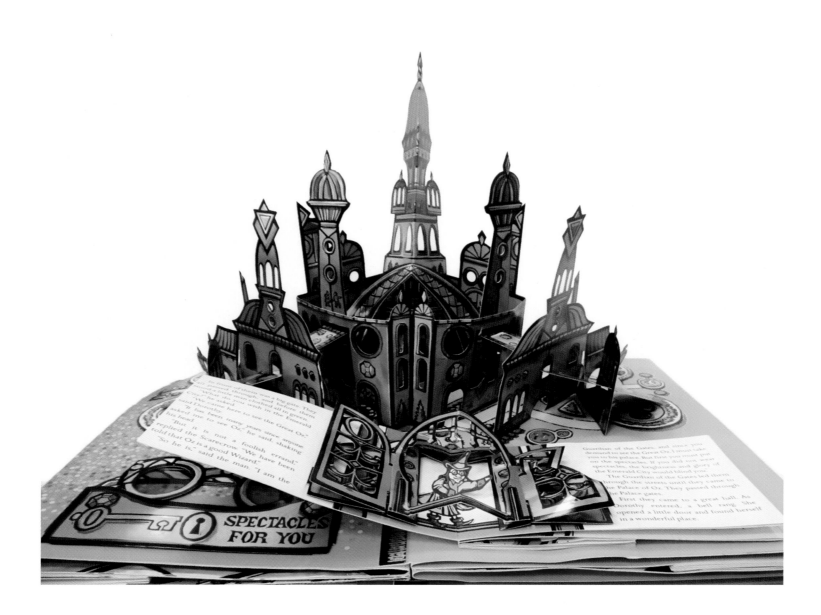

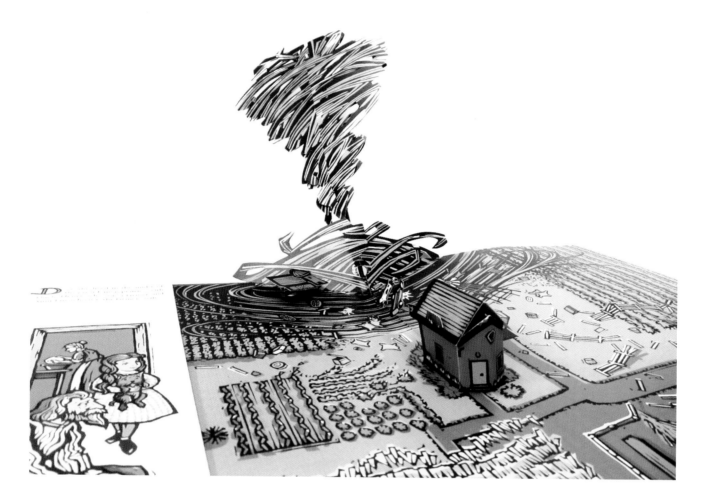

Prince of Pop-Up Books, as a *Wall Street Journal* pro-file proclaimed him.[1] From the mid-1990s onward, he published an average of one full-dress movable book a year while also designing a popular line of three-dimensional greeting cards for the Museum of Modern Art.

About the book: Baum's classic had always been close to the imaginative midwesterner's heart. The first pop-up he ever attempted, as a nine-year-old, had been a 3D rendering of the twister that catapults Dorothy far from Kansas. Try as he might, however, he failed as a child to make the cyclone spin. Years later, Sabuda finally achieved that goal while designing a total of seven double-page three-dimensional spreads for the trade edition whose other special effects include a Wizard-bearing hot-air balloon that seems

to hover tremulously in mid-flight. Sabuda positioned the abridged text in side-panel mini-books-within-the-book that opened to reveal still more pop-up surprises. An accompanying pair of green-tinted glasses allowed readers to view Oz in all its emerald glory, sparkly foil surfaces and all.

Publication history: Sabuda released *The Wonderful Wizard of Oz: A Commemorative Pop-Up* in 2000, the centenary year of the original L. Frank Baum book's publication. It became a *New York Times* bestseller, a rare occurrence at the time for a children's book not about Harry Potter. A special slip-cased, signed edition limited to two hundred copies came with a bonus pop-up. Foreign-language editions appeared in France, Spain, and Japan.

ANTOINE DE SAINT-EXUPÉRY

*born 1900, Lyon, France; died 1944,
at sea near Marseille, France*

Biography: Born to an impoverished family belonging to the French provincial nobility, Antoine de Saint-Exupéry initially opted for a vagabond life as a pilot flying the airmail route that linked France and Francophone North Africa. His lyrical writings about his far-flung adventures brought him literary fame and a flourishing second career during the early years of the Second World War, which he passed in enforced exile in the United States while awaiting his chance to join the battle under the flag of his occupied country. In America, his celebrity skyrocketed thanks not only to the boldface company he kept—Charles Lindbergh, Jean Renoir, and Tyrone Power were just a few of the dashing expat's famous friends—but also due to the genuine merit of his literary output. Enthusiastically received on both sides of the Atlantic, his essay collection *Wind, Sand and Stars* (1939) won both the National Book Award and the Prix Goncourt. His next book, *Flight to Arras* (1942), likewise became a best-

seller. Entangled in a difficult marriage and increasingly out of sorts over the world situation, Saint-Exupéry found solace by rereading Andersen's fairy tales and during the summer and fall of 1943 lost himself in the composition of the bittersweet tale of loneliness, loss, and spiritual resilience that was to be his most lasting achievement, *The Little Prince* (1943).

About the book: Preliminary sketches of the book's otherworldly protagonist had been turning up for years in doodles decorating his letters to friends and in the margins of the manuscript for *Flight to Arras*. Taking note of all this, the wife of one of Saint-Exupéry's American publishers urged him to exploit the character's possibilities. A mix of late-Romantic lyricism and dark philosophical reflection, *The Little Prince* has been read as a song of innocence *and* experience for its time and perhaps for all time. The ethereal hero—literally a visitor from another world (Asteroid B-612)—alights on Earth and meets a fellow outlier, a pilot who crashed his plane in the Sahara and who lives to narrate the seemingly magical child's sad, strange story. The Little Prince's previous encounters, we are told, revealed to him the barrenness of adult logic and imagination, and the elusive nature of love. The author's chronicles of the chance eight-day-long friendship shared by the Little Prince and the pilot seems to suggest that fleeting affinities are the most one can hope for in a deeply flawed and often impassive universe like ours.

Publication history: *The Little Prince* was first published in 1943, in both French and English editions, in the United States. P. L. Travers, in her front-page *New York Herald Tribune* review, warmly praised the book, as did Anne Morrow Lindbergh, herself a bestselling author and wife of Saint-Exupéry's famous aviator friend. It landed on the *New York Times* and *Herald Tribune* bestseller lists, though its rise to the status of a ubiquitous, must-have modern-day classic occurred over time, fueled in part by the author's mysterious disappearance in 1944 during a military flight over France and the eerie resemblance of that fateful episode to the Little Prince's own demise. The first French edition to be published in France appeared two years after the author's death, in 1946.

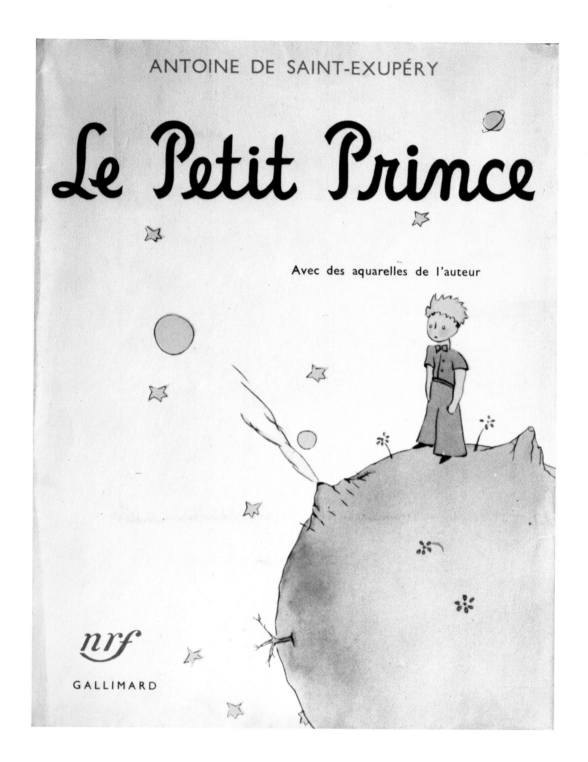

The Little Prince went on to become one of the world's most frequently translated books. (By one reliable estimate it can be read in nearly eighty languages.)[1] It has inspired a dizzying array of stage, film, and television adaptations, a theme park in Ungersheim, France, and licensed toys and mementos galore. In France, where an estimated three hundred thousand copies of the book are sold annually, it was voted the best French literary work of the twentieth century. Saint-Exupéry's manuscript, watercolors, and related material remained in New York and were acquired in 1968 by the Pierpont Morgan Library, now the Morgan Library & Museum, where they are periodically put on public view.

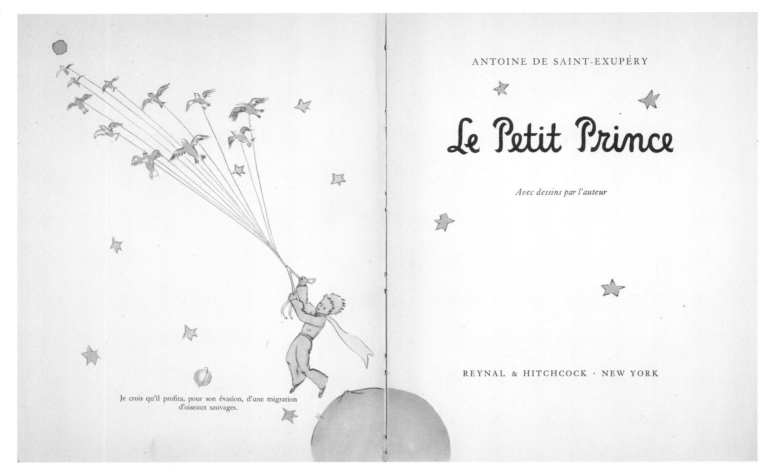

Je crois qu'il profita, pour son évasion, d'une migration
d'oiseaux sauvages.

ANTOINE DE SAINT-EXUPÉRY

Le Petit Prince

Avec dessins par l'auteur

REYNAL & HITCHCOCK · NEW YORK

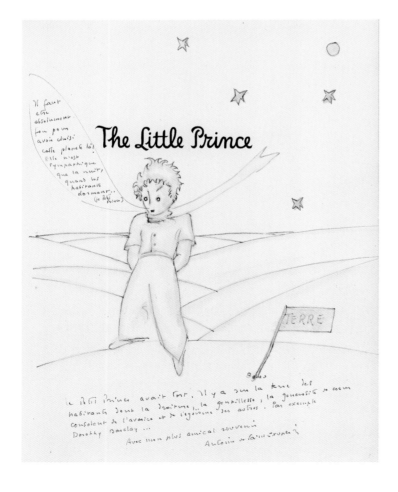

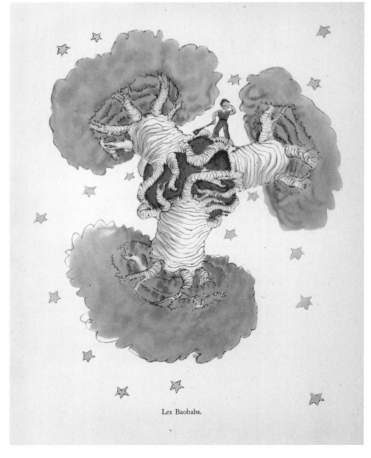

Les Baobabs.

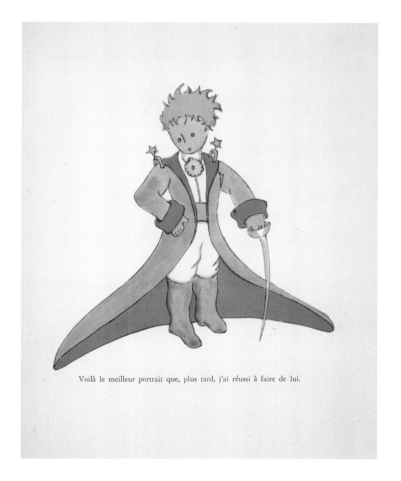

Voilà le meilleur portrait que, plus tard, j'ai réussi à faire de lui.

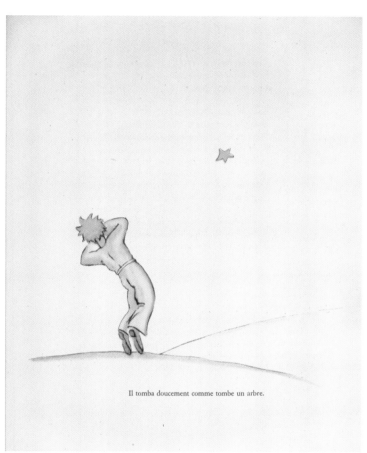

Il tomba doucement comme tombe un arbre.

Opposite: Covers for the 1963 and revised 1980 editions

RICHARD SCARRY

born 1919, Boston, Massachusetts, US;
died 1994, Gstaad, Switzerland

Biography: When Richard Scarry informed his father, a Boston department store owner, that he would not be joining the family business but intended instead to become an artist, the response was sure and swift. The elder Scarry painted a grim picture of the impoverished life and spaghetti dinners that lay ahead. He need not have worried. After honing his drawing skills at Boston's School of the Museum of Fine Arts and as a cartoonist for the US military's newspaper, *Stars and Stripes*, Scarry headed to New York to show his portfolio around. His career took off when he met the editors of Golden Books, who kept the industrious artist at his drawing table almost continuously for the next twenty years.

Scarry ranked high among the list's most productive workhorses, illustrating six Golden titles in 1949 alone. By the mid-1950s, as his value to the company became increasingly evident, he began to question both the financial arrangements being offered him and the creative goals he wished to pursue. At a company where flat-fee payments to artists remained the rule, he now asked for and was granted a royalty. He also felt the urge to develop larger-scale projects, written as well as illustrated by him, and thus more fully under his own artistic control. As Scarry's fame and fortune skyrocketed, he and the lawyer who now negotiated contracts on his behalf decided to try their luck with other publishers as well. In later years, Scarry's new book projects all originated at Random House, even as his substantial Golden backlist remained a vital going concern.

About the book: The publishers of Golden Books were pioneers of consumer product branding and marketing. Their book covers rarely credited either the author or illustrator, thereby directing all attention to the brand itself: the Golden name, the beguiling decorative gold-tinsel spine, the uniform look and format, the reassuring endorsement of "Mary Reed, PhD, Teachers' College." It was therefore a notable departure from this patten when the company in 1963 unveiled an oversize picture book dictionary whose creator's

name received such prominent billing as to imply that he himself, not Golden Books, *was* the brand. *Richard Scarry's Best Word Book Ever* was also designed with foreign editions expressly in mind. Vocabulary words in this unconventional dictionary were arranged not alphabetically but rather in clusters based on real-world usage, with words, for example, about dinnertime grouped together on one unified double-page spread and words about city street life on another. The plan allowed for the captions to be dropped into place in black line for each language during a separate stage of the printing process, with all the color work having been printed first in one massive (and cost-effective) press run. Scarry would be among the first children's book artists to achieve superstardom at the Bologna Children's Book Fair by means of such international coeditions.

Publication history: Scarry's densely detailed, frenetically "busy" illustrations had a cartoonish, theme-park vibe that doomed them at award time with aesthetically high-minded American children's librarians but made them exceedingly popular with children.

Progressive educators welcomed the word book's gamelike approach to visual learning and praised it as a clever application of the concept that Bank Street College of Education founder Lucy Sprague Mitchell had termed "relationship thinking": the idea that true learning is all about understanding the interconnectedness of facts, objects, and experiences. Scarry's winsome scenes effortlessly encouraged children to think in precisely that way. The same mix of playfulness and educational value also made *Richard Scarry's Best Word Book Ever* appealing to parents who, as chain bookstores proliferated in American suburban shopping malls in the 1960s and after, had more and more chances to discovery Scarry's big, cheery volume for themselves. At the time of the artist's death in 1994, four million copies of *Richard Scarry's Best Word Book Ever* had been sold worldwide. Foreign-language editions include Polish, Russian, Ukrainian, Slovenian, Serbian, Norwegian, Spanish, French, Dutch, German, Icelandic, Japanese, Chinese, Korean, and Afrikaans.

MEALTIME

The Pig family is having a special holiday meal. There is so much good food to enjoy! What do you see on the table that you like to eat?

carving knife and fork

roast beef

meat platter

tablespoon

coffeepot

teapot

saltshaker

pepper shaker

fork

dinner plate

glass

cream pitcher

cup

knife

saucer

spoon

sugar bowl

napkin

turkey

cake

milk pitcher

squash

baked potatoes

green beans

gelatine

cranberry sauce

mashed potatoes

beets

onions

ice cream

peas

steak

butter

soup

pie

salad

rye bread

white bread

rolls

BINETTE SCHROEDER

born 1939, Hamburg, Germany;
died 2022, Gräfelfing, Germany

Biography: Binette Schroeder grew up in Garmisch-Partenkirchen, a resort town in the Bavarian Alps originally settled by the Romans and home to medieval castle ruins and spectacular natural vistas—more than enough inspiration for a young person with a talent for narrative art. In 1957, a year after her family moved to Munich, she studied graphic design at a nearby private school, then embarked on advanced coursework at the Shule für Gestaltung Basel (Basel School of Design), all the while deferring her initial, less practical-sounding dream of illustrating children's books for a living. She found her first professional employment as a commercial artist and portrait photographer. Schroeder was thirty when she published her first picture book, *Lupinchen* (1969), and immediately garnered international attention.

About the book: *Lupinchen* is an Andersen-esque picture book fairy tale about the adventures of a doll come to life. As in Andersen, the dream-fantasy narrative is anchored in an acute sympathy for young children's often-underestimated susceptibility to loneliness and sadness, and in an absolute faith in the power of children's imagination to counter, and come to terms with, the dark side of their emotional lives. As we first meet her, lonely Lupinchen has gathered a cadre of her friends around her—Mr. Klappaufundzu, Mister Humpty Dumpty, and two others. Flamboyant Klappaufundzu cleverly builds a house out of paper for the group to have a party in, but a storm soon blows them, house and all, out to sea. Unexpectedly—and ironically, given the famous rhyme about the egg man who takes a fall and breaks disastrously into pieces—it is shy, timorous Humpty Dumpy who ultimately saves the day.

Schroeder painted the story's scenes in restrained but radiant gouache with sweeping backdrops of undifferentiated sea and sky against which the actors of her tabletop drama are crisply delineated with a high degree of graphic sophistication. The formative influence of the surrealist painters—especially René Magritte for his startlingly discordant imagery and Salvador Dalí for his symbolic interpretation of landscape—is apparent in these haunting paintings, but Schroeder, unlike those earlier artists, seems just as committed to propelling a story forward as she is in stopping her viewers in their tracks via arrestingly

Lupinchen

Erzählt und illustriert von Binette Schroeder

Nord
Süd

strange images that short-circuit thought and perception. The introduction of the well-known character of Humpty Dumpty seems a gesture meant not merely to surprise and delight but also to expand the parameters of Lupinchen's world in such a way as to make us feel that we have literally entered the realm of the imagination, where all timeless characters dwell.

Publication history: *Lupinchen* received multiple honors, including the Biennial of Illustration Bratislava Golden Apple Award, France's Prix Loisirs-Jeunes "Best Book," and a silver medal from the IBA Leipzig. It was published in at least eleven foreign-language editions, although not always under its original title. In the United States, for example, *Lupinchen* became *Flora's Magic House*. For the Spanish and Catalan editions, it became *Rosina*. Its strong reception heralded the arrival of a significant illustration talent whose work has been regularly exhibited throughout Europe and Japan.

RONALD SEARLE

*born 1920, Cambridge, UK; died 2011
Draguignan, France*

Biography: The self-assured, left-handed son of hard-bitten working-class parents, Ronald Searle puzzled those closest to him when by age five he began avidly—then compulsively—to draw and, by eleven, to show formidable talent as a caricaturist. Leaving academics behind for good four years later, Searle pursued his passion for drawing at the Cambridge School of Art while publishing his first cartoons in the distinguished Cambridge University literary magazine *Granta* and in a local daily paper.

With the outbreak of the Second World War, Searle enlisted in the British army, and ended up as a Japanese prisoner of war in Singapore, where he was held despite failing health under brutal conditions. The large cache of war drawings he produced during this extreme period of his life served as the foundation, he often said afterward, for everything he later created as an artist.

The first evidence of this, however oblique, came with the rush of St. Trinian's cartoons he drew for *Lilliput* magazine during the postwar years, in which he presented a darkly comical portrait of life at an ostensibly proper British girls' boarding school. This cartoon series, the immense popularity of which grew to become a burden on him, was in a sense Searle's *Lord of the Flies*, a satirical reflection on—and lament over—the dominant place of aggression in human nature.

Searle first created art for young readers as the illustrator of Geoffrey Willans's four classic Molesworth books, starting with *Down with Skool!: A Guide to School Life for Tiny Pupils and Their Parents* (1953). Children's book illustration remained a comparatively minor focus of his overall output, even after his first wife, Kaye Webb, left *Lilliput* to direct Puffin Books, where she became one of the juvenile publishing industry's most dynamic figures.

During the 1960s, Searle left Webb and England for a new life in France. Illustrated journalism for *Life* and *Holiday* magazines took up much of his time as he also ventured into animation and produced a variety

of books for adults, including an homage to a longtime friend, illustrator André François. He published the acerbic *Marquis de Sade Meets Goody Two-Shoes* in the same year—1994—that he illustrated Lee Wardlaw's feisty (but far less provocative) picture book, *The Tales of Grandpa Cat*. In his later years, Searle was proudest of his satirical cartoons for the French daily *Le Monde*.

About the book: *Down with Skool!* treated young Nigel Molesworth's chronic bad spelling and the glaring inadequacies of the much-vaunted British public school system as two halves of the same running joke. Searle undertook the illustrations almost despite himself, having only recently shed his burdensome St. Trinian's obligations. But Willans's frayed and frazzled, hypocrisy-laced world, as first elaborated in *Punch* and the children's magazine *The Young Elizabethan*, greatly appealed to him, and so he was game to give pictorial life—to the tune of 120 drawings—to Willans's tongue-in-cheek vignettes about the perils of attending school alongside "various swots, bulies, cissies, milksops greedy guts and oiks"—not to mention headmasters of assorted stripes.[1] In the volume's highlight, Searle unfurls a droll sequence of five grandly decked-out, full-page historical panoramas ("A GAUL marching into Italy"; "a ROMAN marching into Gaul"; "a Gaul and a Roman passing each other in the Alps"; "a GAUL returning to Gaul"; "a ROMAN returning to Rome") that slyly put the ludicrous goings-on at St. Custard's school in a larger perspective.

Publication history: With its initial appearance in England in the fall of 1953, *Down with Skool!* had sales of nearly fifty-eight thousand copies by Christmastime, an even stronger reception than had been accorded the last of the St. Trinian's books a year earlier. Three sequels followed, all illustrated by Searle. A 1987 four-part BBC Radio 4 series called *Molesworth*, by Simon Brett, revisited the books' protagonist in middle age. The first US edition appeared in 1954 from the Vanguard Press, Dr. Seuss's original publisher. The Molesworth books have returned to print periodically in single-volume editions, most recently from England's Folio Society. Foreign-language editions have appeared in Spanish and Catalan.

Table of Grips and Tortures for Masters

The plain blip for numskulls.

Side hair tweak exquisitely painful.

Single-hair extraction for non-attenders.

The cork in the storm for violent temperaments.

Portable rack for maths masters (with thumbscrew attachment).

The headshave with ruler.

The Cumberland creep from behind with silver pencil.

The simple open furnace.

BRIAN SELZNICK

born 1966, East Brunswick Township, New Jersey, US

Biography: As a child with an imagination on overdrive, Brian Selznick put his family's suburban backyard to excellent use, building a fortress "island" for playing out his G.I. Joe fantasies and, on a different note, constructing a cottage dwelling for trolls. A talent for storytelling on the grand scale ran in the family: His grandfather's first cousin was David O. Selznick, producer of *A Star Is Born*, *Gone with the Wind*, and *Spellbound*, among other Hollywood film classics. With the encouragement of his parents and his high school art teacher, Selznick enrolled at the Rhode Island School of Design (RISD), where he majored in theater design. Friends had suggested that he might make a good children's book illustrator, but Selznick at first resisted the idea, pointedly not taking the RISD classes taught by David Macaulay and Chris Van Allsburg and skipping a guest lecture by Maurice Sendak, as he later recalled for an interviewer.[1] In the years immediately following graduation, he found that what he most wanted to do

creatively was draw. It was only after he took a job as a salesclerk at Eeyore's bookstore, a New York children's book mecca, that Selznick's fate was sealed.

His early books, including *The Houdini Box* (1991) and *The Boy of a Thousand Faces* (2000), reflected the artist's longtime fascination with genre fiction, stage magic, and other forms of popular culture. The critical success of these and a string of other one-off picture books led to a life-changing meeting with Maurice Sendak, who gave Selznick's first efforts qualified praise but bluntly added that he had yet to tap into his full potential. Both shaken and emboldened by the encounter, Selznick next published *The Invention of Hugo Cabret* (2007).

About the book: At 534 pages, *The Invention of Hugo Cabret* was the most strangely formatted "picture book" in history. In reality, it was a hybrid work that melded elements of the picture book, graphic novel, the wordless novel as developed by Frans Masereel and Lynd Ward, and the genre of silent film that its narrative memorialized. Selznick fashioned a story that made key plot points of industrial-age technol-

2.9.11

2.9.13

ogies ranging from precision clockworks and side-show automata to steam locomotives and motion picture projection. With the period streets of early twentieth-century Paris for a backdrop, the book had romantic atmosphere and epic sweep to spare.

Publication history: Critical response to *The Invention of Hugo Cabret* was enthusiastic in the extreme. For once, no one in the American library and book-selling community seemed thrown by the challenge of categorizing a book that so blithely defied compartmentalization by straddling multiple genres. The American Library Association awarded the book its 2008 Caldecott Medal. In 2011, Martin Scorsese's feature film adaptation, *Hugo*, went into general release, in some theaters in a special 3D version. Foreign-language editions included French, Spanish, Catalan, Italian, German, Danish, Norwegian, Russian, Hungarian, Polish, Chinese, Japanese, and Thai.

MAURICE SENDAK

born 1928, Brooklyn, New York, US; died 2012, Danbury, Connecticut, US

Biography: As the youngest of three children, Maurice Sendak made the most of his status as the "baby" of the family—the sickly, fearful baby of an emotionally volatile Polish Jewish immigrant family that the Great Depression had reduced to a threadbare existence. Young Sendak's artistically talented older brother, Jack, allowed little "Moishe" to tag along with him as an adoring apprentice. His glamorous older sister, Natalie, brought him along on dates. The sketchbook drawings he made as a teenager—including many depicting the healthier youngsters who played in the streets below the seminomadic family's various Brooklyn apartments—furnished him, an essentially self-taught artist, with his first portfolio. Forgoing college, Sendak instead found work in the display department of the celebrated Manhattan toy emporium FAO Schwarz, where he made important contacts that led to a first

illustration assignment from Harper's legendary editor Ursula Nordstrom.

As his sketchbooks had already demonstrated, Sendak was an extraordinarily perceptive and sympathetic interpreter of childhood. His unsentimental drawings revealed the hidden complexities of young children's emotional world, showing children not as they ought to be but rather as they are. His oddly proportioned characters bore little resemblance to the perfect specimens depicted in advertising—or in other children's books of the time.

Sendak had illustrated more than fifty books, nearly all written by others, when he published *Where the Wild Things Are* (1963), a picture book that had a transformative impact not only on his own career but also on children's book illustration as an art form. In the wake of that triumph, he emerged as a kind of spokesperson and ambassador for the field at large. The scope of his creative work later expanded to include original designs and adaptations of his books for the theater, ballet, opera, and film.

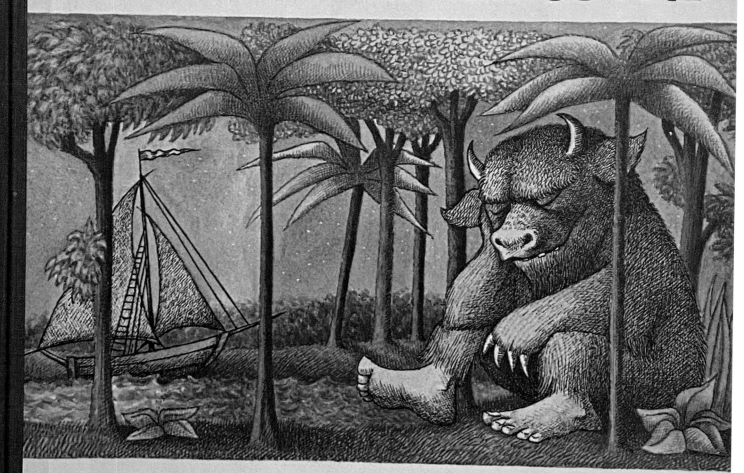

WHERE THE WILD THINGS ARE

STORY AND PICTURES BY MAURICE SENDAK

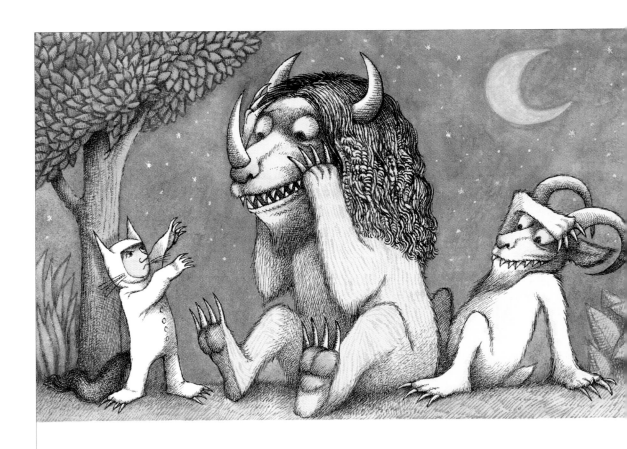

till Max said "BE STILL!"
and tamed them with the magic trick

About the book: Sendak had wanted for years to produce a complete picture book: a work of the highest artistry in which text and pictures merged as seamlessly as in the creations of his heroes William Blake and Randolph Caldecott. In 1955, he sketched—then set aside—a dummy titled "Where the Wild Horses Are," a nearly wordless story about a small boy in search of adventure. He returned to the project in early 1963, writing story drafts every day or two for weeks until most elements of the now-classic tale had fallen into place. In a second dummy prepared in May of 1963, Sendak changed the word "horses" to "things," having realized that the choice freed him to depict Max's alter egos in whatever guise he wished. In taut lyrics and self-assured graphics, Sendak presented readers with a powerful outward projection of a small child's inner rage and capacity for redemption. In doing so, he ushered the picture book world into the Freudian age.

Publication history: Sendak's struggle over the story's resolution—his protracted search during the summer of 1963 for Max's rationale for giving up his newfound paradise and returning home—pressed Harper's production schedule to the limit, almost forcing the book's postponement until the following year. From the outset, most reviewers recognized *Wild Things* as a landmark work. In later years, Sendak himself tended to exaggerate the degree to which his ostensibly scary

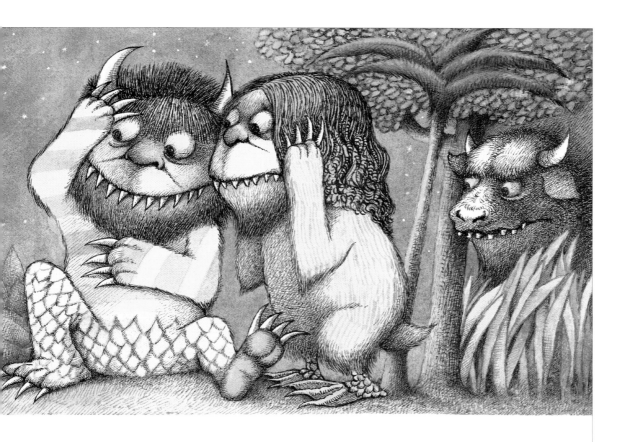

**of staring into all their yellow eyes without blinking once
and they were frightened and called him the most wild thing of all**

picture book had generated a scandal. In any case, after *Where the Wild Things Are* was awarded the 1964 Caldecott Medal, it guaranteed the book a permanent place of honor in library and school collections across the United States.

The psychoanalyst Bruno Bettelheim registered the most notable dissent when, in the March 1969 issue of *Ladies' Home Journal*, he criticized the story's food-deprivation theme as excessively harsh and potentially damaging to the very young.[1] (Inexplicably, in his bestselling *The Uses of Enchantment* of 1976, Bettelheim would make a compelling case for the beneficial effects on young children's development of the very kind of emotionally bracing story that

Where the Wild Things Are epitomized.) By 1980, when America's leading art book house, Harry N. Abrams, took the unprecedented step of canonizing Sendak with the publication of a full-dress coffee-table-style monograph, *Where the Wild Things Are* had been published in thirteen foreign-language editions. In time, it became one of the world's best-known picture books (alongside Eric Carle's *The Very Hungry Caterpillar*), and the inspiration not only for plush toys, a Macy's Thanksgiving Day Parade float, and an endless stream of poster and advertising art, but also for an opera, a feature film, and for countless parents in the United States and elsewhere who chose to name their newborn sons Max.

DR. SEUSS
born Theodor Seuss Geisel

born 1904, Springfield, Massachusetts, US;
died 1991, La Jolla, California, US

Biography: "Ted" Geisel, as friends and colleagues called him, grew up in a German American family of beer brewers and bakers. At Dartmouth College, he edited the campus humor magazine until being unceremoniously dismissed from the job following an Easter-time—and Prohibition era—incident involving a bottle of gin. After doodling his way through two years of graduate studies in English literature at Oxford University, Geisel published his first cartoon in the *Saturday Evening Post* in 1927 and found lucrative work in New York in corporate advertising. He was married by then and signing his cartoons and ad work "Dr. Seuss"—the degree was self-conferred—and he had dipped a toe into book publishing as the illustrator of the bestselling American edition of a British humor compilation for adults of children's witticisms, *Boners* (1932).[1] He entered the children's book world with a bang a few years later as the author and illustrator of *And to Think That I Saw It on Mulberry Street* (1937),

a picture book that prompted the New York Public Library's hard-to-impress Anne Carroll Moore to dub Geisel the "American Edward Lear."

Following the rise of fascism in Europe, Geisel drew hundreds of satirical cartoons in opposition to Hitler and Mussolini and supporting the American war effort in *PM*, a sophisticated, left-leaning New York daily. In 1943, he enlisted in the army and was assigned to the propaganda film unit headed by Frank Capra. After peace was declared, he concentrated on making children's books, first as an author-illustrator and, starting in 1958, also as the publisher of Beginner Books, a Random House imprint inspired by his own landmark book of the previous year, *The Cat in the Hat* (1957).

About the book: During the years of the tense Cold War standoff between the United States and the Soviet Union, many Americans focused their fears on the seeming failure of their nation's educational system to keep pace with that of their chief global adversary. The inferior quality of American science education was of particular concern, as were subpar literacy levels among schoolchildren. In an effort to reverse the latter trend, an editor at Houghton Mifflin whom Geisel knew

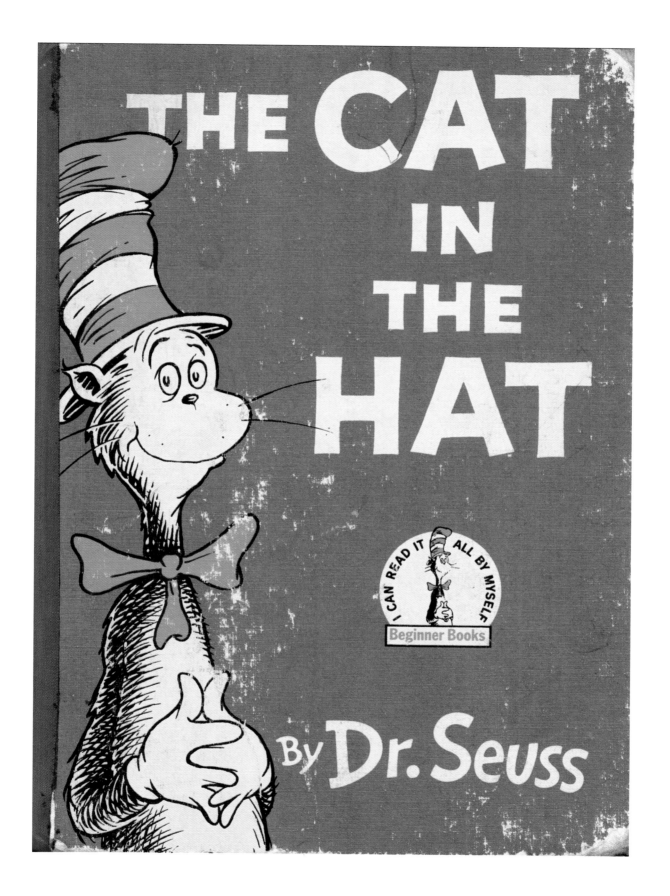

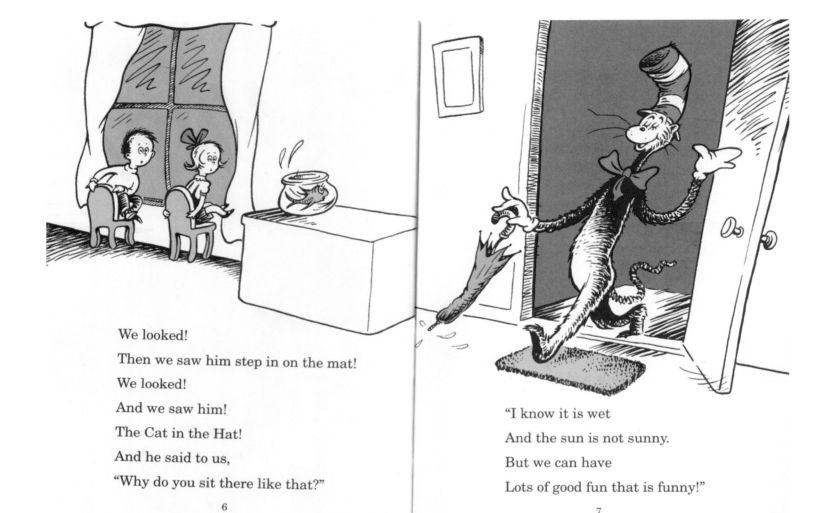

We looked!

Then we saw him step in on the mat!

We looked!

And we saw him!

The Cat in the Hat!

And he said to us,

"Why do you sit there like that?"

6

"I know it is wet

And the sun is not sunny.

But we can have

Lots of good fun that is funny!"

7

from the army proposed that "Dr. Seuss" invent a new kind of primer for beginning readers to supplant the ubiquitous "Dick and Jane" warhorse series: a jauntily written illustrated narrative composed from a "controlled vocabulary" list of 348 easily recognized "sight words"—a book that for once children would learn to read from because they found reading it was so much fun. The red, white, and blue color scheme of the illustrations suggested a patriotic subtext for a book largely motivated by the desire to keep America's Cold War enemy at bay. The story's manic protagonist with his off-kilter stovepipe hat and red bowtie even bore a certain resemblance to Uncle Sam.

The Cat in the Hat also lent itself surprisingly well to a Freudian interpretation, with the feverishly out-of-control cat a stand-in for the id, the scowling goldfish for the admonitory superego, and the hapless children caught between these two forces of nature as the ego that struggles to strike a proper balance. A more recent critique of the book enlisted a selective mix of biographical details and examples of illustrations from other Seuss books that clearly did perpetuate racial or ethnic stereotypes to argue that Geisel's cat was himself derived from the disgraced tradition of American minstrelsy. Fans of the book seem largely to have found the argument unpersuasive, but the reappraisal of the Seuss legacy it helped initiate made apparent that Geisel's history of representing non-white characters was indeed a problematic one and prompted his publisher in 2021 to put six of his more than sixty books out of print.

Publication history: *The Cat in the Hat* has had an extraordinary impact on American children's book publishing and popular culture. It helped launch an important new genre—the literary beginning reader for use in schools and at home—side by side with a somewhat similar title developed at Harper & Brothers, *Little Bear*, by Else Holmelund Minarik, with illustrations by Maurice Sendak, which appeared just a few months later in the fall of 1957. The huge and immediate commercial success of *The Cat in the Hat* prompted Random House (which, in keeping with its long-standing contract with Geisel, had retained the right to publish the trade edition, with Houghton Mifflin's slightly earlier edition limited to the educational market) to institutionalize the genre within a dedicated permanent imprint with Geisel at the helm. P. D. Eastman and Stan and Jan Berenstain were among the imprint's other early contributing author-artists. The barnstorming national publicity tour that Geisel undertook for the 1958 sequel *The Cat in the Hat Comes Back* established a new industry paradigm for juvenile book promotion. Geisel's Cat became the Beginner Books logo and one of the world's most widely recognized children's-book-related images, the inspiration for a US Postal Service stamp, a Macy's Thanksgiving Day Parade balloon, a Broadway musical, and a Hollywood film, among countless other iterations. Although an exceptionally difficult challenge for translators, *The Cat in the Hat* has been published in French, Chinese, Swedish, and Latin.

ERNEST H. SHEPARD

born 1879, St. John's Wood, London, UK;
died 1976, Midhurst, UK

Biography: "Kipper" Shepard, as friends and colleagues called him, was the son of a London architect and a respected watercolorist's daughter. Both parents were talented amateur actors as well, and Shepard, the second of their three children, grew up in an atmosphere of steady appreciation for the arts. Following a preparatory education at St. Paul's School, where his talent for drawing was recognized, Shepard undertook serious art studies culminating in a scholarship to the Royal Academy Schools. By 1906, he had established himself as a book illustrator and contributor to *Punch*, Britain's premier humor magazine. He was invited to join the "*Punch* table," or illustration staff, in 1921, and rose to lead cartoonist in 1945, a position once held by John Tenniel.

Shepard was known for his easy smile and optimistic manner, but he was also a naturally shrewd businessman and tough-minded professional who during the First World War had earned distinction in battle, rising to the rank of major. Back from the war, he brought a new vitality to *Punch*, prompting the magazine's historian R. G. G. Price to remark, "With Shepard, the rest of *Punch* began to look static. . . . Even when the scene . . . was a conversation one feels that there was a wind in the room and that someone had just moved and that someone else was about to move."[1] Despite this record of accomplishment, Shepard somehow did not seem the obvious choice to A. A. Milne when the London playwright, humorist, and literary lion offered the magazine eleven verses from the manuscript that would afterward be published as *When We Were Very Young* (1924). Once Milne overcame his initial hesitation, however, he was grateful for Shepard's nimble, expressive drawings that helped introduce to the world the soon-to-be-immortal characters Christopher Robin and Winnie-the-Pooh and that catapulted the artist's reputation skyward. Shepard went on to illustrate all four Pooh books published in the author's lifetime. Though he benefited mightily from his association with the series, Shepard later expressed some regret at having seen the rest of his vast and varied body of work eclipsed by his identification with "that silly old bear."[2]

About the book: *Winnie-the-Pooh* followed by two years the runaway success of *When We Were Very Young*. Milne had sent Shepard detailed notes about the illustrations he thought necessary for the new book. Shepard obliged his collaborator by visiting the author both in London and at his East Sussex home, Cotchford Farm, where he sketched the surrounding countryside. Leaving no stone unturned, Shepard also had photographs made of Milne's young son Christopher Robin and his stuffed toy animals.[3] In the end, the artist modeled Pooh not on the Milne child's toy (or the real "Winnie" that the boy had fallen in love with at the London Zoo), but rather on his own son Graham's stuffed bear, Growler.[4]

Publication history: *Winnie-the-Pooh* (1926) struck a chord with war-weary readers on both sides of the Atlantic, who hailed the book as a salutary dose of childlike wisdom for a dark and troubled world. When initial sales did not measure up to those of *When We Were Very Young*, Milne and Shepard went back to work and produced a second verse collection, *Now We Are Six* (1927), including several poems featuring Christopher Robin, Pooh, and friends. Soon after their fourth and final major collaboration, *The House at Pooh Corner* (1928), appeared, the extensive marketing of the Pooh franchise began in earnest with the broadcast of the BBC *Children's Hour* radio adaptation, the mounting of various stage productions, and the marketing of a Christopher Robin tea set, a painted ceramic Winnie-the-Pooh bookend set, notecards, nursery prints, jigsaw puzzles, board games, and countless other novelty items and spin-offs.[5]

Although the Pooh books had their detractors—notably the acerbic American wag Dorothy Parker—they quickly surged to modern-classic status, taking their place among the best-selling children's books of all time. Shepard lived to see his Pooh drawings exhibited at the Victoria and Albert Museum in 1969, a rare tribute at the time for a children's book illustrator. His illustrations remained well known even after Disney acquired film and other licensing rights to the Pooh books in 1961, although in the end the Disney versions of the characters have undoubtedly supplanted them for the children of more recent generations.

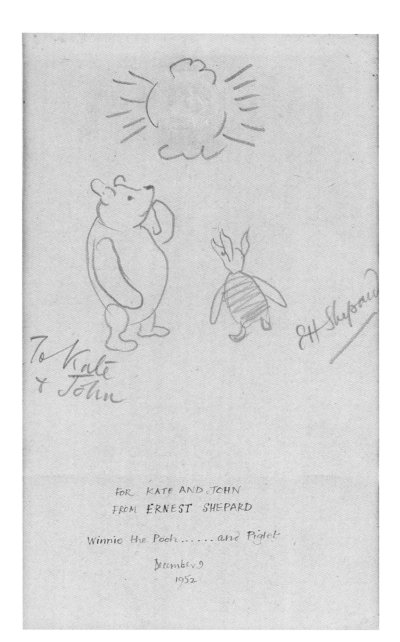

PETER SÍS

born 1949, Brno, Czechoslovakia

Biography: Although the strictures of life under Communist rule in Cold War–era Czechoslovakia did not discourage Peter Sís from pursuing a career in art, the experience of top-down censorship and suppression of dissent had a major impact on both the path he chose and the work he created. As an animation student during the 1960s, Sís learned the fabulist's art of cunning indirection: how to conceal a social or political comment within a seemingly innocuous image or narrative. Inspired in part by the mandalas his documentary filmmaker father brought home from Tibet, he also developed a code-like private pictorial language that became a hallmark of his subsequent illustration work—a visually arresting iconography meant to pry open the viewer's imagination while keeping some secrets to itself.

In 1982, Sís traveled to Los Angeles to document the summer Olympics as a member of a Czech government–sponsored film crew. Once there, he decided to seek political asylum and was granted permission to remain in the United States. Among his first American art commissions was the poster design for the film *Amadeus*. At about this time, a mutual friend introduced him to Maurice Sendak, who urged him to move to New York and to illustrate children's books. Taking Sendak's advice, he freelanced for the *New York Times Book Review, Time*, and other publications as he developed his first picture book projects.

In the years that followed, Sís maintained both personal and cultural ties to his native country. After the fall of the Communist regime, the Czech Republic honored him with exhibitions and other recognition. In 2012, Sís won the international Hans Christian Andersen Award for illustration as the nominee of the Czech Republic.

About the book: A major strand of Sís's book work has been a series of picture book biographies of iconoclastic historical figures notable for their challenges to received opinion and for their bravery in the face of ridicule and condemnation. Following conventionally formatted picture books about Christopher Colum-

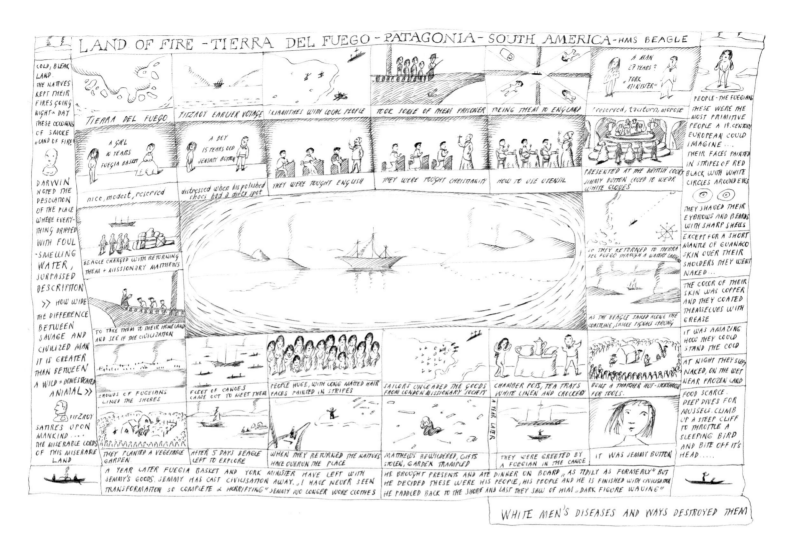

bus and Galileo came the longer, graphically far more ambitious *The Tree of Life: Charles Darwin* (2003).

As in the earlier books, the most remarkable feature of *The Tree of Life* had less to do with traditional portraiture per se than with a complex visual layering of insights about an extraordinary individual's world, mind, and spirit. Sís's lifelong fascination with maps and diagrams, gardens and mazes, monumental structures and other built environments, and natural forms all came into play in these elaborately choreographed page layouts that harmonize multiple scenes, vignettes, and storylines.

Publication history: Sís published *The Tree of Life: Charles Darwin* one month after being named the recipient of a 2003 MacArthur "genius" grant. The convergence of these events resulted in a flood of American media attention, especially as Sís was the first children's book illustrator to win the glamorous prize. The MacArthur grant was in fact only the latest of many top-rung honors to come his way, including three Caldecott Honors, the Andersen, and others. *The Tree of Life* went on to be published in at least ten European and Asian foreign-language editions. The original art for the book was exhibited internationally.

PUBLIC LIFE: Darwin decided he needed to produce more work to be accepted as a first-class naturalist and planned to write a short paper on barnacles. He ended up spending the next eight years studying living and fossil barnacles. Then, in 1851–1854, he published four volumes on them. He won the recognition he was looking for and honors as well.

PRIVATE LIFE: His work was interrupted by a long period of ill health, and in 1849 he took the then-popular water cure, which helped him. His favorite daughter, ten-year-old Annie, developed symptoms similar to his and died in 1851. Another son, Horace, was born three weeks later.

SECRET LIFE: His writings about evolution sat on the shelf.

PUBLIC LIFE: Darwin became a pigeon breeder, hoping that by studying the variations in domesticated pigeons (descended from the rock dove) he might find clues to support his theory of adaptation to an environment and natural selection. He also did experiments with plants and seeds.

PRIVATE LIFE: In 1858, his youngest son, Charles Waring, died of scarlet fever. The family fled Down House.

SECRET LIFE: On September 9, 1854, he wrote in his journal: "Began sorting notes for species theory." He dusted off his secret writings, took another look at an unpublished essay he had written in 1844 about the transmutation of species, and in 1857 wrote a letter to the American botanist Asa Gray, outlining his theory. Then, on June 18, 1858, he received a manuscript from Alfred Russel Wallace, a young botanist collecting specimens in the Malay archipelago, setting forth much the same conclusions as Darwin's about natural selection. Darwin turned to Lyell. He wrote, "Your words have come true with a vengeance that I should be forestalled . . ." Lyell and Hooker came up with a plan to establish Darwin's priority.

ALFRED RUSSEL WALLACE's manuscript came as a bombshell to Darwin. His friends Lyell and Hooker arranged for Wallace's paper, together with a summary of Darwin's 1844 essay and outline of his theory, to be presented to the Linnaean Society on July 1, 1858. There was no reaction; the president of the society called it an uneventful year. Relieved, Darwin set to work. Over the next eight

On the Origin of Species sparked an explosion. Thomas Henry Huxle

THE
GREAT OXFORD
DEBATE, JUNE 30, 1860.
Darwin's theory is attacked by
Samuel Wilberforce, Bishop of Oxford,
who was coached by Richard Owen. The
bishop asked Huxley if it was through his
grandfather or his
grandmother that he was descended from
an ape. Huxley replied that he'd rather
be the grandson of an ape than
related to a man who misused
his mind for the

While Darwin's friends defended his theory
of evolution by natural selection—especial-
ly T. H. Huxley, who was called "Darwin's
bulldog"—Darwin kept on working. He was
always puzzling over something—orchids,
earthworms, facial expressions—and spent
the next twenty years revising his earlier
books and writing new ones.

1862 On the Various Contrivances by
Which British and Foreign
Orchids Are Fertilised by Insects, and
on the Good Effects of Intercrossing
1865 The Movements and Habits of
Climbing Plants
1868 The Variation of Animals and Plants
under Domestication
1871 The Descent of Man, and Selection
in Relation to Sex
1872 The Expression of the Emotions in
Man and Animals (One
of the first books illustrated with
photographs; 5,267 copies sold in one day.)
1876 The Effects of Cross and Self
Fertilisation in
the Vegetable Kingdom
1881 The Formation of Vegetable Mould,
Through
the Action of Worms, with
Observations on Their Habits (Horace Darwin
designed a special
instrument called the Worm Stone to measure
the action of worms.)

My industry has been nearly as great as it
could have been in the observation and

ESPHYR SLOBODKINA

*born 1908, Chelyabinsk, Russia; died 2002,
Glen Head, New York, US*

Biography: Growing up in Russia and the Soviet Union as the daughter of an oil company manager and within a family that placed a high premium on culture and education, Esphyr Slobodkina was given every encouragement to develop her talent for art. In 1928, she followed her older brother to New York to continue her studies. Enrolling in the conservative National Academy of Design, she honed her classical drawing skills but also broke with tradition to embrace the modernist ideals of a colorful fellow Russian whom she met at the Academy, Ilya Bolotowsky. By the mid-1930s, Slobodkina and Bolotowsky had married—and divorced—and become founding members of a group of like-minded painters and sculptors who called themselves the American Abstract Artists. Although largely ignored by the Eurocentric New York museum world hierarchy,

the remarkable band also included Balcomb Greene, Charles G. Shaw, Suzy Frelinghuysen, and others.

Always on the lookout for supplementary income, Slobodkina took a tip from a friend and presented her portfolio to a children's book editor reputed to have adventurous taste. The editor, Margaret Wise Brown, was a brilliant and prolific picture book writer as well as the guiding force behind the small new Greenwich Village–based publishing firm of W. R. Scott. Whenever Brown met an illustrator she wished to publish, she simply went home and composed a manuscript to order overnight.

Slobodkina's first published work as an illustrator, *The Little Fireman* (1938), came about in this way. The illustrations are notable both for being among the first examples of semiabstract art and the very first instance of collage art in an American picture book. With editorial guidance and encouragement from Brown, Slobodkina published her first solo effort, *Caps for Sale*, two years later, on Scott's fall 1940 list.

About the book: *Caps for Sale: A Tale of a Peddler, Some Monkeys & Their Monkey Business* was the artist's retelling of a traditional folktale of unknown origin. The flatly stylized, deliberatively naive illustrations reflected the artist's childhood affection for paper dolls and her fascination with Russian folk art and design motifs. Commenting in her unpublished memoir on her approach in *Caps* to balancing abstraction with representation, Slobodkina observed: "This [hapless peddler] being a very specific individual, there was no question of dropping details of his face. He wasn't just any Little Fireman, a symbolic figure with which any child was expected to identify. My peddler was to be a person, a character, and any child dramatizing the story would, I felt, naturally play him as an actor plays a part."[1]

Publication history: The first edition was well reviewed but so poorly printed in three colors that Scott, to make amends, invited Slobodkina to reillustrate the book from scratch. The second, 1947, edition was printed in a subtler palette and proved far more satisfactory. The relaunch catalyzed sales and sent *Caps for Sale* on its way to becoming a modern classic with foreign editions published in French, Spanish, Danish, Swedish, Chinese, Korean, Afrikaans, Hebrew, and Zulu. In 1996, Harper took over publication of the book in the United States along with several other children's titles it had acquired from Scott through its purchase of an intermediary rights holder, Addison-Wesley. A full-dress musical stage production based on *Caps for Sale* made its debut at New York's New Victory Theater in 2016.

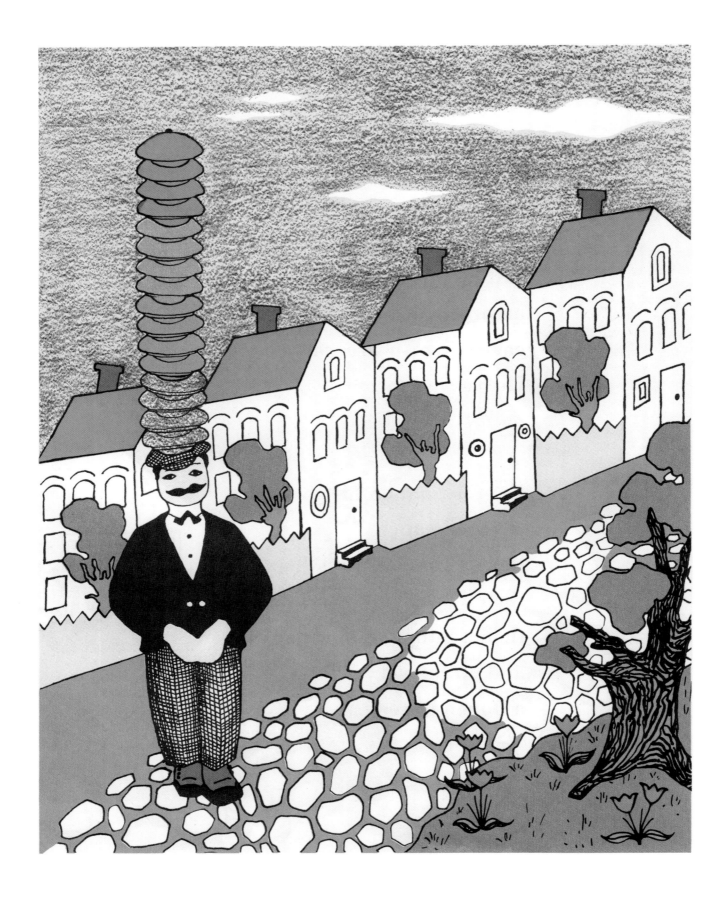

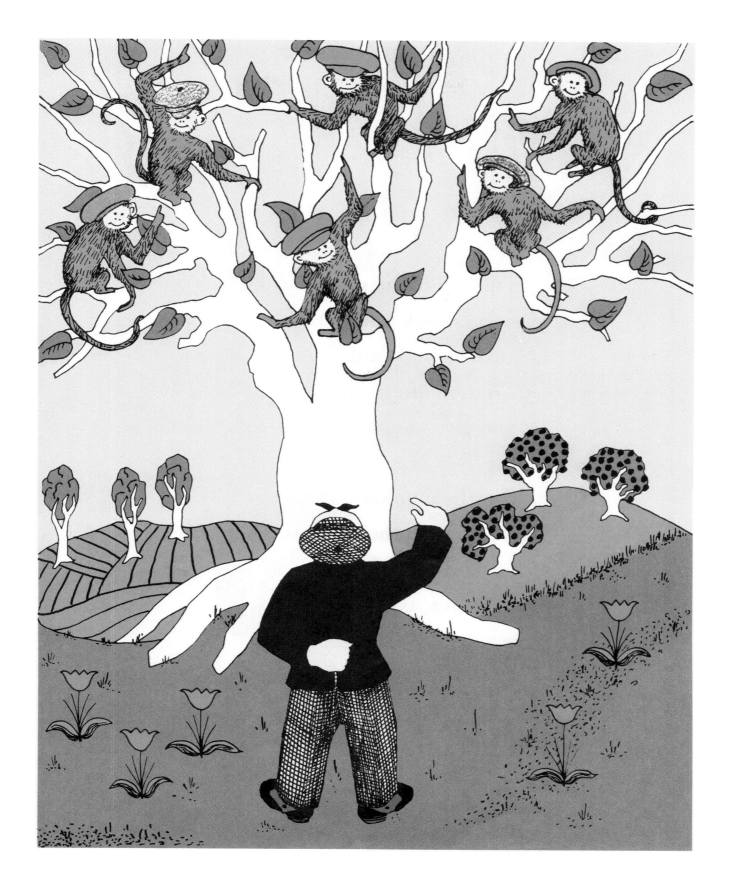

LANE SMITH

born 1959, Tulsa, Oklahoma, US

Biography: Shy, laconic, appraising Lane Smith studied editorial illustration at ArtCenter College of Design in Pasadena, where an interest in the work of "naïve" artists such as Paul Klee and Alexander Calder prompted him to have a look at the children's picture books in the college library. After graduation, he headed for New York and began freelancing for the *New York Times, Time, Mother Jones, Ms.,* and *Sport*. The dark, punk-inflected drawings in Smith's portfolio had little in common with typical 1980s children's book art. But times were changing, and the period's media-savvy, college-educated new wave of twenty- and thirty-year-old parents—the first generation to have grown up on Maurice Sendak, Shel Silverstein, and Tomi Ungerer—were primed to accept a more knowing vision of life's first years, and a few publishers sensed this. Smith's first picture book credit resulted from an editor's positive response to twenty-six archly macabre paintings, each pegged to a letter of the alphabet, which he had developed as a portfolio piece. Poet Eve Merriam composed brief poems for each of the paintings for the book published as *Halloween ABC* (1987). Soon afterward, Smith joined forces with two other collaborators with whom he formed much longer-lasting associations, writer Jon Scieszka and designer Molly Leach.

When they met, Scieszka was a schoolteacher and aspiring children's book writer who shared Smith's irreverent sensibility. Their first published collaboration, *The True Story of the Three Little Pigs* (1989), was a tongue-in-cheek mash-up of the traditional nursery tale, and it became a *New York Times* bestseller. Central to the book's distinctive look and appeal was the off-kilter sophistication of its visual design and typography. This was the contribution of Smith's girlfriend and future wife, magazine art director Molly Leach.

About the book: *The Stinky Cheese Man and Other Fairly Stupid Tales* (1992) was the trio's follow-up effort, and it proved to be a history-making book. This time around, Scieszka prepared a series of devil-may-care parodies of old-chestnut folktales such as "Jack and the Beanstalk," "the Ugly Duckling," and "Little Red Riding Hood," and the collaborators put their heads together to match the anarchic, Marx Brothers–inflected verbal hijinks blow for blow with art and design elements that all felt a bit unhinged. The table of contents came somewhere in middle of the book. So did a page announcing "The End." The type on another page appeared to be melting from the heat of the baking oven depicted in the illustration. Collaged snippets of pictorial details from a hodgepodge of children's classics added another layer to the merry chaos. Smith's expressionist art winked conspiratorially at the reader from every page.

When she opened the oven to see if he was done, the smell knocked her back. "Phew! What is that terrible smell?" she cried. The Stinky Cheese Man hopped out of the oven and ran out the door calling, "Run run run as fast as you can. You can't catch me. I'm the Stinky Cheese Man!"

The little old lady and the little old man sniffed the air. "I'm not really very hungry," said the little old man. "I'm not really all that lonely," said the little old lady. So they didn't chase the Stinky Cheese Man. The Stinky Cheese Man ran and ran until he met a cow eating grass in a field. "Wow! What's that awful smell?" said the cow.

Publication history: *The Stinky Cheese Man* was an instant bestseller in part because large numbers of college students and adult book collectors purchased copies for themselves. Noting the trend, the publisher took the highly unusual step of advertising the book on late-night national television. *The Stinky Cheese Man* received a 1993 Caldecott Honor and was widely recognized by librarians and teachers as an important contribution to the Dr. Seuss tradition of books that even the most reluctant readers were likely to find irresistible. It spawned countless imitations of its tongue-in-cheek humor and freewheeling approach to design and for all intents and purposes signaled the end of the era in American picture books when young children were presumed to be innocent about life and uncritical of the timeless tales of tradition. Foreign-language editions include French, Portuguese, Chinese, Korean, and Japanese.

WILLIAM STEIG

born 1907, Brooklyn, New York, US; died 2003, Boston, Massachusetts, US

Biography: "I was going to be a seaman, like Melville," William Steig once recalled, "but the Great Depression put me to work."[1] The third of four sons of ardent Jewish socialists, Steig began to draw at an early age and was that rare aspiring artist whose parents gave him their wholehearted blessing. Joseph and Laura Steig preferred their children to choose creative careers rather than be exploited—or exploit others—in a conventional job. Steig sold his first drawing to *The New Yorker* in 1930, quickly became a regular contributor, and was soon supporting his parents. Over the next seven years, he remained in the top rank of *New Yorker* artists, perhaps second only to the preternatural Saul Steinberg.

Steig moved beyond gag cartooning to produce "symbolic drawings" generated by a freer approach to image making that he was encouraged to explore by his friend and mentor, the maverick psychoanalyst Wilhelm Reich. He published drawings of this kind in a number of well-received collections, most notably *The Lonely Ones* (1942), in which first appeared an image

that also circulated widely during the war years as a poster: that of a crumpled man cowering in a box over the caption "People are no damn good." Steig was in his sixties when, at the urging of his fellow *New Yorker* cartoonist Robert Kraus, he launched a new phase of his career as a picture book artist with the publication by Kraus's Windmill Press of *Roland the Minstrel Pig* and *CDB!*, both in 1968.

Steig, who never completely shed his New York accent and earthy, streetwise manner, was able to translate his playful conversational style into winning story texts that served as a platform for his graceful, droll, and intensely colorful illustration art. Although he preferred spontaneous doodling to the more controlled kind of drawing required for sustaining a continuous picture book narrative, he thrived in the new art form and went on to produce two soulful illustrated novels for young readers as well.

About the book: Steig won the 1970 Caldecott Medal for his third picture book, *Sylvester and the Magic Pebble*. In characteristic fashion, he had crafted a story that was at once emotionally gripping and uproariously funny. The theme of a child's separation from his parents owed something to Steig's then-current situation as a recently divorced parent living apart from his young daughter. He later said that he chose a donkey as the story's protagonist because, as beasts of burden, donkeys epitomized the admirable, working-class values he had grown up admiring in contrast, say, to the prancing, preening manner of show horses.

In the story, the magic pebble with wish-granting powers that Sylvester comes upon by chance embodies Steig's sense of the wonder of everyday existence, an article of faith he shared with another of his lifelong heroes, William Blake. As this wise and artful story goes on to suggest, to possess such a magic talisman is not enough. One must also know *what* to wish for—or, like Sylvester, risk being trapped in a terrible predicament. Steig's picture book has few equals for the fearlessness with which it plumbs the depths of raw loneliness and despair before resolving itself in a happy ending that is both joyful and wholly earned. *Sylvester and the Magic Pebble* was Steig's Blakean *Songs of Innocence and Experience* rolled into one.

Publication history: Eager to shed the lucrative advertising work he also did but felt morally ambivalent about, Steig was delighted to discover that winning the Caldecott Medal could work wonders for book sales and an illustrator's long-term prospects. Always a fluid writer, he went on to write and illustrate nearly thirty children's books, several of which have been published in multiple foreign-language editions. In his last years, he collaborated on a handful of books with his wife, Jeanne Steig, and illustrator Harry Bliss.

As a Caldecott Medal winner, *Sylvester and the Magic Pebble* was bound to reach a large international audience. Foreign editions have included German, Danish, Italian, Portuguese, Catalan, Spanish, French, Romani, Russian, Korean, Japanese, Chinese, Afrikaans, and Hebrew. It was not *Sylvester*, however, but *Shrek!* (1990), a late-career story about a curmudgeonly ogre, that indirectly brought Steig his largest audience when DreamWorks adapted that book (albeit quite loosely) for a series of phenomenally successful animated feature films.

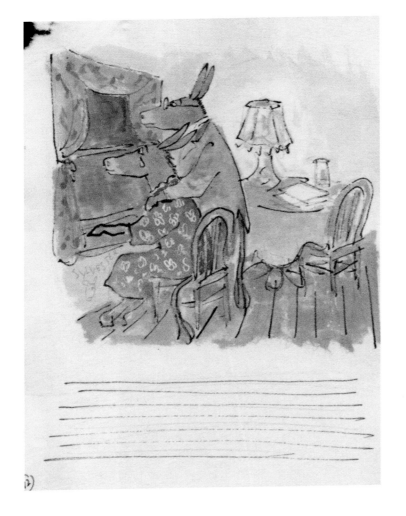

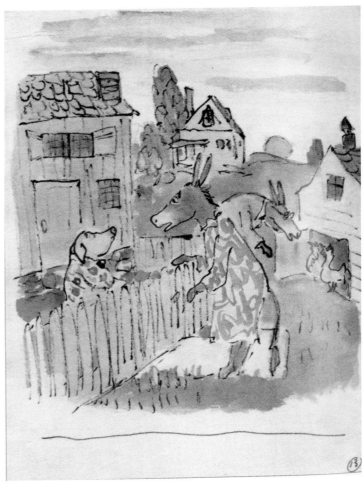

SHAUN TAN

born 1974, Fremantle, Western Australia

Biography: Shaun Tan once told an interviewer, "Travelling and drawing are very similar activities in that they force you to look at everything carefully."[1] Similar, but not quite the same: Tan found that he could draw only when he was *not* also travelling, and that for him the very act of drawing had the power to reveal a hidden core of meaning in even the most un-travel-worthy of places, for example the strip malls he took for granted while growing up in suburban middle-class Western Australia.

As a schoolchild, Tan wrote and illustrated science fiction stories, but only for fun rather than because he had dreams of a life in the arts. If asked then, he might have predicted a future for himself as a geneticist. He was a university student when art finally grabbed him. The satisfaction he derived from the occasional freelance illustration jobs he found to help finance his education gradually pointed him in the direction of picture-book-making as a career objective. In the years after graduation, he established the pattern of illustrating one or more picture books a year, sometimes also writing the story. Then, around 2001, he took a giant leap by undertaking the monumental project that five years later came to be known around the world as *The Arrival* (2006).

About the book: *The Arrival* was published just as the graphic novel was gaining widespread recognition as a serious art form, and the illustrated book for older audiences (including adults) was emerging as an exciting arena for experiments in visual narrative. As a wholly wordless book, *The Arrival* made sophisticated use of comics-style sequential storytelling techniques and strategies while dispensing altogether with word and thought balloons and hewing to a magical-realist pictorial style that had more in common with Magritte than the funny papers.

Tan's arresting sepia-tone drawings, housed between faux-distressed photo-album covers, document the arduous journey of an unnamed man from his unspecified home country to a distant land where he struggles to establish a new life against the backdrop of an inhumanly scaled, nightmarish cityscape. The vast arrival pavilion suggests an amped-up version of New York's historic immigrant collection center, Ellis Island. But Tan has discouraged any such literal reading, preferring to leave open the possibility of a more general interpretation: "We all find ourselves in landscapes that we don't fully understand, even if they are

familiar . . . There is also the idea that any creative thinking carries some problem of identity and meaning, that individuality needs to be endlessly negotiated."[2]

Publication history: *The Arrival* was published in the UK and Australia in 2006 and in the United States the following year. Art Spiegelman led the parade of A-list graphic novelists who hailed *The Arrival* as a signal achievement. Writing in an advance comment on the book's potential for reaching a crossover audience, Spiegelman observed: "For adults, Tan's New World offers a childlike sense of discovery; for children it offers an adult theme made eminently accessible."[3] *The Arrival* garnered a raft of major awards: the Children's Book Council of Australia 2007 Best Picture Book of the Year prize, a 2007 Bologna Children's Book Fair Ragazzi Award Special Mention, the 2007 *New York Times* Best Illustrated Book Award, and the Angoulême International Comics Festival's 2008 Best Comic Book, among others. Tan went on to win the prestigious 2011 Astrid Lindgren Memorial Award for the body of his work.

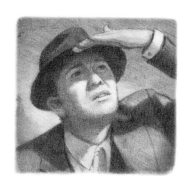

GUSTAF TENGGREN

born 1896, Magra, Sweden; died 1970,
Southport, Maine, US

Biography: With encouragement from his family of decorative artists, Gustaf Tenggren was still quite young when his talent for draftsmanship and visual storytelling came to light. His first published illustrations appeared in 1917 in the Swedish annual *Bland tomtar och rroll* (*Among Gnomes and Trolls*). Two years later, following the example of his father and older brother, Tenggren left Sweden in pursuit of the American Dream, taking up residence in Cleveland, Ohio, where a rude shock awaited him when the first American editors he met told him that his accomplished drawings were too dark and fantastical for their taste. Shaken but undaunted, Tenggren took time out to adjust his drawing style to the American market and in 1922 swept

triumphantly into New York, quickly grabbing up all the book contracts and assignments from top magazines like *Good Housekeeping* and *Redbook* that he could want. In 1936, Walt Disney recruited Tenggren as a concept artist for the Disney Studios just as the company was gearing up to produce the world's first feature-length animated film, *Snow White and the Seven Dwarfs*. He made significant contributions to that film as well as to *Pinocchio, Fantasia*, and *Bambi* before returning to New York for the greater artistic freedom and control that illustrating children's books had to offer. In 1942, he illustrated *The Poky Little Puppy*, one of twelve picture books on the inaugural list of an innovative mass-market publishing venture, Little Golden Books. Over the next twenty years, Tenggren illustrated dozens of Golden Books in a variety of formats.

About the book: As one of the first twelve Little Golden Books released in October 1942, *The Poky Little Puppy* represented a publishing experiment in several respects. The new line of twenty-five-cent books was a collaborative venture of Simon & Schuster, then an upstart New York publishing firm known for its populist approach to sales and marketing, and the Western Printing Company, a Midwestern Goliath with powerful presses capable of achieving enviable economies of scale. The partners' combined expertise allowed them to dramatically undersell the competition at a time when the average picture book cost between $1.50 and $2.00. Novelist Janette Sebring Lowrey wrote *The Poky Little Puppy*'s spritely text on a busman's holiday and for a modest flat fee. Tenggren received a small royalty. The artist's approach to the project was, in a sense, to re-imagine the Seven Dwarfs—popular characters he had had a major hand in developing at Disney—as the book's equally hard-to-resist puppies.

Publication history: The uniform trim size and look, the Swedish-style (stapled) binding, and rock-bottom retail price were among the factors that dissuaded high-end retailers, at first, from stocking Little Golden Books, and in the weeks leading up to the line's initial release, its success appeared to be very much in doubt.

Wherever the books were offered for sale, however, they sold out immediately, and throughout the war years, when paper rationing was a vexing issue for publishers generally, the partners' greatest challenge was to keep pace with the ever-growing demand. When in 1984 the one billionth Little Golden Book was due to roll off the presses, a copy of *The Poky Little Puppy* was chosen for the honor, as it had remained the line's consistent top seller from 1942. Foreign rights to Little Golden Books were first sold after the Second World War. Foreign language editions of *The Poky Little Puppy* include Chinese, Dutch, Spanish, Greek, German, Danish, Finnish, French, Indonesian, Korean, and Swedish.

1889

JOHN TENNIEL

born 1820, London, UK; died 1914, London, UK

Biography: On realizing that the academic training offered at London's Royal Academy of Art was not to his liking, John Tenniel, then a shy but forthright young man, dropped out and set about training himself to draw from memory. After an interval during his twenties when he considered concentrating on painting, Tenniel sought out freelance illustration work and soon caught the eye of the editors at *Punch*. In 1850, Tenniel accepted the staff position vacated by Richard Doyle.

Known for his dry wit, knack for animating a figure, and for his fastidious attention to detail, Tenniel in 1861 replaced John Leech as *Punch*'s lead illustrator. He was thus an artist of high reputation when in January 1864 an unknown Oxford mathematics lecturer named Charles Dodgson approached him about illustrating a children's fantasy he had recently composed. That April, after some initial hesitation, Tenniel

accepted the commission to illustrate *Alice's Adventures in Wonderland* (1865) and embarked on one of the most consequential collaborations in children's book history. Tenniel illustrated the sequel, *Through the Looking-Glass* (1871) as well but, for reasons that remain uncertain but may have had to do with Dodgson's penchant for control, he declined to work on most subsequent projects by the author known to the world as Lewis Carroll. (They did collaborate again on the 1890 abridgment for younger children, *The Nursery Alice*.) Queen Victoria knighted Tenniel in 1893 for his lifetime of art-making and public service.

About the book: Tenniel, who disliked drawing from a model, seems to have invented the iconic Alice of his illustrations from memory or imagination. She bears no resemblance, in any case, to the much-photographed Alice Liddell, the daughter of the Oxford dean at whose urging Dodgson improvised the earliest version of the Wonderland tale during a summer outing. Curiously, Tenniel's Alice *does*, however, resemble a girl depicted in the crowd scene of a June 1864 *Punch* cartoon drawn by him, on a subject related to the American Civil War. The artist, who had already started work on Dodgson's fantasy, may have used the cartoon as a sort of dry run.

The first recorded version of the improvised *Alice* story was a handmade, one-of-a-kind manuscript titled *Alice's Adventures Under Ground* (1864), with Dodgson's own illustrations. He presented it as a keepsake to Alice Liddell in late November of 1864. Once Dodgson's thoughts turned to publication, however, he felt the absolute need not only to improve upon and expand the text but also to secure the services of a first-rate professional illustrator—a cost he assumed in return for a higher percentage of the profits. It was at this point that he turned to Tenniel. Dodgson also art directed Tenniel to some extent, but it is not altogether clear (as some have speculated) that his perfectionism led to a falling-out between them.

Publication history: Dodgson planned publication of *Alice's Adventures in Wonderland* for July 4, 1865, three years to the day after the story had been born. But when Tenniel bitterly complained about

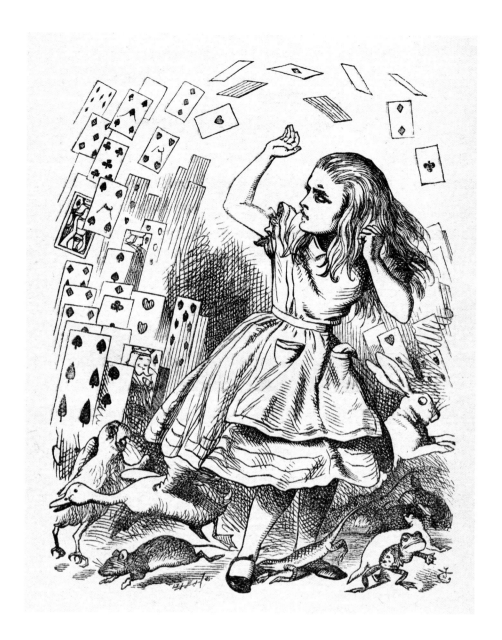

the quality of the initial printing, Dodgson agreed to pull back the first copies that had gone out to readers, and the publisher, Macmillan, undertook to reprint the book from scratch. Meanwhile, an American publisher, Appleton, bought up the imperfect sheets and released the book later that year in the United States. It was finally published in the UK in early 1866.

Despite this inauspicious start, *Alice* was an immediate and sustained commercial and critical success on both sides of the Atlantic. Translations into French and German appeared in 1869, followed by an Italian translation two years later. In all, more than 170 translations would be published around the world in *Alice*'s first 150 years.

Tenniel's substantial role in the creation of Carroll's masterpiece greatly added to his fame. In later years, he produced exact copies of the *Alice* illustrations for sale or as gifts, and looked on (after 1907, when *Alice* passed into the public domain in Britain) as a seemingly endless parade of other illustrators vied to put their stamp on Wonderland. Scores of artists have undertaken this quest, but none, including even Walt Disney, may be said to have supplanted Tenniel, whose forty-two pencil drawings rank high among the world's best-known pictorial icons.

CHAPTER II.

THE POOL OF TEARS.

"Curiouser and cu-
riouser!" cried Alice
(she was so much sur-
prised, that for the
moment she quite for-
got how to speak good
English); "now I'm
opening out like the
largest telescope that
ever was! Good-bye,
feet!" (for when she
looked down at her
feet, they seemed to
be almost out of sight,
they were getting so
far off) "Oh, my poor
little feet, I wonder

PIG AND PEPPER. 93

at least not so mad as it was in March." As she said this, she looked up, and there was the Cat again, sitting on a branch of a tree.

"Did you say pig, or fig?" said the Cat.

"I said pig," replied Alice; "and I wish you wouldn't keep appearing and vanishing so suddenly: you make one quite giddy."

"All right," said the Cat; and this time it vanished quite slowly, beginning with the end of the tail, and ending with the grin, which remained some time after the rest of it had gone.

WALTER TRIER

born 1890, Prague, Austro-Hungarian Empire;
died 1951, near Collingwood, Ontario, Canada

Biography: One of Weimar Germany's leading satirical cartoonists and an ardent anti-fascist, Walter Trier was born into a middle-class German Jewish family in Prague. After completing his art studies at the Royal Academy in Munich, Trier moved to Berlin, where he met with sustained success as an illustrator for *Lustige Blätter* (*Funny* Papers) and *Berliner Illustrirte Zeitung* (*Berlin Illustrated Newspaper*) before fleeing the Nazi regime in 1936 and moving to London, where he resumed his career.

By then, Trier had entered into a fruitful collaboration with German journalist, poet, and songwriter Erich Kästner, whose first children's book, *Emil and the Detectives* (1929), with illustrations by Trier, was an instant sensation. Kästner, whose pacifist views had prompted him to turn to writing for children—the people he believed most capable of change—continued in

the same vein well after the war years. In 1960, *Emil*'s author was honored with the Hans Christian Andersen Award.

Trier illustrated fifteen of Kästner's books for young readers while also becoming a ubiquitous presence in British homes as the regular cover artist, from 1937 to 1949, of *Lilliput*, a popular monthly "pocket magazine for everyone" featuring humor, fiction, photography, and art. A typical *Lilliput* cover design depicted a well-turned-out young couple and their Scottie dog comically engaged as a threesome in some carefree leisure activity. After the war, Trier joined his married daughter in Canada, where he continued to do his work and where, shortly before his death in 1951, the University of Toronto mounted a retrospective exhibition of his paintings.

About the book: *Emil and the Detectives* stood apart from the German children's fiction of its day as a tale set not in the once-upon-a-time story-realm of the Grimms or the slapstick fantasy world of Wilhelm

Busch, but rather in bustling, cosmopolitan 1920s Berlin. As the illustrator of Kästner's tough-minded yet endearing tale of adult duplicity and childhood resilience and heart, Trier brought a light but unsentimental touch to fluid line work salted with sly moments of satirical wit. The children Trier memorializes in these scenes clearly face an uphill battle as newcomers to a fiercely hierarchical and opportunistic society, and the illustrations themselves, like their subjects, are a persuasive and nuanced blend of knowingness and naïveté.

Publication history: *Emil and the Detectives* became a bestseller in Weimar Germany and was subsequently published in more than fifty translations. It is a grim testament to its iconic status in Germany that when the Nazis publicly burned other books by Kästner, *Emil* was spared. Among the first young readers of the 1938 American edition was the ten-year-old, Brooklyn-born

Maurice Sendak, who decades later recalled the pleasure he had taken in the story's sense of "real danger and playful comedy and total lack of condescension."[1] The book has inspired five film adaptations, the first of which, with a screenplay by Billy Wilder, was released in 1931 to great commercial success. Later feature-length adaptations appeared in Germany, England, and the United States, and in 2013 London's National Theatre staged *Emil and the Detectives* as its Christmas holiday show. Asked at the time of that production to account for *Emil*'s longevity, British children's book author and storyteller Michael Rosen observed: "... Children's fiction often appeals to a child's longing for omnipotence."[2] Because young people are "smaller, un-powerful members of the human race," Rosen said, they crave stories with young heroes who, like Emil, cheerfully take adult matters into their own hands, and triumph.

TOMI UNGERER
born Jean-Thomas Ungerer
born 1931, Strasbourg, Alsace; died 2019, Cork, Ireland

Biography: As a twelve-year-old growing up in annexed Alsace during the Second World War, Tomi Ungerer predicted his own future, scribbling in the margins of a schoolbook: "I am and am called Hans Ungerer/I shall be the wanderer."[1] Sure enough, in 1956, after being expelled from a French art school, he boarded a ship bound for New York and began landing freelance work both as a satirical cartoonist and children's book author/illustrator.

Ungerer's first mentor in the latter realm was Harper editor Ursula Nordstrom, who welcomed him into the ranks of the mavericks she published—a select group of artists and writers that included Maurice Sendak, Crockett Johnson, Ruth Krauss, Gene Zion, Margaret Bloy Graham, and Charlotte Zolotow. Ungerer himself would later bring Shel Silverstein into the fold.

During the 1960s, he produced a steady stream of saucy, elegant drawings and advertisements for *Esquire, Harper's Bazaar,* and the *New York Times* while at the same time courting controversy (from the staid cultural perspective of American children's book officialdom) by savaging the United States' participation in the Vietnam War in a series of widely disseminated posters. With the appearance of his self-published erotica collection, *Fornicon* (1969), Ungerer doubtless sabotaged his chances of winning the American juvenile book world's highest accolades. He left the United States for good in 1970, moving first to Canada and then to Ireland and back to his native Strasbourg. In his later years, prestigious European honors rained down on him both for his artwork and humanitarian activities. In 1998, he received the Hans Christian Andersen Award for illustration.

About the book: Besides Nordstrom, Ungerer shared with Maurice Sendak a second remarkable juvenile editor, Farrar, Straus and Giroux's Michael di Capua. *The Beast of Monsieur Racine* (1971) is the high point of their work together. It is an extravagant exercise in tongue-in-cheek mischief featuring a main character who is not a child but rather an elderly French gentleman and inventor who is visited one day by a mysterious creature unknown to science. The open-minded man befriends the beast, inviting him into his home and offering him rare delicacies and hours of good conversation. Not everyone is as accepting of the beast as the man is, however, and Ungerer takes this story as an opportunity to satirize the fear that often grips a group when they are suddenly faced with a strange and potentially menacing outsider. In the end, the beast turns out to be nothing but a hoax perpetrated by two daring young children who have hidden themselves inside an artful costume. On discovering the truth of the matter, the good gentleman is unfazed and simply welcomes the news as one more of life's little surprises.

Ungerer booby-trapped the large-format illustrations with other surprises for readers to discover on their own. Randomly placed in the bustling crowd scenes is an occasional blood-curdling detail—a head pierced by an umbrella, a disembodied hand dripping

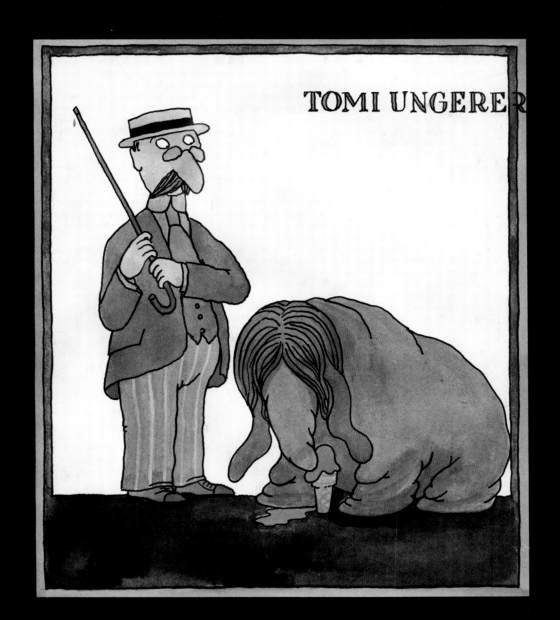

TOMI UNGERER

THE BEAST OF MONSIEUR RACINE

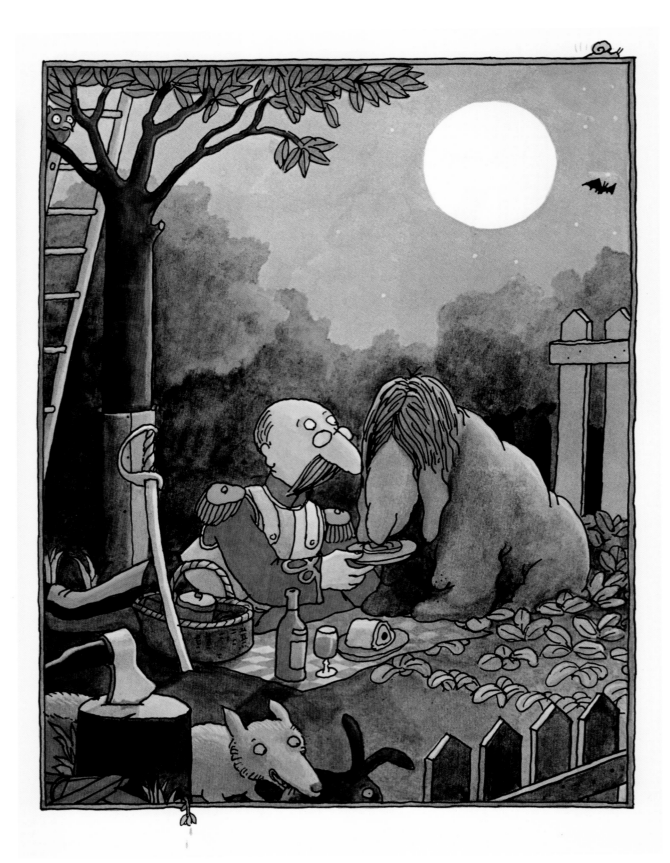

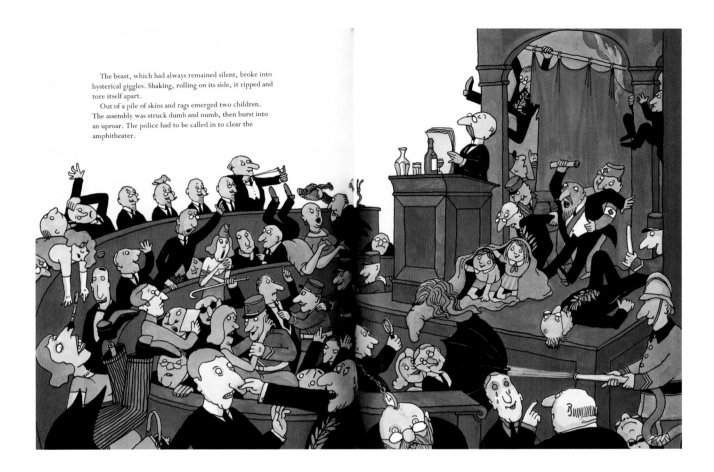

The beast, which had always remained silent, broke into
hysterical giggles. Shaking, rolling on its side, it ripped and
tore itself apart.
　　Out of a pile of skins and rags emerged two children.
The assembly was struck dumb and numb, then burst into
an uproar. The police had to be called in to clear the
amphitheater.

blood. Ungerer believed that children took special delight in finding these grizzly sideshow curiosities and understood that it was thrilling for them to happen upon subject matter they knew their parents would consider taboo. He also knew of course that some parents and critics would *not* be thrilled. But for Ungerer, the important thing was to create picture books that made young people feel respected and trusted as well as richly entertained.

Publication history: *The Beast of Monsieur Racine* was Ungerer's twentieth children's book. Following his well-established pattern, it originated in the United States and was released two years later in Germany and France. Although the American Library Association's Caldecott Medal deliberations have always been held in strict secrecy, it is hard to imagine that Ungerer's supremely deft and self-assured book did not come up for consideration in 1972, or that the still-recent scandal of *Fornicon* played no part in the deliberations. In any case, although the awards jurors passed

over the book, it proved to have considerable staying power anyway. Commending *The Beast of Monsieur Racine* in 2000 to parents, *New York Times* critic Eden Ross Lipson praised it as a "quirky fable . . . [of] Gallic worldliness [and] inimitable style."[2] The tough-minded American historian and commentator Barbara Bader called it a work of "passion and panache" by an artist for whom "the expression 'devilishly clever' could have been coined."[3] In general, Ungerer's books fared better in Europe, where his run as a superstar remained unbroken for decades, than in the United States, where artists and designers continued to admire his work but librarians tended to regard it as a sort of guilty pleasure. A 2013 documentary feature film *Far Out Isn't Far Enough: The Tomi Ungerer Story*, a major retrospective at New York's Drawing Center two years later, and an extensive program of reissues by Phaidon all pointed to a new peak of interest in this extraordinary picture book artist's singular achievement.

CHRIS VAN ALLSBURG
born 1949, Grand Rapids, Michigan, US

Biography: Like millions of American children of the postwar baby boom generation, Chris Van Allsburg grew up with an ample grab bag of children's popular culture at his beck and call. He avidly read *Mad* magazine and Disney comic books, drove a go-cart, and built model cars and planes. He liked to draw and impressed his classmates with his ability to sketch a reasonable likeness of *Blondie*'s hen-pecked Dagwood Bumstead. His favorite picture book was Crockett Johnson's *Harold and the Purple Crayon*, the story of another daydreamy boy with a passion for doodling.

Van Allsburg studied art at the University of Michigan and at the Rhode Island School of Design (RISD), where one of his teachers was David Macaulay. He concentrated on sculpture and developed an affin-

ity for surrealist conundrums and visual double takes. Central to his emerging aesthetic was a preference for art that posed a question or implied a story that was left to be completed in the viewer's imagination.

Once out of school, he grew impatient with sculpture and began to make drawings in a similar vein, prompting his wife, a schoolteacher, and Macaulay, who had become a friend, to suggest that he consider illustrating picture books. From the publication of his first book, *The Garden of Abdul Gasazi* (1979), Van Allsburg won lavish praise—and prize recognition—for the dark humor and sophistication of his highly rendered black-and-white images and the gamelike ingenuity of his stories. He received his first Caldecott Medal for his second book, *Jumanji* (1981), and a second Caldecott Medal for *The Polar Express* (1985).

About the book: Drawn from a variety of unconventional vantage points, *Jumanji* made a powerful visual impression on its first readers. Stylistically. Van Allsburg's sleek, emotionally cool, and mildly menacing Conté pencil drawings appeared to owe very little to children's book art of the past. The artist's sense of childhood as an inherently unsettling time certainly implied the influence of Maurice Sendak, but the more immediate inspirations were from the world of painting, most notably the work of the Belgian surrealist René Magritte. Van Allsburg himself recalled that *Jumanji* began as a series of daydreams and the interior dialog they prompted. He would imagine a kitchen invaded by monkeys, then ask himself: "How did they get there? 'They escaped from the zoo' isn't a very interesting answer. [But] 'The monkeys sprang from a board game' *is* interesting."[1]

The two children who play the board game called Jumanji look old beyond their years. The world-weariness that is so plainly written on their faces is at once Van Allsburg's most startling and most characteristic choice, and a sign of his emphatic renunciation of the sentimental stock images of childhood that showed such resilience in postwar American consumer culture—except in odd corners like *Mad* and the picture books of Crockett Johnson, Maurice Sendak, and a few others.

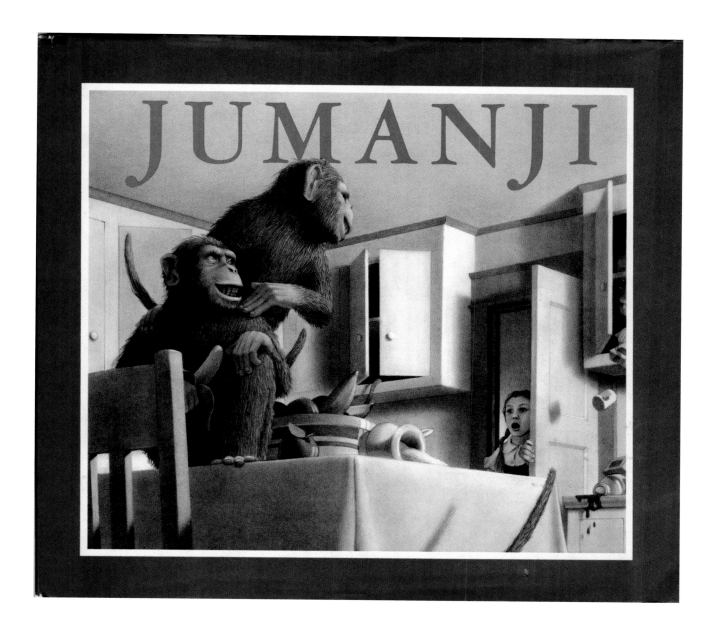

Publication history: Winning the Caldecott Medal for *Jumanji* validated Van Allsburg's decision to focus on books. For the next twenty-five years, he published a new book almost annually. He also continued to teach at RISD for years afterward, offering rigorous drawing classes and a course called Design Your Own Country in which students were required to create maps and postage stamps and fabricate other documentation of a nation-state of their own devising.[2]

Jumanji has been published in French, Spanish, Danish, Japanese, and Chinese editions, among others. In 1995 it was made into a feature film directed by Joe Johnston and starring Robin Williams, Bonnie Hunt, Kirsten Dunst, and Bradley Pierce. A sequel directed by Jake Kasdan titled *Jumanji: Welcome to the Jungle* was released in 2017, starring Dwayne Johnson, Jack Black, Kevin Hart, and Karen Gillan.

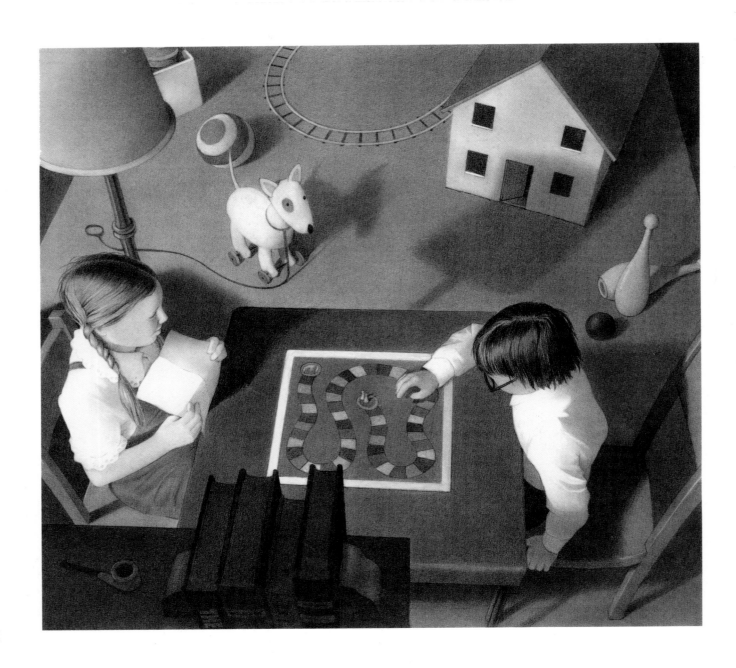

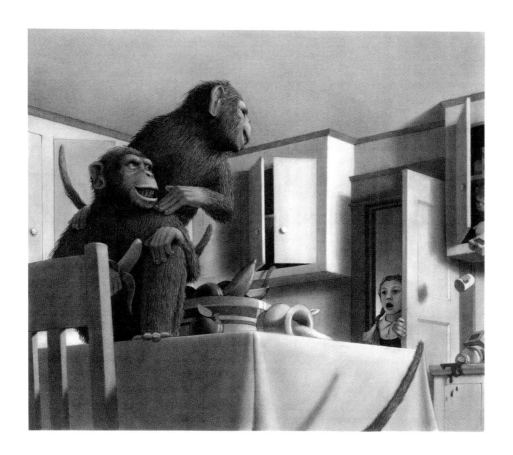

LEONARD WEISGARD

born 1916, New Haven, Connecticut, US;
died 2000, Glumsø, Denmark

Biography: The only child of a British-born American shopkeeper and a Polish Jewish émigré mother, Leonard Weisgard was born in New Haven, Connecticut, and raised in modest circumstances in London and New York City. He studied modern dance with Martha Graham and art at Brooklyn's Pratt Institute before dropping out of school to launch a career in the visual arts. The Russian Constructivists, the American designer E. McKnight Kauffer, and the Cubist Stuart Davis were among his chief influences as Weisgard undertook a full menu of commercial assignments, including window displays, print advertisements, and magazine illustration. He was twenty in August 1937 when he published his first *New Yorker* cover design, the contract for which he was too young to sign himself.

The next year, with one picture book already under his belt, he met Margaret Wise Brown, the charismatic writer and editor at a small publishing firm dedicated to the educational philosophy of New York's progressive Bank Street School. Weisgard's modernist inclinations meshed perfectly with Brown's determination to make the picture book new by discarding the sentimental romanticism of past decades in favor of an irreverent, gamelike approach to read-aloud storytelling that invited the child's collaborative participation. Over the next twelve years, Brown and Weisgard would create nearly forty books together, including his 1947 Caldecott Medal winner, *The Little Island*.

Like other experimental artists of his generation, Weisgard felt a strong affinity for naïve or primitive art, which he believed had the power to express basic truths that academic art glossed over. As his career took off, he became an early serious collector of American folk art and artifacts and lived in a historic eighteenth-century house in Roxbury, Connecticut, a creative community where his neighbors included playwright Arthur Miller, novelist William Styron, and artist Alexander Calder.

Among the young artists Weisgard mentored during a long and fruitful career was Maurice Sendak, whom he met at the FAO Schwarz toy emporium in New York, where the ambitious young Brooklyn artist had found work as a window dresser.

First he heard the big noises

MEN HAMMERING
Bang bang bang

AUTOMOBILE HORNS
Awuurra awuurra

HORSES HOOFS
Clop clop Clop clop

ANOTHER LITTLE DOG
Bow wow wow

It began to snow
But could Muffin hear that?

Disillusioned by the Vietnam War, Weisgard in 1969 moved his family to Denmark, where he lived in retirement after having illustrated more than two hundred children's books written by Brown, himself, and others.

About the book: The uniquely talented and prolific Margaret Wise Brown often composed a manuscript to order for the artists with whom she wished to collaborate. In the late 1930s, as a W. R. Scott editor, she found herself in an enviable position. Of the origins of *The Noisy Book* (1939), her first collaboration with Weisgard, she would later recall, "I wrote the book and we"—again referring to herself—"published it."[1]

Weisgard's illustrations show how fully he had absorbed the Bank Street aesthetic. The limited, toy-bright palette and compositional arrangement of rhythmical forms reflected Bank Street founder Lucy Sprague Mitchell's understanding of the young child as a keenly receptive sensory learner. The freewheeling organization of type on the page exuded the playful spirit that Mitchell and her colleagues believed most appropriate to books for the youngest ages. The semi-abstract cast of the art invited a more active style of imaginative engagement than images rendered in a literal-minded, naturalistic vein. The city in Weisgard's illustrations suggested a kind of building-block world like the one that young children themselves routinely built at preschool with the popular natural-wood "unit blocks" that had been purposefully designed for them by one of Mitchell's colleagues as non-prescriptive, "open-ended" play materials.

Publication history: *The Noisy Book* appeared on Scott's second, fall 1939, list, and like most other Scott books was largely ignored by the librarian/critics of the day, who favored traditional once-upon-a-time tales and were made uneasy by a book that urged children to raise a ruckus. Its modest initial sales were overwhelmingly to progressive preschools. Brown and Weisgard collaborated on six sequels (an eighth Noisy volume, *The Winter Noisy Book*, was illustrated by Charles G. Shaw, 1947). In 1950, in an effort to cement Brown's loyalty, the much older and larger publishing firm of Harper & Brothers acquired the rights to the entire Noisy Book series from Scott. The books have periodically gone in and out of print ever since.

The major impact of *The Noisy Book* and its sequels was to help establish the model for a revolutionary new relationship between young children and their books, one that transformed the traditionally hushed and reverential library-story-hour experience into a lively—at times even boisterous—performance or game. The aim and upshot of the experiment was to give young children a greater sense of ownership of their books and to reinforce their confidence in the value of their own ideas.

WALTER WICK

born 1953, Hartford, Connecticut, US

Biography: As a student at Paier College of Art in his home state of Connecticut, Walter Wick trained for a career in commercial art. Print advertisers, at the time, routinely called upon photographers for enticing images of all manner of merchandise, from bourbon to automobiles, and Wick's fascination with staged photography and the nuances of lighting made him an ideal prospect.

At the heart of Wick's passion for such work was an interest in the photographer's power to control and shape the viewer's experience of the material world, at times by enlivening mundane reality through the introduction of an ambiguous or fantastical element. With this idea in mind, he began to experiment with the staging of elaborate visual illusions, publishing his first photograph of this kind, "The Amazing Mirror Maze," in 1981 in *Games* magazine, where editor Will Shortz (later the *New York Times*' famed "puzzle master") immediately recognized his extraordinary talent.

After producing numerous images in this vein, Wick was offered the chance to collaborate on a children's book. Jean Marzollo, an editor at Scholastic who admired the clarity, inventiveness, and wit of his work, proposed a joint project with herself as the author. Published in 1992, *I Spy: A Book of Picture Riddles* was an immediate commercial and critical success.

About the book: Marzollo, whose training was in early childhood education, had envisioned a picture book with a series of riddles that prompted readers to search, treasure-hunt style, for an array of small objects hidden within each densely detailed photograph. Wick easily rose to the challenge, creating panoramic scenes as notable for their vibrant lighting, color sense, and composition as for their effectiveness as visual puzzles. Marzollo had conceived the book for children of ages four to eight who would enjoy testing their competence as observer-detectives. To everyone's surprise, *I Spy* and the many sequels it spawned proved to have strong appeal for a far broader age spectrum of readers.

Publication history: Wick was fortunate in his timing. While, by the 1990s, photography was hardly a novel choice for children's book illustration, the field's critics had been slow to recognize still-image photography as a legitimate art form. In the past, photographs had often been dismissed as the visual equivalent of a compilation of facts—literal slices of reality that did little to interpret their subjects or nourish the imagination. It was not a coincidence that no photographer had ever won the Caldecott Medal. In the United States, a handful of photographers had nonetheless gained ground as illustrators in the picture book realm, notably Tana Hoban, a creator of concept books for very young children, Ken Robbins, Nina Crews, and the anonymous creators of the British-based Eyewitness series of photographically illustrated reference books.

In 1992, *I Spy: A Book of Picture Riddles* was selected for the New York Public Library's prestigious *100 Titles for Reading and Sharing* and was a major commercial success. It was published in numerous foreign-language editions including German, Swedish, Norwegian, Portuguese, Spanish, Polish, Japanese, Chinese, Korean, Afrikaans, and Hebrew, and served as the inspiration for an astounding number and variety of spin-off books, puzzles, and video games, as well as an Emmy-winning educational television series.

I spy a shovel, a long silver chain,
A little toy horse, a track for a train;

A birthday candle, a pretty gold ring,
A small puzzle piece, and a crown for a king.

Top left: Promotional piece by Walter Wick, ca. 1980, and the inspiration for the "Odds and Ends" spread of the original *I Spy* book; bottom left: "Fasteners" poster for Scholastic magazine *Let's Find Out*, edited by Wick's future collaborator Jean Marzollo, and suggested by the promotional piece, above; right: 1981 cover for *Games* magazine, featuring design experiments (objects that appear to defy gravity and others) later employed in the first *I Spy* book

DAVID WIESNER

born 1956, Bridgewater, New Jersey, US

Biography: A child of the American postwar baby boom generation, David Wiesner grew up in a comfortable New Jersey suburb where he and his friends attended public schools and had a nearby swamp, brook, and cemetery as colorful backdrops for their make-believe adventures. The "class artist" from his earliest years in school, he developed an interest in art history before reaching his teens and trained himself by copying drawings he admired, whether from reference books or *Agents of SHIELD*, an action comic notable for its wordless sequences. In a high school film class, Wiesner and his friends made a silent vampire movie, *The Saga of Butchula*.[1] Purely visual narrative continued to intrigue him as an undergraduate at the Rhode Island School of Design (RISD).

At RISD, Wiesner studied design and visual problem-solving with David Macaulay and attended a talk given by children's book illustrator Trina Schart Hyman, who was then also the art director of the well-regarded children's magazine *Cricket*. Hyman commissioned Wiesner to create a cover design for

Cricket and encouraged him to consider illustrating children's books, an art form he had not given much thought to before then.

Moving to New York after graduation, Wiesner took Hyman's advice and found freelance work as a book illustrator and cover artist. His second *Cricket* cover featured a deadpan sci-fi fantasy scenario involving frogs perched on flying lily pads—a foretaste of his 1992 Caldecott Medal–winning fantasy *Tuesday*. Wiesner would go on to win two more Caldecott Medals—an astonishing feat previously accomplished only by Marcia Brown—and to create innovative work in the realms of the digital app and graphic novel.

About the book: In *Tuesday*, Wiesner gave free rein to his tongue-in-cheek, absurdist sense of humor and confirmed his consummate skill as a photorealist watercolorist. The illustrations' dramatic impact also owed a great deal to Wiesner's knack for choosing unique points of view. "Nowhere," David Macaulay wrote in an appreciation of his former student's handiwork, "is the power of point of view more clearly displayed, or more masterfully handled, than in *Tuesday*."

Publication history: *Tuesday* received strong reviews in the United States and proved to be a favorite with American schoolteachers, who took advantage of its evocative imagery, playful spirit, and minimalist text to prompt young students to write and illustrate stories of their own—"Next Tuesday" sequels, as Wiesner himself took to calling them.[2] The striking sophistication of Wiesner's art also brought *Tuesday* notice as confirmation of a growing trend that favored picture books—those by Chris Van Allsburg, Lane Smith, and Anthony Browne also belonged—with strong adult crossover appeal. The book's broad-based popularity seemed as well to undercut the long-standing belief that young people naturally outgrew illustration as an element of their reading experience as they moved up the ladder of years to third grade and beyond.

Tuesday was published in French, Italian, Spanish, Dutch, German, Chinese, Japanese, and Korean editions, among others. In 2002, it was adapted as an animation short subject by director Geoff Dunbar with ex-Beatle Paul McCartney as producer, and with Paul, the late Linda McCartney, and Dustin Hoffman among the contributing voice-over performers.

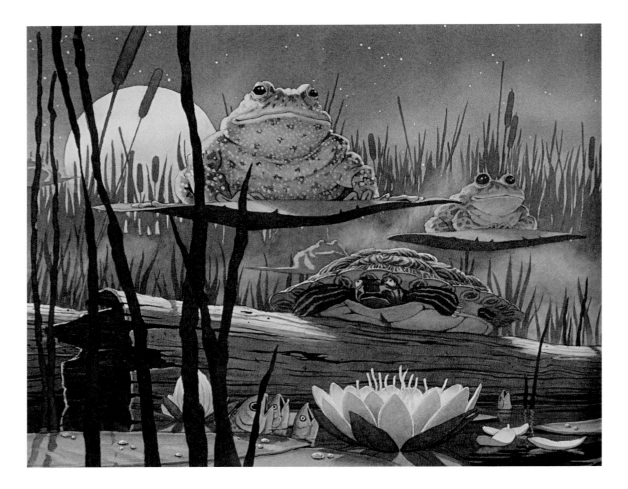

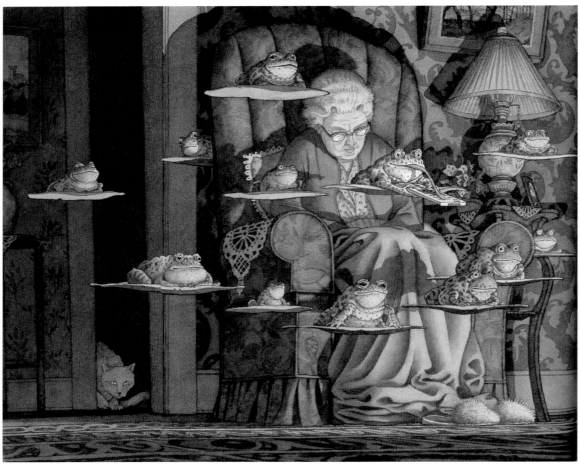

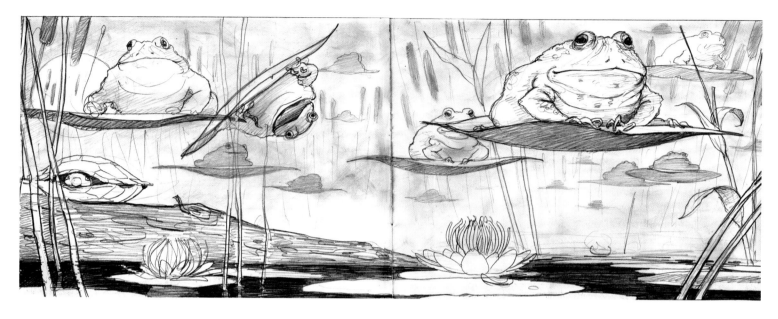

MO WILLEMS

born 1968, Des Plaines, Illinois, US

Biography: Mo Willems's Dutch parents immigrated to the United States shortly before the birth of their son and settled in New Orleans, where the quick-witted boy grew up unable to shake the feeling of being an outsider. Willems's sense of humor served as a first line of defense. As a teenager, he began doing sketch comedy at local clubs, then took his act to London to try out his material before audiences there. These early trial-by-fire performing experiences, followed by a productive stretch as a scriptwriter and animator for the children's public television program *Sesame Street*, taught Willems important lessons about narrative pacing, targeted character development, and deadpan delivery that later served him well as a creator of picture books and beginning readers.

Willems struggled initially to find a publisher for his first picture book, *Don't Let the Pigeon Drive the Bus!* (2003). One reason for this may have been the commitment he had made to himself to illustrate the book in a style simple enough to allow children to feel that might do as well themselves. Some editors demurred at the sight of what looked to be drawings that barely exceeded stick figures in complexity. Once Willems had landed at Hyperion, however, he proved to be a tireless bookmaker, with an abundance of clever tricks up his sleeve and endless insight into the trials and tribulations of early childhood.

About the book: Willems set *Knuffle Bunny: A Cautionary Tale* (2004) in the streets of brownstone Brooklyn, New York, where he and his wife and young daughter, Trixie, were living at the time. Working at his computer, he overlaid black-and-white photographs of street and shop scenes with cartoonish color drawings of his characters, a young hipster family of three. Willems had thought at first that by using photographs, essentially as ready-made scenery, he would save time and greatly simplify the task of illustration. The opposite proved to be case, however, when in order to line up background details precisely behind his characters, it became necessary to digitally manipulate the photographs again and again. When all was said and done, the juxtaposition of media made for a highly effective blending of fantasy and reality.

In this book, Willems also proved himself a master at pinpointing pivotal moments in a young child's development. The story about a toddler who temporarily loses track of her favorite stuffed animal unfolds in an atmosphere of uproarious farce, especially once the child descends into tantrum mode and her well-meaning but clueless father is left struggling to interpret the inconsolable girl's garbled pre-speech. It is not until the toy bunny is finally returned to the little girl that she finally utters her very first words: "Knuffle Bunny!"—of course. In one of many satirical touches, Willems shows that, in contrast to the dad, the girl's mother has no trouble whatsoever understanding her daughter's gibberish.

She did everything she could to show how unhappy she was.

Publication history: *Knuffle Bunny* was a major American critical and popular success. It received a 2005 Caldecott Honor (as had *Don't Let the Pigeon Drive the Bus!* the previous year) and was followed by two sequels. Its more complex artwork, compared with that of the pigeon book, had doubtless helped solidify Willems' credentials as an illustrator.

Willems became an outspoken participant in the children's book world's debate concerning the impact of digital art and digital publishing on the picture book. While more at home than most illustrators with computer-generated art and with the potential for adapting books for the new media, Willems insisted

that the traditional printed book continued to have an essential role to play in children's lives. In his 2011 Zena Sutherland Lecture, he said: "So back to my question of 'Why books?' What if books are better *because* they don't do things, because they *can't* do things? What if the thing that makes books great, that makes them essential, is that books *need us*? They're simple. You invest in them and become part of them. You contribute. They can be read, but they can also be *played*. I'm not really interested in you guys reading my books a hundred times; read it twenty times and then make *your own* story. Go from consuming a story to creating your own. This is a magical thing to me."[1]

Trixie helped her daddy put the laundry into the machine.

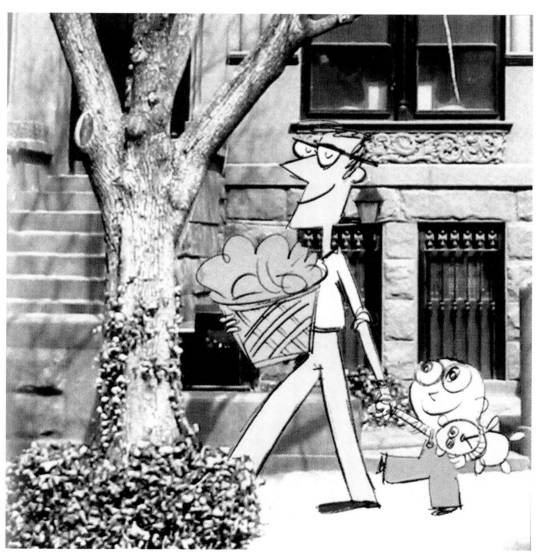

GARTH WILLIAMS

born 1912, New York, New York, US; died 1996, Guanajuato, Mexico

Biography: "Everybody in my home was always either painting or drawing," Garth Williams, the elder child of British expat artists, recalled of his life on a New Jersey farm.[1] Williams's father drew cartoons for the American humor magazines *Judge* and *Life*. His mother painted landscapes and was a pipe-smoking suffragist. When his parents separated, Williams at age five went with his mother to live first in Canada and later in England, where he studied at the Royal Academy of Arts. "Portraits were my strong point," he recalled. He applied for, and won, a 1936 Prix de Rome prize in sculpture because, as he once explained with a wink and a nod to an interviewer, he needed the money to buy gasoline for his two cars.

Williams sustained a leg injury while working in civil defense during the London Blitz and decided to return to America. Once in New York, he made the rounds of magazines and book publishers with his portfolio. *The New Yorker* took a few of his humorous drawings but told him his work was "too wild and too European." But the children's book editors at Harper and Simon & Schuster (the latter of which had recently launched Little Golden Books) were eager for his services. Williams received the plum Harper assignment to illustrate E. B. White's first children's book, *Stuart Little* (1945), at about the same time that he met the mercurial picture book author Margaret Wise Brown, with whom he collaborated on a number of memorable projects, including Harper's *Little Fur Family* (1946) and the Little Golden Book *Mister Dog* (1952). Williams went on to illustrate White's second children's book, *Charlotte's Web* (1952), as well as notable books by Russell Hoban, George Selden, Randall Jarrell, and Charlotte Zolotow, among others, and to re-illustrate Laura Ingalls Wilder's classic Little House series of historical novels (1953).

About the book: As senior *New Yorker* staff members, E. B. White and his wife, Katharine, had been quicker than some of their colleagues to recognize Williams's talent and sent a note to Harper editor Ursula Nordstrom recommending the artist for *Stuart Little*. The

virtuosity and wit of Williams's drawings for that book left no doubt that he should illustrate White's next children's book, too.

In *Charlotte's Web*, White had written a paean to nature and a sly comment on human folly as seen from the perspective of a wise and imaginative spider. For Williams, a major challenge was to find a convincing way to convey the complex personality of the title character without grotesquely Disney-fying her by the unnatural addition of a face. He researched spider anatomy and opted to treat Charlotte as he would a dancer who expressed herself principally by means of pose and gesture. In the case of Wilbur and the other barnyard animals, he pursued a different, equally effective strategy, drawing each character with high humor and observational finesse in a style that blended a strong impression of human-like responsiveness and awareness with an overall sense of the characters as animals one might meet at any farm. Williams gave the larger animals palpable heft and volume, a legacy of his prior work as a sculptor. The facial expressions he assigned to the animals—in preparation for which he sketched his own face repeatedly as he also consulted

a mirror—navigated the fine line between anthropomorphism and naturalistic depiction with an exquisite subtlety that has rarely been matched.

Publication history: *Charlotte's Web* was both an immediate and lasting critical and commercial success, except in certain quarters. In 1953, the American Library Association awarded White a Newbery Honor, its lesser prize for literature, a lukewarm result that most likely reflected the uneasiness of 1950s librarians with a story for grade-school children that made a central plot point of the death its heroine. Williams's illustrations further burnished his already solid reputation and confirmed his place in the top rank of acknowledged black-line masters alongside John Tenniel, Ernest Shepherd, and Edward Ardizzone. Of all the worthy American illustrators who did not receive a Caldecott Medal, Williams was arguably the most deserving. *Charlotte's Web* has been translated into more than twenty languages, including Bengali, Telugu, and Cherokee.

N. C. WYETH
born NEWELL CONVERS WYETH

born 1882, Needham, Massachusetts, US;
died 1945, Chadds Ford, Pennsylvania, US

Biography: In 1902, nineteen-year-old N. C. Wyeth became one of twenty students accepted by Howard Pyle into the master's new experimental, total-immersion art school, which convened in Wilmington, Delaware, during the cold months and in the wide-open spaces of Chadds Ford, Pennsylvania, in summer. Wyeth shared his mentor's dream to elevate the level of American illustration through a wholehearted embrace of imagination, rigorous research, and direct observation as guiding principles. Pyle recognized from the start that Wyeth had star potential, and within a year of the latter's arrival at the school, the tall, athletically built young man had made good on his promise by landing a cover assignment for the *Saturday Evening Post* for which he painted a spirited depiction of a bucking bronco. Soon afterward, at Pyle's urging, Wyeth traveled west to sketch and paint firsthand the kinds of quintessentially American subjects that had come to absorb him.

Wyeth developed a lucrative career as a magazine artist with a reputation for technical virtuosity and narrative flair, and in 1911 he branched out to inaugurate the Scribner's Illustrated Classics series by creating a suite of paintings for Robert Louis Stevenson's *Treasure Island*. For the next three decades, he turned out memorable broad-brush narrative paintings for a long shelf of more than twenty-five classic boys' adventure stories by Stevenson, Jules Verne, James Fenimore Cooper, and others, becoming in effect the American Arthur Rackham. In later years, Wyeth, who had also ventured successfully into the realm of corporate advertising, felt trapped by the breakneck pace of his freelance activities and grew increasingly ambivalent about the worth of a painting that was tethered to the requirements of a client or text. He flirted with Impressionism as practiced by members of the artists' colony in New Hope, Pennsylvania, but never abandoned the work for which he had long since become justly famous. He was close to completing a series of monumental murals depicting life in Plymouth Colony when, in the fall of 1945, a train struck the car he was driving, killing both him and his grandson.

About the book: For *Treasure Island,* Wyeth created seventeen arresting full-color illustrations that Scribner tipped in on coated stock. Wyeth had painted them with gusto, always aiming for the sweeping theatrical effect. Coiled-spring action poses, intense, expressionist characterizations, dramatic lighting, and surprising perspectives were among the many arrows in this illustrator's quiver, and Wyeth deployed them all to maximum effect.

Publication history: As the first volume in what came to be known as the Scribner's Illustrated Classics series, *Treasure Island* caused a sensation. The initial sale was "phenomenal," Wyeth reported to his mother without exaggeration: nine hundred copies per week, with the first printing exhausted by December 18.[1] For American librarian-critics who were keen to foster the growth of a homegrown literature for American children, Wyeth's emergence as an illustrator in the grand tradition of the holiday gift book represented a big leap forward. As the New York Public Library's Anne Carroll Moore would write in *Crossroads to Childhood* (1926): "Mr. Wyeth's pictures for [*Treasure Island*] and for *Kidnapped* and the *Black Arrow* brought Stevenson home to many boys and girls." *Treasure Island* became a perennial bestseller and influence on the imagery of adventure on the high seas in Hollywood and popular culture generally.

*"One more step, Mr. Hands," said I, "and I'll blow
your brains out!" (p. 204)*

For all the world, I was led like a dancing bear (p. 244)

ZHANG LEPING

born 1910, Jiaxing, Zhejiang, China; died 1992, Shanghai, China

Biography: The comic strip and the artist Zhang Leping came of age together in China in the first decades of the last century. Born into a poverty-stricken family in the eastern coastal province of Zhejiang, Zhang was forced to drop out of school at an early age but was able, in his late teens, to move to Shanghai, the Chinese epicenter for comics, to study art after relatives noted his natural talent for drawing. The so-called January 28 [1932] incident—a prelude to the Second Sino-Japanese War—presented the young man with his first opportunity to make a name for himself as the creator of cartoons that encapsulated the nationalist spirit of the moment for a popular audience. He first drew his now famous character Sanmao, or "Three Hairs," in 1935, for a newspaper strip cartoon that was unusual at the time both for featuring a child protagonist and for presenting wordless narratives that even an illiterate peasant could "read." The self-reliant wandering

orphan boy became a potent symbol of the Chinese people's struggles and aspirations in a turbulent and rapidly changing world. For Chinese children, Sanmao was their Mickey Mouse, their Popeye.

According to the artist's son Zhang Rongrong, the elder Zhang stopped drawing *Sanmao* comics during the Japanese occupation of 1937–1945 and joined a group of roving cartoonists producing anti-Japanese propaganda. After the war, *Sanmao* returned in the pages of the respected daily *Ta Kung Pao*, with wordless stories that reflected on the cruelty of war from an innocent child's perspective. His first postwar book, *Sanmao Joins the Army* (1946), lampooned the inequities and absurdities of military life. With the publication in 1948 of the compilation *Wanderings of Sanmao*, Zhang's trickster child hero became a beloved avatar of Chinese resilience in the face of relentless suffering, and for many adult fans a clarion call for a meaningful government response to the plight of Shanghai's homeless children.

During the 1950s, Zhang worked as a children's book editor while creating new *Sanmao* stories that

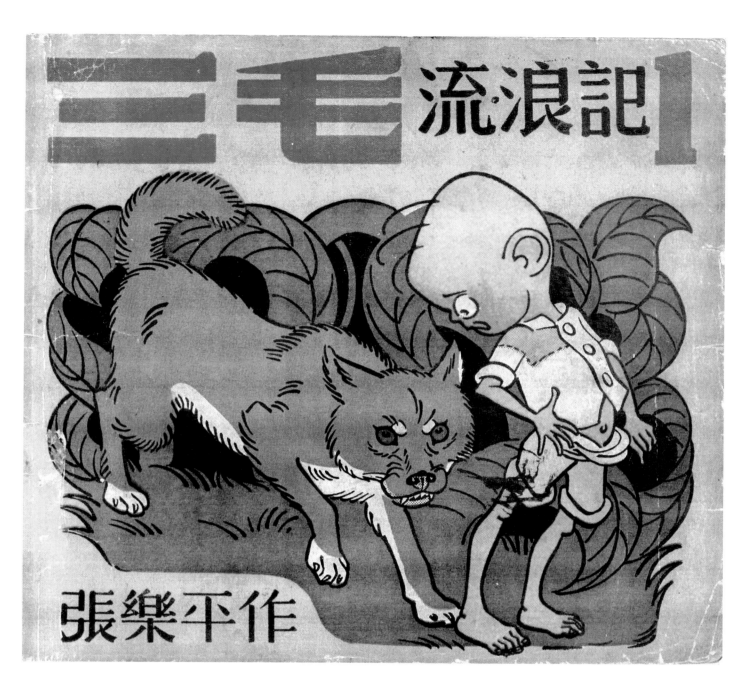

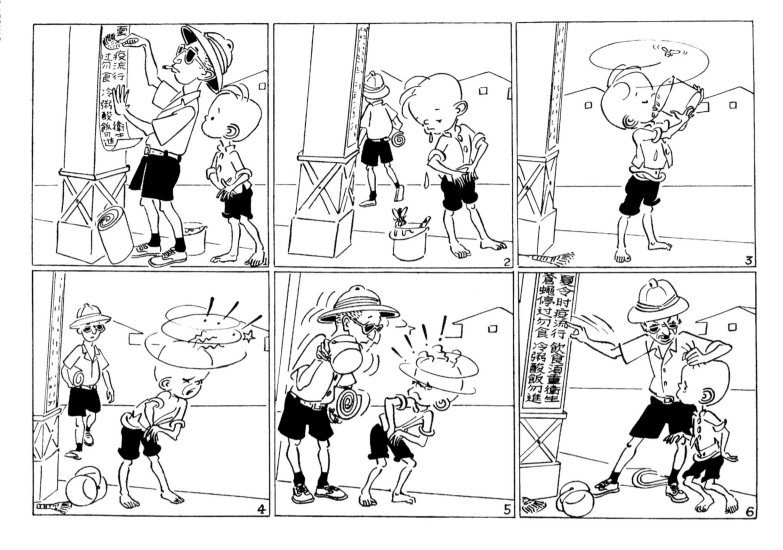

endorsed the Communist regime. Targeted early on during the Cultural Revolution, he was again forced to set aside *Sanmao* for several years during the 1960s but resumed drawing his signature character—although no longer as a homeless, forgotten child to be pitied—a decade later and continued on through the 1980s.

About the book: Published in April 1948, *Wanderings of Sanmao, or The Story of Sanmao's Vagrant Life*, brought together 261 wordless comics set in Shanghai during the time of the civil war between the Nation-

alists and Communists. In one typically bittersweet scenario, Sanmao meets a man in shabby clothes who has happened along with a pair of babies in baskets with the intention of selling them at market. The man proceeds to place a sign in front of each baby, indicating its price. Always quick to learn from experience as he hunts down his next meal, Sanmao improvises a scheme to "sell" himself as well, preparing his own sign with a price that undercuts the competition. In another story, he pushes a well-dressed young girl off a bridge and into the river, then—playing the hero—dives in to

rescue the child and collect a reward from the grateful and unsuspecting father.

Publication history: Although not initially created solely with a young audience in mind, this collection of Zhang's work became twentieth-century China's most widely read children's book by far. Zhang Rongrong recalled that his father routinely tested the *Sanmao* cartoons on his own children in advance of publication, "to see whether we could understand. If we couldn't, he would restart."[1]

Zhang cowrote the script for the first feature film based on *Sanmao, an Orphan in the Streets*. Produced by Shanghai's Kunlun Film Company and released in December 1949, it became liberated China's first feature film and was distributed in the United States as *The Winter of Three Hairs*. A steady stream of other adaptations has followed in a variety of media, including animation, live-action film, television soap opera, live theater, and puppet theater—repurposing and reimagining Zhang's iconic character for new times.

ZHU CHENG-LIANG
born 1948, Shanghai, China

Biography: Zhu Cheng-Liang spent his student years in Suzhou, Jiangsu Province, an ancient city long known as the Venice of the East for its picturesque canals and stone bridges and its classical gardens and other important contributions to Chinese art and culture. Western-style picture books were all but unknown in 1950s China, and Zhu later traced his earliest memories of illustration to the *lianhuanhua*, or cheap, palm-sized pulp comic books that enthralled him with their realistic depictions of everyday Chinese life, which he found at a local library. During the Cultural Revolution (1966–1976), he became a *zhiqing*, or "educated youth," and left his formal studies behind to work as a hand laborer in the countryside. In 1973, he enrolled in Nanjing Fine Arts College, where he studied oil painting. Upon graduation three years later, he joined the staff of the Nanjing-based Jiangsu Fine Arts Publishing House as an editor and book designer. In the late 1970s, he also turned his hand to illustrating

children's books and soon became known for adopting a fresh graphic approach for each new text rather than holding fast to a uniform style.

The book: *A New Year's Reunion* (2011), written by Yu Li-Qiong, puts a human face on the real-life stories of the more than two hundred million Chinese migrant laborers who throughout the year work at jobs at a great distance from their homes and reunite with their families only during the week of the Chinese New Year celebration. (Family gatherings at this special time of year have a long history in China, but rapid economic development following the Cultural Revolution resulted in vast numbers of Chinese workers deciding to trade protracted periods of dislocation for higher wages, thereby transforming the holiday period into the world's largest annual migration.) Zhu's experiences during the Cultural Revolution left him with a feeling of kinship with workers like the father featured in Yu Li-Qiong's story, thus making the project a particularly meaningful one for him.

Maomao, a girl of about five and an only child, narrates. First, she describes her anticipation of the return of her father, a construction worker, for the holiday; then the joy of their shared experiences—a trip to the barber shop, a glimpse of the annual dragon dance—all mingled with the bittersweet realization that the visit will not last for long. Zhu has painted warm, nostalgic scenes of family togetherness in which red, the lucky color in China, predominates, and of neighborliness and solidarity in a time of communal celebration. The setting, although left unidentified, might well be the historic district of Suzhou, where rows of two- and three-story dwellings still line the old streets in contrast to the endless clusters of anonymous apartment towers that so many twenty-first-century Chinese families call home. Compositionally, Zhu's illustrations have the intimate feel and framing of snapshots from a family album and include even close-up portraits of Maomao and her parents: a rare illustration choice up until then for a Chinese picture book and, as such, a striking statement about the value of an ordinary individual's thoughts and feelings.

Publication history: *A New Year's Reunion* was first published in 2007 in Taiwan by Hsin Yi Publications. In Taiwan, the tradition of publishing Western-style picture books dates back to the 1970s, in contrast to mainland China, where a commitment to the genre was just taking hold. In 2009, the book was chosen as the first winner of the Feng Zikai Chinese Children's Picture Book Award, a prize established one year earlier to spur interest in the genre on the part of Chinese authors and illustrators across the world. The publication to critical acclaim of *A New Year's Reunion* by Walker UK and its US sister company, Candlewick, was seen by many in the West as a sign that China might soon join Japan and Korea as Asian centers of creative children's book illustration.

Foreign-language editions of *A New Year's Reunion* include English, French, Spanish, Japanese, and Korean.

LISBETH ZWERGER

born 1954, Vienna, Austria

Biography: As the elder daughter of an Austrian industrial designer, Lisbeth Zwerger grew up in a house filled with art supplies and steeped in a refined sense of beauty. She enjoyed drawing, reading, and daydreaming at home. Academic studies did not suit her well, and at art school she found herself being pushed in a direction she did not wish to go: away from figurative fantasy painting and toward abstraction. The insistence that she try the latter, more "modern" style of art may have had some benefit for her, after all. Arthur Rackham was among the first illustrators she admired—except for his tendency to crowd every bit of an image with pictorial detail. As Zwerger developed her own distinctive style, she made inspired use of simpler, essentially abstract backdrops to intensify an illustration's emotional impact.

Zwerger began illustrating picture books in her twenties and was quickly recognized for her interpretations of Grimm and Andersen tales. She was married at the time to the English illustrator John Rowe, who encouraged her to take a freer approach to color, a direction she pursued with increasing abandon in later years. Even in her brown and gray early period, however, Zwerger produced books with broad visual appeal that owed much to her rare ability to inject a spark of life into each of her characters' expressions and physical gestures, to the lightly held precision of her drawing, and to her classical approach to the double-page-spread as a proscenium stage framing a moment of high drama. Zwerger was just thirty-six in 1990 when she received the international Hans Christian Andersen Award for illustration—an astonishing achievement.

About the book: "Hansel and Gretel" ranks high among the best known of all Grimm tales and deservedly so, as it is such a tautly constructed symbolic story about the primal necessities of home, nourishment, love, and the will to live. Zwerger presents the brother

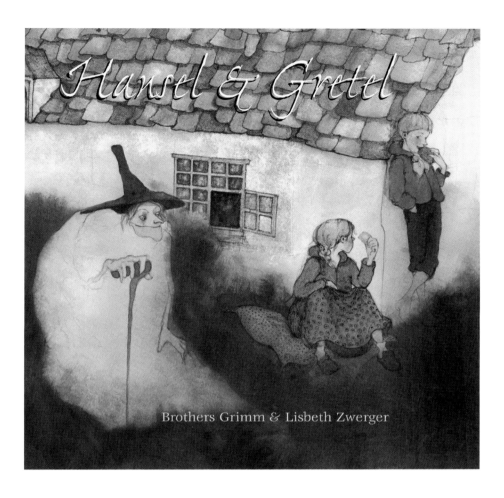

and sister whom their parents abandon in the forest as a subtle mix of childlike innocence and acute alertness to the needs of the moment. Their cheeks are rosy and their eyes sharply focused. When they first meet the witch in the woods, the children appear not even to notice the latter's stage-ily evil demeanor, but when the time comes to save themselves, they act swiftly and without hesitation. The fog-like backgrounds that had just then become one of Zwerger's most characteristic graphic gestures create a tantalizingly dream-like and mysterious atmosphere. Magritte occupies an honored place in this artist's pantheon of creative influences. Her affinity for the enigmatic painter is encapsulated in her observation that pictures "should be mysterious because it makes you want to look at them again and again, to solve the riddle."

Publication history: Published in 1979, *Hansel and Gretel* was Zwerger's third children's book, and her timing was good on at least two counts. First, her professional coming-of-age coincided with a renewed focus on traditional fairy tales as literature of special value for the young, a revival spurred by the publication in 1976 of psychoanalyst Bruno Bettelheim's *The Uses of Enchantment* (the German-language title translates as "Children Need Fairy Tales"). In addition, postwar efforts to foster an international exchange of children's literature further fueled the appreciation of folktales, which some critics argued were not only "timeless" but also "universal" tales—and thus part of the common cultural inheritance of the children of a shrinking but still perilous world. The Bologna Book Fair had by then been facilitating the sale and purchase of foreign rights to children's books for more than a decade. Zwerger's fairy-tale retellings were ideal candidates for international copublication, and along with the picture books of Eric Carle, Anno Mitsumasa, Maurice Sendak, Dick Bruna, and a few others, they swept the field. Zwerger's books went on to be published in at least twenty languages.

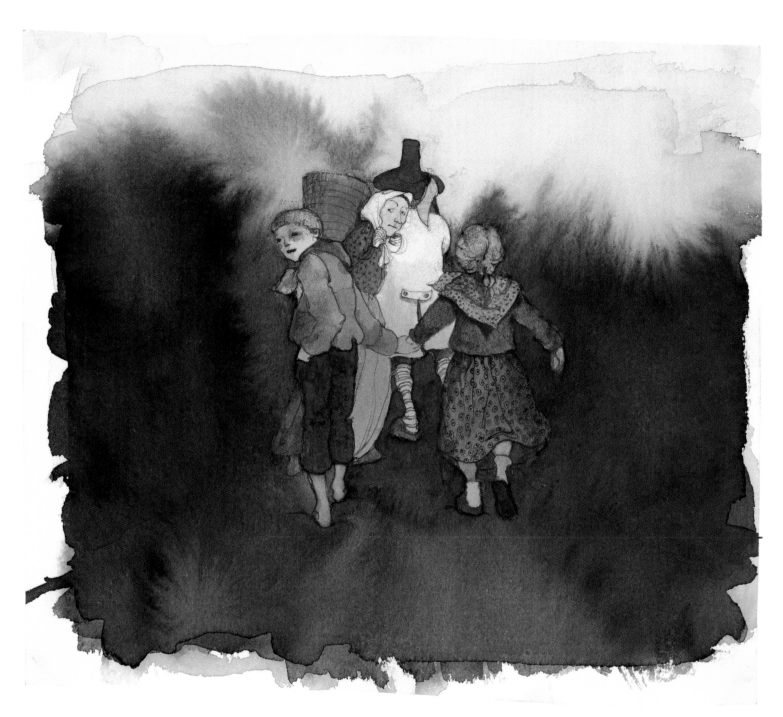

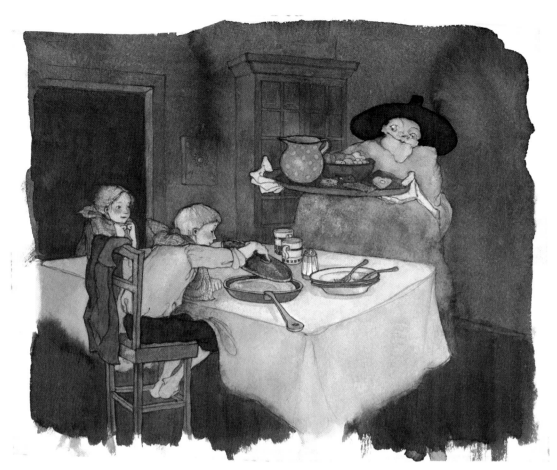

ACKNOWLEDGMENTS

A great many people have generously come to my aid by making needed images, research materials, and information available. My sincere thanks go to you all: Ao De; Ajia; Brian Alderson; the late Anno Mitsumasa; the late Barbara Bader; Carolina Ballester; Giovanna Ballin (Corraini Edizioni); Nathanie Beau; Claudia Zoe Bedrick (Enchanted Lion Books); the late Ann K. Beneduce; Louise Borden; Dik Broekman (Rubinstein); the late Ashley Bryan; the late John Burningham; the late Eric Carle; Trenton Carls and Maegan Squibb (Cape Ann Museum); Bryan Collier; Kitty Crowther; Dennis M. V. David; Jennie Dunham; Barbara Elleman; Christian Epanya; Lynne Farrington (Kislak Center for Special Collections, University of Pennsylvania); Robert L. Forbes; David Ford; Miela Ford; Roy Freeman; Christina Geiger (Christie's); Christine Giviskos and Kiki Michael (Zimmerli Art Museum, Rutgers University); Peter Glassman (Books of Wonder); Peter Harrington Books; Rachel Hass, Ellen Keiter, and Jaime Pagana (Eric Carle Museum of Picture Book Art); Judy Taylor Hough; Karen Nelson Hoyle; Thacher Hurd; Motoko Inoue; Ito Motoo; Sybille Jagusch (Library of Congress); Louise Lareau (New York Public Library); Suzy Lee; Carl Lennertz (Children's Book Council); Annie Lionni; Elisabeth Lortic; David Macaulay; Olga Maeots (Library for Foreign Literature, Moscow); Frederik Markusse (Centraal Museum, Utrecht); Jane McCloskey; Sarah McCloskey; Sam McCullen (dPictus); Roger Mello; Anelle Miller (Society of Illustrators); Karen Provensen Mitchell; Rodrigo Morlesin; Diane Muldrow; the late Iona Opie; Helen Oxenbury; Elena Pasoli and Isabella DelMonte (Bologna Children's Book Fair); Geneviève Patte; Aimee Philipson (Seven Stories National Centre for Children's Books); the late Jerry Pinkney; Deborah Pope (Ezra Jack Keats Foundation); Neal Porter (Neal Porter Books/Holiday House); Chris Raschka; Eric Rayman; Ellen G. K. Rubin; Ellen Hunter Ruffin (de Grummond Children's Literature Collection, University of Southern Mississippi); Robert Sabuda; Ann Marie Mulhearn Sayer (Esphyr Slobodkina Foundation); Justin G. Schiller; Linda Schreyer; Brian Selznick; the late Maurice Sendak; Sibylla Shekerdjiska-Benatova; Peter Sís; Lane Smith; Leonora Smith; Jean Steig and the late William Steig; Patrik Steorn (Gothenburg Museum of Art); Takesako Yuko (Chihiro Art Museum); Holly Thompson; Erik Titusson (Lilla Piratfölaget); Avery Fischer Udagawa; the late Tomi Ungerer; June Vail; Sophie Van der Linden; Hilary Van Dusen (Candlewick Press); Dilys Williams Vargas; Lisa Von Drasek and Caitlin Martineau (Kerlan Collection, University of Minnesota); Cynthia Weill (Bank Street College of Education); Abigail Weisgard, Christina Weisgard, and Ethan Weisgard; Jennifer Weitz; Walter Wick; David Wiesner; Mo Willems; Xu Derong; Timothy Young (Beinecke Rare Book & Manuscript Library, Yale University); Zhang Hong (Magic Reading); Zhang Weijun; Zhu Cheng-Liang; Zhu Ziqiang; and Lisbeth Zwerger.

I recall with great warmth and appreciation the work of my late agent George M. Nicholson of Sterling Lord Literistic, who was instrumental in launching this project, and thank his successor Elizabeth Bewley for her help in guiding it toward completion.

My special thanks to my wonderful editors at Abrams, Chelsea Cutchens and Tracy Carns, for their consummate professionalism, immense resourcefulness, and steadfast support, and for their patience over the long years of this book's preparation. To everyone at Abrams (and at Overlook before it), my deepest gratitude: Michael Jacobs, for wholeheartedly embracing this project following the death of Overlook's founder, the great Peter Mayer; editorial assistant Shelby Ozer and research intern Daniel Dobbs for their vital work in securing needed permissions; managing editor Lisa Silverman; and Abrams's splendid designer Darilyn Carnes. Working with you all has been a pleasure.

—L.S.M.

A CHRONOLOGY OF BOOKS

1823 *Collection of German Popular Stories* retold by Jakob and Wilhelm Grimm, illustrated by George Cruikshank

1845 *Slovenly Peter* by Heinrich Hoffmann

1846 *A Book of Nonsense* by Edward Lear

1865 *Alice's Adventures in Wonderland* by Lewis Carroll, illustrated by John Tenniel
Max and Moritz (A Story of Seven Boyish Pranks) by Wilhelm Busch

1870 *In Fairyland: Pictures from the Elf-World* by William Allingham, illustrated by Richard Doyle

1874 *Beauty and the Beast* by Walter Crane

1878 *The Diverting History of John Gilpin* by William Cowper, illustrated by Randolph Caldecott

1879 *Under the Window: Pictures & Rhymes for Children* by Kate Greenaway

1883 *The Merry Adventures of Robin Hood* by Howard Pyle

1887 *International Circus* by Lothar Meggendorfer

1895 *A Home* by Carl Larsson

1896 *Joan of Arc* by Louis-Maurice Boutet de Monvel

1900 *The Wonderful Wizard of Oz* by L. Frank Baum, illustrated by W. W. Denslow

1901/1902 *The Tale of Peter Rabbit* by Beatrix Potter

1906 *The Tale of the Golden Cockerel* by Alexander Pushkin, illustrated by Ivan Bilibin

1909 *Grimm's Fairy Tales* retold by Jakob and Wilhelm Grimm, illustrated by Arthur Rackham

1910 *Children of the Forest* by Elsa Beskow

1911 *Stories from Hans Andersen* by Hans Christian Andersen, illustrated by Edmund Dulac
Treasure Island by Robert Louis Stevenson, illustrated by N. C. Wyeth

1926 *Clever Bill* by William Nicholson
Winnie-the-Pooh by A. A. Milne, illustrated by Ernest H. Shepard

1928 *Millions of Cats* by Wanda Gág

1929 *Emil and the Detectives* by Erich Kästner, illustrated by Walter Trier

1930 *Angus and the Ducks* by Marjorie Flack

1931 *Daniel Boone* by Esther Averill and Lila Stanley, illustrated by Feodor Rojankovsky
The Story of Babar by Jean de Brunhoff

1933 *The Picture Play Book* by Rose Celli, illustrated by Nathalie Parain

1936 *Little Tim and the Brave Sea Captain* by Edward Ardizzone

1939 *Madeline* by Ludwig Bemelmans
Mike Mulligan and His Steam Shovel by Virginia Lee Burton

The Noisy Book by Margaret Wise Brown, illustrated by Leonard Weisgard

1940 *Caps for Sale: A Tale of a Peddler, Some Monkeys & Their Monkey Business* by Esphyr Slobodkina

1941 *Curious George* by H. A. Rey and Margret Rey
Make Way for Ducklings by Robert McCloskey

1942 *The Poky Little Puppy* by Janette Sebring Lowrey, illustrated by Gustaf Tenggren

1943 *A Child's Good Night Book* by Margaret Wise Brown, illustrated by Jean Charlot
The Little Prince by Antoine de Saint-Exupéry

1945 *Animals for Sale* by Bruno Munari

1946 *Tintin in America* by Hergé

1947 *Goodnight Moon* by Margaret Wise Brown, illustrated by Clement Hurd

1948 *Wanderings of Sanmao, or The Story of Sanmao's Vagrant Life* by Zhang Leping

1950 *The Great Big Fire Engine Book* by Tibor Gergely

1952 *Charlotte's Web* by E. B. White, illustrated by Garth Williams

1953 *Down with Skool!: A Guide to School Life for Tiny Pupils and Their Parents* by Geoffrey Willans, illustrated by Ronald Searle

1954 *Cinderella, or the Little Glass Slipper* by Marcia Brown
The Happy Lion by Louise Fatio, illustrated by Roger Duvoisin

1955 *Harold and the Purple Crayon* by Crockett Johnson
Miffy by Dick Bruna
Play with Me by Marie Hall Ets

1956 *See and Say: A Picture Book in Four Languages* by Antonio Frasconi

1957 *The Cat in the Hat* by Dr. Seuss
Sparkle and Spin: A Book About Words by Ann Rand, illustrated by Paul Rand

1960 *Inch by Inch* by Leo Lionni

1961 *Tip and Top Build a Motorcar* by Vojtěch Kubašta

1962 *The Snowy Day* by Ezra Jack Keats

1963 *Richard Scarry's Best Word Book Ever* by Richard Scarry
Where the Wild Things Are by Maurice Sendak

1965 *Mr. Gumpy's Outing* by John Burningham

1967 *Norse Gods and Giants* by Ingri D'Aulaire and Edgar Parin D'Aulaire

1968 *Corduroy* by Don Freeman
Staying Home Alone on a Rainy Day by Chihiro Iwasaki

1969 *Lupinchen* by Binette Schroeder
Sylvester and the Magic Pebble by William Steig
The Very Hungry Caterpillar by Eric Carle

1970 *Shapes and Things* by Tana Hoban

1971 *The Beast of Monsieur Racine* by Tomi Ungerer

1972 *George and Martha* by James Marshall

1973 *Cathedral: The Story of Its Construction* by David Macaulay

1978 *Anno's Journey* by Anno Mitsumasa

1981 *Jumanji* by Chris Van Allsburg

1982 *The Tongue-Cut Sparrow* retold by Momoko Ishii, illustrated by Akaba Suekichi

1983 *The Glorious Flight: Across the Channel with Louis Blériot, July 25, 1909* by Alice and Martin Provensen
Gorilla by Anthony Browne

1988 *The Adventures of Pinocchio* by Carlo Collodi, illustrated by Roberto Innocenti

1989 *We're Going on a Bear Hunt* by Michael Rosen, illustrated by Helen Oxenbury

1990 *One, Five, Many* by Květa Pacovská

1991 *Tuesday* by David Wiesner

1992 *Charlie Parker Played Be Bop* by Chris Raschka
I Spy: A Book of Picture Riddles by Jean Marzollo, illustrated by Walter Wick
The Stinky Cheese Man and Other Fairly Stupid Tales by Jon Scieszka, illustrated by Lane Smith

1994 *John Henry* by Julius Lester, illustrated by Jerry Pinkney

1995 *The Dreamkeeper: A Letter from Robert Ingpen to his Granddaughter Alice Elizabeth* by Robert Ingpen
Why? by Nikolai Popov

1998 *Zagazoo* by Quentin Blake

2000 *The Wonderful Wizard of Oz: A Commemorative Pop-Up* by L. Frank Baum, illustrated by Robert Sabuda

2002 *Meninos do Mangue* by Roger Mello

2003 *The Tree of Life: Charles Darwin* by Peter Sís

2004 *Knuffle Bunny: A Cautionary Tale* by Mo Willems

2005 *Le Taxi-Brousse de Papa Diop* by Christian Epanya

2006 *The Arrival* by Shaun Tan
Petit, the Monster by Isol

2007 *The Invention of Hugo Cabret* by Brian Selznick
Let It Shine by Ashley Bryan

2010 *Shadow* by Suzy Lee

2011 *A New Year's Reunion* by Yu Li-Qiong, illustrated by Zhu Cheng-Liang

2012 *Virginia Wolf* by Kyo Maclear, illustrated by Isabelle Arsenault

2013 *Niño Wrestles the World* by Yuyi Morales

2014 *Mère Méduse* by Kitty Crowther

2015 *Trombone Shorty* by Troy "Trombone Shorty" Andrews, illustrated by Bryan Collier

NOTES

INTRODUCTION

1 John Locke, *Some Thoughts Concerning Education* (London: A. and J. Churchill, 1693), 183.
2 John Rowe Townsend, *John Newbery and His Books: Trade and Plumb-Cake for Ever, Huzza!* (Metuchen, NJ, and London: Scarecrow Press, 1994), 25–28.
3 Ann Herring, *The Dawn of Wisdom: Selections from the Japanese Collection of the Cotsen Children's Library* (Princeton, NJ: Cotsen Occasional Press, 2000), 5–24.
4 In 2018, the Spanish publisher Libros del Zorro Rojo issued a new, Spanish-Latin edition of Comenius's classic book with original illustrations by Paulo Kreutzberger. In 2019, it received a Ragazzi Award for Nonfiction (one of four conferred that year) by the Bologna Children's Book Fair.
5 Lewis Carroll, *Alice's Adventures in Wonderland*, illustrated by John Tenniel (London: Macmillan, 1866), 1–2.
6 John Canemaker, *Winsor McCay: His Life and Art* (New York: Abbeville Press, 1987).
7 Ruari McLean, *The Reminiscences of Edmund Evans, Wood Engraver and Color Printer, 1826–1905* (Oxford: Clarendon Press, 1968).
8 Leonard S. Marcus, *Randolph Caldecott: The Man Who Could Not Stop Drawing* (New York: Frances Foster/Farrar, Straus and Giroux, 2013).
9 Ellen Key, *The Century of the Child* (New York and London: G. P. Putnam's Sons, 1909), 106–190. First published in Sweden in 1900.
10 Maurice Sendak, "Lothar Meggendorfer," *Caldecott & Co.: Notes on Books & Pictures* (New York: Michael di Capua/Farrar, Straus and Giroux, 1988), 51–60.
11 Leonard S. Marcus, *Minders of Make-Believe: Idealists, Entrepreneurs, and the Shaping of American Children's Literature* (Boston: Houghton Mifflin, 2008), 71–109.
12 Leonard S. Marcus, *Margaret Wise Brown: Awakened by the Moon* (Boston: Beacon Press, 1992), 33–182.
13 Herring, 77–101.
14 For the contrast in critical sentiment about the comics between America and Europe, see, for example, Bradford W. Wright, *Comic Book Nation: The Transformation of Youth Culture in America* (Baltimore and London: Johns Hopkins University Press, 2001), and Michael Farr, *Tintin: The Complete Companion* (San Francisco: Last Gasp, 2002).
15 Leonard S. Marcus, *Golden Legacy: The Story of Golden Books* (New York: Random House, 2017).
16 Jella Lepman, *A Bridge of Children's Books* (Dublin: O'Brien Press, 2002).
17 Carla Poesio, "The Beginnings," *Bologna: Fifty Years of Children's Books from Around the World*, ed. Giorgia Grilli (Bologna: Bononia University Press, 2013), 49–58.
18 Aree Cheunwattana, "Bunko: The Home and Community Library in Japan: A Qualitative Study," in *Information Development*, vol. 24, issue 1 (February 1, 2008), 17–23.
19 Giorgio Maffei, *Munari's Books* (Mantova: Corraini Edizioni, 2002), 70–77.
20 Leo Lionni, *Between Worlds: The Autobiography of Leo Lionni* (New York: Alfred A. Knopf, 1997); Steven Heller, *Paul Rand* (New York: Phaidon, 2000); and Eric Carle, *The Art of Eric Carle* (New York: Philomel Books, 1996).
21 Selma G. Lanes, *The Art of Maurice Sendak* (New York: Harry N. Abrams, 1980), 77–108.
22 Leonard S. Marcus, "Mitsumasa Anno," *Show Me a Story!: Why Picture Books Matter* (Somerville, MA: Candlewick Press, 2012), 7–17.
23 Karen Raugust, "Children's Publishing in China: Highlights of the first GKC China Deep Dive," *Publishers Weekly*, December 8, 2015, www.publishersweekly.com/pw/by-topic/childrens/childrens-industry-news/article/68894-children-s-publishing-in-china-highlights-from-the-first-gkc-china-deep-dive.html.
24 Julie Bosman, "Picture Books No Longer a Staple for Children," *New York Times*, October 7, 2010, www.nytimes.com/2010/10/08/us/08picture.html.
25 The museum's history is outlined on its official website: "History of the Chihiro Art Museum," Chihiro Art Museum, accessed January 28, 2022, https://chihiro.jp/en/foundation/history/.
26 A partial list of children's book art museums and exhibitions spaces would include the Eric Carle Museum of Picture Book Art (Amherst, MA); the National Center for Children's Illustrated Literature (Abilene, TX); the Mazza Museum (Findlay, OH); House of Illustration (London); Seven Stories (Newcastle, UK); Miffy Museum (Utrecht, Netherlands); the Moomin Museum (Tampere, Finland); Heinrich Hoffmann and Struwwelpeter Museum (Frankfurt, Germany); and Hyundai Museum of Kids' Books & Art (Seongnam, South Korea).
27 Robert Lawson, "The Caldecott Medal Acceptance," *The Horn Book* (July 1941), 277.

ISABELLE ARSENAULT

1 Anne Carroll Moore, *My Roads to Childhood* (Boston: The Horn Book, 1961), 350–51.

LUDWIG BEMELMANS

1 Robert van Gelder, "An Interview with Ludwig Bemelmans," *New York Times Book Review*, January 26, 1941, 44 and 65.
2 John Bemelmans Marciano, *Bemelmans: The Life & Art of Madeline's Creator* (New York: Viking, 1999), 40, 45.

ELSA BESKOW

1 "Elsa Beskow and her Swedish Children's Books," Floris Books, accessed January 23, 2018, www.florisbooks.co.uk/authors/elsa-beskow.php.

IVAN BILIBIN

1 Sergei Golynets, *Ivan Bilibin* (New York and Leningrad: Harry N. Abrams/Aurora Art Publishers, 1981), 10.
2 Ibid., 13.

QUENTIN BLAKE

1 Leonard S. Marcus, *Show Me a Story! Why Picture Books Matter* (Somerville, MA: Candlewick Press, 2012), 21.

LOUIS-MAURICE BOUTET DE MONVEL

1 Quoted in "Louis-Maurice Boutet de Monvel," Wikipedia: https://en.wikipedia.org/wiki/Louis-Maurice_Boutet_de_Monvel.
2 Gerald Gottlieb, introduction to *Joan of Arc*, by Maurice Boutet de Monvel, (New York: Pierpont Morgan Library/Viking Studio, 1980), 10–11.

MARCIA BROWN

1 Leonard S. Marcus, *A Caldecott Celebration: Seven Artists and Their Paths to the Caldecott Medal* (New York: Walker, 2008), 13.
2 Ibid., 15.

ANTHONY BROWNE

1 Julia Eccleshare, "Portrait of the Artist as a Gorilla," *Guardian*, July 28, 2000, http://theguardian.com/books/2000/jul/29/booksforchildrenandteenagers.
2 "Kurt Maschler Awards," *Book Awards*, accessed January 28, 2022, www.bookawards.bizland.com/kurt_maschler_award_for_children.htm.

JOHN BURNINGHAM

1 "Mr. Gumpy's Outing," *Kirkus Reviews*, October 1, 1971, www.kirkusreviews.com/book-reviews/john-burningham/mr-gumpys-outing/.

VIRGINIA LEE BURTON

1 Barbara Elleman, *Virginia Lee Burton: A Life in Art* (Boston: Houghton Mifflin, 2002), 113.

RANDOLPH CALDECOTT

1 *Randolph Caldecott: His Early Art Career* (London: Sampson, Low, Marston, Searle & Rivington, 1886), 115.
2 Quoted in Judy Taylor et al., *Beatrix Potter, 1866–1943: The Artist and Her World* (London: F. Warne, 1987), 107.

JEAN CHARLOT

1 Karen Thompson, "Jean Charlot: Artist and Scholar," *Jean Charlot: A Retrospective*, (Honolulu: University of Hawai'i Art Gallery, 1990), https://library.manoa.hawaii.edu/

departments/charlotcoll/J_Charlot/char-lotthompson.php.

2 Jean Charlot, interview by Miriam L. Wesley and Alice W. Hollis (transcript), August 18, 1961, Archives of American Art, Smithsonian Institution, Washington, DC, 19.

CHIHIRO IWASAKI

1 Khetsirin Pholdhampalit, "Her Greatest Gift Was Hope," *The Nation*, October 12, 2014, www.pressreader.com/thailand /the-nation/20141012/281500749495569.

2 Sandra L. Beckett, *Crossover Picturebooks: A Genre for All Ages* (New York and Abington: Routledge, 2012), 10.

INGRI D'AULAIRE AND EDGAR PARIN D'AULAIRE

1 Quoted in Frances Clarke Sayers, *Anne Carroll Moore: A Biography* (New York: Atheneum, 1972), 86.

2 Michael Chabon, "Preface," *D'Aulaires' Book of Norse Myths*, by Ingri and Edgar Parin d'Aulaire (New York: New York Review Books, 2005), xii.

W. W. DENSLOW

1 Susan E. Meyer, *A Treasury of the Great Children's Book Illustrators* (New York: Harry N. Abrams, 1983), 258.

2 Katharine M. Rogers, *L. Frank Baum, Creator of Oz: A Biography* (New York: St. Martin's Press, 2002), 88.

3 Ibid., 89.

ROGER DUVOISIN

1 Anita Silvey, ed., *The Essential Guide to Children's Books and Their Creators* (Boston: Houghton Mifflin, 2002), 132.

CHRISTIAN EPANYA

1 Christian Epanya, interviewed by Hubert Marlin Jr., *Flashmag!*, October 22, 2012, www.flashmagonline.net/ blog/1010634-interview-with-christian -epanya-innate-author-and-illustrator.

MARJORIE FLACK

1 Anita Silvey, *Children's Books and Their Creators* (Boston: Houghton Mifflin, 1995), 244.

2 Louise Seaman Bechtel, *Books in Search of Children: Speeches and Essays* (New York: Macmillan, 1969), 163.

3 Barbara Bader, *American Picturebooks from Noah's Ark to the Beast Within* (New York: Macmillan, 1976), 62.

ANTONIO FRASCONI

1 Quoted in Doris de Montreville and Donna Hill, eds., *The Third Book of Junior Authors* (New York: H. W. Wilson, 1972), 91.

2 Douglas Martin, "Antonio Frasconi, Woodcut Master, Dies at 93," *New York Times*, January 21, 2013, www.nytimes .com/2013/01/22/arts/design/antonio -frasconi-woodcut-master-dies-at-93 .html.

3 Anne Commrie, ed., "Antonio Frasconi," *Something About the Author*, vol. 53 (Detroit: Gale Research, 1988), 49.

4 Ibid., 46.

5 Bader, *American Picturebooks*, 344.

DON FREEMAN

1 Edith McCullough, *The Prints of Don Freeman: A Catalogue Raisonné* (Charlottesville: University Press of Virginia, 1988), 1; Don Freeman, interview by Betty Hoag (transcript), June 4, 1965," Archives of American Art, www.aaa.si.edu/collections/interviews/ oral-history-interview-don-freeman-12155.

2 Leonard S. Marcus, Introduction to *Corduroy & Company: A Don Freeman Treasury* (New York: Viking, 2001), ix.

WANDA GÁG

1 Wanda Gág, *The Girlhood Diary of Wanda Gág, 1908–1909: Portrait of a Young Artist*, ed. Megan O'Hara (Mankato: Blue Earth Books, 2001), 7.

2 Michael Patrick Hearn, "Wanda Gág," *Dictionary of Literary Biography*, vol. 22, ed. John Cech (Detroit: Gale Research, 1983), 183.

3 Anne Carroll Moore, *New York Herald Tribune*, September 9, 1928, reprinted in Moore, *The Three Owls: Third Book* (New York: Macmillan, 1925), 110.

KATE GREENAWAY

1 Meyer, *A Treasury of the Great Children's Book Illustrators*, 112.

TANA HOBAN

1 Susan Hirschman, interview by Leonard S. Marcus, *The Horn Book* (May/June 1996), 284.

2 Marcus, *Show Me a Story!*, 115.

HEINRICH HOFFMANN

1 Leonard S. Marcus, "Heinrich Hoffmann," *Writers for Children: Critical Studies of the Major Authors Since the Seventeenth Century*, ed. Jane M. Bingham (New York: Charles Scribner's Sons, 1988), 290.

ISOL

1 Jury citation, Astrid Lindgren Memorial Award, 2013, www.alma.se/en/Laureates/2013-Isol/.

EZRA JACK KEATS

1 Ezra Jack Keats, "1963 Caldecott Medal Acceptance Speech," 1963, www.ezra -jack-keats.org/caldecott-award -acceptance/.

2 Nancy Larrick, "The All-White World of Children's Books," *Saturday Review of Literature* (September 11, 1965), 63–65.

VOJTĚCH KUBAŠTA

1 William Grimes, "Wizard Who Made Art Jump Off the Page," *New York Times*, January 31, 2014, C23.

EDWARD LEAR

1 Quoted in "Edward Lear," Wikipedia: https:// en.wikipedia.org/wiki/Edward_Lear.

2 John Lehmann, *Edward Lear and His World* (New York: Thames & Hudson, 1977), 47.

LEO LIONNI

1 Leo Lionni, *Between Worlds: The Autobiography of Leo Lionni* (New York: Alfred A. Knopf, 1997), 12.

2 Ibid., 13.

JAMES MARSHALL

1 Marcus, *Show Me a Story!*, 128.

LOTHAR MEGGENDORFER

1 Peter Haining, *Movable Books: An Illustrated History* (London: New English Library Ltd, 1979), 65.

2 Maurice Sendak, *Caldecott & Co.: Notes on Books and Pictures* (New York: Farrar, Straus and Giroux, 1988), 59.

BRUNO MUNARI

1 Edith K. Ackermann, "Deep Influences on Thinking and Learning": https://web .media.mit.edu/~edith/personal.html.

2 Giorgio Maffei, *Munari's Books* (Mantova, Italy: Corraini, 2009), 27.

3 Ibid., 70.

4 "Outstanding Juveniles of the Year," *New York Times* (December 1, 1957), 364.

WILLIAM NICHOLSON

1 Colin Campbell, *William Nicholson: The Graphic Work* (London: Barrie & Jenkins Ltd, 1992), 159.

2 Anne Carroll Moore, *My Roads to Childhood* (Boston: The Horn Book, 1961), 344.

3 *Clever Bill*, Egmont Publishing, www .egmont.co.uk/books/clever-bill /9781405283328.

HELEN OXENBURY

1 Marcus, *Show Me a Story!*, 162.

KVĚTA PACOVSKÁ

1 Quoted by International Board on Books for Young People site: https://fundraising .ibby.org/scarfs?tx_cartproducts_prod ucts%5Bproduct%5D=4&cHash=50b 685132baf5a4adb2ebea188a32965.

2 Leonard S. Marcus, "Children's Books: *One, Five, Many* by Kveta Pacovska," *New York Times Book Review*, March 24, 1991, BR 35.

NATHALIE PARAIN

1 Bader, *American Picturebooks*, 126.

NIKOLAI POPOV

1 Nikolai Popov, author's note in *Why?* (New York: minedition, 2021).

BEATRIX POTTER

1 Quoted in Sayers, 227.

ALICE AND MARTIN PROVENSEN

1 Alice and Martin Provensen, "Caldecott Medal Acceptance," *Horn Book*, August 1984, 444–48.

HOWARD PYLE

1 See for instance the assessment of Henry C. Pitz, *Howard Pyle: Writer, Illustrator, Founder of the Brandywine School* (New York: Clarkson N. Potter, 1975).

2 Taimi M. Ranta, "Howard Pyle's *The Merry Adventures of Robin Hood*: The Quintessential Children's Story," in *Touchstones: Reflections on the Best in Children's Literature*, vol. 2, ed. Perry Nodelman (West Lafayette, IN: ChLA, 1987), 213.

ARTHUR RACKHAM

1 Brigid Peppin and Lucy Micklethwait, *Book Illustrators of the Twentieth Century* (New York: Arco, 1984), 241.

2 Tony Geer, "The Fairy Tales of the Brothers Grimm," the Book Blog, March 13, 2012, http:/thebookblog.com/review/the-fairy-tales-of-the-brothers-grimm.

PAUL RAND

1 Paul Rand, *Thoughts on Design* (San Francisco: Chronicle, 2014), 9.

2 Louise Seaman Bechtel, "The A.I.G.A. Children's Book Show of 1958," reprinted in Bechtel, *Books in Search of Children*, 59–60.

3 Steven Heller, "Designs for Playing," *New York Times Book Review*, November 12, 2006, www.nytimes.com/2006/11/12/books/review/Heller.t.html.

FEODOR ROJANKOVSKY

1 Bader, *American Picturebooks*, 118–19.

2 Ibid., 119.

3 Ibid., 119.

4 Irving Allen, Polly Allen, and Tatiana Rojankovsky Koly, *Feodor Rojankovsky: The Children's Books and Other Illustration Art* (Englewood, FL: Wood Stork Press, 2014), 120.

ROBERT SABUDA

1 Alexandra Alter, "The Reigning Prince of Pop-Up Books," *Wall Street Journal*, October 1, 2011, www.wsj.com/articles/SB10001424052970204831304576597200764936760.

ANTOINE DE SAINT-EXUPÉRY

1 Stacy Schiff, *Saint-Exupéry: A Biography* (New York: Henry Holt, 1994), 445.

RONALD SEARLE

1 Geoffrey Willens, *The Compleet Molesworth*, illus. Ronald Searle (London: Pavilion Books, 1985), 7.

BRIAN SELZNICK

1 Brian Selznick, interview by Gavin J. Grant, n.d., ca. 2001, Indiebound, www.indiebound.org/author-interviews/selznick.

MAURICE SENDAK

1 Bruno Bettelheim, "The Care and Feeding of Monsters," *Ladies' Home Journal* (March 1969), 48.

DR. SEUSS

1 Judith and Neil Morgan, *Dr. Seuss & Mr. Geisel* (New York: Random House, 1995), 71.

ERNEST H. SHEPARD

1 Rawle Knox, ed., *The Work of E. H. Shepard* (New York: Schocken Books, 1979), 104.

2 Tim Benson, "The Man Who Hated Pooh," BBC News, March 6, 2006, http://news.bbc.co.uk/2/hi/uk_news/magazine/4772370.stm.

3 Knox, *The Work of E. H. Shepard*, 112.

4 Alison Flood, "The Real Winnie-the-Pooh Revealed to Have Been 'Growler,'" *Guardian*, September 4, 2017, www.theguardian.com/books/2017/sep/04/real-winnie-the-pooh-revealed-to-have-been-growler.

5 Brian Sibley, *Three Cheers for Pooh: The Best Bear in All the World* (New York: Dutton, 2001), 94–95.

ESPHYR SLOBODKINA

1 Leonard S. Marcus, "Modernist at Story Hour: Esphyr Slobodkina and the Art of the Picture Book," in Sandra Kraskin, Karen Cantor, et. al., *Rediscovering Slobodkina: A Pioneer of American Abstraction* (Manchester, VT, and New York: Hudson Hills Press, 2009), 124.

WILLIAM STEIG

1 Silvey, *Children's Books and Their Creators*, 434.

SHAUN TAN

1 Shaun Tan, interview by Mitchell Jordan (transcript), *Bookslut*, July 2009, www.bookslut.com/features/2009_07_014748.php.

2 Ibid.

3 Scholastic, "*The Arrival* Book Focus" n.d., www.scholastic.com/teachers/articles/teaching-content/arrival-book-focus/.

WALTER TRIER

1 Maurice Sendak, introduction to *Emil and the Detectives* by Maurice Sendak (New York: The Overlook Press, 2007), 5–6.

2 Kate Connolly, "*Emil and the Detectives*: Michael Rosen on the Trail of a Children's Classic," *Guardian*, May 2, 2013, www.theguardian.com/books/2013/may/02/emil-and-the-detectives-michael-rosen.

TOMI UNGERER

1 Tomi Ungerer, *Tomi: A Childhood under the Nazis* (Boulder, Dublin, London, Sydney: Roberts Rinehart, 1998), epigraph.

2 Eden Ross Lipson, *The New York Times Parent's Guide to the Best Books for Children* (New York: Three Rivers Press, 2000), 120.

3 Bader, *American Picturebooks*, 544, 550.

CHRIS VAN ALLSBURG

1 Marcus, *A Caldecott Celebration*, 31–32.

2 Chris Van Allsburg, interview by Jennie McDonal (transcript), Center for the Collaborative Classroom, n.d., www.collaborativeclassroom.org/blog/interview-with-chris-van-allsburg-part-2/.

LEONARD WEISGARD

1 Margaret Wise Brown, "Leonard Weisgard Wins the Caldecott Medal," *Publishers Weekly*, July 5, 1947, 42.

DAVID WIESNER

1 Silvey, *Children's Books and Their Creators*, 470; Marcus, *A Caldecott Celebration*, 39.

2 Marcus, *A Caldecott Celebration*, 44.

MO WILLEMS

1 Mo Willems, "Why Books? The Zena Sutherland Lecture," *Horn Book*, October 21, 2011, www.hbook.com/2011/10/authors-illustrators/why-books-the-zena-sutherland-lecture.

GARTH WILLIAMS

1 Leonard S. Marcus, "Garth Williams," *Publishers Weekly*, February 23, 1990, 201.

N. C. WYETH

1 Silvey, *Children's Books and Their Creators*, 481; David Michaelis, *N. C. Wyeth: A Biography* (New York: Alfred A. Knopf, 1998), 211.

ZHANG LEPING

1 "Sanmao, China's favorite son turns 70," China Daily, July 28, 2005, www.chinadaily.com.cn/english/doc/2005-07/28/content_464182.htm.

IMAGE CREDITS

Introduction
Pages from *Orbis Sensualium Pictus* courtesy of Newberry Digital Collections. Pages from *A Little Pretty Pocket-Book* courtesy of the Miniature Book Collection, Library of Congress, Rare Book and Special Collections Division. "Sing a Song for Sixpence," from *The Complete Collection of Pictures & Songs* by Randolph Caldecott (G. Routledge and Sons: London and New York, 1887), Library of Congress, Rare Book and Special Collections Division. Chihiro Iwasaki, Fish and Yellow Rain Shoes, 1968 (a study for pp. 16–17 of *Ame no Hi no Orusuban*), courtesy of Chihiro Art Museum. Illustration from *The Very Hungry Caterpillar* by Eric Carle (Philomel Books, 1969), collection of Eric and Barbara Carle © 1969, 1987 Penguin Random House LLC. Preliminary art for *The Snowy Day* © Ezra Jack Keats Foundation. Photograph of 1967 Bologna Children's Book Fair courtesy of the Bologna Children's Book Fair.

AKABA SUEKICHI
Illustrations from *Shitakiri Suzume* (*The Tongue-Cut Sparrow*) written by Momoko Ishii (1982) and illustrated by Akaba Suekichi. Reprinted with permission from Fukuinkan Shoten Publishers, Inc. Preliminary art (dummy) for *Shitakiri Suzume* (*The Tongue-Cut Sparrow*) and artist photograph courtesy of the Akaba family and Chihiro Art Museum.

ANNO MITSUMASA
Illustrations from *Anno's Journey* by Anno Mitsumasa © 1977 by Fukuinkan Shoten Publishers, Tokyo. Reprinted with permission. Artist photograph courtesy of Fukuinkan Shoten Publishers, Inc.

EDWARD ARDIZZONE
Illustrations from *Little Tim and the Brave Sea Captain* by Edward Ardizzone. Copyright © 1936 The Ardizzone Trust. Reprinted with permission. Artist photograph by Popperfoto via Getty Images/Getty Images.

ISABELLE ARSENAULT
Material from *Virginia Wolf* written by Kyo Maclear and illustrated by Isabelle Arsenault is used by permission of Kids Can Press Ltd., Toronto. Text © 2012 Kyo Maclear. Illustrations © 2012 Isabelle Arsenault. Artist photograph by Dominique Lafond.

LUDWIG BEMELMANS
Illustrations from *Madeline* by Ludwig Bemelmans. Copyright © 1939 by Ludwig Bemelmans; copyright renewed © 1967 by Madeleine Bemelmans and Barbara Bemelmans Marciano. Used by permission of Viking Children's Books, an imprint of Penguin Young Readers Group, a division of Penguin Random House LLC. All rights reserved. Preliminary art: Line drawing © Ludwig Bemelmans. Permission granted by Ludwig Bemelmans LLC. Illustration for *Madeline and the Gypsies* (Puffin Books, 1958) by Ludwig Bemelmans. Gift of Kendra and Allan Daniel in memory of Trinkett Clark, whose "Trinkettness" will endure in the spirit of children's illustration. © 1986, 1987 Madeleine Bemelmans and Barbara Bemelmans. Artist photograph © Fred Stein/Bridgeman Images.

ELSA BESKOW
Illustrations from *Children of the Forest* by Elsa Beskow. Images reprinted courtesy of the Estate of Elsa Beskow. Artist photograph courtesy of TT News Agency/Alamy Stock Photo.

IVAN BILIBIN
Illustrations from *The Golden Cockerel* illustrated by Ivan Bilibin are in the public domain. Illustrations and artist photograph courtesy of Shakko/Wikimedia Commons.

QUENTIN BLAKE
Book cover and illustration from *Zagazoo* by Quentin Blake. Copyright © 1998 by Quentin Blake. Reprinted by permission of Orchard Books, an imprint of Scholastic Inc. Artist photograph courtesy of ukartpics/Alamy Stock Photo.

LOUIS-MAURICE BOUTET DE MONVEL
Illustrations from *Jeanne d'Arc* by Louis-Maurice Boutet de Monvel are in the public domain. Illustrations courtesy of Justin G. Schiller, Battledore Ltd. Artist photograph courtesy of Sjaddde/Wikimedia Commons.

MARCIA BROWN
Illustrations from *Cinderella* copyright © 1971 by Marcia Brown; used by permission of Simon & Schuster Children's Publishing. Preliminary art, illustrations, and artist photograph courtesy of M. E. Grenander Department of Special Collections and Archives, University Libraries, University at Albany, SUNY.

ANTHONY BROWNE
Illustrations from *Gorilla* by Anthony Browne. Copyright © 1983 by Anthony Browne. Reproduced by permission of the publisher, Candlewick Press, on behalf of Walker Books, London. Artist photograph courtesy of Random House Children's Books/Wikimedia Commons. Preliminary art courtesy of Seven Stories, The National Centre for Children's Books.

DICK BRUNA
Illustrations from *Miffy* by Dick Bruna copyright © 1955, 1963 by Mercis bv. Reprinted with permission. Photographs of Dick Bruna at work and preliminary art by Ferry André de la Porte copyright © copyright Mercis bv. Photograph of Miffy statue © Mercis bv. Artist photograph © Martin Godwin.

ASHLEY BRYAN
Illustrations from *Let It Shine* copyright © 2007 by Ashley Bryan; used by permission of Simon & Schuster Children's Publishing. Artist photograph © Bill McGuiness.

JOHN BURNINGHAM
From *Mr. Gumpy's Outing* © 1971 by John Burningham. Reprinted by permission of Henry Holt Books for Young Readers. All rights reserved. Artist photograph courtesy of Walker Books, Ltd.

VIRGINIA LEE BURTON
Illustrations from *Mike Mulligan and His Steam Shovel* reproduced with permission of Houghton Mifflin Harcourt. First edition cover of *Mike Mulligan and His Steam Shovel* by Virginia Lee Burton, Houghton Mifflin Company, 1939. Collection of Barbara Elleman. Preliminary art courtesy of the Virginia Lee Burton papers, Special Collections & University Archives, University of Oregon. Preliminary sketch and artist photograph courtesy of the Cape Ann Museum Library and Archives.

WILHELM BUSCH
Illustrations from *Max and Moritz* illustrated by Wilhelm Busch are in the public domain. Illustrations courtesy of GersWsUpload/Wikimedia Commons. Cover image courtesy of Justin G. Schiller, Battledore Ltd. Artist photograph by Ernst Hanfstaengl, München 1878, courtesy of Rainer Zenz/Wikimedia Commons.

RANDOLPH CALDECOTT
Illustrations from *The Diverting History of John Gilpin* illustrated by Randolph Caldecott are in the public domain. Illustrations courtesy of the Miriam and Ira D. Wallach Division of Art, Prints and Photographs: Picture Collection, the New York Public Library Digital Collections. Artist photograph from *Randolph Caldecott: A Personal Memoir of His Early Art and Career* by Henry Blackburn (London: Sampson Low, Marston, Searle, & Rivington, 1886).

ERIC CARLE
Illustrations from *The Very Hungry Caterpillar* by Eric Carle. Copyright © 1969, 1987 by Eric Carle. Used by permission of Philomel, an imprint of Penguin Young Readers Group, a division of Penguin Random House LLC. All rights reserved. First edition cover and illustrations from *The Very Hungry Caterpillar* by Eric Carle (Philomel Books, 1969), collection of Eric and Barbara Carle © 1969, 1987 Penguin Random House LLC. Eric Carle, book dummy illustrations for "A Week with Willi Worm," 1969. Collection of Eric and Barbara Carle. © Penguin Random House LLC. Artist photograph: Eric Carle in studio, 2015 © The Eric Carle Museum of Picture Book Art.

JEAN CHARLOT
Illustrations from *A Child's Good Night Book* by Margaret Wise Brown, illustrated by Jean Charlot. Copyright © 1943, 1950 by Margaret Wise Brown. Copyright renewed 1978 by Roberta B.

Raunch. Used by permission of HarperCollins Publishers. Artist photograph courtesy of Prismatic Pictures/Bridgeman Images.

CHIHIRO IWASAKI
Illustrations reprinted with permission from *Ame no Hi no Orusuban* (*Staying Home Alone on a Rainy Day*) by Chihiro Iwasaki (concept by Yasoo Takeichi, 1968). Reprinted with permission from Shiko-sha Co. Ltd. Copyright © 2022 Chihiro Art Museum. Chihiro Iwasaki, Fish and Yellow Rain Shoes, 1968 (a study for pp. 16–17 of *Ame no Hi no Orusuban*), courtesy of Chihiro Art Museum. Artist photograph courtesy of Chihiro Art Museum.

BRYAN COLLIER
Text copyright © 2015 Troy Andrews and Bill Taylor. Illustrations copyright © 2015 Bryan Collier. Used by permission of Abrams Books, an imprint of ABRAMS, New York. All rights reserved. Preliminary art and artist photograph courtesy of Bryan Collier.

WALTER CRANE
Illustrations from *Beauty and the Beast* illustrated by Walter Crane are in the public domain. Illustrations courtesy of San Francisco Public Library/Internet Book Archive. Artist photograph courtesy of Julian Felsenburgh/Wikimedia Commons.

KITTY CROWTHER
Illustrations from *Mère Méduse*, Kitty Crowther © 2014, *l'école des loisirs*, Paris. Preliminary art © Catherine Crowther. Reprinted with permission. Artist photograph courtesy of Catherine Crowther.

GEORGE CRUIKSHANK
Illustrations from *Collection of German Popular Stories* illustrated by George Cruikshank are in the public domain. Illustrations courtesy of RaboKarbakian/Wikimedia Commons. Artist photograph courtesy of the Boston Public Library Arts Department, Carte de Visite Collection.

INGRI AND EDGAR PARIN D'AULAIRE
Illustrations from *Norse Gods and Giants* by Ingri and Edgar Parin d'Aulaire, published by New York Review Books. Copyright © by Ingri and Edgar Parin d'Aulaire. Copyright © renewed 1995 by Nils d'Aulaire and Per Ola d'Aulaire. All rights reserved. Preliminary art from the collection of the Edgar Parin and Ingri D'Aulaire Papers, Beinecke Rare Book and Manuscript Library, Yale University. Artists photograph courtesy of the Estate of Ingri and Edgar Parin D'Aulaire.

JEAN DE BRUNHOFF
Illustrations from *The Story of Babar* by Jean De Brunhoff. Copyright © 1933, renewed 1961 by Penguin Random House LLC. Used by permission of Random House Children's Books, a division of Penguin Random House LLC. All rights reserved. Illustrations from *Histoire de Babar* courtesy of the Bibliothèque nationale de France. Facsimile illustrations from the *Histoire de Babar* maquette from The Morgan Library & Museum/Art Resource, NY. Artist photograph courtesy of Goodreads.

W. W. DENSLOW
Illustrations from *The Wonderful Wizard of Oz* illustrated by W. W. Denslow are in the public domain. Cover and interior illustrations courtesy of the Library of Congress, Rare Book and Special Collections Division. Title page image courtesy of Christie's Images, Ltd. Preliminary art courtesy of the Miriam and Ira D. Wallach Division of Art, Prints and Photographs: Picture Collection, the New York Public Library Digital Collections. Artist photograph from of Oz Wiki.

RICHARD DOYLE
Illustrations from *In Fairyland: A Series of Pictures from the Elf-World* illustrated by Richard Doyle are in the public domain. Fairy Queen illustrations courtesy of the Metropolitan Museum of Art, Gift of Lincoln Kirstein, 1970. Illustrations courtesy of the Miriam and Ira D. Wallach Division of Art, Prints and Photographs: Picture Collection, the New York Public Library Digital Collections. Artist photograph courtesy of the Metropolitan Museum of Art, The Albert Ten Eyck Gardner Collection, Gift of the Centennial Committee, 1970.

EDMUND DULAC
Illustrations from *Stories of Hans Andersen* illustrated by Edmund Dulac are in the public domain. Illustrations and artist photograph courtesy of Cygnis insignis/Wikimedia Commons.

ROGER DUVOISIN
Illustrations from *The Happy Lion* by Louise Fatio and illustrated by Roger Duvoisin. Illustrations copyright © 1954 by Roger Duvoisin. Copyright renewed 1982 by Louise Fatio Duvoisin. Used by permission of Random House Children's Books, a division of Penguin Random House LLC. All rights reserved. Preliminary art courtesy of the Zimmerli Art Museum, Gift of Louise Fatio Duvoisin, photographed by Peter Jacobs. Artist photograph courtesy of the Estate of Roger Duvoisin.

CHRISTIAN EPANYA
Illustrations from *Le Taxi-Brousse de Papa Diop* by Christian Epanya courtesy of Editions Syros, Paris. Artist photograph courtesy of Christian Epanya.

MARIE HALL ETS
Illustrations from *Play With Me* by Marie Hall Ets, copyright © 1955, renewed 1983 by Marie Hall Ets. Used by permission of Viking Children's Books, an imprint of Penguin Young Readers Group, a division of Penguin Random House LLC. All rights reserved. Preliminary art and artist photograph courtesy of the Kerlan Collection, Children's Literature Research Collections, University of Minnesota Libraries. Artist photograph by George Cserna.

MARJORIE FLACK
From *Angus and the Ducks* © 1997 by Marjorie Flack. Reprinted by permission of Farrar, Straus and Giroux Books for Young Readers. All Rights Reserved. Reprinted by permission of Harold Ober Associates. Copyright © 1930 by Marjorie Flack. Artist photograph courtesy of the William Rose Benét Papers, Yale Collection of American Literature, Beinecke Rare Book and Manuscript Library.

ANTONIO FRASCONI
Illustrations from *See and Say* reproduced with permission of Houghton Mifflin Harcourt. Reproduced with permission. Pig and sheep illustrations for *See and Say: A Picture Book in Four Languages* by Antonio Frasconi courtesy of the Eric Carle Museum of Picture Book Art, gift of the Frasconi Family © 1955 Antonio Frasconi. Artist photograph © National Academy of Design, New York/Bridgeman Images.

DON FREEMAN
Illustrations from *Corduroy* by Don Freeman, copyright © 1968 by Don Freeman. Used by permission of Viking Children's Books, an imprint of Penguin Young Readers Group, a division of Penguin Random House LLC. All rights reserved. Preliminary art courtesy of the Kerlan Collection, Children's Literature Research Collections, University of Minnesota Libraries. Artist photograph courtesy of Roy Freeman.

WANDA GÁG
Illustrations from *Millions of Cats* by Wanda Gág. Illustrations copyright © 1928 by Wanda Gág; copyright renewed © 1956 by Robert Janssen. Used by permission of G. P. Putnam's Sons, an imprint of Penguin Publishing Group, a division of Penguin Random House LLC. All rights reserved. Preliminary art courtesy of the Kerlan Collection, Children's Literature Research Collections, University of Minnesota Libraries. Portrait of the artist courtesy of the Kerlan Collection, University of Minnesota/Wikimedia Commons.

TIBOR GERGELY
Illustrations from *The Great Big Fire Engine Book* by Golden Books, "Pictures" by Tibor Gergely; copyright © 1950, 1959, renewed 1978, 1987 by Penguin Random House LLC. Used by permission of Golden Books, an imprint of Random House Children's Books, a division of Penguin Random House LLC. All rights reserved. Artist photograph courtesy of Linda Schreyer.

KATE GREENAWAY
Illustrations from *Under the Window* by Kate Greenaway are in the public domain. First

edition cover courtesy of Tom Nealon, Pazzo Books. Illustrations courtesy of the Miriam and Ira D. Wallach Division of Art, Prints and Photographs: Picture Collection, the New York Public Library Digital Collections and the Baldwin Library of Historical Children's Literature in the Department of Special Collections and Area Studies, George A. Smathers Libraries, University of Florida. Preliminary art courtesy of the de Grummond Collection. Artist photograph by Elliott & Fry, courtesy of Wikimedia Commons.

HERGÉ
Illustrations from *Tintin in America* by Hergé. Copyright © Hergé/Moulinsart 2018. Reprinted by permission. Artist photograph © AGIP/Bridgeman Images.

TANA HOBAN
Illustrations from *Shapes and Things* copyright © 1970 by Tana Hoban; used by permission of Simon & Schuster Children's Publishing. Cover and illustrations courtesy of the de Grummond collection. Artist photograph courtesy of Miela Ford.

HEINRICH HOFFMANN
Illustrations from *Struwwelpeter* illustrated by Heinrich Hoffman are in the public domain. First edition illustrations courtesy of Justin G. Schiller, Battledore Ltd. Preliminary art and l'enfant terrible sketch from the Struwwelpeter Museum courtesy of Daderot/Wikimedia Commons. Manuscript illustration, 1844, courtesy of the Germanisches Nationalmuseum. Artist photograph courtesy of WQUIrich/Wikimedia Commons.

CLEMENT HURD
Illustrations from *Goodnight Moon* by Margaret Wise Brown, illustrated by Clement Hurd. Copyright © 1947 and renewal copyright © 1975 Albert E. Clark III Living Trust dated April 4, 2013, and Peaceable Kingdom, LP. Used by permission of HarperCollins Publishers. Artist photograph courtesy of Thacher Hurd.

ROBERT INGPEN
Illustrations from *The Dreamkeeper* by Robert Ingpen, copyright © minedition AG, Zürich. All Rights reserved. Artist photograph courtesy of Robert Ingpen.

ROBERTO INNOCENTI
Illustrations from *The Adventures of Pinocchio* © Roberto Innocenti, reprinted by permission of The Creative Company, Mankato, MN. Artist photograph by Marcello Mencarini, courtesy of Bridgeman Images.

ISOL
Illustrations from *Petit, the Monster* by Isol. Courtesy of Groundwood Books Ltd., Toronto. www.groundwoodbooks.com. Artist photograph © Stefan Tell.

CROCKETT JOHNSON
Illustrations from *Harold and the Purple Crayon* by Crockett Johnson, illustrated by Crockett Johnson. Text copyright © 1955 by Crockett Johnson, copyright © renewed 1983 by Ruth Krauss. Used by permission of HarperCollins Publishers. Artist photograph courtesy of DragonflySixtyseven/Wikimedia Commons.

EZRA JACK KEATS
Illustrations from *The Snowy Day* by Ezra Jack Keats, copyright © 1962 by Ezra Jack Keats; copyright renewed © 1990 by Martin Pope, Executor. Used by permission of Viking Children's Books, an imprint of Penguin Young Readers Group, a division of Penguin Random House LLC. All rights reserved. Preliminary art © Ezra Jack Keats Foundation. Artist photograph courtesy of the Ezra Jack Keats Foundation.

VOJTĚCH KUBAŠTA
Illustrations from *Tip and Top Build a Motocar* © Vojtěch Kubašta. Reprinted with permission by the heirs of Vojtěch Kubašta and Albatros Media a.s. From the collection of Ellen G. K. Rubin, photographed by Nicole Neenan. Artist photograph © Maršál Stan, dated September 25, 1984.

CARL LARSSON
Illustrations from *Ett hem* by Carl Larsson are in the public domain. Illustrations courtesy of Nationalmuseum, Stockholm. First edition title page courtesy of Catfisheye/Wikimedia Commons. Artist photograph courtesy of Thuresson/Wikimedia Commons.

EDWARD LEAR
Illustrations from *A Book of Nonsense* by Edward Lear are in the public domain. © Look and Learn/Bridgeman Images. Preliminary art courtesy of the Frederick R. Koch Collection, Beinecke Rare Book and Manuscript Library, Yale University. Artist photograph courtesy of the photograph collection of Actia Nicopolis Foundation, Preveza, Greece.

SUZY LEE
Illustrations from *Shadow* © 2010 Suzy Lee. Used with permission of Chronicle Books LLC, San Francisco. Visit ChronicleBooks.com. Artist photograph and preliminary art courtesy of the artist. Copyright © Suzy Lee.

LEO LIONNI
Illustrations from *Inch by Inch* by Leo Lionni. Copyright © 1960, copyright © renewed 1988 by Leo Lionni. Reprinted with permission of The Lionni Family. Artist photograph from Penguin Random House.

DAVID MACAULAY
Illustrations from *Cathedral* reproduced with permission of Houghton Mifflin Harcourt. Preliminary art and artist photograph courtesy of David Macaulay.

JAMES MARSHALL
Illustrations from *George and Martha* written and illustrated by James Marshall, reprinted with permission of Houghton Mifflin Harcourt. Artist photograph courtesy of the Estate of James Marshall.

ROBERT MCCLOSKEY
Illustrations from *Make Way for Ducklings* by Robert McCloskey. Copyright © 1941, renewed © 1969 by Robert McCloskey. Used by permission of Viking Children's Books, an imprint of Penguin Young Readers Group, a division of Penguin Random House LLC. All rights reserved. First edition cover of *Make Way for Ducklings* by Robert McCloskey (Viking Press, 1941), collection of Barbara Elleman © 1941, 1969 Robert McCloskey. Preliminary art for *Make Way for Ducklings* courtesy of the Boston Public Library Arts Department (sketches) and the May Massee Collection, Emporia State University, copyright © 1941 Robert McCloskey. Used by permission. Photograph of Ducklings, Boston Public Garden, Boston, Massachusetts, courtesy of Rizka/Wikimedia Commons. Artist photograph from Penguin Young Readers Group.

LOTHAR MEGGENDORFER
Illustrations from *Internationaler Zirkus* by Lothar Meggendorfer are in the public domain. From the collection of Ellen G. K. Rubin, photographed by Nicole Neenan. Artist illustration from *Die Gartenlaube*, 1889, courtesy of Enomil/Wikimedia Commons.

ROGER MELLO
Illustrations from Meninos do Mangue by Roger Mello, originally published by Companhia das Letrinhas. Reprinted with permission. Artist photograph by Volnei Canonica.

YUYI MORALES
Excerpts from *Niño Wrestles the World* by Yuyi Morales. Copyright © 2013 by Yuyi Morales. Reprinted by permission of Roaring Brook Press, a division of Holtzbrinck Publishing Holdings Limited Partnership. All Rights Reserved. Artist photograph by Yisel Solange.

BRUNO MUNARI
Cover and illustrations from *Il venditore di animali* by Bruno Munari, © Bruno Munari. All rights reserved to Maurizio Corraini s.r.l. Artist photograph courtesy of Mondadori Portfolio/Getty Images.

WILLIAM NICHOLSON
Illustrations from *Clever Bill* by William Nicholson. Illustrations copyright © 1926 Desmond Banks. Published by Egmont UK Limited and used by permission. Artist photo courtesy of Opencooper/Wikimedia Commons.

HELEN OXENBURY

Illustrations from *We're Going on a Bear Hunt* written by Michael Rosen and illustrated by Helen Oxenbury. Illustrations copyright © 1989 by Helen Oxenbury; used by permission of Simon & Schuster Children's Publishing and reproduced by permission of Walker Books Ltd, London SE11 5HJ, www.Walker.co.uk. Preliminary art reprinted by permission of the artist, courtesy of Walker Books, Ltd. Artist photograph courtesy of Walker Books, Ltd.

KVĚTA PACOVSKÁ

Illustrations from *Eins, fünf, viele* by Květa Pacovská, copyright © minedition AG, Zürich. All Rights reserved. Artist photograph courtesy of Michael Neugebauer Publishing.

NATHALIE PARAIN

Illustrations from *Les jeux en images* courtesy of éditions MeMo. *Les jeux en images* by Nathalie Parain © éditions MeMo, 2014. Artist photograph courtesy of éditions MeMo.

JERRY PINKNEY

Illustrations from *John Henry* by Julius Lester and illustrated by Jerry Pinkney. Illustrations copyright © 1994 by Jerry Pinkney. Used by permission of Dial Books for Young Readers, an imprint of Penguin Young Readers Group, a division of Penguin Random House LLC. All rights reserved. Preliminary art for *John Henry* copyright © 1994 by Jerry Pinkney, courtesy of the estate of Jerry Pinkney. Artist photograph by Thomas Kristich, 2008.

NIKOLAI POPOV

Illustrations from *Warum* by and illustrated by Nikolai Popov © minedition AG, Zurich. All Rights reserved. Artist photograph courtesy of Michael Neugebauer Publishing.

BEATRIX POTTER

Illustrations from *The Tale of Peter Rabbit* by Beatrix Potter are in the public domain. Self-published 1901 edition cover and first edition cover courtesy of Christie's Images, Ltd. Illustrations courtesy of Justin G. Schiller, Battledore Ltd. Artist photograph courtesy of Express Newspapers/Getty Images.

ALICE AND MARTIN PROVENSEN

Illustrations from *The Glorious Flight: Across the Channel with Louis Bleriot July 25, 1909* by Alice and Martin Provensen, copyright © 1983 by Alice and Martin Provensen. Used by permission of Viking Children's Books, an imprint of Penguin Young Readers Group, a division of Penguin Random House LLC. All rights reserved. Preliminary art and photograph of the artists courtesy of Karen Provensen Mitchell.

HOWARD PYLE

Illustrations from *The Merry Adventures of Robin Hood* illustrated by Howard Pyle are

in the public domain. Cover and illustrations courtesy of Internet Archive. Artist photograph courtesy of the Frances Benjamin Johnston Collection, Library of Congress Prints and Photographs Division.

ARTHUR RACKHAM

Illustrations from *Grimm's Fairy Tales* illustrated by Arthur Rackham are in the public domain. Illustration of "Spindle, Shuttle, and Needle" courtesy of Black Morgan/Wikimedia Commons. Illustration of "The Nose Tree" courtesy of The Stapleton Collection/Bridgeman Images. Illustrations of "The Seven Ravens" and "Little Red Riding Hood" © British Library Board. All Rights Reserved/Bridgeman Images. Artist photograph courtesy of RaboKarbkian/Wikimedia Commons.

PAUL RAND

Illustrations from *Sparkle and Spin* © 2006 Ann and Paul Rand. Used with permission of Chronicle Books LLC, San Francisco. Visit ChronicleBooks.com. Photograph of Paul and Ann Rand courtesy of Daniel Lewandowski, https://www.paulrand.design/.

CHRIS RASCHKA

Book cover and illustrations from *Charlie Parker Played Be Bop* by Chris Raschka. Copyright © 1992 by Christopher Raschka. Reprinted by permission of Orchard Books, an imprint of Scholastic Inc. Preliminary art and artist photograph courtesy of Chris Rascka.

H. A. REY AND MARGRET REY

Illustrations from *Curious George* reprinted with permission of Houghton Mifflin Harcourt. Preliminary art and artists photograph courtesy of the de Grummond Collection, reprinted with permission of the Estate.

FEODOR ROJANKOVSKY

Illustrations from *Daniel Boone: Historic Adventures of an American Hunter among the Indians*, edited by Esther Averill and Lila Stanley, illustrated by Feodor Rojankovsky. Reprinted with permission of the estate of Feodor Rojankovsky. First published in 1931 by Domino Press, Paris. Artist photograph courtesy of Wieralee/Wikimedia Commons.

ROBERT SABUDA

Illustrations from *The Wonderful Wizard of Oz* copyright © 2000 by Robert Sabuda; used by permission of Simon & Schuster Children's Publishing. First edition cover and artist photograph courtesy of Robert Sabuda.

ANTOINE DE SAINT-EXUPÉRY

Illustrations from *The Little Prince* reproduced with permission of Houghton Mifflin Harcourt. Front cover of *Le Petit Prince* © Archives Charmet/Bridgeman Images. Half-title page photo © Christie's Images, Ltd./Bridgeman

Images. Interior illustrations © British Library Board. All Rights Reserved/Bridgeman Images. Artist photograph © Tallandier/Bridgeman Images.

RICHARD SCARRY

Illustrations from *Richard Scarry's Best Word Book Ever* by Richard Scarry, copyright © 1963 and renewed 1991 by Penguin Random House, LLC. Used by permission of Golden Books, an imprint of Random House Children's Books, a division of Penguin Random House LLC. All rights reserved. Artist photograph courtesy of Penguin Random House.

BINETTE SCHROEDER

Illustrations from *Lupinchen* by Binette Schroeder. Courtesy of NordSüd Verlag AG, Franklinstrasse 23, CH 8050 Zürich. Reprinted with permission. Artist photograph © Stephanie von Becker.

RONALD SEARLE

Illustrations from *Down with Skool!* by Geoffrey Willans and Ronald Searle, copyright © 1953 Ronald Searle Cultural Estate. Reproduced by kind permission of the Ronald Searle Cultural Estate and the Sayle Literary Agency. Original illustration courtesy of the private collection of Robert Forbes. Artist photograph © Zbigniew Fitz.

BRIAN SELZNICK

Book cover and illustrations from *The Invention of Hugo Cabret* by Brian Selznick. Copyright © 2007 by Brian Selznick. Reprinted with permission of Scholastic Inc. Preliminary art photographs courtesy of Brian Selznick, 2022. Artist photograph by Slimane Lalami.

MAURICE SENDAK

Illustrations from *Where the Wild Things Are* by Maurice Sendak, illustrated by Maurice Sendak. Copyright © 1963 by Maurice Sendak, copyright renewed 1991 by Maurice Sendak. Used by permission of HarperCollins Publishers. Artist photograph courtesy of Clarence Patch/Wikimedia Commons.

DR. SEUSS

Book cover and illustrations from *The Cat in the Hat* by Dr. Seuss, trademark™ and copyright © by Dr. Seuss Enterprises, L.P. 1957, renewed 1985. Used by permission of Random House Children's Books, a division of Penguin Random House LLC. All rights reserved. Artist photograph by Al Ravenna, courtesy of the Library of Congress Prints and Photographs Division.

ERNEST H. SHEPARD

Illustration from *Winnie-the-Pooh* by A. A. Milne, illustrated by E. H. Shepard. Line illustration copyright © E. H. Shepard, 1926. Reproduced with permission from Curtis Brown Group Ltd on behalf of The Shepard Trust.

"Winnie the Pooh . . . And Piglet" (pencil on paper) courtesy of Lyon & Turnbull/Bridgeman Images. Artist photograph by Howard Coster © National Portrait Gallery, London.

PETER SÍS
From *The Tree of Life: Charles Darwin* © 2003 Peter Sís. Reprinted by permission of Farrar, Straus and Giroux Books for Young Readers. All Rights Reserved. Preliminary art courtesy of the Peter Sís. Artist photograph © Vít Bělohradský.

ESPHYR SLOBODKINA
Illustrations from *Caps for Sale* by Esphyr Slobodkina, Tamara Schildkraut, illustrated by Esphyr Slobodkina. Read by: Ann Marie Mulhearn. Text copyright © 1940 and 1947 Esphyr Slobodkina. Copyright renewed 1968 by Esphyr Slobodkina. Cover art copyright © 1940 and 1947 Esphyr Slobodkina. Copyright renewed 1968 by Esphyr Slobodkina. Preliminary art and artist photograph courtesy of the Slobodkina Foundation.

LANE SMITH
Illustrations from *The Stinky Cheese Man: And Other Fairly Stupid Tales* by Jon Scieszka and illustrated by Lane Smith. "Illustrations" by Lane Smith, copyright © 1992 by Lane Smith. Used by permission of Viking Children's Books, an imprint of Penguin Young Readers Group, a division of Penguin Random House LLC. All rights reserved. Preliminary art reproduced with permission of the artist. Author photograph (headshot) by Bob Shea. Author photograph (with painting) courtesy of the artist.

WILLIAM STEIG
Illustrations from *Sylvester and the Magic Pebble* copyright © 1987 by William Steig; used by permission of Simon & Schuster Children's Publishing. Preliminary art reprinted with permission of the Estate of William Steig. Artist photograph courtesy of the Estate of William Steig.

SHAUN TAN
Book cover and illustrations from *The Arrival* by Shaun Tan. Copyright © 2006 by Shaun Tan. Reprinted with permission of Scholastic Inc. Artist photograph courtesy of Kaiketsu/Wikimedia Commons.

GUSTAF TENGGREN
Illustrations by Gustaf Tenggren; from *The Poky Little Puppy* by Janette Sebring Lowrey. Copyright © 1942, renewed 1970 by Penguin Random House LLC. The Poky Little Puppy is a trademark of Penguin Random House LLC. Used by permission of Golden Books, an imprint of Random House Children's books, a division of Penguin Random House LLC. All rights reserved. Preliminary art and artist photograph courtesy of the Kerlan Collection, Children's Literature Research Collections, University of Minnesota Libraries.

JOHN TENNIEL
Illustrations from *Alice's Adventures in Wonderland* by John Tenniel are in the public domain. Illustrations © British Library Board. All Rights Reserved/Bridgeman Images. Line illustration of Alice © Lebrecht Authors/Bridgeman Images. Artist self-portrait courtesy of Grenavitar/Wikimedia Commons.

WALTER TRIER
Illustrations from *Emil and the Detectives* illustrated by Walter Trier. Copyright © Atrium Verlag AG, Zürich 1935. Artist photograph courtesy of Martin wolf/Wikimedia Commons.

TOMI UNGERER
Illustrations from *The Beast of Monsieur Racine* by Tomi Ungerer. First published by Farrar, Straus and Giroux, New York, 1971. Copyright © 1972 Diogenes Verlag AG, Zürich, Switzerland. All rights reserved. Reproduced with permission. Artist photograph courtesy of Bridgeman Images.

CHRIS VAN ALLSBURG
Illustrations from *Jumanji* reproduced with permission of Houghton Mifflin Harcourt. Artist photograph courtesy of Houghton Mifflin Harcourt.

LEONARD WEISGARD
Illustrations from *The Noisy Book* by Margaret Wise Brown, illustrated by Leonard Weisgard. Copyright © 1939 by Margaret Wise Brown. Copyright © renewed 1967 by Robert Brown Rauch. Used by permission of HarperCollins Publishers. Preliminary art and artist photography courtesy of the Weisgard family.

WALTER WICK
Book cover and illustration from *I Spy* by Jean Marzollo, photographs by Walter Wick. Text copyright © 1991 Jean Marzollo. Photographs copyright © 1991 by Walter Wick. Reprinted by permission of Scholastic Inc. Preliminary art courtesy of the artist: Wick Studio Hardware; Fasteners; Games Cover. Walter Wick Portrait, 2012, courtesy of Walter Wick.

DAVID WIESNER
Illustrations from *Tuesday* reproduced with permission of Houghton Mifflin Harcourt. Preliminary art and artist photograph courtesy of David Wiesner.

MO WILLEMS
Illustrations from *Knuffle Bunny: A Cautionary Tale* by Mo Willems. Text and illustrations copyright © 2004 by Mo Willems. Reprinted by permission of Disney • Hyperion Books, an imprint of Disney Book Group, LLC. All rights reserved. Preliminary art copyright © 2004 by Mo Willems. Used with permission. Artist photograph © Trix Willems.

GARTH WILLIAMS
Illustrations from *Charlotte's Web* by E. B. White, Kate DiCamillo, illustrated by Garth Williams. Copyright © 1952 by E. B. White. Text copyright renewed 1980 by E. B. White. Illustrations copyright © renewed 1980 by the Estate of Garth Williams. Cover art copyright © renewed 1980 by the Estate of Garth Williams. Used by permission of HarperCollins Publishers. Cover artwork courtesy of Justin G. Schiller, Battledore Ltd. Artist photographs contributed by Leticia and Dilys Williams.

N. C. WYETH
Illustrations from *Treasure Island* illustrated by N. C. Wyeth are in the public domain. Cover illustration courtesy of Bridgeman Images. Illustrations courtesy of Internet Archive. Artist photograph courtesy of Charles Scribner's Sons Art Reference Department records, 1839-1962, Archives of American Art, Smithsonian Institution.

ZHANG LEPING
Illustrations from *Wanderings of Sanmao* by Zhang Leping. Used with permission. First edition cover and artist photographs courtesy of Mr. Zhang Weijun.

ZHU CHENG-LIANG
Illustrations from *A New Year's Reunion* by Yu Li-Quong, illustrations by Zhu Cheng-Liang. Text copyright © 2007 by Yu Li-Quong. Illustrations copyright © 2007 by Zhu Cheng-Liang. Reproduced by permission of the publisher, Candlewick Press, on behalf of Walker Books, London. Artist photograph courtesy of Professor Zhu Ziqiang.

LISBETH ZWERGER
Illustrations from *Hansel and Gretel* by Brothers Grimm and Lisbeth Zwerger, copyright © minedition AG, Zürich. All Rights reserved. Artist photograph courtesy of Michael Neugebauer Publishing.

Every reasonable effort has been made to obtain all permissions and supply complete and correct credits; if there are errors or omissions, please contact Abrams Books so that corrections can be addressed in any subsequent edition.

Editor: Chelsea Cutchens
Designer: Darilyn Lowe Carnes
Managing Editor: Lisa Silverman
Production Manager: Alison Gervais

Library of Congress Control Number: 2018958790

ISBN: 978-1-4197-3898-2
eISBN: 978-1-68335-659-2

Text copyright © 2023 Leonard S. Marcus
Image credits can be found on pages 427-431

Jacket © 2023 Abrams

Printed and bound in Malaysia
10 9 8 7 6 5 4 3 2 1

Abrams books are available at special discounts when purchased
in quantity for premiums and promotions as well as fundraising or
educational use. Special editions can also be created to specifica-
tion. For details, contact specialsales@abramsbooks.com or the
address below.

Abrams® is a registered trademark of Harry N. Abrams, Inc.

ABRAMS The Art of Books
195 Broadway, New York, NY 10007
abramsbooks.com